Film on the Faultline

Film on the Faultline

Edited by Alan Wright

intellect Bristol, UK / Chicago, USA

First published in the UK in 2015 by
Intellect, The Mill, Parnall Road, Fishponds, Bristol, BS16 3JG, UK

First published in the USA in 2015 by
Intellect, The University of Chicago Press, 1427 E. 60th Street,
Chicago, IL 60637, USA

Copyright © 2015 Intellect Ltd

All rights reserved. No part of this publication may be reproduced, stored in a retrieval system, or transmitted, in any form or by any means, electronic, mechanical, photocopying, recording, or otherwise, without written permission.

A catalogue record for this book is available from the
British Library.

Copy-editor: MPS Technologies
Cover designer: Stephanie Sarlos
Production manager: Claire Organ
Typesetting: Contentra Technologies

Print ISBN: 978-1-78320-433-5
ePUB: 978-1-78320-435-9
ePDF: 978-1-78320-434-2

Printed and bound by Hobbs, UK

Contents

Introduction: Film Theory as Seismic Research — 1
 Alan Wright

Chapter 1: A Tale of Two Cities: San Francisco 1906 and *Earthquake in Adelaide* — 21
 Stephen Morgan

Chapter 2: The Wrath of Heaven: The Great Kantō Earthquake and Japanese Cinema — 47
 Alex Bates

Chapter 3: Earthquakes in Film: Exploring Visualization Strategies — 71
 Ozge Samanci

Chapter 4: The Virtual of Disaster: Science, Politics and Tectonics in Roland Emmerich's *2012* — 93
 Axel Andersson

Chapter 5: *Aftershock*: The Cultural Politics of Commercializing Traumatic Memory — 109
 Jinhua Li

Chapter 6: The Just Distance: Abbas Kiarostami and the Aftermath of Devastation — 125
 Steve Choe

Chapter 7: Towards a Natural History of the Cinema: Walter Benjamin, Film and Catastrophe — 147
 Allen Meek

Chapter 8: Seismic Energy and Symbolic Exchange in *When a City Falls* — 163
 Kevin Fisher

Chapter 9:	Landscapes in Conflict in Contemporary Chilean Film Antonia Girardi	181
Chapter 10:	The Earth Still Trembles: On Landscape Views in Contemporary Italian Cinema Giorgio Bertellini	197
Chapter 11:	Cinema in Reconstruction: Japan's Post 3.11 Documentary Joel Neville Anderson	215
Chapter 12:	Ordinary Extraordinary: 3.11 in Japanese Fiction Film Eija Niskanen	233
Chapter 13:	Earthquake/ΣΕΙΣΜΟΣ Yuri Averof	247
Chapter 14:	Home in a Foreign Land Nora Niasari	253
Chapter 15:	*Moving*: An Interview with Park Kiyong Zhou Ting-Fung	259
Chapter 16:	"What I Really Saw Could Not Possibly Be Reflected in a Movie": Abbas Kiarostami on *Life and Nothing More ...* Hossein Najafi	275
Chapter 17:	*Tres Semanas después/*Life Goes On José Luis Torres Leiva	283
Notes on Contributors		289

A portion of the royalties for this book will be donated to the relief fund for the earthquake in Nepal.

Introduction: Film Theory as Seismic Research

Alan Wright

Wānanga Tū, Wānanga Ora

Ko Rūaumoko e ngunguru nei!	Hark to the rumbling of the Earthquake God!
Hī Au! Au! Aue hā!	Feel the energy!
Ko Rūaumoko e ngunguru nei!	It is Rūaumoko who trembles and stirs!
Hī Au! Au ! Aue hā!	Feel the energy!
I a haha	Take it in
Ko te iwi Māori e ngunguru nei!	Hark to the awe of Māori people!
Hī Au! Au! Aue hā!	Feel the energy!
Ko te Waipounamu e ngunguru nei!	It is the Southern nation that trembles and stirs!
Hī Au! Au ! Aue hā!	Feel the energy!
I a haha	Take it in
Ko te whare wānanga e ngunguru nei!	Hark to the rumbling of the places of learning!
Hī Au! Au! Aue hā!	Feel the energy!
Ko te Wānanga o Waitaha e ngunguru nei!	It is University of Canterbury that trembles and stirs!
Hī Au! Au! Aue hā!	Feel the energy!
I a haha	Take it in
Tūruki, tūruki	Take action
Paneke, paneka	Make a difference
Haere mai te toki	Bring forth the challenge
Haumi ē, hui ē, taiki ē	Gather, bind, all is set

The kōrero pūrākau (ancient stories) refer to the time when the sky father Ranginui was separated from the earth mother Papatuanuku. They had an unborn child, Rūaumoko, who was still inside his mother's womb. The pūrākau assert that today he remains there, sometimes moving and turning inside Papatuanuku. When he moves, the earth shakes and so he has become known as the god of earthquakes.

Rūaumoko is invoked in this way usually on ceremonious occasions to signal respect for the mana of one to another. In the final analysis, turbulence is followed by calm.[1]

I did not understand the words at the time but I must have felt their power. Their meaning would only become apparent through the act of writing. They found their place at the beginning of this book, whether by fate or coincidence, after the decision had been made to compile the current collection of essays and interviews. The original idea for *Film on the Faultline* had been generated by the experience of excitement, exhaustion and distress in the days following the violent earthquake in Christchurch, the second largest city in New Zealand, on February 22nd, 2011.

The Canterbury earthquake, like many other seismic disasters of such magnitude, left a host of powerful images and memories in its wake. What happened then is now a matter of record: you can read about the event online or in news reports or watch video clips on Youtube or Facebook that were filmed at the time on mobile devices and cameras. You can see buildings collapse and people running this way and that in fear and confusion. There are pictures of a vast cloud of dust rising over the city, of cars and buses under rubble, of the Christchurch Cathedral as its walls crumbled. TV cameras, stationed beneath the blackened shell of the CTV Building, the iconic epicentre of the disaster, kept vigil as rescue teams searched the wreckage for survivors. Many of the building's occupants, including 70 foreign students, died in the earthquake.

Then, on March 11th, the images from Japan overwhelmed us...

*

The haka, which stands here in the place of a poetic invocation, was performed a few weeks after the earthquake at an emergency briefing for university staff in preparation for a return to work. Amidst the speeches on safety and security and the strategic plan for the progressive resumption of services, a group of Māori colleagues and friends quietly recited the *waiata* [Māori song] in *te reo*. It struck a chord (with me at least). The collective performance of the *waiata* offered a poignant testament, a public acknowledgement of the loss, however deferred, that everyone had experienced as a result of the earthquake. It also revealed the extent to which the discourse of crisis management and operational planning was at odds with a more intimate and immediate understanding of the meaning of the disaster. This vague premonition was confirmed much later upon reading the text of the *waiata* in English.

The words of the haka express a particular relationship to power. They demand respect for the awesome power of Rūaumoko, the god of earthquakes, but they also encourage an awareness of the creative potential released in the encounter between human agency and natural disaster. By affirming the collective spirit of the people [*tū*] and "the connection of all living things" [*ora*], the *waiata* converts the deadly power of the quake into a source of vital energy. It conveys, with the full force of a categorical imperative, the need to recognize and realize the existential, ethical, political and material dimension of the earthquake as a catastrophic event. The earthquake places the very principle of being at stake. The challenge, as laid down by the Rūaumoko haka, is to gather and bind the

seismic energy of the quake as a positive source for action rather than to limit or fix its creative promise.[2]

*

After the earthquake, our colleagues in the Sciences and Engineering brought their knowledge and expertise to bear upon the events in Christchurch. They did a tremendous job in analysing the risks and results of seismic activity. They played an important role in the media and other public discussions and have made a remarkable contribution to the city's recovery. The Arts and Humanities have much to contribute as well to an understanding of the earthquake from a social, cultural, historical and theoretical perspective. An earthquake is a conceptual event of telluric proportions. In many respects, the political, ethical and ontological categories that ground the project of modernity in its current globalized form are unthinkable beyond the limits of catastrophe. The great Lisbon earthquake of 1755 is often cited as the mythic catalyst for many of the foundational texts of the Enlightenment, such as Kant's "Analytic of the Sublime" and Voltaire's *Candide*. The senseless destruction, pain and human suffering wrought by the disaster could only be comprehended from the vantage point of a secular frame of reference, a position of critical distance and human understanding as opposed to one of divine judgment or sovereign authority. "Through the power of reason and its moral law," Gene Ray writes in reference to the Kantian Sublime, "the great evil of natural catastrophe is elevated, transfigured, and 'sublimed' into a foil for human dignity."[3] But a trembling, a shaking and shattering very much on the order of an earthquake, *Enschütterung* is the term used by Kant, signals the immanent persistence of a moment or movement of breakdown at the very core of Enlightenment thought.[4]

If Lisbon supplied a new conceptual paradigm for Goethe, Voltaire, Kant and their contemporaries, the spate of earthquakes between 2010 and 2012 could serve, perhaps, a similar function in relation to the traumatic legacy of modernity and its most recent variations. Indeed, after the earthquake, Christchurch felt like it had more in common not only with Haiti or Chile but also with Athens and Cairo. The global financial crisis or the Arab Spring suddenly seemed more real, their cause and effects more urgently visible in the ruined facades of shop fronts and businesses in what remained of the so-called CBD. For a moment, the naked truth was apparent. One could read the natural history of destruction in the skeletal remains of damaged buildings and eerily empty streets.

The earthquake marks the violent irruption of nature into history. It functions less as an exceptional occurrence, a sublime phenomenon, than as a symptomatic event. In this respect, the work of Giorgio Agamben provides a philosophical model for conceptualizing the disaster whose first tremors were felt in Lisbon and the subsequent state of emergency which continues to this day. *Homo Sacer*, Agamben's most well known book, represents a tectonic shift in exposing the fundamental fracture that defines the political and ethical life of the western subject. Agamben argues that the invasive action of biopolitics lays bare a profound fault in the structure of being. It constitutes the domain of human life as both the object and subject of power.

Homo Sacer opens with the reflection that the ancient Greeks "had no single term to express what we mean by the word 'life.'"[5] They maintained a strict distinction between the simple natural life shared by all living things (*zoē*) and the qualified form of existence lived by men (*bios*), that is, the particular mode of living of the citizen in the polis or the philosopher in relation to the "good life" *(eu zēn)*.[6] The metaphysical health and happiness of the species reside in the exclusion of "bare life," as Agamben calls it, from the human community. At the same time, however, "bare life remains included in politics in the form of the exception," as that which determines the limits of sovereignty and subjectivity.[7] Agamben asserts that "the entry of *zoē* into the sphere of the *polis* […] constitutes the decisive event of modernity."[8] The original schism that formed the identity of *homo sacer* appears now as the "biopolitical fracture" that defines all human life on planet Earth.

A symbolic rupture of a similar nature is also evident at the level of language. Antonio Negri's radical critique of capital and empire turns upon the difference in meaning between *potenza* and *potere*. Agamben's proposition that potentiality exists as a capacity to *be* or *not be*, that it holds itself in reserve despite the passage to actuality, depends upon the same crucial conceptual distinction.[9] The philosophical history of this productive tension runs like a submerged faultline from Aristotle and Spinoza to Walter Benjamin and Gilles Deleuze.

The English term 'power' corresponds inadequately to its more nuanced equivalents in Italian [*potenza* and *potere*], French [*puissance* and *pouvoir*] and Latin [*potentia* and *potestas*]:

> *Potenza* resonates often with implications of potentiality as well as with decentralised or mass conceptions of force or strength. *Potere,* on the other hand, refers more typically to the might or authority of an already structured and centralised capacity, often an institutional apparatus like the state.[10]

Furthermore, as Léopold Lambert observes in his commentaries on Spinoza, "*potestas* needs indeed a referent to dominate or be dominated by to effectuate itself."[11] Its existence seeks an object. Its strength is directed outwards towards people and things. *Potentia,* to the contrary, expresses itself as "a capacity or an intensity," the form in which "a relationship to the whole world," the composition of a "harmony," is conceived.[12] Spinoza calls this state of being, Joy.

In *L'abécédaire,* Claire Parnet asks Gilles Deleuze to speak about the concept of Joy.[13] For Deleuze, "Power [*pouvoir*] is always an obstacle blocking the realization of powers of action [*puissance*]," a means of separating subjects "from what they are capable of doing." Joy, on the other hand, "is everything that consists in fulfilling a power of action [*puissance*]." Deleuze explains himself by means of an image of natural destruction:

> The typhoon is a power [*puissance*], it must delight in its soul but […] it's not in destroying houses that it delights, it's in its own being. Taking delight [*la joie*] is always delighting in being what one is, that is, in having reached where one is.

After a long theoretical preamble, we return to our point of departure. The typhoon possesses the same sense of *potenza* or *puissance* as Rūaumoko. All is set now: "Feel the energy! Take it in. Take action."

*

Film has always played a crucial role in the imagination of disaster. From its earliest days, cinema has been fascinated by images of ruin and collapse. The camera registered the impact of seismic events in the immediate aftermath of the 1906 San Francisco earthquake. In New Zealand, footage from the Napier earthquake of 1931 shows the destruction of the town. In *Green Dolphin Street* (Saville, 1947), Hollywood even recast colonial New Zealand as the fictional setting for a special effects megaquake and tsunami. These films, when viewed from the perspective of the temporality of disaster, now contain an unrealized historical charge.

An early film by the Lumière Brothers, *The Demolition of a Wall*, is a graphic example of cinema's fascination with ruin and collapse. Johannes von Moltke writes that "as peculiarly modern forms of grasping contingency and temporality, they [both] activate ways of knowing the past and its relation to the present."[14] The Lumière film "captures a transient moment" – the work of destruction, the collapse of the wall – and then reconstitutes the event by reversing the course of time. The original image is mechanically restored as the film is played backwards. Ruins also reveal the variable nature of time. The ruin serves as a visual emblem of contingency and impermanence but it also stands as an evocative memorial to the foreclosed possibilities of the past, "the memory traces of an abandoned set of futures."[15] The ruin presents an idea of the object as it once was and will soon come to be.

Both the ruin and the film image preserve an indexical relationship to reality, a material record of any given moment in time or space. The realist tendency of the cinematic image, as famously argued by Siegfried Kracauer and André Bazin, invests the representational function of film with an ontological substance. Film supplied the ground for a redemptive experience of temporality. Mary Ann Doane notes that "the indexical sign is the imprint of a once-present and unique moment, the signature of temporality."[16] The cinematic image retains the visible traces of memory, mortality and mutability in the same way as geological strata display an organic record of the natural history of the earth or the ruin portrays a symbolic image of cultural decline and decay. The concept of time, in all of these instances, corresponds to the state of "petrified unrest," as described by Walter Benjamin. Film acts as the medium, therefore, for recovering a sense of historical time as fractured, discontinuous and multivalent.

Charles Darwin's account of the 1835 Concepciòn earthquake in Chile conveys a comparable feeling of dislocation and disorientation:

> A bad earthquake at once destroys our oldest associations: the earth, the very emblem of solidity, has moved beneath our feet like a thin crust over a fluid; – one second of time

has created in the mind a strange idea of insecurity, which hours of reflection would not have produced.[17]

The scientific observer is plunged into a vortex of cognitive and conceptual uncertainty. The disruptive effect of the earthquake provokes an epistemic crisis. Time, as a measure of distance and duration, is confounded in an instant. The familiar properties of chronology and causality – continuity, progression and permanence – are momentarily, perhaps finally, suspended:

> It is a bitter and humiliating thing to see the works, which have cost man much time and labour, overthrown in one minute; yet compassion for the inhabitants was almost instantly banished, by the surprise in seeing a state of things produced in a moment of time, which one was accustomed to attribute to a succession of ages.[18]

Darwin becomes conscious of the earthquake as a temporal catastrophe, as well as a human disaster, an event that exists as a state of exception within the order of time. The rubble and wreckage left in the wake of a destructive earthquake clears the way for a radical shift in the perceptual and conceptual experience of temporality. A revolutionary conception of history is inscribed within the phenomena of natural destruction. The passage of historical time suddenly appears as an active and unstable procedure of rupture and renewal. The earthquake opens up a fissure in the constitution of time.

The configuration of space is subject to a similar dialectical tension under seismic conditions. The opposition between stillness and motion is simultaneously sustained and annulled in the same way as the interval between past, present and future, as experienced by Darwin, is condensed and dissolved. Solid forms and structures hold together because of the constant threat of their own disintegration. In this connection, Heinrich von Kleist makes an interesting critical observation upon the architectural integrity of the arch as a material and conceptual object:

> I was walking back to the city, lost in my thoughts, through an arched gate. Why, I asked myself, does this arch not collapse, since after all it has no support? It remains standing, I answered, *because all the stones tend to collapse at the same time* ...[19]

In passing through the arch, Kleist steps across the threshold of modernity. He enters the terrain of intellectual, historical and social breakdown that informs the thinking of the Enlightenment. Kleist's archway provides a useful analogy, therefore, for the cracks in the foundation of knowledge and belief that open up a new way of seeing the world. Jane Madsen adopts Kleist's remark as an arresting poetic image for "the space of collapse." The apparent stability of the arch is a function of a spatial and temporal mirage: "an arch as a technical, engineered, construction is collapse held in temporal abeyance."[20] Its demise is indefinitely deferred yet its destruction is always imminent. The arch stands as a monument, Madsen

argues, to its own "immanent and actual collapse." As Kleist demonstrated in his fictional work and in his life, disorder, disruption and fragmentation is the true condition of existence. Catastrophe is the order of the day.

Kleist, of course, is also the author of "The Earthquake in Chile." In that story, Jerónimo, a prisoner who is awaiting his lover Josefa's execution in despair, is about to hang himself from a pillar when the earthquake strikes:

> [G]reat cracks appeared in the walls all round him, the whole edifice toppled toward the street and would have crashed down into it had not its slow fall been met by that of the house opposite, and only the arch thus formed by chance prevented its complete destruction.

The earthquake breaks the magic spell that holds things together. Beams, bricks and masonry topple along with the institutional and ideological structures that they house – the Family, the Church and the Law. Every arch, as Kleist shows, draws its strength and solidity from a fundamental design fault. Its downfall is its destiny. No longer subject to the constraints of spatial and formal conformity, *all the stones ... collapse at the same time*. "At the very centre of the catastrophe," as Madsen notes, Kleist creates a paradoxical space: the scene of destruction is also the site of renewal and release. Jerónimo's survival, as short-lived as it will be, is insured by the deconstructed remnants of buildings and walls. The disaster produces a "provisional architecture" (27), a makeshift refuge, a temporary passage or portal through which the subject gains access to a totally reconstituted vision of self and other, space and place, society and morality, life and death, being and nothingness. Freedom, for Kleist and his characters, only becomes possible at the moment of collapse.

The frame provides an obvious cinematic equivalent for the arch as described by Kleist. The "terrain of collapse," as explored by Jane Madsen, could serve as the ideal location for a film set. If the arch, in its formal and technical perfection, contains the foundations of its own ruin, then the elements of cinema's dissolution (and ultimate restitution) may be enclosed within the borders of the frame. The essential gesture of cinema will be to work "the limits of its own milieu," in an effort to "eclipse the propriety of its boundaries," as Michael Tawa proposes in *Agencies of the Frame: Tectonic Strategies in Cinema and Architecture*.[21] It is not a matter of eliminating or escaping the constraints of the medium but of employing the constitutive elements of cinema – time and space, motion and materiality – in a way that revises the conventional understanding of film as a material and conceptual practice.

Tawa pays close attention to the tectonic principles of film, those aspects of cinema as an art of assemblage, construction and conveyance, in order to theorize its immanent qualities:

> Cinema frames places, landscapes and environments. It organizes the screen spatially in particular ways. It modulates duration and montage to construct specific temporalities.

It manipulates light, sound and the technologies of film production to convey particular ambiances and atmospheres.[22]

But how might film displace or deflect the laws of "chronological, sequential and linear" logic, for instance, while remaining within their limits? Can it, Tawa wonders, "constitute what is proper to cinema and at the same time what is least kinematic"?[23] In other words, Tawa seems to suggest, cinema might disclose the shadowy presence of its own double, the ghostly image of the Other.

Tawa cites Tarkovsky's method of representing dreams or memories as an example of an effective tectonic strategy. According to Tarkovsky, one must not replicate "the vagueness, the opacity, the improbability of a dream" with "elaborate devices" or mysterious effects; rather, the dream "must be shown with the utmost precision" by means of "unusual and unexpected combinations, and conflicts between, entirely real elements."[24] Tawa concludes that

> in order to convey the real character of a situation, event, object, place or world […] there must be a significant element of unreality or artificiality, of playing with or distorting the "realistic" in such a way as to amplify its "real" content.[25]

There is no point in imitating the condition of a dream. Its substance and sense cannot be expressed through formal invention or literal translation. For the real to appear, for a dream to seem real, it must contain a grain of difference or, in our terms, a slight fault. "Cinema must expose reality," Tarkovsky insists, "not cloud it." It does so by placing the emphasis on the tectonics of film, by engaging and experimenting with the material and technical resources of cinema. Only in this way, Tawa asserts, will "the foundational and familiar existential characteristics, elements and processes of reality […] convey [their] unsettling and uncanny dimensions." His final comment resonates with many of my earlier statements about the strange temporal and spatial disturbance that the earthquake produces in the fabric of reality: "[T]he most unsettling, the most unfamiliar and extraordinary experiences happen to take place precisely in the midst of the most ordinary and mundane of circumstances."[26]

The chain of reference from Darwin to Kleist to Tarkovsy, from the quake to the ruin, from the arch to the frame, leads to some surprising conclusions about the tectonic structure of cinema. Tawa's important book suggests a method and a model for considering film theory as a branch of seismic research. I have merely adopted the conceptual pun at the heart of his work, the idea of cinema as a "tectonic strategy," and used it as a critical analogy for an analysis of the earthquake as a subject for film. *Film on the Faultline* positions itself, therefore, as a preliminary entry in the emergent field of "cinetectonica."

*

The earthquake, as an actual or imaginary event, places the cinematic apparatus under immense stress. It takes considerable conceptual and material effort to withstand its impact.

Under such extreme conditions, the essays and accounts in *Film on the Faultline* maintain a critical focus upon the limits and possibilities of cinema as a mode of representation and expression. They unsettle easy assumptions and accepted notions about contemporary cinema by shifting the focus away from the privileged objects of critical and cultural acclaim towards what may seem like a more peripheral set of concerns. The earthquake indicates a fissure, a rupture that forces us to reconsider our established notions of film history and criticism. Faultlines, by definition, are located on the edges of tectonic plates. Film history and theory too must confront the tectonic shift in focus away from the centre (Europe, North America) towards the periphery (the Southern Cone, the Pacific Rim, China, Central Asia and the Caucasus, the Mediterranean Basin and North Africa).

From within the context of Film Studies as an academic discipline, the earthquake seems a topic of minor or marginal interest, a novelty item at best. Yet film-makers from across the globe have shown how the aftermath of a major quake has forever transformed lives and communities, often with devastating effect. The films discussed in this book cover a wide range of genres and styles (horror, melodrama, art cinema, essay film, documentary, animation, autobiography and, of course, the disaster film) and include films from all over the world (Iran, Italy, Greece, China, Japan, Korea, Chile, the United States, Australia and New Zealand). The essays included in the collection address a number of vital critical issues; aside from questions of narrative form, genre and style, they engage with cinema as a form of popular memory and personal testimony, with the problem of modernity and history, with heritage, home and exile, mourning, trauma and survival, with landscape and community, urban planning and renewal, with local and national politics, with racial, ethnic and indigenous experience of natural disaster, with disaster as media spectacle, with banality, catastrophe and everyday life, with the temporality of crisis, the event and emergency.

On the whole, *Film on the Faultline* covers relatively unexplored territory. A number of books have appeared on the disaster film but they are primarily interested in genre and visual spectacle.[27] The earthquake is generally treated as an incidental entry in the catalogue of cinematic disasters. *Film on the Faultline* is the first academic text to gather a theoretically informed collection of essays on the subject. The book takes a unique and innovative approach, both in its subject matter and method, because it seeks to maintain a dialogue between cinema as an object of critical study and film as a means of creative practice. For this reason, *Film on the Faultline* includes a selection of statements and interviews with film-makers alongside a diverse sample of essays by film scholars and theorists of various critical and cultural backgrounds. Most, but by no means all, come from regions afflicted by earthquakes.

Adelaide, for instance, could hardly be classified as a seismic hotspot, yet in 1913 it became the site for an unusual cinematic experiment. Stephen Morgan places *Earthquake in Adelaide*, a short film by Harry Krischock, a local photographer and actuality film cameraman, in the context of early media representations of earthquakes and other natural disasters, particularly the widely circulated still and moving images of the aftermath of the Great San Francisco Earthquake of 1906. Krischock simulated the effects of an earthquake

on an Australian city through camera effects and trick photography, blurring the lines between fiction and non-fiction. Morgan draws upon extensive archival research to present a fascinating account of early film production and exhibition in Australia, as well as an historical analysis of the role that film played in the presentation of current events as a subject for cinematic spectacle.

The 1923 Kantō Earthquake wiped out the burgeoning Japanese film industry. Alex Bates addresses the wave of films made in the aftermath of the quake that adopted the popular discourse of *tenken* – heavenly punishment – and adapted it in the form of the melodrama. Many of these films drew upon accounts of real suffering found in contemporary newspapers and magazines to emphasize a particular class based moral code. Bates provides a close reading of a number of the earthquake melodramas, including a lost Mizoguchi film, which offers a compelling picture of the social and cultural morality of Japan on the cusp of modernity.

The visual depiction of seismic disaster has been codified, both at the level of genre and the cinematic image, in a series of predictable gestures and scenarios. Ozge Samanci has created a "map" of such familiar examples from a range of contemporary disaster movies in order to identify the strategies used by film-makers to produce effects of identification, immersion and verisimilitude. Her essay is accompanied by a website, "Snapshots: Representations of Earthquakes in Movies," http://dm.lcc.gatech.edu/~osamanci/earthquakesinfilm.htm, which illustrates the various themes and techniques which constantly recur in the disaster film. Samanci's visual archive was part of a project designed to assist in assessing risk, loss and damage for decision makers in the event of a major earthquake. Her work is a good example of how humanities-based research can inform the social sciences, combining as it does the disciplines of film studies and visual culture with public policy and psychology.

As a powerful ideological system, Hollywood cinema converts the disturbing presence of natural disaster into a more pleasurable form. More often than not, it translates the excessive shock of sudden and spontaneous seismic activity into the generic conventions of the disaster film, with its cast of stock characters, dramatic routines and spectacular scenes of death and devastation. Axel Andersson stresses the importance of the virtual dimension of the ethical, political and scientific challenge raised by the disaster in Roland Emmerich's blockbuster *2012*. Anderrson argues that "the film's preoccupation with forming a community of believers around an initially unverifiable and improbable scenario mirrors the predicament of the cinema itself" that, "as an art of virtualisation, [must] keep its audience close to, yet at a safe distance from, reality" (see p. 106).

The cinematic reconfiguration of disaster as a commercialized product often occurs at the expense of the private experience of memory and trauma. The unprecedented commercial success of Feng Xiaogang's *Aftershock* (2010) at the Chinese box office is predicated upon the creation of a selectively repressive official discourse of public value and social responsibility. The film tells a melodramatic tale of suffering and loss based upon a family's survival of the Tangshan earthquake in 1976 and their eventual reunion thirty two years later after the Sichuan earthquake in 2008. Jinhua Li shows how *Aftershock* functions as a cinematic foil

against which a grand narrative of nation-building and traditional values, such as filial piety, maternal sacrifice and camaraderie, overshadowes the *petit récits* of survivors' private memories. The personal process of healing assumes the form of a politicized collective memory, a sanitized version of China's long march to modernization.

The films of Abbas Kiarostami, by contrast, seek to present a cinematic ethics that, in the words of the philosopher Jean-Luc Nancy, does "justice to life insofar as it knows death." Steve Choe examines how Kiarostami achieves the "just distance" in the representation of mourning and loss in *Life and Nothing More …* (1991), a film made in the wake of the earthquake that devastated the region around Koker in north-eastern Iran. Choe argues that Kiarostami's response to the catastrophe demands an ethical and ontological commitment that respects those who have suffered the disaster both as subjects and objects of the cinematic gaze. Kiarostami affirms life in the face of death by marking the passing of the present into a collective past – a passing that is also integral to cinema's basic historicity, suggesting not only a spatial distance between the camera and its human subjects, but also a temporal distance between loss and life that directs the comportment of the film viewer towards finitude.

Trauma and catastrophe have defined attempts to theorize the experience of modernity. In contemporary visual culture, film and media often present an increasingly biopolitical image of disaster that reduces the social and historical identity of victims and survivors to the condition of bare life, a term used by Giorgio Agamben, as discussed previously, to describe the dehumanized form of existence produced by the sovereign exercise of power in modern times. Allen Meek counters this tendency by returning to Walter Benjamin's writings on film and catastrophe. Meek locates the formulation of Benjamin's "seismic" theory of history, with its emphasis on dislocation and shock, within the context of his radio talk on the Lisbon earthquake of 1755 and his visit to post-revolutionary Moscow in 1927. Benjamin, as is well known, opposes the myth of historical and technological progress with a critical method that deploys a modernist poetics of montage, mimesis and gesture. Meek shows, however, how the idea of "natural history" [*naturgeschichte*] an important but overlooked concept in Benjamin's philosophical arsenal, offers a powerful theoretical tool against the use of the "biopolitical image" as an ideological weapon in the administration of "disaster capitalism" and the unequal distribution of global networks of power, media and political agency as reflected in contemporary images of catastrophe.

Kevin Fisher presents an equally original reading of the work of Jean Baudrillard in his analysis of *When a City Falls* (2011), a documentary made during and after the major earthquakes that struck Christchurch, New Zealand, in 2010/2011. The particular values of documentary realism that the film adheres to – authenticity, immediacy and interactivity – ultimately work to neutralize the "symbolic challenge" unleashed by the seismic energy of the quake. The film's reluctance to interpret or interrogate the political context of the event and its aftermath, along with its apparent refusal of the commodified forms of media spectacle, betrays, according to Fisher, an inherent conflict that defines the seductive power of the image in "the age of simulation." *When a City Falls* seeks to remain true to this singular

authentic moment, to hold on to the shattering experience of the quake, but, in order to do so, must convert its symbolic energy into a naturalized product of social exchange. The process of signification, the "precession of images" in Baudrillard's terms, works to contain the political economy of excess and expenditure released by the natural disaster. The use value of the cinematic sign restores sense and meaning to a world in disarray. Hence, the film's "nostalgic" appeal to notions of local and national identity (Kiwi ingenuity, resourcefulness and resilience), community and civic pride that exist in an ideological space divorced from the global effects of those same neo-liberal ideals that prevail in contemporary New Zealand. Fisher identifies, however, aspects of the film, particularly its use of sound, that escape the deadlock between use value and symbolic exchange.

A crisis in visual representation and narrative form is even more readily apparent in the films that Antonia Girardi analyses. She discovers the emergence of a kind of seismi imaginary in a range of Chilean films, including *Cofralandes*, an experimental documentary by Raul Ruiz, and "The Filmic Map of a Country," an online archive of short films at www.mafi.tv. The geology and geography of Chile, as Girardi suggests, have given rise to the creation of a "telluric cartography," a cinematic map of the territory that shifts and changes shape like the uncertain ground upon which it is based. The landscape no longer functions as the neutral setting for a drama defined in terms of action, character and performance. The visual field, like the fractured landscape itself, suffers a profound deformation. The relationship between figure and ground is inverted, focus shifts, the frame loses its boundaries and the camera strays, slows or stops. Space dissolves and time is distended. Girardi claims in a bold theoretical move that the technical and aesthetic manoeuvres of films like *La Repuesta* (1961), *Tres semanas después* (2010) (see p. 187) and others also operate at the level of sense and meaning to shatter the discursive identity of subject and object, of seeing and believing, of nation and nature. Chile is a "landscape in conflict," as the title of her essay indicates, not a territory defined by the sovereign exercise of power [*potere*].

Giorgio Bertellini also pays close critical attention to location, place and spatial experience as contested sites for understanding national identity and social values. His essay discusses the sustained interest of contemporary Italian film-makers in the representation of the landscape and physical environment as the revelatory setting for the defacement of the nation's geopolitical and cultural patrimony. Bertellini situates this cinematic trend within the broader context of an epistemic turn across many disciplines and artistic fronts towards an environmental ethics that opposes the commercial speculation and political opportunism that has resulted in the wholesale corruption, neglect and abuse of the Italian natural landscape with a more democratic conception of civic responsibility and the public good. Bertellini shows how Sabina Guzzanti's documentary *Draquila: Italy Trembles*, a satirical and polemical assault on Berlusconi's cynical response to the L'Aquila earthquake, exposes comparable forms of spatial and anthropological degrado. The film recounts a woeful tale of the suspension of civil liberties under the guise of an artificially orchestrated state of exception. The natural disaster and the social catastrophe that followed were granted the special status of "*grandi eventi*," a quasi-legal category that permitted state agencies and

private interests to bypass building and planning regulations, to expropriate land, to relocate citizens, demolish their homes and move them to camps or swiftly erected housing estates.

Within months of the 3.11 earthquake, tsunami and subsequent nuclear disaster in Japan, a number of fictional and non-fictional films were made, many of which were also sharply critical of the authorities and deeply committed in their support and sympathy for the victims of the disaster. Joel Neville Anderson examines the role that documentary film can play in the reconstruction process as a means of recording, remembering and recounting the effects of 3.11. Anderson is especially attentive to new forms of digital witnessing and image-sharing and the ways in which they might extend the style and content of traditional documentary film-making. His examples display a highly reflexive engagement with the act of filming, with the relationship between the film-maker and the documentary subject, with the various media platforms and devices that can be used to convey a visual image of the disaster, with the representation of a decimated landscape and of lives and communities that have been totally destroyed. Anderson focuses on a recurrent motif in his chosen films – the tenuous link between memory and identity supplied by family photographs salvaged from the wreckage and reframed for the screen. Here, cinema finds a way of negotiating the personal and public meaning of the orphaned image, of restoring its lost value and of recognizing, in the face of the Other, its commitment to the collective task of recovery and renewal.

In her survey of fictional films that implicitly or explicitly deal with the 3.11 disaster, Eija Niskanen discovers a similar concern with situating personal stories of loss and grief within the context of Japan's recent national and social history. The unresolved traumas of the past continue to haunt the popular imagination in the present. The everyday banality of contemporary Japanese society, along with the pressure to conform and to maintain consensus and order, disguises a collective history of pain and anguish. The narrative of madness and violence, apparent in films like *River* (Hiroki, 2011), *Since Then* (Shinozaka, 2012) and *Himizu* (Sono Sion, 2012), is a displaced manifestation of the "moral and social malaise" of the nation. In these films, it seems, the Tohuko quake, tsunami and the Fukushima nuclear meltdown take on the role of an allegorical image for the current constellation of events in Japan. 3.11, Niskanen concludes, ultimately reveals that ordinary life has long since assumed the quality of an insupportable fiction. The need to confront the extraordinary reality of the present situation is all the more urgent.

Film on the Faultline ends with a selection of statements, interviews and reports from directors whose films have directly met the "challenge" of the earthquake. As is fitting, the film-makers have the last word. They describe their motivations, intentions, reactions and impressions. They place the films within the context of their own work as well as commenting upon the social and cultural conditions of their production and reception. In the process, they offer an insight, as previously mentioned, into the "limits and possibilities of cinema itself" (see p. 12).

Yuri Averof explains how *ΣΕΙΣΜΟΣ (Earthquake)*, a documentary about the 1953 quake that destroyed the Greek island of Kefalonia, had its origins in his involvement with the

shooting of *Captain Corelli's Mandolin* (Madden, 2001), a film that includes a memorable scene that recreates the earthquake. Around 100,000 people were displaced and dispersed from their homeland. The quake wiped out a traditional way of life but it also ushered in a new modern era. Averof and his partner, Rea Apostolides, skilfully weave together a number of documentary modes in order to evoke a state of nostalgia in which the present is thoroughly suffused with the past. The film combines rare footage from the period, an autobiographical text by the poet Stratis Haviaras and interviews and testimony from residents to create a poetic meditation upon memory, history, nation, exile and emigration.

Nora Niasari continues the reflection on home and belonging in her piece on the making of *Talca Interrupted*. Her own experience of displacement as an Iranian exile in Australia, as well as her studies in architecture and urbanism, has informed her films to date. Niasari travelled to Chile after the earthquake in February 2010 and returned at regular intervals to film the reconstruction process in Talca. The film focuses upon the fate of "Casa Antunez" and the extended family that lived for generations in the now ruined house. The dilapidated building stands as the site of collective memories and dreams for the future, a space of conflict but also a source of reconciliation. Its demolition promises, in the end, a renewed commitment to family, community and locality as the foundation for a common identity.

The experience of dislocation and dispossession in the wake of a major earthquake is compounded in the case of the migrant or the refugee. The struggle for cultural and social acceptance, the quest for a sense of home and happiness in a foreign land, may prove a more difficult ordeal, certainly a more sustained and solitary one, than the challenge of survival during and after a natural disaster. Kiyong Park's film *Moving* considers the philosophical and psychological response of a Korean couple to the Christchurch earthquakes in which their business was destroyed and their hopes for the future dashed. In an informative discussion with Zhou Ting-Fung, Park talks about the constraints and opportunities he encountered whilst working on the film. The feature-length documentary consists almost entirely of a single interview where the couple address the camera directly. Their story is occasionally interrupted by extended long takes, shot from a fixed position, of abandoned city streets, parks and buildings. Whereas *When a City Falls* was choral in scope and tone, *Moving* has the quality of a chamber piece, spare, lyrical and open.

Such ethical and aesthetic rigour is a hallmark of the films of Abbas Kiarostami, as noted by Steve Choe in his essay on *Life and Nothing More* …. Kiarostami reveals a more personal side to Hossein Najafi in a casual and candid exchange about the same film. Kiarostami talks about his journey to Koker and tells some amusing anecdotes about incidents that he witnessed first-hand but could not include in the film. In the process, he comments upon the restrictive climate for film-making in Iran and the hypocritical attitude of critics and audiences alike towards censorship and Islamic law.

For different reasons but with the same motivation, José Luis Torres Leiva recalls his disgust at the "pornographic" media coverage of the 2010 earthquake in Chile. *Tres semanas después* provides a powerful corrective to the stock footage of televised disaster. Torres Leiva refuses to use personal testimony or any form of commentary to describe the catastrophe,

concentrating instead on the ravaged features of the landscape as a means of conveying the apocalyptical scale of the disaster. The camera passes through the devastated terrain in an endless tracking shot. Its gaze calmly surveys the wreckage and debris left in the wake of the earthquake as the visual record of a crisis in the conceptual categories of time, space, landscape and territory. Torres Leiva, as Antonia Girardi shows in her discussion of the film, is mapping the contours of the "telluric cartography" of Chile in cinematic form.

*

All research, to some degree or other, fulfils a personal need. *Film on the Faultline* is my own attempt to think about what happened to us in Christchurch and to place it within a critical context. While the book exists as an academic product, it was written quite consciously from a position outside or beyond the constraints of what might be considered standard professional/professorial practice. I hope that it will be received in the same spirit.

Of course, the work is by no means my own. I thank all the contributors for their excellent essays. They have also shown much patience and goodwill during the editing process. Intellect Press has demonstrated a real commitment to the project. I have received strong support and guidance from Jelena Stanovnik, Melanie Marshall and Claire Organ in bringing the work to publication.

The book is dedicated to the memory of my mother, Isabel Wright, who was a source of great strength, comfort and kindness over the years. She remained constant and true throughout her life. Not much could shake her resolve, except perhaps, as many in Christchurch can attest, the odd aftershock or two.

The material in *Film on the Faultline* provided the basis for an interesting class. Thanks to all the students involved for their engagement and feedback. Our discussions contributed to the final shape of the book. I am also grateful to the Cinema Studies students at the University of Canterbury in general for sticking with the programme after the earthquake and helping to lay the foundations for the future.

A number of colleagues and friends generously provided advice, encouragement, contacts and information. I appreciate their willingness to share their knowledge. In the early stages, Melis Behlil, Jasper Sharp, Adrian Martin, Kiyong Park and Shinji Kitagawa kindly offered suggestions and addresses. Catalina Botez was committed to the project but was unable to contribute. In Chile, Iván Pinto, Jorge Morales and Gonzalo Maza responded enthusiastically. Stephen J. Clark translated the texts from Spanish in a thorough and timely manner. Angus Hikairo Macfarlane graciously provided the text of his version of the Rūaumoko haka. Tim Wong, the editor of the *Lumière Reader*, gave his approval to reprint a revised version of the interview with Kiyong Park. José Luis Torres Leiva granted permission to republish his article on *Tres semanas después*, which originally appeared in the online journal *Mabuse*, and also to screen the film in Christchurch. Nora Niasari, Kiyong Park, Naomi Kawase (*3.11: A Sense of Home*) and Isamu Hirabayashi (*663114*) agreed to show their films as well.

The College of Arts at the University of Canterbury provided generous research support towards the completion of the project. I would also like to thank my colleagues William Chang, Jeanette King, Jack Copeland, Paul Millar and Mary Wiles for their help and encouragement. Nick Paris from Alices gave up his time and shared his thoughts on the history and future of film in Christchurch. Mark Stapleton visited regularly; we are the happy recipients of his bracing wit and amused concern. I remain ever thankful to Nicole and Leni whose company and loving support I enjoy every day.

Notes

1. I am grateful to Angus Hikairo Macfarlane for the transcription and translation of this contemporary variation of the traditional Māori haka to Rūaumoko.
2. *Green Dolphin Street* (Saville, 1947) offers a curious variant on the story of Rūaumoko. The inner turmoil of its characters is displaced externally onto their surroundings in one of the most climactic scenes of the movie. The threat of the Other returns with a vengeance in the form of a powerful earthquake that destroys a Māori village and terrifies its inhabitants, including the pregnant Marianne (Lana Turner). As the earth rumbles and heaves, the unborn child moves in its mother's womb. When the shaking stops, Marianne has given birth to a healthy baby girl. Rūaumoko has been pacified. His spirit has been subdued and suppressed. His energy has been contained. A changeling takes his place. He has lost his name, his patrimony, his gender and ethnic identity.
3. Gene Ray, "Reading the Lisbon Earthquake: Adorno, Lyotard and the Contemporary Sublime," *The Yale Journal of Criticism*, 17: 1 (Spring 2004), p. 11. For further references to the Lisbon Earthquake and the Enlightenment, see Susan Nieman, *Evil in Modern Thought*, Princeton, Princeton University Press, 2002, *The Lisbon Earthquake of 1755: Representations and Reactions*, eds. Braun and Radner, Oxford: Voltaire Foundation, 2005 and "Foundational Ruins," Alexander Regier in *Ruins of Modernity*, eds. Hell and Schönle, Durham, Duke University Press, 2010. In this volume, Allen Meek addresses the place of the Lisbon Earthquake in Walter Benjmain's theory of history as catastrophe (see Chapter 7, pp. 147–161).
4. "Foundational Ruins," Alexander Regier in *Ruins of Modernity*, eds. Julia Hell and Andreas Schönle. Durham: Duke University Press, 2010, p. 371.
5. Giorgio Agamben, *Homo Sacer: Sovereign Power and Bare Life*, trans. Daniel Heller-Roazen, Stanford: Stanford University Press, 1998, p. 1.
6. Ibid., 2.
7. Ibid., 11.
8. Ibid., 4.
9. Ibid., 39–48.
10. *In Praise of the Common*. Cesare Casarino and Antonio Negri, 224, n. 22. Minneapolis and London: University of Minnesota Press, 2008.

11 Léopold Lambert, http://thefunambulist.net/2013/03/26/spinoza-episode-3-power-potentia-vs-power-potestas/. Lambert's blog entries on Spinoza have also been collected and published by punctum books as an Open Access text.
12 Ibid.
13 *L'abécédaire* (Boutang, 1988) is a feature length interview between Gilles Deleuze and Claire Parnet. Deleuze agreed to the project on the condition that the film be released after his death. The following quotations come from the English DVD version, *Deleuze: from A to Z* (Semiotexte Foreign Agents Series, 2012).
14 Johannes von Moltke, "Ruin Cinema" in *Ruins of Modernity*, eds. Julia Hell and Andreas Schönle, Durham and London: Duke University Press, 2010, p. 376.
15 Ibid., 401.
16 Mary Anne Doane, *The Emergence of Cinematic Time*, 16. Cambridge, MA, and London: Harvard University Press, 2002.
17 Charles Darwin, *The Voyage of the Beagle*, Ware: Wordsworth Editions Ltd, 1997, p. 287.
18 Ibid., 293.
19 As quoted in Jane Madsen, "The Space of Collapse: A Two-Part Terrain," *Interstices* 13, 2012.
20 Ibid., Madsen.
21 Michael Tawa, *Agencies of the Frame: Tectonic Strategies in Cinema and Architecture*, Newcastle: Cambridge Scholars Publishing, 2011, pp. 15 and 17.
22 Ibid., 5.
23 Ibid., 16.
24 Andrey Tarkovsky, *Sculpting in Time*, trans. Kitty Hunter-Blair, Austin: University of Texas Press, 2006, p. 72.
25 Tawa, 7.
26 Ibid.
27 One of the best recent examples is Stephen Keane's *Disaster Movies: the Cinema of Catastrophe*, 2nd edition, New York: Columbia University Press, 2012.

Chapter 1

A Tale of Two Cities: San Francisco 1906 and *Earthquake in Adelaide*

Stephen Morgan

When the first indications of catastrophe appeared on that crisp, spring morning in April 1906, few in San Francisco could have predicted the traumatic events to come. Once the dust had settled, the devastating fires had been extinguished and the smoke cleared, the earthquake had claimed approximately 3,000 lives. Three hundred thousand citizens were left homeless. Damage to property was estimated at $400m (nearly $10bn at current rates).

Fewer still could have predicted the prominent role that visual media would play in working through the catastrophe and fostering understanding and catharsis. San Francisco 1906 was undoubtedly the first major disaster to be widely photographed by amateurs, but it was also the first to gain widespread coverage through the moving image. In the aftermath of the earthquake, tens of thousands of photographs were exposed and thousands more feet of motion picture film were shot. Within weeks, these images had found their way around the world, helping the global public – particularly those in western urban centres not unlike San Francisco – to make sense of the tragedy.

In their book on the social, economic and cultural implications of seismic upheaval, *Earthquakes in Human History*, Zeilinga de Boer and Sanders (2005) suggest that although actual seismic events may be short-lived, most earthquakes have long-lasting after-effects. They compare these after-effects to the "plucking of a long, tight-stretched string representing time" (2005: x). The immediate aftermath is followed by reconstruction, economic revival and, eventually, cultural works. One can trace a direct line along that "plucked string" from the 1906 earthquake to its major Hollywood depiction in *San Francisco* (Van Dyke, 1936), but one can also trace more tenuous links to films that exist as direct responses to those and other seismic traumas in the first decade of the twentieth century.

In 1914, with scenes of San Francisco's destruction still relatively fresh in the public imagination, Harry Krischock – a press photographer and actuality cameraman in Adelaide, South Australia – produced a film that capitalized on the paranoia about the possibility of a massive earthquake in his own backyard. *Earthquake in Adelaide* (Krischock, 1914)[1] made only a fleeting impact when originally shown on local cinema screens, but nevertheless exists as a bold cinematic experiment, toying with notions of truth and fiction while utilizing camera effects and trick photography to simulate a seismic event striking an Australian capital city.

This chapter examines two distinct, but deeply intertwined, cultural after-effects of the San Francisco earthquake. First, it evaluates the almost instantaneous mass of still and

moving images that documented the event and its aftermath, and provided people across America and around the world with a new way of experiencing and understanding disaster. Second and more specifically, it focuses upon an isolated work, created nearly a decade later and half a world away, that draws upon these immediate depictions, and a range of other influences, to create an "imagined" earthquake on film.

The first part of the chapter surveys the broader visual media coverage of San Francisco and other earthquakes in the first decade of the twentieth century and traces the dissemination of these materials to audiences in the emerging metropolis of Adelaide. The second part considers the impact and influence that films, photographs and media reports of the San Francisco disaster had on the creation of *Earthquake in Adelaide*. It places Krischock's film in the context of early media representations of earthquakes and other natural disasters, and examines how it blurs truth and fiction within a nascent trend of actuality films, fictional and non-fictional, that exploit current events and the heightened cinematic spectacle of large-scale disaster.

In his fascinating narrative history of the San Francisco earthquake and fire, Simon Winchester (2006: 26) refers to 1906 as a "hybrid year" between two ages. Metropolitan societies lurched towards a more sophisticated form of modernity. For Winchester, "in the San Francisco that existed at the time of its greatest tragedy, the modern was being half embraced, half disdained" (2006: 29). The relationship between the city and the moving image provides a definitive cultural nexus in the emergence of modern society (Webber and Wilson 2008: 1). Cinema, in addressing notions of urban trauma, as in the case of a major disaster like the San Francisco earthquake, reveals how the medium of film copes when the tenuous edifice of modernity is violently ruptured.

1906 was also a transitional moment for the new medium of film, as it moved from the "cinema of attractions" towards a mode of representation increasingly dominated by narrative (Gunning 1986). Krischock's own film exists in a liminal space, an ambiguous work caught between embryonic notions of fact and fiction, documentary and fantasy, advice and artifice.

Part one: San Francisco 1906

Visual media and San Francisco 1906

In the midst of chaos and tragedy, many San Franciscans responded to the 1906 calamity as spectators. Scores of eyewitnesses used language that made it difficult to distinguish between their sense of magnificent spectacle and their feelings of deep tragedy (Rozario 2007: 121). As soon as the immediate danger had passed, many residents reached for their new, inexpensive cameras and began capturing the scenes of devastation that surrounded them. By comparison with previous urban catastrophes in North America and elsewhere, San Francisco 1906 "exceeded all previous disasters in the degree to which the ruins were

reproduced, circulated, and consumed through the medium of photography" (Yablon 2009: 192).

The increased volume was due, at least in part, to the fact that professional photographers were no longer solely producing the visual record. As well as those amateurs snapping away on their Kodaks in the days following the earthquake, San Francisco's streets were choked with photographers of all types. The camera was now used as a dependable tool by scientists and engineers as well as insurance adjusters (Yablon 2009: 192). One local newsman even claimed that "never since cameras were first invented has there been such a large number in use at any other place as there has been in San Francisco since the 18th of last April" (Edgar A. Cohen, quoted in Rozario 2007: 122). The still photographs and moving images taken in the immediate aftermath of the San Francisco disaster undoubtedly had a transformative effect by "turning the tragedy into spectacle" for all and sundry (Winchester 2006: 265). This very modern act of transformation not only helped to minimize the impact of the events for locals, but it also maximized that impact for those not directly affected, whether elsewhere in the United States or on the other side of the world.

The confluence of professional and amateur photographers, along with the film cameramen that followed them to the stricken city, ensured that San Francisco 1906 developed a visual legacy that would eclipse any previous event of its kind. Winchester describes the images produced as having a "sad eloquence all of their own," a unique representation of the first major natural disaster to have been extensively photographed and, crucially, disseminated (2006: 257). Major earthquakes had, of course, occurred before 1906, often in far more tragic circumstances and with far greater loss of life. San Francisco was deeply felt across the western world, however, not simply because of that city's existence as a modern metropolis, but, more importantly, because the earthquake was the first to gain widespread coverage in the visual media.

As word of the disaster spread, entrepreneurs "wasted no time in turning the calamity into money, tapping into a huge market for stories, pictures and performances of the earthquake" (Rozario 2007: 128). Motion picture cameramen and production units rushed to San Francisco from all over the United States, with representatives of Edison, Vitagraph and others descending on the Bay Area. Siegmund Lubin, an East Coast studio boss, opportunistically sent his best cameramen on the first available train, while his Philadelphia production facility was turned over to the creation and destruction of a miniature San Francisco, restaging the devastation in front of the camera. His company built a steady profit over several months upon the abundance of good footage that both the units provided (Eckhardt 1997: 55). The Biograph Company also went to great lengths to recreate the entire scene in their New York studios, building and then destroying their own scale miniatures of downtown San Francisco and creating a deceptive, yet vastly popular, film in the process (Fielding 2006: 42).

One of the most renowned earthquake films shot in San Francisco in April 1906 was actually recorded before the quake had even occurred. Having relocated from New York earlier that year to establish a small studio in San Francisco, the Miles brothers shot the

second of two travel films for Hale's Tours theatres just four days before the earthquake (Kiehn 2006). *A Trip Down Market Street* (Miles, 1906) was filmed from a cable car and quickly became a vital document, showing a key area of San Francisco immediately prior to its destruction. The brothers were en route to New York with the film when they learnt of the disaster. They rushed back to the city to find their studio destroyed by fire. Undeterred, they too set about filming ruins, refugees and the beginnings of reconstruction (Kiehn 2006).

Earthquakes in the Adelaide media prior to 1906

Early twentieth-century Adelaide supported a relatively diverse print media. The first news photograph appeared on a glossy one-sheet published by *The Chronicle* in 1895. Professional photographers soon had a new outlet for their work. The newspapers discovered a graphically powerful means to convey the horror of natural and man-made disasters to their readers (Zagala in Robinson 2007: 182). Indeed, the introduction of photography transformed Adelaide's newspapers and helped to ensure that they "were no longer intimate, local publications, but celebrations of a newfound globalism" (Sutter 2008: 54). This transformation was clearly evident in the contrasting coverage of international disasters at the turn of the twentieth century.

In June 1896, following the Meiji-Sanriku earthquake and tsunami in Japan, Adelaide newspapers devoted surprisingly few column inches to the calamity, coldly reporting the tens of thousands dead and the destruction of entire villages and towns. A year later, press coverage of a major earthquake in the north-east Indian province of Assam was similarly brief, despite over a thousand deaths. Yet, when San Francisco was struck by earthquake and fire in 1906, Adelaide newspapers clambered for any and all material to fill the scores of pages dedicated to the catastrophe over subsequent days and weeks.

The discrepancy between the scant coverage given to earthquakes in Asia and the much more detailed coverage dedicated to San Francisco is of clear significance. The average Australian may have had more in common with a San Franciscan than with the residents of Japan or India, for instance, but deeply entrenched systems of colonial racism and the "White Australian Policy" adopted by that country's inaugural parliament also played an inevitable role (Lake and Reynolds, 2008: 137). The ten years that separated these earthquakes, however, was also a period of major technological change, with advances in communications media bringing the western world ever closer to the rest of the world. In 1896, photography was still largely the preserve of professionals, photographs were a rare occurrence in newspapers and moving images were still in their infancy. By 1906, the average American could buy a Kodak Brownie camera for just $1, and many major newspapers had begun to publish photographs in earnest. Cinema had evolved from sideshow novelty to a significant global medium. With the concurrent rise of the modern metropolis, a burgeoning sense of globalization also had the effect of drawing disparate urban centres together.

San Francisco, then the most populous city of California, hosted a population of approximately 400,000 in 1906. Adelaide, by contrast, was a planned city, the capital of South Australia, established by colonial proclamation in 1836. By 1906, the city and suburbs housed approximately 180,000 citizens. Situated on the South Australian coast, Adelaide was a long way from any major faultlines or tectonic plates. The city faced very little risk from earthquake, and yet it was no stranger to the trembling earth.

In contrast to the scant coverage devoted to the devastation in Japan and India, an earthquake much closer to home set Adelaide's newspapers abuzz. In May 1897, the southeast of South Australia was struck by an earthquake measuring 6.5 on the Richter scale. People spent the night outdoors in fear that aftershocks might cause their already damaged homes to collapse (Love 2001: 157). In 1902, a magnitude 6.0 earthquake caused severe damage near its epicentre on the Yorke Peninsula and resulted in the fatal heart attacks of two Adelaide residents, Australia's first recorded earthquake-related fatalities (Love 2001: 157). The danger may not have been particularly high, but Adelaide was nevertheless jumpy, and those fears would only increase once its citizens heard about the calamity in San Francisco.

Visualizing San Francisco 1906 in the Adelaide print media

Given the considerable distance between California and Australia, the first reports of the disaster to make their way across the Pacific were, unsurprisingly, written accounts received by cable. In Adelaide, news of the earthquake in San Francisco broke within 48 hours of the initial tremor. Newspapers dedicated entire pages to the events, providing detailed reports, individual accounts of horror and survival, and related stories about everything from the effect on business and trade to how the shocks were felt and recorded across North America and the rest of the world. On April 20th, despite the "exasperatingly fragmentary character" of information emerging from San Francisco, *The Register* devoted a full page to descriptions of events during and immediately after the earthquake. The coverage included information about the spreading fire, details of a handful of specific incidents, news of travelling South Australians, expressions of condolence from community groups and a selection of "experts" hypothesizing about what might have caused the tremor (Anon 1906i).

An editorial in the same newspaper mused over the "frightful calamities" in San Francisco and suggested that "the narrative of the double-disaster, as told in our cable messages to-day, forms one of the most exciting and terrible chapters in the geological records of the earth, within human memory" (Anon 1906j). An editorial in *The Advertiser* made an explicit connection between the tragedy in San Francisco and the increasing sense of global community:

> The telegraph has annihilated time and distance, and with the increasing sense of nearness which the development of civilisation is bringing to nations hitherto sundered,

the dreadful fate which has overtaken San Francisco cannot but affect sensibly the people of Australia.

(Anon 1906l)

Later notices highlighted another key reason for San Francisco's impact on readers in the English-speaking world. In blunt colonialist terms, New Zealand's Prime Minister Richard Seddon encouraged citizens to contribute to a relief fund "as it was people of their own race who were in need" (Anon 1906n).

Many of the early cables were accompanied by images of the city from before the earthquake. Initial reports in *The Register* were dominated by a large line-drawn photo-engraving that revealed, from an elevated perspective, the "principal section of [the] business portion of San Francisco – [now] destroyed by earthquake and fire" (Anon 1906i). Coverage in *The Advertiser* was accompanied by two pre-earthquake images; a photograph of Market Street showing the Spreckels building (home to the *San Francisco Call* newspaper) and an engraving of City Hall (Anon 1906m). Similar coverage continued for days, with written reports often accompanied by maps, photographs from before the earthquake and line-engravings of landmark buildings alongside news of their partial or total destruction (Anon 1906k). Weeklies like *The Australasian*, *The Observer* and *The Chronicle* included special supplements featuring narrative accounts assembled from cables, alongside pre-earthquake photographs, many supplied by "Adelaide citizens who have been resident in San Francisco" (Anon 1906o). These images supplemented those previously published in *The Register* and *The Advertiser* and illustrated the extent of the destruction by providing a visual dimension to the written accounts, especially important for the majority of readers unfamiliar with the city of San Francisco.

Images depicting the aftermath followed soon after. *The Chronicle* filled an entire page of its illustrated section with photographs that brought vivid clarity to the destruction previously only described in words. Among the devastating images were views of partially destroyed buildings at Stanford University, the iconic dome of City Hall, California Street and Nob Hill after the fire, two menacingly evocative images of huge fissures opened up on city streets, and "the fire approaching to finish the work of the earthquake" (Anon 1906p). The importance of these images in conveying the scale of the disaster to Adelaide residents was noted in the pages of *The Advertiser*, which suggested that "things seen are mightier than things heard": although "much has been said and written [...] the only true conception of the horror of the situation is that obtained through the eye" (Anon 1906d). Giving particular praise to the pictures published in *The Chronicle*, the piece concluded with the suggestion that despite the sheer volume of printed word, "more can be learnt of the Californian disaster from a glance at these photographs than from the perusal of columns of reading matter, however realistic it may be" (Anon 1906d). Such reactions, published in contemporary newspapers halfway around the world, only serve to underscore the importance of the visual image in the international mediation of the San Francisco earthquake.

A Tale of Two Cities

Visualizing San Francisco 1906 on Adelaide screens

The first films of post-earthquake San Francisco to appear in Adelaide were promoted a week before of their projection in late June at the Town Hall by C. Sudholz and his "world famous" Bio-Tableau and Entertainers. Advance notices promised "a genuine 'moving' picture portraying the fearful havoc caused by Nature's great upheaval," with views of San Francisco before the event and "excellent pictures" of the aftermath (Anon 1906q). Advertisements (see Figure 1.1) promised the "latest and greatest animated picture of the day, the Great San Francisco Earthquake," and claimed to depict the ruined city with "startling realism, [...] illustrating more forcibly than words the extent and magnitude of this most awful disaster" (Anon 1906e).

In the end, Adelaide audiences would need to wait a little longer to see the devastation first-hand. A short delay meant that the films were finally projected on Wednesday, June 27th, at a special screening attended by the Labour premier Thomas Price and ministers from the state parliament (Anon 1906f). Such was the occasion that Sudholz made special arrangements with rival exhibitors, the Tait brothers, to combine his "thrilling and impressive spectacle" of "moving panoramas of the wrecked city" with their images of "San Francisco fallen and in flames" (Anon 1906f). After a four-night stint at the Adelaide Town Hall, the company moved to the Port Adelaide Town Hall for a single performance, but had to extend the season due to the popularity of this "authentic and vivid realization of the world's greatest disaster" (Anon 1906g).

Figure 1.1: Advertisement for C. Sudholz's Bio-Tableau and Entertainers at the Adelaide Town Hall (*The Register*, 16 June 1906: 12).

Reviews for the Bio-Tableau presentation were hugely positive. *The Register* noted the "considerable enterprise" involved in introducing the films to the Adelaide public so soon after the disaster: as a "true picture of unprecedented ruin [...] the pictures are all that the management claim for them [...] if anybody needs a more convincing idea of how San Francisco was blasted he can get it only by visiting the place in person" (Anon 1906r). *The Advertiser* reported a "large attendance" at the Town Hall presentation of the Bio-Tableau. A deeply contemplative review praised the effectiveness of the San Francisco films, which brought "home more forcibly than any printed description the significance of the disaster" (Anon 1906s). Such was the impact of the Bio-Tableau programme that at the end of its run, *The Advertiser* took the relatively unusual step of advising its readers of their final opportunity to see the "remarkable pictures" before the company left town (Anon 1906t).

Towards the end of July 1906, advertisements began to appear in the *Advertiser* promoting "the great musical and pictorial event of the year." The renowned travelling Corrick family would present their latest show – "for the first time in Australia" – at the Adelaide Town Hall on Saturday, August 4 (Anon 1906a). The film section was billed as "a trip round the world – intensely interesting, absorbing, thrilling, and amusing" and "a pictorial trip from Adelaide to Europe, Asia, Africa, America, and back again" (Anon 1906a). The North American component of the show consisted of "San Francisco before the earthquake, [and] pictures of the ruined city (not hitherto shown in Adelaide)" (Anon 1906a). Subsequent advertisements hailed this programme as "a greater success than ever" and reported that "the large building was packed to overflowing" on opening night (Anon 1906h).

A review of the Corrick show in *The Advertiser* noted that – next to the family's considerable talents as singers, musicians, bellringers and dancers – the chief attraction for the "large and appreciative audience" lay in the "animated pictures [...] by far the best films yet seen in Adelaide" (Anon 1906b). Among "comic views" and scenes from London, Italy and other exotic corners of the world, the review noted "some magnificent views of the destruction of San Francisco by earthquake and fire, rescue work, dynamiting buildings to stop the flames, and the streets of the city before and after the disaster" (Anon 1906b).

The Corrick family films constitute an extensive and vastly important collection of early cinema held by the National Film and Sound Archive of Australia (NFSA), who have preserved many of the films and have researched and recreated some of the family's film shows (Lewis 2007). Unlike many of the other post-earthquake films shown to Adelaide audiences, which remain impossible to identify, NSFA research has revealed that the films of San Francisco "before and after" the earthquake shown by Leonard Corrick in Adelaide were produced by the Biograph and Edison companies respectively. The preserved films were presented in 2011 as part of the NFSA's Corrick Collection series at "Le Giornate del Cinema Muto," the world's premier silent film festival, held annually in Pordenone, Italy. The "before" film, simply titled *San Francisco* (1906), was originally released in 1903 but reissued by Biograph just a month after the quake, while the "after" portion, *San Francisco Disaster*

(1906), is a seven-and-a-half-minute film comprising six of 14 Edison panoramas of the recently decimated city (Lewis 2011: 145–6).

Parallels: the Messina earthquake and tsunami of 1908

It may have become the most historically prominent, for a range of reasons, but San Francisco 1906 was by no means the largest or most damaging earthquake of this period. Nor did it have a monopoly on the public consciousness and media landscape in South Australia. In late December 1908, a massive earthquake struck the narrow strait between the Sicilian city of Messina and Reggio Calabria on the Italian mainland. The quake was rapidly followed by a devastating tsunami. The double disaster killed over 100,000 people and decimated entire cities and towns along the coast. Like San Francisco, the Messina quake attracted scores of cameramen, many working for the major Italian film companies, others acting as agents for key French, British and American producers (Virgolin 2012: 240).

Unsurprisingly, given its scale, the disaster was major news in Adelaide. For weeks, the newspaper covered every last detail of the rising death toll and stories of horror and survival. As with San Francisco two years earlier, expressions of sympathy were plentiful and relief funds were organized, with contributions from state governments, wealthy individuals, community groups and businesses. West's Pictures Entertainment, which owned large cinemas in each of the Australian state capitals, held special matinee screenings with full proceeds donated to the earthquake fund (Anon 1909a). Within a few weeks, a programme of items at the Olympia, the West's cinema in Adelaide, that included footage of several Italian towns that had since been destroyed by the earthquake, drew large numbers of curious viewers (Anon 1909b; 1909c).

By late February, Adelaide exhibitors were clambering to be the first to show "genuine" motion picture depictions of southern Italy after the earthquake. Continental Picture Gardens attracted a "crowded attendance" to its open-air auditorium, where the "vividly illustrated" footage of the earthquake proved a "prominent feature of the evening […] both interesting and instructive" (Anon 1909d). Other footage, screened at the New Pavilion, was praised for its "marked clearness […] the terrible havoc wrought is easily seen, and the marvel not at the number of victims, but that anybody escaped at all" (Anon 1909e).

An earthquake in Adelaide?

In the weeks following the San Francisco earthquake and fire, people were understandably fearful of subsequent disasters. South Australians were no different in this respect. One story, published in *The Chronicle*, told of residents at Green's Plains on Yorke Peninsula,

whose "strong suspicions" of an earthquake "lurking around the district" appeared to be confirmed "when a low, rumbling sound was heard rapidly approaching from the west" (Anon 1906c). Seizing their belongings – "including clocks and small children" – some of the residents "hurried out into the overhanging night, and almost into the track of danger." The distant rumbling was caused not by an earthquake, but by a runaway horse and cart carrying a large iron tank (Anon 1906c). Such stories, though often published to amuse, nevertheless reveal a certain level of public foreboding regarding the possibility of a catastrophic earthquake. Such was the concern about earthquakes in the wake of the dual tragedies of San Francisco and Messina that even the smallest tremor, anywhere in the world, was reported in the Adelaide newspapers. And in June 1909, after years of campaigning from the press, the Adelaide Observatory finally installed its first seismograph.

Despite isolated incidents, however, history suggested that South Australian residents had little reason to fear a major seismic catastrophe. In an interview with *The Advertiser* in February 1914, State Government Astronomer George Frederick Dodwell pointed out that "Australia is rather free from earthquakes" (Anon 1914e). Detailing past seismic activity in South Australia, he admitted that "we may pass 100 years without one, but no one can safely say we won't have one" (Anon 1914e). Dodwell's evasive language is deliberate: a destructive earthquake in South Australia may have been highly unlikely, but only a fool would rule it out entirely.

Part two: *Earthquake in Adelaide*

Krischock as photographer

Henry Ludwig Frank (Harry) Krischock was born in Adelaide on September 1st, 1875, to a German bootmaker and his English-born wife. He sold school textbooks to buy his first camera and by 1897 was working as a clerk for the publishers of a society journal, *Quiz and the Lantern* (Gibberd 2000: 42). In 1903, at the height of photography's popularity in the small city, Krischock opened his first studio. A hundred photography studios operated in Adelaide at the time, a number which only increased in subsequent years despite a crippling, nationwide depression (Zagala in Robinson 2007: 180). Krischock was hired as one of the first dedicated press photographers in South Australia by *The Critic*, a newspaper that delivered its news in "brief articles and interpolated photographs" (Zagala in Robinson 2007: 182). He quickly built a career, supplying photographs, under contract, to a range of local and national newspapers, magazines and journals.

Only recently, however, has Harry Krischock's work as a news photographer come to be recognized and understood. Julie Robinson notes that "photographers like Krischock operated in the commercial and journalistic spheres – outside the realm of clubs, exhibitions and artistic photographic debate – hence their achievements went unacknowledged in

artistic circles" (2007: 144). Others have attempted to reconsider Krischock's work beyond the context of quotidian press photography, with Sutter citing an "apparent creative style and technique in many of his images" (2008: 47). For Lovitt, Krischock's best work brought the two styles together and "melded photojournalist devices with artistic elements of Pictorialism" (Lovitt in Robinson 2007: 194).

Krischock as film-maker

In addition to his photography work, Krischock began making short films of local interest for the Wondergraph Company in 1911. When the first of these were screened, the company was lauded by *The Advertiser* for "securing a budget of local subjects, with the object of passing in pictorial review the principal events of the week in Adelaide" and for deciding to "put on a film each week dealing entirely with local events" (Anon 1911a). Krischock's well-established reputation as a photographer ensured that he was singled out for particular praise; it was noted that he "has achieved a distinct success in his entry to the field of animated photography" (Anon 1911a).

One of Krischock's first films, *Adelaide in a Hurry* (1911), showed the city's inhabitants going about their daily lives. It was produced with the express purpose of attracting people to the Wondergraph film shows to see their likeness on screen (Walker 1988: 380). Later that year, *The Register* drew upon Krischock's increasing reputation as a film-maker by asking him to give a detailed technical explanation of how moving images work and the manner in which they are recorded, processed and presented to audiences (Anon 1911b).

Krischock continued to work as a photographer, while branching out further to supply moving image material to other exhibition houses in partnership with Wondergraph. An advertisement for the Empire Theatre led with the banner line "a splendid reproduction of the Commercial Travellers' Football Carnival, cinematographed for Lyceum Pictures by H. Krischock" (Anon 1911c). Once again, the fact that proprietors felt inclined to credit the film to Krischock is testament to his reputation in Adelaide. Although he was rarely named on Wondergraph advertisements, many, if not all, would have been shot by Krischock. In December 1911, Wondergraph staged a series of beauty contests at their screenings; audiences were encouraged to send in a photograph or to visit Krischock's studio on Hindley Street if they did not yet possess one. The winners were then "cinematographed" by Krischock at his studio and the films were projected at Wondergraph film shows (Anon 1911d; 1911e).

In 1913, Krischock's films were again praised in *The Advertiser*, this time in the sports pages, where his "faithful depiction" of the Great Eastern Steeplechase at Oakbank was commended as "splendid" and "cited as an instance of the skill of the Australian photographer" (Anon 1913a). In this film, Krischock began to test the limits of the actuality format. Rather than simply showing audiences what happened in the race, he placed the sequence of events

within a narrative frame, creating a prologue that depicted how metropolitan race-goers reached the country meet by road and rail, successfully transforming the film from actuality to travelogue.

Later that year, his 1000-feet documentary film *From Pasture to Table* (Krischock, 1913) – completed with an "enormous expenditure of time and money" – detailed how Adelaide obtained its meat via the newly built abattoirs at Gepps Cross (Anon 1913b). The film was given second billing at the grand opening of the Wondergraph Picture Theatre, the company's new permanent exhibition house on Hindley Street (Anon 1913b). In its coverage of the Wondergraph opening, the *Mail* was full of praise for the "thorough manner" in which the film depicted the entire process from farmyard to dinner plate (Anon 1913c). Krischock was "to be congratulated for his work" on a "photographically perfect" film that "certainly refutes the argument that pictures cannot be produced in Adelaide" (Anon 1913d).

Never one to rest on his laurels, Krischock directed the deployment of five cameras at the 1913 Melbourne Cup (a quarter of all those on the course, if Wondergraph's advertisement is to be believed). Described as "the ablest cinematographer in Australia," Krischock produced "the only complete picture of the great race," showing not just the race itself but the crowds arriving, bird's eye views of the course and behind-the-scenes shots of the pre-race preparations of horses and punters alike (Anon 1913e). These relatively sophisticated films reveal that Krischock was already capable of delivering complex productions to audiences. His next major project, however, would prove to be something else entirely, and would require all his hard-earned confidence and technical mastery.

Krischock and *Earthquake in Adelaide*

Drawing upon his previous work as an actuality film-maker, Krischock constructed a sophisticated "imagining" of what might happen if Adelaide were struck by a catastrophic earthquake. As it now exists in the National Film and Sound Archive of Australia, *Earthquake in Adelaide* opens with a title card: "Our 'cine' man dreams" (see Figure 1.2). Through a series of camera tricks, it simulates the earthquake, before ending with the intertitle: "and then he woke up." Next to nothing is known about the actual production, but given Krischock's dexterity as an actuality cameraman, it seems reasonable to assume that the film was produced in a matter of days, rather than weeks, most likely to promote the Wondergraph in much the same way as he had done with *Adelaide in a Hurry* three years earlier.

Alongside the San Francisco films shown in Adelaide in 1906, *Earthquake in Adelaide* may have been influenced by another film screened in Adelaide in March 1914. *When the Earth Trembled* (O'Neill, 1913) is a three-reel narrative fiction film centered around a shipwreck and the 1906 earthquake. Made for the Lubin Company, it features footage shot by their cameramen in San Francisco after the actual disaster, intercut with newly filmed material shot on elaborate sets that were designed to disintegrate during a three-

Figure 1.2: Our 'Cine' Man Dreams- Frame enlargement from *Earthquake in Adelaide* (Krischock, 1914).

minute long earthquake sequence (Eckhardt 1997: 160–1). Announcements in the Adelaide papers referred to the film as "a story founded on the San Francisco earthquake" that is both "intensely dramatic and interesting, and is sure to attract large audiences for the next three days" (Anon 1914c).

Further inspiration came just one week before *Earthquake in Adelaide* opened. The city was shaken by "an adjustment of the surface"; a 5–10-seconds tremor – the worst recorded since the Warooka earthquake of 1902 – sparked considerable alarm, but failed to cause "any damage worth noting" (Anon 1914f). Krischock's employers at the Wondergraph, keen to exploit the fact, used the tremor two days later to promote its current attractions: "The earthquake caused a sensation, but nothing like that caused by the magnificent programme at the Wondergraph Hindley Street" (Anon 1914j).

The timing of the tremor provided an interesting context for *Earthquake in Adelaide*. The earliest public notification of Krischock's film appears in a round up of attractions at Adelaide picture theatres published in *The Advertiser* on June 4th, 1914. The film was shown at the Wondergraph Hindley Street on a bill headed by the Scandinavian drama *Af Elskovs*

Film on the Faultline

WONDERGRAPH

HINDLEY STREET.

WAS SHE JUSTIFIED?

If a woman sees her husband, whom she dearly loves, writhing in agony, is she justified in acceding to his request to put into his hands an instrument by which he can end his life?

£5 REWARD

will be paid to the person who sends in the best answer to the question, "Was She Justified?"

The answers will be judged by a well-known professional gentleman, whose name will be announced later.

Brevity will count in the judging, but at the same time competitors must state clearly their reasons for arriving at their answer, which must be sent in to the Manager not later than Saturday, 13th.

THE EARTHQUAKE,

As seen by the Wondergraph Photographer. Exclusive.

And a host of others.

Evening Prices—2/, 1/, and 6d. Book at Duhst't.

BOOK FOR MONDAY (HOLI-
DAY) NIGHT!

Then you will be sure of getting a seat.

Figure 1.3: Advertisement featuring *Earthquake in Adelaide* at the Wondergraph (*The Mail*, 6 June 1914: 24).

Naade/Was She Justified? (Blom, 1914). Krischock's was described as "an interesting film [...] of more than ordinary interest just now" (Anon 1914a). Although this notice failed to disclose the inherent local interest, other advertisements and notices made the point more clearly. A Wondergraph advertisement placed in the same issue of *The Advertiser* (Anon 1914b) describes a line-up that "[p]ositively created a sensation," claiming that "it is very seldom that so many attractions are to be seen in any one programme" (Anon 1914b) (see Figure 1.3). The advertisement proudly declares that "[t]he Earthquake [was] taken by our

own Cinematographer, and to be seen only at Wondergraph" (Anon 1914b). A review of the "all round excellent programme" in *The Advertiser* highlighted "a picture of the earthquake, as imagined by the Wondergraph cinematographer" (Anon 1914d). Other advertisements, meanwhile, spoke of "a truly wonderful picture" that "will astonish everyone" (Anon 1914h), while a review in *The Register* described a "clever production […] that recalled in striking fashion what might have happened in Adelaide recently" (Anon 1914i), referring explicitly to the tremor that immediately preceded the film's public debut.

Reading and reviewing *Earthquake in Adelaide*

Much of the critical reaction to *Earthquake in Adelaide* seems to draw, not unfairly, upon its novelty value, with little attention paid to its visual inventiveness and wry sense of humour. Framed as a dream, the film adopts a fairly conventional and well-worn structure, typical of films of the period that tend towards the fantastic. Despite being a work of fiction, however, the film is presented in a nascent documentary style and is shot like an actuality on the streets of Adelaide. Its non-fictional context is constructed as a narrative. Krischock deliberately destabilizes the usual fixed angle, as his camera tilts, shudders and shakes in order to best evoke the experience of an earthquake for the viewer. But Krischock's film was also, at its heart, an advertisement. The earthquake featured in the film reduces even the sturdiest looking buildings to ruin, and yet the recently built Wondergraph Theatre is completely unaffected (Walker 1995: 43). One infers that it is the safest place to be should a tremor actually strike.

The narrative structure of *Earthquake in Adelaide* draws specifically on the chain of events during the San Francisco calamity: a large earthquake sparks panic on the streets and causes fires that rage across the city. The kinetic nature of Krischock's portrayal of the earthquake is also reminiscent of the highly evocative metaphors used in newspaper reports and subsequent eyewitness accounts. In the days following the 1906 earthquake, it was all too common to read about the city being "tossed like a feather" or about buildings that "rock like poplars in a storm" or are "crushed like eggshells" (Anon 1906i; 1906m). In Krischock's film, a tilting or rocking camera makes buildings appear as if they were light as a feather or caught in a wild storm (see Figure 1.4). Portions of the film are undercranked to create the illusion of citizens running around in a panic. Superimposition is used elsewhere to make it seem as though the entire city is ablaze (see Figure 1.5). Furthermore, a chimney stack topples in Krischock's "earthquake" just as described in many of the eyewitness accounts from San Francisco.

The visceral style of *Earthquake in Adelaide* was unique in its use of camera effects to connote physical intensity. The necessity of shooting in an actuality mode required Krischock to adopt a visual style that involved shaking and tilting the camera in order to simulate the effect of an earthquake (see Figure 1.4). In this respect, the film differs markedly from other cinematic representations of seismic disruption. In *Cabiria* (Pastrone,

Figure 1.4: The Earthquake Hits - Frame enlargement from *Earthquake in Adelaide* (Krischock, 1914).

1914), the earthquake that causes the eruption of Mount Etna and sparks the epic tale, draws upon elaborate sets, frenetic on-screen action and pacey editing. The camera itself remains rigid, calmly surveying the chaos and destruction. The static framing results in a detached, stagey and melodramatic effect that stands in direct opposition to *Earthquake in Adelaide*'s intensely immediate approach, which seems to situate the viewer at the epicentre of the earthquake itself.

Hell Morgan's Girl (De Grasse, 1917), one of Universal's biggest hits in the silent era, starring Dorothy Phillips and Lon Chaney and now presumed lost, featured the 1906 earthquake as a major plot point. Both studio and star returned to a San Francisco setting for *The Shock* (Hillyer, 1923), in which Chaney's prayers for salvation are answered with the catastrophic earthquake and fire. Like *Cabiria*, the camera remained rigid while the spectacular earthquake raged, with the assistance of movable sets, scale miniatures and stock footage.

Although the camera in *San Francisco* (Van Dyke, 1936) also remains steady, the rapid editing, extravagant design and huge moving sets imbue its earthquake scene with a sense of

Figure 1.5: The City Ablaze - Frame enlargement from *Earthquake in Adelaide* (Krischock, 1914).

genuine shock and menace. Only during the prolonged megaquake of *Earthquake!* (Robson, 1974) do we finally see complex sets and carefully composed special effects recombined with hyperactive camera movement and visual warping to draw viewers into the scene. *Earthquake in Adelaide*, however, produced a similar effect in much the same way almost 60 years earlier.

The cinematic context of *Earthquake in Adelaide*

The year of the San Francisco earthquake also stood as a watershed year for the fledgling art of cinema. The initial novelty of the moving image had waned considerably as the 1900s progressed. By 1906, fiction films had begun to outnumber actualities for the first time (Gunning 1986). The rise of the nickelodeon in the United States and the emergence of purpose-built cinemas in Australia and other countries also resulted in a wholesale change in the very fabric of film distribution and exhibition (Hall and Neale 2010: 15–16).

Although it appears almost a decade later, *Earthquake in Adelaide* nevertheless owes a debt to what Gunning (1986: 57) termed the "cinema of attractions." The moving image, according to Gunning, becomes "less a way of telling stories than a way of presenting a series of views to an audience, fascinating because of their illusory power" (1986: 57). The "illusory power" of *Earthquake in Adelaide* is paramount in its imagining of an earthquake-stricken city. Its local specificity and creative presentation are effective in "inciting visual curiosity, and supplying pleasure through an exciting spectacle – a unique event, whether fictional or documentary, that is of interest in itself" (Gunning 1986: 57).

Earthquake in Adelaide occupies a liminal space between fact and fiction, actuality and documentary. It seems necessary, therefore, to locate its place in film history. Krischock's film, albeit a minor or marginal entry in Australian film history, provided a "projection" of the future, envisaging what might happen in Adelaide if a large earthquake struck. He created a cinematic work of pure spectacle designed to neither shock nor warn but specifically to thrill a local audience. "Spectacle," as an aesthetic phenomenon, is typically associated with space, location and narrative interruption, key elements in what would come to be known as the "disaster movie" (Hall and Neale 2010: 5). Any attempt to define *Earthquake in Adelaide* as a work of "spectacle" is met with difficulty only with regard to "narrative interruption," in large part because the interruption itself essentially serves as the narrative.

Krischock's ability to play with conventional genres also exhibits the modernist tendency towards interruption as an aesthetic device. If early non-fiction films provided a window to the world, a "new generation of moving images shattered that window and reassembled the pieces in order to give form to their notion of the city as experience and film as the medium to evoke it" (Uricchio in Webber and Wilson 2008: 107). Modernity itself was represented as a sequence of shocks in the "city symphonies" of Vertov, Ruttman and Ivens. For *Earthquake in Adelaide*, Krischock reassembled the pieces by adapting the style and structure of the travel genre, drawing from published first-hand accounts of San Francisco 1906 and building upon the imagery of the post-earthquake films. He created a film that occupies a curious space between fiction and documentary, sharing some elements with other "simulated" or recreated actualities – such as the Lubin and Biograph San Francisco films or *The Battle of Santiago Bay* (1898). Krischock's film differs considerably, however, not least in the explicit statement of its conceit that comes with framing the narrative as a dream.

Earthquake in Adelaide, while completely fictitious, falls within the bounds of John Grierson's definition of documentary as "the creative treatment of actuality" (see Nichols 2010: 5). Yet it might be more instructive to find an entirely new term to describe Krischock's film. *Earthquake in Adelaide* shares some common ground with a short story written in the 1870s by Bret Harte, a poet, author and chronicler of California in the pioneer days. *The Ruins of San Francisco* is a satirical piece set in the distant future, concerning the rediscovered city of San Francisco. The city had supposedly been struck by an earthquake and swallowed by the sea in the late nineteenth-century. Harte imagines the descriptions of future archaeological historians of the lost city. Yablon classifies the story as a work

of "prospective history" (Yablon 2009: 191). Shot as an actuality, but based entirely on a fictitious account of what might happen should an earthquake strike Adelaide, it seems reasonable to label Krischock's film a "prospective documentary." It functions in the manner of a traditional documentary, but deals with events that might happen in the future, rather than events that actually happened in the recent or distant past.

Postscript

The destruction of San Francisco by earthquake and fire in 1906 undoubtedly presented an emotional shock for those living in the world's increasingly modernized metropolises. The combination of the earthquake and the narratives that accompanied it – whether written, pictorial or cinematic – had a seismic effect of their own. As described by Zeilinga de Boer and Sanders, the metaphorical string had been plucked and the reverberations echoed around the world (2005: x), mainly because of the communication technologies that had emerged in the nineteenth century to define the experience of the twentieth century: photography, mass media and the moving image.

In adopting and adapting those forms, Krischock drew inspiration from the San Francisco quake and its coverage in the visual media to create a unique film for the time. Bill Nichols (2010: 120) suggests that the "great passion" of early film-makers lay in "exploring the limits of cinema, in discovering new possibilities and untried forms." This is precisely what Krischock achieved in 1914 with *Earthquake in Adelaide* by pushing the limits, blurring the boundaries between fiction and non-fiction and highlighting the tension between documented reality and formal experimentation.

After *Earthquake in Adelaide*, Krischock continued making films for a time. He acted as cinematographer on South Australian feature productions *Remorse, A Story of the Red Plague* (Mathews, 1917) and *Our Friends the Hayseeds* (Smith, 1917). He also continued making actualities, topicals and more sophisticated pieces for exhibition in Wondergraph theatres, including a daring film called *Hunting Kangaroos by Motor Car* (Krischock, 1916). Krischock returned to his first love – photography – in the 1920s, and spent the rest of his working life as a photographer for Adelaide's premier newspaper, *The Advertiser*.

Krischock died in October 1940, at the age of 65. Five years earlier, he and his wife embarked on a seven-month overseas tour, visiting Britain – where he bought the latest equipment and had a chance photograph published in the *Daily Mail*. He also visited North Africa, Asia and the Americas, where he realized a long-held dream of touring the Hollywood studios (Krischock 1935). The year before he died – 25 years after making *Earthquake in Adelaide* – a real-life natural disaster afforded Krischock the opportunity to capture some of his finest images, as a prolonged heat wave gave way to devastating firestorms that ravaged south-eastern Australia.

Earthquake in Adelaide was never screened outside Australia during Krischock's lifetime. In 1981, 75 years after the great San Francisco earthquake and 67 years after Krischock's film,

Earthquake in Adelaide was screened in the United States, where it featured in a retrospective of Australian cinema at the San Francisco International Film Festival (Johnson 1981).

References

Anon (1906a), "Town Hall: The Marvellous Corrick Entertainers," *Advertiser* (Adelaide), July 28th, p. 2.
―――― (1906b), "Amusements: The Corrick Family," *Advertiser* (Adelaide), August 6th, p. 8.
―――― (1906c), "Country News: Green's Plains," *Chronicle* (Adelaide), May 26th, p. 15.
―――― (1906d), "Topics of the Day: Ruined San Francisco," *Advertiser* (Adelaide), May 31st, p. 6.
―――― (1906e), "Amusements: Town Hall," *Register* (Adelaide), June 16th, p. 2.
―――― (1906f), "Amusements: Town Hall / Victoria Hall," *Advertiser* (Adelaide), June 26th, p. 2.
―――― (1906g), "Amusements: Town Hall, Port Adelaide," *Register* (Adelaide), July 4th, p. 10.
―――― (1906h), "Amusements: Town Hall," *Register* (Adelaide), August 6th, p. 10.
―――― (1906i), "Frightful Earthquake – Half San Francisco in Ruins," *Register* (Adelaide), April 20th, p. 5.
―――― (1906j), "Earthquakes and Fire," *Register* (Adelaide), April 20th, p. 4.
―――― (1906k), "The Earthquake," *Register* (Adelaide), April 21st, p. 7.
―――― (1906l), "The San Francisco Disaster," *Advertiser* (Adelaide), April 21st, p. 4.
―――― (1906m), "Disastrous Earthquake in California," *Advertiser* (Adelaide), April 20th, p. 5.
―――― (1906n), "The Earthquake," *Advertiser* (Adelaide), April 26th, p. 5.
―――― (1906o), "A San Francisco Observer Supplement," *Register* (Adelaide), April 26th, p. 4.
―――― (1906p), "The San Francisco Disaster," *Chronicle* (Adelaide), June 2nd, p. 29.
―――― (1906q), "Amusements," *Advertiser* (Adelaide), June 16th, p. 5.
―――― (1906r), "Amusements: San Francisco Earthquake," *Register* (Adelaide), June 28th, p. 6.
―――― (1906s), "Amusements: Bio-Tableau at the Town Hall," *Advertiser* (Adelaide), June 28th, p. 10.
―――― (1906t), "Amusements: The San Francisco Disaster," *Advertiser* (Adelaide), June 30th, p. 11.
―――― (1909a), "Help from West's Pictures Entertainment," *Register* (Adelaide), January 6th, p. 8.
―――― (1909b), "West's Pictures," *Register* (Adelaide), January 23rd, p. 4.
―――― (1909c), "Amusements: West's Pictures," *Advertiser* (Adelaide), January 25th, p. 9.
―――― (1909d), "Amusements: Continental Garden," *Register* (Adelaide), February 22nd, p. 9.
―――― (1909e), "Amusements: The Globe Pictures," *Advertiser* (Adelaide), February 24th, p. 10.
―――― (1911a), "Amusements: The Wondergraph," *Advertiser* (Adelaide), May 23rd, p. 8.
―――― (1911b), "Animated Pictures. At Fourteen a Second. How we Deceive Ourselves," *Register* (Adelaide), September 2nd, p. 8.
―――― (1911c), "Amusements," *Register* (Adelaide), October 17th, p. 2.
―――― (1911d), "Amusements: Wondergraph Picture Pavilion," *Register* (Adelaide), December 18th, p. 2.
―――― (1911e), "Amusements: Wondergraph Picture Pavilion," *Register* (Adelaide), December 25th, p. 2.
―――― (1911f), "Adelaide's Greatest Fire," *Register* (Adelaide), November 25th, p. 12.

—— (1912a), "What Might Happen," *Register* (Adelaide), January 6th, p. 12.
—— (1913a), "Sporting News: The Turf," *Advertiser* (Adelaide), March 29th, p. 17.
—— (1913b), "Advertisement: New Wondergraph Picture Theatre," *Mail* (Adelaide), September 6th, p. 24.
—— (1913c), "Our Meat Supply: Depicted by Cinematograph, A Splendid Film," *Mail* (Adelaide), September 6th, p. 24.
—— (1913d), "The New Wondergraph: A Magnificent New Theatre, Opened on Thursday," *Mail* (Adelaide), September 6th, p. 24.
—— (1913e), "Amusements: Wondergraph," *Advertiser* (Adelaide), November 6th, p. 2.
—— (1914a), "Amusements: Wondergraph Pictures," *Advertiser* (Adelaide), June 4th, p. 18.
—— (1914b), "Amusements," *Advertiser* (Adelaide), June 4th, p. 2.
—— (1914c), "Amusements: Continuous Wondergraph," *Advertiser* (Adelaide), March 9th, p. 7.
—— (1914d), "Amusements: Wondergraph Pictures," *Advertiser* (Adelaide), June 6th, p. 22.
—— (1914e), "The Government Astronomer – Mr. G. F. Dodwell, B. A., F. R. A. S.: Something about his Work," *Advertiser* (Adelaide), February 14th, p. 6.
—— (1914f), "Sharp Earthshock," *Register* (Adelaide), May 29th, p. 9.
—— (1914g), "One Never Knows: Earthquakes and Architecture – South Australian's Refuse to be Frightened," *Advertiser* (Adelaide), May 30th, p. 21.
—— (1914h), "Amusements: Wondergraph," *Advertiser* (Adelaide), June 3rd, p. 2.
—— (1914i), "Amusements: Wondergraph Theatre," *Register* (Adelaide), June 4th, p. 3.
—— (1914j), "Amusements: Wondergraph Hindley-Street," *Advertiser* (Adelaide), May 30th, p. 2.
Blom, A. (1913), *Af Elskovs Naade/Was She Justified?* Copenhagen: Nordisk.
Bonine, R. K. (1906), *San Francisco Disaster*, San Francisco: Edison.
De Grasse, J. (1917), *Hell Morgan's Girl*, Hollywood: Universal Pictures.
Eckhardt, J. P. (1997), *The King of the Movies: Film Pioneer Siegmund Lubin*, London: Associated University Presses.
Fielding, R. (2006), *The American Newsreel: A Complete History, 1911–1967*, 2nd ed., Jefferson, NC: McFarland & Company.
Gibberd, J. (2000), "Krischock, Henry Ludwig Frank (Harry) (1875–1940)," in *Australian Dictionary of Biography*, Vol. 15, Carlton South, VIC: Melbourne University Press, pp. 42–3.
Gunning, T. (1986), "The Cinema of Attractions: Early Film, Its Spectator and the Avant-Garde," in *Wide Angle*, 8: 3/4 pp. 63-70. [Reprinted in Tom Elsaesser (ed.) (1990), *Early Cinema: Space – Frame – Narrative*, London: British Film Institute, pp. 56–62].
Hall, S. and Neale, S. (2010), *Epics, Spectacles, and Blockbusters: A Hollywood History*, Detroit: Wayne State University Press.
Hillyer, L. (1923), *The Shock*, Hollywood: Universal Pictures.
Johnson, A. (1981), "Earthquake in Adelaide," http://history.sffs.org/films/film_details.php?id=1478. Accessed August 18th, 2012.
Kiehn, D. (2006), "The Brothers who Filmed the Earthquake," *San Francisco Silent Film Festival*, http://www.silentfilm.org/pages/detail/2082. Accessed August 20th, 2012.
Krischock, H. (1911), *Adelaide in a Hurry*, Adelaide: Wondergraph Company.
—— (1913), *From Pasture to Table*, Adelaide: Wondergraph Company.

——— (1914), *Earthquake in Adelaide*, Adelaide: Wondergraph Company.
——— (1916), *Hunting Kangaroos by Motor Car*, Adelaide: Wondergraph Company.
——— (1935), "With a Camera Abroad," *Advertiser* (Adelaide), November 2nd, p. 11.
Lake, M. and Reynolds, H. (2008), *Drawing the Global Colour Line: White Men's Countries and the International Challenge of Racial Equality*, Cambridge: Cambridge University Press.
Lewis, L. A. (2007), "The Corrick Collection: A Case Study in Asian-Pacific Itinerant Film Exhibition (1901–1914)," *Journal of the National Film and Sound Archive, Australia*, 2: 2, p 1-9.
——— (2011), "Early Cinema: Corrick Collection – 5," in Catherine A. Suroweic (ed.), *Catalogue: Le Giornate del Cinema Muto/30th Pordenone Silent Film Festival*, Gemona: Le Cineteca del Friuli.
Love, D. (2001), "Earthquakes," in Wilfrid Prest (ed.), *The Wakefield companion to South Australian history*, Kent Town, SA: Wakefield Press, p. 157.
Mathews, J. E. (1917), *Remorse, a Story of the Red Plague*, Adelaide: Mathews Photo-Play Producing Company.
Miles Brothers (1906), *A Trip Down Market Street*, San Francisco: Miles Brothers.
——— (1906), *San Francisco*, San Francisco: Biograph.
Nichols, B. (2010), *Introduction to Documentary*, 2nd ed., Bloomington: Indiana University Press.
O'Neill, B. (1913), *When the Earth Trembled*, Philadelphia: Lubin Company.
Pastrone, G. (1914), *Cabiria*, Turin: Itala Films.
Robinson, J. (2007), *A Century in Focus: South Australian Photography, 1840s–1940s*, Adelaide: Art Gallery of South Australia.
Robson, M. (1974), *Earthquake*, Hollywood: Universal Pictures.
Rozario, K. (2007), *The Culture of Calamity: Disaster & the Making of Modern America*, Chicago: University of Chicago Press.
Smith, B. (1917), *Our Friends the Hayseeds*, Adelaide: Beaumont Smith Productions
Sutter, L. (2008), *Constructing an Adelaide metropolis: the photography of Ernest Gall and Harry Krischock (1860s–1940s)*, unpublished MA thesis, Adelaide: University of Adelaide.
Van Dyke, W. (1936), *San Francisco*, Beverly Hills: Metro-Goldwyn-Mayer.
Virgolin, L. (2012), "How to Tell a Catastrophic Event: The 1908 Messina Earthquake (Italy)," in A. Quintana and J. Pons (eds.), *Le construcció de l'actualitat en el cinema dels orígens/The Construction of New in Early Cinema*, Girona: Museu del Cinema, pp 239–49.
Walker, D. (1988), "The Rise of a Popular Culture – Adelaide Cinema 1896–1913," in Andrew D. McCreadie (ed.), *From Colonel Light into the Footlights: The Performing Arts in South Australia from 1836 to the Present*, Norwood, South Australia: Pagel Books, pp. 370–81.
——— (1995), *Adelaide's Silent Nights: A Pictorial History of Adelaide's Picture Theatres during the Silent Era (1896–1929)*, Canberra: National Film & Sound Archive of Australia.
Webber, A. and Wilson, E. (eds.) (2008), *Cities in Transition: The Moving Image and the Modern Metropolis*, London: Wallflower Press.
Winchester, S. (2006), *A Crack in the Edge of the World: The Great American Earthquake of 1906*, London: Penguin Books.
Yablon, N. (2009), *Untimely Ruins: An Archaeology of American Urban Modernity, 1819–1919*, Chicago: University of Chicago Press.
Zeilinga de B., J. and Sanders, D. T. (2005), *Earthquakes in Human History: The Far-Reaching Effects of Seismic Disruptions*, Princeton: Princeton University Press.

Note

1 Two notes of clarification. First, while the film is typically credited as being c.1911 (a date also attributed to its records at the NFSA), I have found no record of it playing in cinemas any earlier than June 1914, a date also cited by South Australian cinema historian Dylan Walker (1995). In any case, the appearance on screen of the Wondergraph picture theatre on Hindley Street means the film could not have been made any earlier than 1913. Furthermore, I have elected to use the now-standard title of *Earthquake in Adelaide*, despite contemporary newspaper advertisements suggesting that, if the film ever had an official title, it was known simply as *The Earthquake* (although it has also been identified as *The Earthquake: What Might Happen*).

Chapter 2

The Wrath of Heaven: The Great Kantō Earthquake and Japanese Cinema

Alex Bates

The Great Kantō Earthquake of 1923 was one of the worst natural disasters in recorded history. The initial shock had a magnitude of approximately 7.9, serious by any calculation, but, like many destructive natural events, the damage caused by the tremors paled in comparison to that caused by subsequent linked disasters(Takemura Masayuki 2003: 44). Fires sprung up in over a hundred different places simultaneously and quickly covered the city. After the last shocks had subsided and the fires had died out, the residents of Tokyo could finally survey the damage. The city was a burnt out shell of its former glory, its streets and canals littered with the bodies of the dead. The devastation made exact numbers impossible, but over 100,000 people were listed as killed or missing. Two thirds of Tokyo and most of Yokohama lay in ruins. The earthquake crippled the political, economic and cultural capital of the Japanese empire. Confusion continued for days and reconstruction took years.

One dominant theme emerged as people surveyed the damage in an attempt to make sense of the devastation, heavenly punishment or *tenken*. Industrialist Shibusawa Eiichi was the first to propose the idea publicly. He wrote, "Tokyo has become a demon of chaos, normal life has been abandoned, morals have deteriorated from laxity, the five filial relationships of Confucius can no longer be seen, and immorality is rampant' (Hori Shin 2004: 133–134).[1] These faults, he said, made Japan ripe for a punishment from heaven. Shibusawa's indictment is vague and he did not expound further on the precise reasons the heavens decided to unleash the destruction, even in later essays. Nevertheless, other critics soon echoed his pronouncement and were more specific in their condemnation. Some singled out cinema as one cause for the moral degeneration. In response, several fictional films, rapidly produced by the studios, alluded to or even parroted heavenly punishment discourse in their depiction of the disaster. After exploring the general effect of the earthquake on the film industry, this chapter will focus on the various fictional melodramas that were made in its aftermath. In particular, several films used the disaster to contribute to discourses on *tenken*, possibly in a move to placate officials who had been concerned about the moral effect of cinema in previous years. Despite their support of the conservative rhetoric of divine punishment, however, these films took the idea that the disaster was retribution for Japan's decadence and linked it not to the cultures of Asakusa movie houses and dance revues, but instead pointed to the excesses of the wealthy. Within these films, we can see the hegemonic struggle to control how the earthquake was inscribed with meaning and how they adapted the discourse to comment on the inequalities of Taisho Japan.

The earthquake and the film industry

The destruction of Tokyo deeply affected both the production and reception of culture throughout Japan. The largest and most prestigious universities, publishing houses and film studios were located in the city and its suburbs, and all were in some state of ruin and disarray in the aftermath of the earthquake. In many cases the buildings themselves were gone, machinery was destroyed, key supplies such as paper and film were difficult to come by, important collections of art and books were turned to ash, and major figures in the intelligentsia and cultural industries fled to the country and other cities to await reconstruction. In short, Tokyo was unable to function as the cultural capital it had been for centuries.

The film industry had been hit like many others. Tokyo had been the heart of the film world, both in terms of production and audience. Before the quake, all of the major studios were located in Tokyo. The largest and longest running studio, Nikkatsu, was established in 1912. By 1923 Nikkatsu was starting to shift towards the more "progressive" film techniques and styles of Hollywood. The largest competitor was Shōchiku, a relatively new company (1919) that had made huge gains in popularity by staying abreast of the latest trends in "American-style" movies. Nikkatsu had its studios in Mukōjima to the north-east of the city, and Shōchiku had its studios in Kamata to the south-west of the city. There were a few other smaller studios as well, such as Teikoku Kinema Geijutsu (Teikine) and Makino Motion Picture Company. The latter, named after its owner and founder Makino Shōzō, started as a splinter group from Nikkatsu, and produced period action films (*jidai-geki*) in Kyoto. Makino's studio, along with a Nikkatsu satellite studio also specializing in period action films, made Kyoto an alternative centre for the film industry – albeit on a much smaller scale – and this proved to be beneficial once disaster struck.

All major studios located in Tokyo suffered extensive losses in the disaster. Ushihara Kiyohiko, a Shōchiku director, recounted watching the collapse of buildings in the Kamata studio: "The brick film warehouse collapsed before our very eyes with a symphonic crescendo, taking with it the actor's lodgings […] In an instant the whole studio was a numbing spectacle of chaos and ruin" (1968: 123).[2] The studio was not the only loss borne by Shōchiku. The downtown offices in Kyobashi were engulfed by the flames, vast quantities of valuable film stock were destroyed as warehouses burned and the same fate extended to many of the films in its archives. Close to a hundred theatres under contract with Shōchiku were out of commission (Tanaka Jun'ichirō 1980a: 357). Nikkatsu similarly lost its offices in Nihonbashi and theatres under its control and the damage at the Mukōjima Studio was considerable (1994: 222–225). With the capital in ruins, the studios had no choice but to relocate, at least temporarily, and Kyoto was the obvious choice.

Nikkatsu was able to relocate to the Taishogun studio, its Kyoto *jidai-geki* branch studio, insufficient though it was, but Shōchiku had nowhere to go. Plans had been in the works to open a Shōchiku studio in the Shimogamo area, and the studio had purchased the land, but nothing had been built. Though Shōchiku immediately began work on developing

their land, Makino offered his Toji-in studio as a temporary substitute. Peter High asserts that this arrangement was beneficial for both parties. Shōchiku had access to a studio and could produce films to meet the contractual demands of distributors and Makino benefited from the "riches in human expertise now flooding [Kyoto]" (1985: 82). The added expertise enabled Makino to improve the quality of his films and thus to compete with his former parent company, Nikkatsu. Shōchiku was not as interested in *jidai-geki* and was thus not as worried about competition from Makino. According to High, Makino got the better end of the bargain and his Kyoto studio's experimentations in high action "American-style" *jidai-geki* ushered in a golden age of *jidai-geki* that characterized the immediate post-quake years.

With conditions in Kyoto being less than ideal, Shōchiku returned the production of their contemporary dramas to Toyko and the rebuilt Kamata Studio by early 1924. Nikkatsu, on the other hand, enlarged their Taishogun studio to accommodate the influx of personnel and the need for increasing the output. With this studio sufficient for their needs, Nikkatsu chose not to rebuild the Mukōjima studio. While some parts of the facility were usable and films were made there until November, Nikkatsu soon wrote off the entire location and sold the land. Nikkatsu did not return to Tokyo for over a decade, until the Tamagawa Studio was completed in 1934. During that time, as Mitsuyo Wada-Marciano has pointed out, Shōchiku dominated the market for modern contemporary dramas and comedies (2008: 5).

In addition to the relocation of the studios, the film industry also had to deal with the loss of theatres. Before the quake, Tokyo had been not only the centre for production, but the centre of consumption as well. Downtown Tokyo had the largest concentration of theatres in the nation. In May of 1923 there were 114 movie theatres in Tokyo, almost double that of any other major metropolitan centre; Osaka for example had 58 (Iwamoto and Makino 1994: 33). The majority of these were in Asakusa, the district of Tokyo that had served as a centre for entertainment since the Edo era. Asakusa was characterized by a high concentration of theatres of all kinds – cinema, cabaret, music and drama – many of which were hastily constructed wooden buildings that made the area especially prone to fires. In a list of "Principal Buildings Destroyed in the Earthquake and Fires," the *Japan Times* reported that Asakusa lost 37 major theatres; it is unlikely that there were any that survived (September 18th, 1923). By comparison the second largest number of theatres destroyed was in Kanda, which lost only five. Though Asakusa and other areas ravaged by fire bore most of the complete losses, almost all of the theatres in Tokyo were damaged badly enough to be out of commission for at least a month. Beyond the considerable effort required to repair and rebuild theatres, the industry had to grapple with government interference in exhibition. On September 3rd martial law was imposed on the disaster area and consequently all "entertainment" was prohibited. Despite their protests exhibitors were unable to show films even in makeshift buildings or outdoors.[3] This contributed to the loss of revenue needed to help with the costs of rebuilding. Finally, on September 25th, studio executives succeeded in persuading the government to lift the ban, though films that "destabilized the populace" remained expressly forbidden.

Table 2.1: Cinemas and Attendance in the Tokyo Region 1923–1924.

Month	Number of theaters	Total attendance	Average per theater
January 1923	109	1,765,000	16,192
May 1923	114	1,440,000	12,631
November 1923	77	886,000	11,506
December 1923	95	907,000	9,547
January 1924	103	2,164,000	21,010
May 1924	127	1,889,000	14,874
December 1924	168	1,352,000	8,054

The first post-quake films were shown in Tokyo on September 27th in a free outdoor exposition. The first permanent theatre to reopen, Nikkatsu's Takinokawa Banzaikan, did so on September 30th. Others followed quickly; the Dentsūkan in Koishikawa, the Ikebukuro Heiwakan and the Naruko Fujikan opened on the following day. These theatres were in regions not heavily damaged by the disaster and had sustained only minor damage. Asakusa and other areas in the *shitamachi* (the plebian half of Tokyo) were practically razed to the ground, and took longer to rebuild. Nevertheless, by mid October the *Japan Times* reported that 30 theatres were being planned for the Asakusa district and that ten of those were expected to be running before the year was out (October 10th,1923: 1). In a testament to the speed of recovery, the earliest records after the quake show that there were 77 theatres operating in Tokyo by November of 1923 (Iwamoto and Makino 1994: 33). Many of the newly rebuilt theatres were modern facilities that attested to the cinema's aspirations towards a higher class image as part of an attempt to revise the status of cinema as a whole (Gerow 2010: 195) (see Table 2.1: Cinemas and Attendance in the Tokyo Region 1923–1924).

Once the theatres reopened, they experienced brisk sales. An oft-cited example of film attendance following the earthquake claims that the Dentsūkan in Koishikawa recorded 18,600 people by mid October, over 5 times that of pre-quake levels (Tanaka Jun'ichiro 1980b: 11). While the Dentsūkan number is impressive, there were very few theatres open in October compared to pre-quake levels. Even if every theatre open in October reported similar figures, the overall film attendance for the month would still be substantially lower than reports of attendance earlier that year. Nevertheless, by May of 1924 monthly spectatorship in Tokyo surpassed pre-quake levels and Tokyo had more theatres than it had before the disaster (Iwamoto and Makino 1994: 33–34). The same growth can be seen beyond Tokyo. In 1923 there were 703 theatres nation wide and by the end of 1924 that number had grown to 1032. In 1919 yearly cinema attendance was just shy of 7,300,000 and by 1924 it was about 54,000,000, growing to 153,000,000 by 1926 (Iwamoto and Makino 1994: 34–35), (Yamada 1978: 325). Industrial expansion can also be seen in the rise in feet of film processed by censors. In 1923 the number of feet processed by censors in 1923 was 4,148,000 feet compared to 8,177,000 feet in 1924 (Tanaka Jun'ichiro 1980b: 12). The

Chart 1: Average Monthly Attendance in Tokyo between 1918 and 1927 (in thousands)

difference is staggering, but attendance numbers do not show a similar rise, suggesting that these figures are likely the result of a combination of longer films and an increasing level of state intervention in the film industry following the earthquake. Some have suggested such numbers are linked to an audience desire for escapism following the disaster, and there is evidence for a slight increase in 1924 beyond the standard growth of the industry[4] (see Chart 2.1: Average Monthly Attendance in Tokyo between 1918 and 1927 [in thousands]). Nevertheless, the earthquake had little effect on the overall trajectory of growth in either direction.

Despite the significant impact the disaster had on finances and infrastructure, studios, distributors and exhibitors had the capital available to rebuild quickly, and industry figures show that the growth continued unabated. Though the earthquake had little effect on the growth of the industry in the years following, it did lead to increased specialization and higher quality. The earthquake drastically altered the landscape of Tokyo, which shed the remnants of the old nineteenth-century city of Edo and arose from the ashes as a fully modern city of concrete, asphalt and neon. This change resulted in the most lasting effect of the earthquake on the film industry, the division of labour between Tokyo and Kyoto. Though the trend was evident before the earthquake, film production afterwards was further split geographically along historical and generic lines. Period dramas following the quake were filmed in Kyoto by the Nikkatsu and Makino studios that drew upon the expertise of technical staff who had relocated to the area. Tokyo, on the other hand, became the location

for dramas and comedies set in the present, with Shōchiku dominating those genres. But for both locations the quake created a blank slate upon which a new generation of film-makers rebuilt the industry more closely aligning itself with the standard set by Hollywood. Donald Richie and Joseph Anderson suggest that the earthquake made it possible for audiences to accept the changes as well. They write:

> One of the reasons that more advanced films were acceptable at all was that the earthquake and its resultant confusion had upset the industry to the extent that many of the old concepts were relinquished and completely new methods and ideas were adopted.
>
> (Anderson and Richie 1982: 48)[5]

The earthquake thus became a symbol of rupture that gave meaning to the artistic and industrial changes that were already in process.

Earthquake films

A key part of the reconstruction process was to produce more films and generate revenue to rebuild. Originally it was actual footage of the disaster that drew the crowds. Such films were probably included in the first programmes of the Tokyo theatres once they were reopened, but the first recorded exhibition of earthquake films in Tokyo was in an advertisement announcing the reopening of Nikkatsu's Ushigome Theater on October 2nd (*Yomiuri shinbun*, October 2nd,1923: 2). The film, *Earthquake Pictures* (*Daishinsai shashin*), consisted of footage taken by the Nikkatsu Mukōjima camera operators at least partially under the direction of Mizoguchi Kenji (Andrew and Andrew 1981: 5). "Death defying" footage of the catastrophe in *Earthquake Pictures* received top billing in the newspaper advertisement, and was set apart from the other films by its prominent placement. Relative length gives another clue as to the main attraction of the program. *Earthquake Pictures* was made up of eight reels, whereas the fictional "feature," Fox Studio's *The Night Horseman*, had only five. Nikkatsu's film was one of many that were made by film studios, newspaper companies and government agencies.

 These non-fiction films were shown across the nation and the world. In a short story set in the rural town of Kōfu, for example, Masamune Hakuchō depicts his protagonist, who has fled the disaster in Tokyo, walking past cinemas advertising earthquake films (Masamune Hakuchō 2003: 55). Six days before the first theatre in Tokyo was opened on the last day of September, a two-reel film of the catastrophe reached New York. As the film travelled, it made the newspapers in both Japan and America. It went by boat to the west coast and then by plane across the continent, apparently "breaking world record for the shipment of motion picture news films" (*Japan Times*, October 4th, 1923) As soon as it arrived in New York, it was relayed across the Atlantic and shown in London on

October 8th.[6] This was a major event and filmgoers of the world were interested in the footage.

One of the most famous of these non-fiction films was *Great Kantō Earthquake,* shot by a young cameraman named Shirai Shigeru between September 1st and 3rd. Shirai captured everything from the aftershocks and fires themselves, to the fleeing masses and floating corpses. Though there was not really a category called "documentary" at the time, this combination actuality and newsreel is considered by the film-maker and critic Tsuchimoto Noriaki to be "Japan's first documentary film" because of the artful way Shirai captured the devastation (1985: 329). According to Shirai's autobiography, the filming was fraught with difficulties, not the least of which was the inherent danger in filming a disaster up close. Illustrating the difficulties faced by the entire industry, Shirai struggled with the lack of film stock and a place to develop the exposed film, eventually creating a makeshift darkroom to develop the film himself. His effort paid off. The film was very successful and the Japanese Ministry of Education bought the film to use for educational purposes and as a record of the disaster. The ministry later enlisted Shirai to continue filming the aftermath for posterity, thus beginning its educational film programme.

Though his film was later sanctioned and even purchased by the government, Shirai had difficulties with the authorities while filming. Shirai reports having to cut the film short when approached by an army official after martial law was imposed, and he was even taken to headquarters for questioning. According to Shirai's compelling tale of the shooting, the film would have been lost had he not switched the canisters and handed the official a reel of only partially exposed film (Shirai Shigeru 1983: 49). Trouble with officials went beyond this incident. Though there is no account of its filming, the Nikkatsu footage was banned a few days after its debut. The stated reason was fear it would "destabilize the populace," particularly because it included footage of the troops sent in during martial law. A compromise was reached and the film in question was shown two days later, with the offending portion removed (*Yomiuri Shinbun*, October 6th and 8th, 1923: 2). Subsequent newspaper advertisements capitalized on the fact that it had been banned, by prefacing the title in advertisements with the word "controversial," which certainly heightened its popularity.[7]

The difficulties faced by Shirai in the days after the disaster, the banning of all film exhibition for the month of September, and the problems with Nikkatsu's earthquake footage even after that ban was lifted, all reveal the government's close attention to film in the months after the earthquake. The state had been wary of cinema from the teens when they developed separate oversight and censorship rules for cinema in particular (Gerow 2010).[8] In the midst of the instability and the confusion of the aftermath, film was seen as a potentially inflammatory medium that could lead to crime or even larger unrest. The initially wary response of the government proved to industry insiders that they would need to convince those in power that cinema could be a force for good or their business could be in jeopardy. Though morality tales were frequent in earlier films as well, they were particularly evident in fiction films depicting the disaster. And several dealt explicitly with the morality highlighted in heavenly punishment discourse.

Heavenly punishment and fictional earthquake melodramas

The idea that the Kantō Earthquake was brought about by the depravity of the Japanese people is closely linked with the writings of Shibusawa Eiichi. Though nuances changed slightly through various iterations of his theory, the central ideas – namely that the disaster was in response to degeneracy among the people and that a return to Confucian moral fortitude would be necessary for rebuilding – remain constant. This idea was most prominently expounded in an official pronouncement by the imperial household office. This document, the second imperial rescript on "Strengthening the National Spirit," gave Shibusawa's ideas the tacit approval of the emperor himself.[9] In the midst of its discussion of the need for both moral and structural rebuilding, the rescript cautions the public about lax morality:

> In recent years much progress has been made in science and human wisdom. At the same time, *frivolous and extravagant habits* have set in, and even rash and extreme tendencies are not unknown. If these habits and tendencies are not checked now, the future of the country, we fear, is dark, the disaster which [sic] befell the Japanese nation being very severe.
> (Fujisawa Morihiko and Office, B.o.S.A.H. 1926: frontispiece)

The first imperial response to the disaster was in a rescript issued the week after the quake that emphasized the naturalness of the disaster. Though this was a terrible event, the rescript explicitly stated, "It is beyond human will or effort to prevent the inexorable convulsions of nature" (Fujisawa Morihiko and Office, B.o.S.A.H. 1926: frontispiece). By the time the second rescript was announced in November, over two months later, heavenly punishment had become the dominant theme and the implication in the passage cited above was that the actions of the people led to the disaster. Though the "frivolous and extravagant habits" are not mentioned by name, a link between national decadence and the disaster is implied by the assertion that the future of the country rests on reversing the moral decay.

While both Shibusawa and the rescript were vague about the actual causes of the divine punishment or *tenken*, other critics spelt out their issues with the state of Japanese morality with great clarity. The Christian thinker Uchimura Kanzō and Tenrikyo priest Okutani Fumitomo were some of the few literal interpreters of the disaster as divine punishment. As early as September 5th Uchimura wrote in his diary that he felt "as if an angel had brought down his sword against the entire city in judgment. But I believe this was a benevolent judgment" (Hori Shin 2004: 153). Uchimura developed the idea further in an essay for *The Housewife's Companion* (*Shufu no tomo*) that directly referenced Shibusawa. After applying a quote from Isaiah to Tokyo, "Ah sinful nation, a people laden with iniquity, a seed of evildoers," Uchimura continued:

> Look at the theaters and the department stores and the frivolous men and women who frequent them […] If this is Japan then I would be embarrassed to have been born

Figure 2.1: Contemporary map of the fires. Kazama Tetsutarō. *Saigo no dai Tōkyō no ryakuzu* (Nagasawa Printing, 1923).

here. Japan before the earthquake, especially Tokyo, was the kind of place in which the righteous could not endure.

(Uchimura Kanzō 1983: 18).[10]

Okutani Fumitomo also saw the depravity as specifically linked to the entertainment districts: "Places that served to satisfy people's greed and desire have been completely destroyed" (Schencking 2008: 305). The proof, for these critics, was that areas like Asakusa and Ginza were destroyed whereas "residential" areas were spared.

What Uchimura and Okutani chose to ignore, however, was that while the devastated areas they mentioned were not solely residential, they were, in fact, where most of Tokyo's citizens resided.[11] The area they call "residential" was the *yamanote*, home to the new middle-class office workers and to the estates of the aristocrats, which had a population of 1,116,300 in 1923. Asakusa and Ginza were in the *shitamachi*, the more plebian half of the city, where 1,148,000 people lived (Fujisawa Morihiko and Office, B.o.S.A.H. 1926: 87–88). They mostly comprised the old middle-class shopkeepers and small business owners along with the labourers employed in the factories of the area. Maps of the damage show that

the *shitamachi* was hit the hardest, but the casualty statistics also show that it was far from populated only by the decadent cinema patrons and their like. Though 2,500 people died in the *yamanote*, almost 90,000 were killed in the *shitamachi*. The critics' middle-class bias and their desire to see proof of a divine hand in the destruction made them blind to those living in the devastated *shitamachi* (see Figure 2.1).

A Keio University economist Horie Kiichi similarly singled out cinemas and entertainment districts for scorn, though he was hesitant to apply an overtly religious tone to his writing. Unlike Uchimura and Okutani, who saw the entertainment district as harbouring sin, Horie based his critique of cinema on the fact that it was an unproductive waste of time and money. Horie's primary concern was with luxury and, for him, materialism, rather than lax morality, was the target of his criticism. Horie shares this view with Shibusawa, who often decried the "audacious luxury" of the current "*nouveau riche* age," and the imperial household agency with their mention of "frivolous and extravagant habits."[12] That materialism was the primary focus of critics is clear in the work of historian Charles Schencking, who has written on divine punishment following the earthquake in his study of the discourses of reconstruction. Materialism was mentioned by almost every critic he cites. Even moral philosopher Fukusaku Yasubumi, who included "sexual slackness" in his list of traits that brought on the disaster, ultimately focused his attacks on Japan's rampant materialism (Schencking 2008: 304).

These critics together show two distinct trends in *tenken* discourse (though there was considerable overlap). On one hand, people like Uchimura and Okutani stressed that retribution was primarily due to the rise of immorality explicitly linked to the entertainment districts. On the other, Horie and most others held that materialism was the biggest factor. Though these writers chose different aspects of society to criticize, including the entertainment industry, the discourse soon coalesced around the idea of materialism and Uchimura's and Okutani's more religious moralizing ended up as a minor theme. Of the two trends, it is the evils of materialism that are most often referenced in films of the day.

The Japanese film industry took advantage of the non-fiction films' popularity by using them to attract patrons to theatres and also by incorporating actual footage and quake related plots into their productions. Before the end of 1923 at least 11 fiction films were released that dealt with the earthquake directly. According to most film historians these earthquake films were a passing trend that disappeared as the novelty wore off. It is difficult to say otherwise because none of the films remain for examination. Writing about 20 years after their release, Hazumi Tsuneo panned such films as of little interest to film history because they were nothing more than faddish works with questionable production values (1951: 150). Hazumi's word is usually taken at face value though he was only in his early teens when these films were released. Though Hazumi could be right in his assessment of the artistic quality of the films, they nevertheless provide insight into the moral values of the time and how those values are revealed in melodrama. While it is hard to gauge their quality without the films themselves, external writings

reveal that most of these films were melodramatic tales that participated in larger moral discourses.

In *The Melodramatic Imagination,* Peter Brooks identifies the melodramatic mode as "a mode of conception and expression, a certain fictional system for making sense of experience" (1995: xvii). This particular fictional system serves to foreground an unspoken moral code. As he writes, "[W]e may legitimately claim that melodrama becomes the principal mode for uncovering, demonstrating, and making operative the essential moral universe in a post-sacred era" (1995: 15). In his study of early film and stage melodramas, Ben Singer, following Brooks, has outlined five common characteristics of melodrama as a genre: pathos, overwrought emotion, moral polarization, non-classical narrative structure, and sensationalism. Singer notes that though every melodrama does not necessarily have each characteristic, various combinations of these results in melodrama (2001: 44–49).[13] There is a coherent moral world view that is palpable in the post-quake cinematic melodramas, in which the earthquake is usually perceived as a force for good. The film industry was, at least in part, targeted as one reason for the divine intervention in the form of the earthquake, and moralizing films could be seen as a way to counteract such criticism.

Though all films about the earthquake had a moral component, not all dealt explicitly with heavenly punishment. In some cases the quake acts as a *deus ex machina*, resolving the conflict or helping the villain change heart, thereby playing a role in the moral structure of the film. In the Shōchiku film *Daichi wa ikaru / The Earth is Angry* (Ushihara Kiyohiko, 1923), for example, the earthquake strikes right at the moment the villain takes aim at the hero, allowing him to rescue the kidnapped woman and escape. This use of the disaster as *deus ex machina* is also found in the 1924 American film *Torment*, directed by Maurice Tourneur. The film was released in February and thus while the disaster was still fresh in the minds of the American viewers. *Torment,* about an international intrigue involving the Russian crown jewels, used the recent news from Japan to heighten the tension by contriving to have the criminals caught in Yokohama right at the moment the quake strikes. For this scene, *Torment* used actual footage from the disaster, likely taken from newsreel films that were rushed across the Pacific to be shown across the West. The earthquake not only adds to the drama but also allows the thieves to reflect on their actions and mend their ways while trapped in the rubble (Waldman 2001: 117). The Nikkatsu *jidai-geki Ansei ibun Ōedo no daijishin / Strange Tales of the Ansei Edo Great Earthquake* (Kobayashi Yaroku, 1923), set during an earthquake 60 years earlier, similarly resolves its conflict with the advent of the disaster. In the film a father is blamed for a wallet gone missing and his son confesses in order to save him. The dilemma is resolved when the wallet is found following the earthquake. While not exactly a *deus ex machina*, the innocence of an earthquake orphan convinces the criminal to reform in Nikkatsu's *Suki na ojisan / A Likable Man* (Suzuki Kensaku, 1923). In these cases, the occurrence of the earthquake is a crucial element of the plot, but the moral code is not directly related to the disaster. Rather, they show the earthquake as a force for good, at least in part, and thus imply the unseen hand of a divine power allowing the hero to be saved or the villain to repent.

Shōchiku's *Shi ni men shite / Facing Death* (Ōkubo Tadamoto, 1923) is similar to these films in that the earthquake is not shown to have any explicit divine origin, but its moral nevertheless relates to *tenken* discourse. *Facing Death* was released in Osaka only one month after the disaster, the first earthquake melodrama to be exhibited. It focused on the innocence of a young girl who has yet to be tainted by the perils of modernity and who is threatened by greed. The plot revolved around a miner, Shōhei (Shiga Yasurō) and his daughter Ohatsu (Takao Mitsuko) who were returning to their hometown via Tokyo. There, they stop at a cheap hotel and a scene shows Shōhei counting out his life savings in the room. Suddenly the earthquake strikes and father and daughter quickly flee the building. Remembering his money, Shōhei returns to his room despite his daughter's pleas. Though she tries to wait for him, she is carried off in the fleeing crowd. Ohatsu believes her father is dead, but then hears that he is alive in a temporary hospital. She is led to a man who is unrecognizably burnt and covered in bandages. Though the man claims not to remember Ohatsu, he has her father's distinctive wallet and the nurses attribute his lack of memory to trauma. Ohatsu takes to caring for this man and tries to nurse him back to health. One day while collecting rations Ohatsu meets a man also claiming to be her father, though he too is bandaged. After some effort Ohatsu is convinced he is telling the truth. Through this chance meeting, the man in the hospital is revealed as an imposter. He had taken advantage of the confusion to steal the father's life savings. After his confession, the imposter pleads for their forgiveness saying that Ohatsu's kindness was his salvation. The reunited father and daughter take pity on this man and shed a tear for him before he "ascends on that journey from which there is no return" (Fukui Shirō 1923: 42). The melodrama in this story emphasizes the dichotomy between the corrupt city and the pure countryside and functions as a broad critique of anti-materialism.

Facing Death attempted to draw a strong connection between the real earthquake and its recreation both as a marketing ploy and to emphasize its moral position. The young child actress playing Ohatsu, Takao Mitsuko or Micchan as she was affectionately referred to, was featured in the November issue of *Shōchiku gahō / Shōchiku Illustrated* as both actress and earthquake survivor. In the photos, Micchan is seen both in her role as Ohatsu clinging to a telephone pole after the quake and as herself after fleeing the fires with her two cats (see Figures 2.2 and 2.3). Later the magazine included Micchan's own earthquake survival story, supposedly told in her girlish voice. The text uses the feminine pronoun *atashi* and the feminine emphatic particle *wa*, rather than a more neutral and objective reporting style (Takao Mitsuko 1924: 20–21). A review of the film in the same issue praises Micchan's realistic acting and links it to the fact she had "tasted this kind of fear." "After the intertitle 'It's a quake' appeared, when Mr. Shiga grabbed Micchan and headed outside, his attitude or expression and Micchan's frightened face, were so sincere they pierced my heart" (Itami Saburō 1923: 18–19). The implication is that if Micchan lived through the quake, then her performance as Ohatsu has that much more truth to it. A similar gesture towards authenticity can be found in an early film melodrama of the Titanic disaster, *Saved from the Titanic* (Étienne Arnaud, 1912). *Saved from the Titanic* heavily advertised the fact that

Figures 2.2–.3: Takao Mitsuko after fleeing the fires with her cats (left) and as Ohatsu in Shōchiku's *Facing Death* (right). *Shōchiku gahō*, 1:11, November 1923, p. 20.

the main actress in the fictional story, Dorothy Gibson, was actually a survivor from the doomed ship (Bottomore 2000: 110). In both cases, the experience of the actress in the real disaster lends authenticity and thus moral authority to the film.

Beyond the spectacle of the earthquake itself, *Facing Death* traffics in several melodramatic tropes identified by Brooks and Singer. In this simple plot we have innocence threatened, mistaken identity and emotional partings and reunions. Linda Williams has pointed out that in melodrama the threat posed to innocence is often couched in terms of a threat to the sanctity of the home (2001: 28). In this case, the thief invades the most intimate conception of "home": the relationship between father and daughter. In so doing the thief helps clarify the moral polarity of the melodrama, namely that the city is a place where criminality threatens family. According to the summary in the *Kamata* fan magazine, the film opened with a shot of the widowed father and daughter as passengers on a horse drawn cart traveling on a mountain path. Her father mentions that it will be faster when they ride on an automobile. The puzzled Ohatsu has never heard of an automobile and is unaware of the technological frights of the city. When at last she sees a car, she stares with a "curious suspicion." Riding on the bus to the city, Ohatsu clings to her father's knee in fright (Anonymous 1923c: 26–27). In her study of Meiji ideology, Carol Gluck has pointed out that migration from the countryside to the city had been treated in the national discourse as a disease: *tokai netsu* or city fever (Gluck 1985: 159). She notes how the city became seen as a site of decadence and materialism that infected the rest of the country through the (relatively easy) transportation of people and ideas. But as Gluck points out, the perceived urban maladies "represented a veritable catalogue of the attributes of a modernizing society" (Gluck 1985: 177). In other words, it

Film on the Faultline

is impossible to separate the ills identified by ideologues from the progress of modernity. Ohatsu's fear emphasizes how she remains unsullied by the technological advancements of modernity and the concomitant moral decay of the city.

Once in the city this innocent girl is threatened on multiple levels – the first being that of the earthquake itself. But the earthquake is not shown as the primary danger: Ohatsu safely escapes with her father. Rather the threat is posed by her father Shōhei abandoning her to return to the unstable boarding house. It is not the earthquake, but Shōhei's pursuit of money that endangers his daughter. The next threat is the overwhelming pressure of the fleeing crowds, the cause of Ohatsu's inability to wait for her father. More sinister still is the invasion of the intimate father-daughter relationship through the father's replacement by the thief. The menacing force in the film is not the earthquake, but the corrupting power of money (seen in both the father and the thief) and the anonymous mass of urban crowds. Both of these are contrasted with the rural and youthful innocence of Ohatsu.

These threats are resolved at the conclusion of the film. The thief dies and Shōhei gives away his money to help the poor. But the final solution is not merely the immediate removal of the threat, but a retreat to the country where they can be safe. According to the *Kamata* summary, in the final scene Ohatsu asks her father where they should go, and he replies, "to our home [*furusato*] in the mountains." Shōhei and his daughter have had enough of the city. They realize that the benefits of urban living are outweighed by the costs – the masses of people and especially those unscrupulous enough to take advantage of a major catastrophe to rob a widower and his daughter.

Melodrama exaggerates the good and evil in each character to help clarify its moral code. In this case the divide between city and country is as polarized as that between the innocent girl and the menacing villain. This draws on a worldview, not unique to Japan, that sees the countryside as a repository of traditional morality, a sanctuary from urban social ills. The exact word used for countryside or homeland in the summary of *Facing Death* is *furusato*. The discourse surrounding the *furusato*, or home in the country, is linked specifically to the modernization of the Meiji era. As Stephen Vlastos puts it, "[T]he valorization of the farm village as the heart and soul of Japan belongs to a modern discourse that developed in reaction to social cleavages and national anxieties attendant on industrialization" (Vlastos 1998: 80). These Meiji era discourses that set up an idealized nostalgic homeland in the countryside [*furusato*] were still very much on the mind in 1923 and continued into the thirties.[14] Mizoguchi, whose earthquake melodrama *Haikyo no naka / Amid the Ruins* (Mizoguchi Kenji, 1923) also ended with a happy couple returning to the countryside, made at least four films with *furusato* or *kokyō* in the title into the thirties. Though the earthquake does not necessarily act as a divine punishment, the city is nevertheless identified as a site of crime and decadence.

Shōchiku's *Facing Death* was a subtle critique of city corruption and materialism, but did not reference class difference directly. Other films more explicitly depicted the earthquake as an awakening for those who had been "infected" with materialism in the heady years leading up to the disaster. The film *Juichiji gojuhappun / Two Minutes to*

Noon (Shimazu Yasujirō, 1923), the time of the initial earthquake, for example, was more pointed in its critique. *Two Minutes to Noon* drew specifically upon critiques of luxury found in heavenly punishment discourse by centring the story on an affluent housewife shaken out of her worldly lifestyle. In a scene particularly noted by reviewers, she appears at a relief meeting in her finery only to be embarrassed by the contrast with everyone else, who had dressed simply, either out of respect or necessity. This scene especially reinforced the anti-luxury discourse of Horie Kiichi, along with reformer Abe Isō and author Chikamatsu Shūkō among others. Chikamatsu Shūkō, for example, called for the complete banishment of "useless luxury goods and vain decorations," singling out diamonds and silk kimonos specifically (Chikamatsu Shūkō 1923: 219). In Mizoguchi Kenji's earthquake film, *Haikyo no naka / Amid the Ruins* (1923), the message was similarly targeted towards the affluent. It was about a woman who had grown dissatisfied with her overly materialistic existence with her wealthy husband. While looking for her husband after the earthquake, she finds an old beau who shows her what a simpler life could have been (Sasō Tsutomu 2001: 218–227).

Both *Two Minutes to Noon* and *Amid the Ruins* reflected the trend against materialism and luxury in heavenly punishment discourse, but two films explicitly invoked *tenken*. The first, *Honoo no yukue / The Direction of the Flames* (Ikeda Yoshinobu, 1923) from the Shōchiku studios, included a prophet character calling for the world to change its ways or face the punishment of heaven. The second, a Nikkatsu film directed by Suzuki Kensaku titled *Daichi wa yuragu / The Earth Shakes* (1923), reworked a Hollywood movie to depict an upper class family who refuse to heed the warning provided by the disaster. In both of these films divine punishment is actually part of the plot and the films themselves clearly articulated the idea.

The Direction of the Flames was based on a novel serialized in the Osaka *Asahi* newspaper about a couple whose future together is jeopardized by the greed of a father. Everything is resolved after the earthquake when they realize that some things are more important than money. Though this general theme of the story is an oft-repeated trademark of romantic films and the ending resembles the *deus ex machina* ending of films like *The Earth is Angry* or *Torment*, the film explicitly drew upon heavenly punishment discourse for its moral center. This is apparent in the inclusion of a prophet figure who is shown calling for repentance before the disaster. Without the film it is hard to say how large a role he played, but in the *Kinema Junpō / Movie Times* review of the film, published in December 1923, the prophet, played by Okada Sōtarō, is third on the list of cast members (Anonymous 1923a: 9). Clues from the serialized novel hint at how he may have appeared in the film. The novel begins with the Dōzawa family commenting on a prophet talking to a crowd outside their home. He calls out to those who would listen:

> Beware and keep your pride in check. Do you think your duty to the gods is merely to wear beautiful kimono, eat rich foods, and live in gaudy palaces? Something dreadful will come of it. When the world is touched by heaven's anger, it will be turned upside down.

The patriarch of the family, Dōzawa Keigorō, agrees: "He speaks the truth […] Those who grow too prideful will incur heaven's wrath, no heaven's punishment" (Tachibana Sueo 1923: 6–7). In the world of *The Direction of the Flames* even the wealthy, it would seem, recognized the excesses of late Taisho Japan.

The most scathing critique of the wealthy was *The Earth Shakes*, filmed by the Nikkatsu Mukōjima crew. Though the studio was greatly damaged, the film was shot amid the ruins and was released in October of 1923. An on-location photo emphasizing this fact ran in the November issue of *Nikkatsu gahō / Nikkatsu Illustrated* magazine showing Suzuki Kensaku directing two of his actresses with burnt out trees, rubble and a crowd of curious onlookers in the background. *The Earth Shakes* takes its premise from the 1919 Cecil B. DeMille melodrama *Male and Female*.[15] In *Male and Female*, a rich family must survive on a deserted island with help from their butler, and in the Nikkatsu remake, the situation is changed to post-quake Tokyo. There is also a more significant alteration in theme. *Male and Female* is about love overcoming class difference, but *The Earth Shakes* is about the perils of extravagance and the pleasures of simple life. Hazumi Tatsuo claims that this film was in fact the first Japanese film to depict class conflict (1951: 150).

Like *Male and Female*, *The Earth Shakes* opens with images of the aristocratic family, the Kurauchi's, that emphasize their wealth and idleness. According to the summary printed in the *Nikkatsu Illustrated* magazine, the patriarch, played by Yamamoto Kiichi, "has a keen sense of class-consciousness." His three daughters "change their outfits both morning and night" and exemplify the lives of profligacy they lead. (Anonymous 1923b: 40–41). This detail not only points to their wastefulness, but also calls attention to the importance of clothing in discourses criticizing the wealthy, a fact also seen in *Two Minutes to Noon*. As further evidence of their extravagance, the Kurauchi family has many servants in their household, with at least four credited in contemporary reviews. The film focuses on one of these servants, the cook Yūzō, who is simply happy with his lot in life despite working from dawn to dusk. In great contrast to the family, Yūzō is described as "pious toward nature and full of common courtesy" (Anonymous 1923b: 41).

The audience's interpretation of the film as an allegory of divine punishment is not left to chance. The name Kurauchi itself implies both wealth and insularity – the *kura* character means storehouse or treasury and the *uchi* means within. In other words, they are living in a storehouse full of wealth without a concern for the outside world. The summary in the Nikkatsu produced fan magazine describes the Kurauchis as not only extravagant, but "absorbed in the dream of prosperity, *just as if representing Japan*" (Anonymous 1923b: 40) (emphasis mine). By equating the Kurauchis with Japan the anonymous author of the summary makes the allegory explicit: This is a story about what Japan was like before the earthquake and what Japan must do to survive the subsequent tribulation.

As if to make the link to divine punishment discourse even more explicit, when the earthquake strikes the summary simply says, "One day, heavenly punishment (*tenken*) arrives" (Anonymous 1923b: 41). The Kurauchi's, coddled by their wealth, must rely on their kind cook. Yūzō helps them deal with their new situation by gathering food and

making a shelter. Despite the changes in circumstance, the patriarch of the family remains firm in his ideas of class and propriety. A contemporary reviewer praised Yamamoto Kiichi for his depiction of Kurauchi Kanzō as caricature of a man who "retained his strong class-consciousness even in a disaster" (Anonymous 1924: 139). A still included in the November 1923 issue of *Nikkatsu Illustrated* supports the reviewer's assessment. In it, Yamamoto sits eating a rice ball being waited upon by a servant, keeping up his own image of propriety despite being incongruously surrounded by rubble.

In contrast to the humorous persistence of her father, the youngest daughter Ranko, played by Mizuki Kyōko, adapts to her surroundings and finds joy in the menial labour necessary for survival. This she does under the kind tutelage of the cook Yūzō. Once Ranko begins to repent of her materialism and begins to work, she is rewarded by a new sense of accomplishment. As the summary tells us, "[compared to the boredom of idling away her time, she clearly felt the exhilaration that came welling up from sweat and toil" (Anonymous 1923b: 41). In one of the few stills available of the film, we see Yūzō and Ranko looking upon a simple family scene amid the ruins. While the context is unclear, this scene most likely served to showcase an ideal simple family in contrast to the entitled Kurauchi family (see Figure 2.4).

Figure 2.4: Mizuki Kyōko as Ranko and Kuzuki Kōichi as Yūzō (behind the cart to the right) look toward another refugee family in a still from *The Earth Shakes*. Image courtesy of the National Film Center, the National Museum of Modern Art, Tokyo.

In the view of the film, the rest of the family does not fare so well. As a whole, they follow the father and refuse to let go of their aristocratic ideas. Finally they leave the ruins, "without realizing that they were the rotting corpses of a society clinging to its own emptiness on a ghostly carriage of death" (Anonymous 1923b: 42). The boldness of the metaphor would shame even the categorical ranting of the most vitriolic of *tenken* supporters. The message is clear – the nation needs people unsullied by urban materialism like Yūzō or repentant urbanites like Ranko who are willing to work towards recovery. Should Japan desire to avoid a ride on a "ghostly carriage of death" it must follow the trajectory of Ranko by recognizing the error of its ways and returning to the exhilaration that arises from "sweat and toil." *The Earth Shakes* and other earthquake films that criticize urban materialism see the earthquake as a corrective force that leads back to a time of morality and simplicity.

These films clearly show an engagement with the discourse of heavenly punishment, but they leave us with the question, Why? Why would these films participate in a discourse that at times criticized the industry? And why would they show films that criticized their paying customers, their audience. First, cinema was a mass entertainment and there would be little economic consequence in alienating the wealthy at the expense of the more plebian customers. Furthermore, no member of the audience is meant to believe that those criticized are similar to themselves. They would, rather, be expected to sympathize with those who realize the effect of their wardrobe and dress simply or laugh at the difficulties faced by a wealthy daughter as she learns to cook. At the same time, the industry has a motive for moralizing. The Japanese film industry, like others across the world, was interested in legitimizing itself as a proper art form and proving itself to be a medium capable of transforming society for the better. By participating in a dominant moral discourse of the time they were able to show that films could be a motivation for good at a time when the "national spirit" needed support. In other words, the industry as a whole was trying to deny that it was 'frivolous' or a luxury. Finally, by focusing on the wealthy in particular, these films were able to distract attention from the industry's role in other frivolous entertainment without alienating their audience. As a result of the moralizing messages in the films, none of the earthquake related fictional films were targeted by the censors.

The films made after the Great Kantō Earthquake celebrate the simple life and the way that the disaster equalized society. In reality though, this was far from the truth. As is true of most disasters, it was those residents of the *shitamachi* who bore the brunt of the quake, exacerbating pre-existing socioeconomic divisions in the city. Those living in the *yamanote* and beyond in the suburbs weathered the quake relatively easily. Though they may not have been realistic, these films helped reframe the *tenken* discourse from one that criticized those who attended cinema to one that criticized the wealthy. As time passed, later iterations of the *tenken* idea seldom mention cinema, but, like the films themselves, focus on the wealthy. How large a role these films played is debatable, but as *tenken* discourse developed, the inequalities of wealth and the perils of materialism became the norm for critics, not frivolous entertainment like film.

References

Anderson, J. and Richie, D. (1982), *The Japanese Film: Art and Industry*, Princeton, NJ: Princeton University Press.
Andrew, D. and Andrew, P. (1981), *Kenji Mizoguchi: A Guide to References and Resources*, Boston: G. K. Hall.
Anonymous (1923a), "Nihon eiga ran," *Kinema junpō*, 145, pp. 9–11.
—— (1923b), "Daichi wa yuragu," *Nikkatsu gahō*, 1, pp. 40–42.
—— (1923c), "Shi ni men shite: daishingai ni kakawaru aiwa," *Kamata*, pp. 26–27.
Anonymous (1924), "Daichi wa yuragu," *Katsudō zasshi*, 10, pp. 139.
Bates, Alex (2010), "Authentic Suffering, Anxious Narrator: Survivor Anxiety in Nagata Mikihiko's 'The Wild Dance of the Flames,'" *Japan Forum*, 22, pp. 357–380.
Bottomore, S. (2000), *The Titanic and Silent Cinema*, East Sussex, England: Projection Box.
Brooks, P. (1995), *The Melodramatic Imagination: Balzac, Henry James, Melodrama, and the Mode of Excess*, New Haven: Yale University Press.
Chikamatsu Shūkō (1923), "Tensai ni arazu tenken to omoe," *Kaizō*, 5, pp. 216–219.
Dodd, S. (2004), *Writing Home: Representations of the Native Place in Modern Japanese Literature*. Cambridge, MA: Harvard University Press.
Yamada Kazuo, ed. (1978), *Eiga no jiten*. Gōdō Shuppan,
Fujisawa Morihiko and Office, B.o.S.A.H. (1926), *The Great Earthquake of 1923 in Japan*. Naimushō-Shakaikyoku.
Fukui Shirō (1923), "Shi ni men shite," *Katsudō kurabu*, 6: 10, pp. 40–42.
Gerow, A. (2010), *Visions of Japanese Modernity: Articulations of Cinema, Nation, and Spectatorship, 1895–1925*, Berkeley, CA: University of California Press.
Gluck, C. (1985), *Japan's Modern Myths: Ideology in the Late Meiji Period*. Princeton: Princeton University Press.
Havens, T. (1974), *Farm and Nation in Modern Japan: Agrarian Nationalism, 1870–1940*. Princeton: Princeton University Press.
Hazumi Tsuneo (1951), *Eiga gojūnenshi*. Sōgensha, Osaka.
High, Peter (1985), "Japanese Film and the Great Kanto Earthquake of 1923," *Kokusai kankei gakubu kiyō*, 31, pp. 71–84.
Hori Shin (2004), "Kantō daishinsai to tenkenron: Shibusawa Eiichi wo chushin ni," in *Rekishi to bungaku: Kantō daishinsai*, Kyōritsu Joshi Daigaku Sōgō Bunka Kenkyūjo Kanda Bunshitsu, pp. 129–153.
Itami Saburō (1923), "Shinsai aiwa 'Shi ni men shite' wo miru," *Shōchiku gahō*, 1, pp. 18–19.
Iwamoto Keiji and Makino Mamoru (Eds.) (1994) *Eiga nenkan Showa hen,* Nihon Tosho Sentā.
Makino Mamoru (1994), "1924 (Taisho 13) nen, Nihon eiga to 'Kinema junpō,'" *Kinema junpō*, 1.
Masamune Hakuchō (2003), "Tanin no saigai," *Hennentai Taishō bungaku zenshū*, 13, pp. 53–69.
Masumoto Kinen (1987), *Jinbutsu Shōchiku eigashi: Kamata no jidai*. Heibonsha.
Narita Ryūichi (1998), *"Kokyō" to iu monogatari: toshi kūkan no rekishigaku*, Yoshikawa Kōbunkan.
Sasō Tsutomu (2001), *Mizoguchi Kenji, zensakuhin kaisetsu*, Kindai Bungeisha.
Schencking, J. Charles (2008), "The Great Kanto Earthquake and the Culture of Catastrophe and Reconstruction in 1920s Japan," *The Journal of Japanese Studies*, 34, pp. 295–331.

Shirai Shigeru (1983), *Kamera to jinsei: Shirai Shigeru kaikoroku*. Yuni Tsūshinsha.
Singer, B. (2001), *Melodrama and Modernity: Early Sensational Cinema and its Contexts*, New York: Columbia University Press.
Tachibana Sueo (1923), *Honoo no yukue*, Seibunkan Shoten, Osaka.
Tadokoro Shigeyasu (1923), "Tenken no moto ni hirefu shite," *Shin-seinen*, 4, pp. 2–10.
Takao Mitsuko (1924), "Koneko wo nihiki idaita mama," *Shōchiku gahō*, 1, pp. 20–21.
Takemura Masayuki (2003), *Kantō daishinsai: Dai Tōkyō ken no yure wo shiru*, Kajima Shuppankai.
Tanaka Jun'ichirō (1980a), *Eiga no hattatsushi: katsudō shashin no jidai*, Chūō kōronsha,
—— (1980b), *Eiga no hattatsushi: musei kara tōkī e*, Chūō kōronsha.
Tsuchimoto Noriaki (1985), "Jissha eiga wo miru," in Imamura Shōhei, Satō Tadao et al. (eds.), *Nihon eiga no tanjō*, Iwanami Shoten.
Uchimura Kanzō (1983), "Tensai to tenbatsu oyobi tenkei," *Uchimura Kanzō zenshū*, 28, pp. 18–20.
Ushihara Kiyohiko (1968), *Kiyohiko eigafu gojūnen*, Kagamiura Shobo.
Vlastos, S. (1998), "Agrarianism without Tradition," in *Mirror of Modernity: Invented Traditions of Modern Japan*, Berkeley, CA, University of California Press, pp. 79–94.
Wada-Marciano, M. (2008), *Nippon Modern: Japanese Cinema of the 1920s and 1930s*, Honolulu: University of Hawai'i Press.
Waldman, H. (2001), *Maurice Tourneur: The Life and Films*, Jefferson, NC: McFarland & Co..
Williams, L. (2001), *Playing the Race Card: Melodramas of Black and White from Uncle Tom to O. J. Simpson*, Princeton: Princeton University Press.
Yano, C. (2002), *Tears of Longing: Nostalgia and the Nation in Japanese Popular Song*, Cambridge, MA: Harvard University Press.

Notes

1. This excerpt originally ran in the *Hokkai Times* on September 11th, 1923.
2. Translated in (High 1985:77). The story of the Kamata Studio in the earthquake and what happened to various Shōchiku directors and actors is also told in Masumoto Kinen (1987: 58–65).
3. Makino Mamoru, "1924 (Taisho 13) nen, Nihon eiga to 'Kinema junpo,'" *Kinema Junpo fukkokuban*, 1 (Heibun sha, 1994), p. 19.
4. Tanaka Jun'ichirō has used the Dentsūkan number to support his argument that cinema in Japan experienced 'explosive prosperity' after the earthquake (Tanaka Jun'ichirō 1980b: 11–12). Other Japanese film historians, namely Peter B. High and Makino Mamoru, have made similar arguments following Tanaka. (High 1985: 82), (Makino Mamoru 1994: 20).
5. This is the gist of Peter High's argument as well.
6. See also *Japan Times*, September 27th, October 10th, 1923 and *New York Times*, September 26th, 1923.
7. See for example *Yomiuri Shinbun*, October 10th and 14th, 1923, p. 2.
8. See in particular chapter 1, "The Motion Pictures as a Problem."

9 This is my translation of the rescript title: "Kokumin seishin no sakkō no shōsho." In the English version the title is: "Imperial Edict Enjoining Sincere and Strenuous Life." The Japanese version and my translation emphasize the national.
10 Originally in the October 1923 issue of *Shufu no tomo* (vol. 7 no. 10). Uchimura references Isaiah 1: 4–6.
11 I have discussed the issue of class in the Kantō Earthquake in my article, (Bates 2010: 357-380).
12 These terms appear in Shibusawa's writing (Hori Shin 2004:134, 137), also (Tadokoro Shigeyasu 1923: 4) and (Fujisawa Morihiko and Office, B.o.S.A.H. 1926: frontispiece).
13 Brooks actual list of characteristics is as follows: "the indulgence of strong emotionalism; moral polarization and schematization; extreme states of being, situations, actions; overt villainy, persecution of the good, and final reward of virtue; inflated and extravagant expression; dark plottings, suspense, breathtaking peripety" (Brooks 1995: 11–12).
14 For more on *furusato* and agricentrism discourse, see (Havens 1974: pp. 3-14, 111-132), (Narita 1998: 2-18), (Yano 2002: pp. 13-37). See also Stephen Dodd's analysis of the *furusato* theme in high literature of the time (2004: 1-24). In all these cases, the entire book is relevant to the discussion but I have identified key passages.
15 The connection between the films was pointed out by Hazumi Tsuneo (1951: 150). DeMille's film was in turn an adaptation of J. M. Barrie's play *The Admirable Mr. Crichton*.

Chapter 3

Earthquakes in Film: Exploring Visualization Strategies

Ozge Samanci

Policy-makers have the capacity to minimize the possible damage created by an earthquake in a populated area if they have the required information represented in a comprehensible way. Through the visual simulation of hazards and risks, seismic loss assessment aims to identify the most influential attributes and criteria in earthquake decision making in order to improve our understanding of the perception, assessment and communication of risk. A visualization project based on the creation of a visual vocabulary and grammar drawn from film can aid decision making in the event of an earthquake and directly affect the process of minimizing risk and damage. I was part of a research group that made empirical and experimental tests which explored the effects of visualizations on engineers and decision makers. The study of the representation of the earthquake in the movies offers a novel perspective for developing software maps by merging the approaches of film studies, visual culture and humanities with public policy and psychology.

Method

The representation of an earthquake in a fiction film has most likely been produced by a layman such as a director, a cinematographer or an art director rather than by a specialist such as a seismographer, a scientist or a geologist. The disjunction between the interfaces offered by a layman and a specialist contains significant potential for research. Even though, in the case of earthquakes, the information for risk visualization has often been gathered by scientists, policy-makers are not necessarily scientists and they may not be familiar with scientific terminology. Establishing a link between scientists and policy-makers presents a significant challenge. A film survey can help identify, more broadly, communicative strategies.

To this end, we compiled a list of films which portrayed earthquakes, drawn from the databases of the American Film Institute, the definitive reference work for American feature length films, and the Internet Movie Database (imdb.com), a fan created online database. A keyword search for "earthquake" yielded approximately 200 titles which included *Intacto* (Fresnadillo, 2001), *Masumiyet / Innocence* (Demirkubuz, 1997), *Superman* (Donner, 1978), *A View to Kill* (Glen, 1985), Kingu Kongu tai Gojira /*King Kong versus Godzilla* (Honda, **1962),** *Volcano* (Jackson, 1997), *Earthquake* (Robson, 1974), *Escape from LA* (Carpenter, 1996), *The Running Man* (Glaser, 1987), *Earthquake: Nature Unleashed* (Takács, 2004) and *The Big One: The Great Los Angeles Earthquake* (Elikann. 1990), *The Great San Francisco Earthquake* (2005). With the exception of the *Great San Francisco Earthquake*, all films in

this list can be classified as fiction. The availability of the titles from video rental services and library sources designated the final list.

Six hundred frames from 12 films were selected, captured and analysed in order to illustrate the strategies of cinematic visualization that they employed in the representation of earthquakes. The films surveyed revealed a number of common themes and familiar techniques, which supplied the basis for a set of categories that were then used to develop software maps to aid in visualization and decision strategies for seismic loss assessment. The reader should consult the website "Snapshots: Representations of Earthquakes in Movies" [http://dm.lcc.gatech.edu/~osamanci/earthquakesinfilm.htm] in order to view the frames and figures that I will refer to throughout the chapter. The site currently exists in two versions. In Version I, the frames are presented in linear order [http://dm.lcc.gatech.edu/~osamanci/earthquake/earthquake.htm]. All frames sourced from a single movie appear within a single slide show. In this way, viewers are able to see the earthquake related frames in relation to story development. This version functions as a support for Version II that presents the frames according to visual strategies [http://dm.lcc.gatech.edu/~osamanci/earthquake/filmtech.htm].

After identifying these visual and thematic categories, we applied the concepts of "inside perspective" and "outside perspective" as developed by Bryant and Tversky (1999) to describe how viewers and participants imagine themselves in relation to the scene. Bryant and Tversky study the effects of various representations by taking a three dimensional representation of a character surrounded by objects to six sides of the body. They found that "[a]lthough 3D models and depth-enriched diagrams promoted a 3D mental representation but flat diagrams did not, instructions to adopt an inside perspective enabled 3D mental representation from flat diagrams" (Bryant and Tversky 1999: 155). While few of the frames in the sample completely exhibit insider or outsider points of view, the majority of representations contain representational strategies that enforce both points of view. The viewer of the film is invited to imagine themselves as simultaneously inhabiting a space that is both inside and outside the field of action. Whether the product of a conscious or an unconscious creative choice on the part of the film-maker, a balance between insider and outsider perspectives helps the spectator to continue viewing without feeling alienated. In the theatre the same technique is referred to as the "fourth wall," the boundary between the stage and audience that has been removed, so to speak, but that continues to exist as an invisible barrier that prevents the action of the play from invading the real world.

If the film offers a protracted and intense experience of the insider perspective, the viewers will lose the boundary between their own presence in the real world and their virtual existence through the identification process in the world represented on screen. In this case, the viewers perceive any emotional or physical danger that the characters in the film face as a danger that they encounter too. A self-protective act will alienate them and cause the fourth wall to collapse. On the other hand, if the film offers a similarly complete depiction of the outside perspective, the viewers will not feel empathy for the characters. The simultaneous use of insider and outsider perspectives recalls the function of the desaturation theory in filmic representation. According to Zettl (2007: 80), "[T]he desaturation theory suggests

that by desaturating even to the point of omitting chromatic colors altogether, we can entice the viewer to participate in the event, to look into rather than merely at it." Examples of the application of the desaturation theory in colour films are plentiful, especially in bloody and violent scenes. For instance, in *Edward Scissorshands* (Burton, 1990), the desaturated colour of the blood keeps the scene from appearing too realistic and thus prevents over-identification and consequently alienation. Similarly, in films that portray earthquakes, the insider perspective requires high identification while the outsider perspective produces alienation. These opposed representational strategies raise issues related to the concepts of self-consciousness, verisimilitude, presence, immersion and realism.

Identification, alienation and self-consciousness

There is no simple or clear-cut definition for the term identification. Freud and Lacan define identification from a psychoanalytic perspective while Baudry and Metz define it in terms of film theory. These theoreticians, in their different ways, insist upon the primary and secondary processes of identification.

According to Metz (1986: 49) primary cinematic identification describes the spectator's identification with the act of looking itself: "[T]he spectator *identifies with himself*, with himself as a pure act of perception (as wakefulness, alertness): as condition of possibility of the perceived hence as a kind of transcendental subject, anterior to every *there* is." In other words, primary identification involves the spectators' awareness of their own absence on the screen. Primary identification is the necessary step toward secondary cinematic identification which Metz (Metz 1986: 56) defines accordingly:

> As for identifications with characters, with their own different levels (out-of-frame character, etc.) they are secondary, tertiary cinematic identifications, etc; taken as a whole in opposition to the simple identification of the spectator with his own look, they constitute together secondary cinematic identification, in the singular.

A spectator can identify with a character, with many characters at the same time, and also with the camera. I will be referring to secondary cinematic identification as the means for establishing the spectator's imaginary access to the film through their attachment to characters and camera movements.

Brecht (1957) defines the alienation effect [*Verfremdungseffekt*] as a theatrical and cinematic device that causes an interruption in the process of identification. According to Brecht (1957: 91), the alienation effect "prevents the audience from losing itself passively and completely in the character created by the actor, and which consequently leads the audience to be a consciously critical observer."

The definition of self-consciousness is open to divergent interpretations, however. According to Robert Stam (Stam 1985: 1), "[r]eflexivity […] points to its own mask and

invites the public to examine its design and texture." Stam defines reflexivity in cinema as a product of "films which point to their own factitiousness as textual constructs." David Bordwell (Bordwell 1993: 58) discovers self-consciousness in cinema in "the extent [to which] the narration displays a recognition that it is addressing an audience," an observation which recalls Stonehill's definition of self-consciousness in the novel (Stonehill 1988: 3) as "an extended prose narrative that draws attention to its status as a fiction." The fiction makes the narrator, audience, or narration visible. For example, a film may acknowledge its status as a fiction by directly including the director, by positioning the film-maker in front of the camera, by suddenly emphasizing film form, by playing with conventions and thereby disappointing the audience's expectations, by revealing the film is constructed, by showing the technical equipment, by making the actors gaze directly at the audience, by including an audience in the film, by commenting on the film industry, studios, other actors, actresses or, finally, through intertextual references to other films.

Verisimilitude, immersion and realism

The concept of verisimilitude is also open to the procedures of alienation and identification. The credibility of a specific convention, theme or image may be destroyed by placing it within the confines of another genre. According to Chatman (1990) audiences come to recognize and interpret conventions by "naturalizing" them through the process of verisimilitude. A set of paradigms, determined by the laws of physics, exists in the audience's mind in relation to the perception of reality. If something consistent with these laws is presented to the audience, it is not necessary to define new paradigms. If a new concept of reality is created, as happens in the science fiction genre, it will only remain convincing if it establishes a new connection with existing reality. For example, since a set of paradigms had already been established by earlier science fiction films, it is possible to use existing paradigms without creating new definitions in contemporary science fiction. Thus, each genre builds up its own concept of reality. In other words, the audience gains a sense of immediacy about a specific genre through watching other films from the same genre. While seeing people fly, even without explanation, is considered acceptable in science fiction film, a similar occurrence will not have credibility in a costume drama. In animation, as opposed to all other genres, everything is possible and there is no requirement for defining paradigms.

Therefore, strategies for the creation of self-consciousness in film should be considered alongside the concept of verisimilitude. In *Superman* (1978), for example, the lives of hundreds of train passengers are saved when Superman closes the gap in the rails caused by an earthquake. The train passes through his body yet nothing happens to him. In the superhero genre, this scene does not create a self-conscious moment. However, if a supernatural event occurs in *Earthquake* (1974), a film with a more realistic narrative, it will produce a moment of alienation, a break in the identification process. Consequently, a break in verisimilitude will often create an "outside perspective" for the viewers.

Figure 3.1 a-c: Stills from *Street* (1976).

The concepts of immersion and realism are also related to identification and alienation. The degree of realism and immersion determines the viewers' or the performers' awareness of their separate existence from the representational world of a film or other simulated virtual reality. According to Schubert et al. (2001), immersion determines the objective description of technology. Slatter and Wilbur (1997: 604) define immersion as "the extent to which computer displays are capable of delivering an […] illusion of reality to the senses of a human participant." An immersive engagement with the screen does not of course preclude the presentation of a heightened sense of realism.

Lombard and Ditton (1997) introduce two different types of realism: "social realism" and "perceptual realism." Social realism includes the events that could take place in the non-mediated world while perceptual realism concerns the look or sound of the representations. For example, Caroline Leaf's animated movie, *Street* (1976) tells the story of a family taking care of a dying grandmother whose young grandson waits impatiently for her to pass away so that he will get her room. *Street* is high in social realism but low in perceptual realism (see Figure 3.1).

Figure 3.2a-b: Stills from *Final Fantasy: The Spirits Within* (2001).

In contrast, the CGI generated movie *Final Fantasy: The Spirits Within* (2001), set in 2065, tells the story of the fight between humans and a race of invading, phantom-like aliens. *Final Fantasy: The Spirits Within* offers a low social realism and high perceptual realism (see Figure 3.2).

Categories and strategies

The visual strategies identified in the films surveyed are readily apparent and compelling. Filmmakers produce meaning through media specific techniques such as relations between frame and perspective, camera angle and movement, colour, light, décor, *mise-en-scène*, sound, acting, make-up and editing. A frame-by-frame analysis revealed that perspective relations, camera movements, and lighting were the most frequently visited tools for interpreting the experience of an earthquake. The following table lists the more obvious categories for describing the cinematic effects employed in depicting a seismic event:

1. Film Techniques
 a. Items entering the frame from above
 b. Flickering TV and computer screens
 c. Bird's eye view
 d. Wide angle
 e. Flashlight
 f. Shaky camera
2. Surface of the Earth
 a. Ground
3. Architecture
 a. Icons
 b. Buildings
 c. Bridges
 d. Towers
 e. Collapsed
4. Series of Disasters
 a. Uncontrolled electric current
 b. Collapsing dam
 c. Flood
 d. Explosions
 e. Fire
 f. Leaking pipes
 g. Traffic accidents
 h. Loss of communication
 i. Pillage
 j. Elevator accidents
 k. Nuclear accidents
 l. Lines for food
 m. Trapped people
5. Face and Body
 a. Faces

b. Gestures
 c. Hanging Bodies
 d. Panic
 e. Foetal Position.
6. Objects
 a. Ceiling lamp
 b. Falling furniture
 c. Swinging and trembling items
7. Representation
 a. Maps
 b. Seismographs
 c. Computer graphics
 d. Analogue models
 e. Drawing theme parks
 f. Comparisons
8. Absurd moments
 a. Absurd moments and tiny details
9. Animals
 a. Behaviours of animals
10. Apocalypse
 a. Dark future
 b. Boiling pools
11. Moral Lessons
 a. Family union
 b. Brevity
 c. Race
 d. Private and public spaces
 e. Politics
12. Verbal representation
 a. Verbal representation of an earthquake

Film techniques

In a fictional film, spectators tend to forget about spaces that are not visible on the screen such as those areas above, below or adjacent to the frame. In horror films, for instance, items unexpectedly enter from the forgotten region beyond the frame, especially from above. In the case of representing earthquakes, objects such as bricks, stones, furniture, and concrete columns often fall into the frame from above (see Figure 3.3).

The use of a frame within the frame is also a common effect. In the moment of a major earthquake, nature overwhelms all cultural boundaries. Accordingly, repeated shots of flickering computer and television screens signify the collapse of technology. For instance,

Figure 3.3: *Earthquake* (1974).

Figure 3.4: Bird's eye view in *Earthquake* (1974).

in *The Big One: The Great Los Angeles Earthquake* (1990), flickering computer and television screens emerge as a secondary frame within the main frame (see website).

Film-makers use camera angles to position the viewer in a specific location, establishing a hierarchy between the events, characters and the audience. The bird's eye view or aerial shot, which provides the audience with an omnipotent perspective, is a commonly used camera angle in earthquake related movies (see Figure 3.4). The camera assumes such an elevated position after the tremors have ended in order to let the audience see the impact of the quake in its entirety. These images function as establishing shots, showing panicking people running like tiny ants to the exits, escaping from the city in their cars, lost amongst thousands of dead bodies sequenced one after another.

Earthquake films frequently use wide-angle shots to emphasize the relationship between human beings and the environment. After the earthquake, the city gains an apocalyptic look. In order to emphasize the scale of the disaster, wide-angle shots offer a combined view of the shocked humans wandering within the ruined city (see Figure 3.5). In addition to camera angles, shaky camera footage often represents the movement created by the earthquake.

In terms of lighting sources, flashlights are iconic in disaster movies. They give agency to the characters. A flash light can divide the darkness like a sword and can also function as a weapon. It can throw some parts of the frame into darkness. Consequently, a flashlight becomes a handy tool for making invisible objects visible and for creating surprise and

Figure 3.5: Wide angle: Human beings versus environment in *Earthquake* (1974).

Figure 3.6: The changes on the surface of the earth in *Superman* (1978).

suspense (see website). For example, in *Earthquake* (1974) a flashlight exposes a crack in the dam, further adding to the impending sense of doom.

2) Surface of the earth

The surface of the earth is mostly perceived as solid, concrete and stable. When it tears apart like a piece of paper, the cracking ground or popping sidewalk displays the change of power relationships at the moment of the earthquake. What seemed safe suddenly becomes deadly. In *Superman,* for instance, an aerial shot of the San Andreas Fault, which opens and closes before our eyes, exposes the fractured surface of the earth (see Figure 3.6).

3) Architecture

The destruction of architectural structures in the form of collapsing buildings, bridges, and towers is conveyed most expressively in the spectacular demise and demolition of famous iconic sites. The elephant shaped statue at La Brea Tar Pits sinks into the pool in *Volcano* and *The Great Los Angeles Earthquake*. The Golden Gate Bridge collapses in *Superman*. The Hollywood sign explodes in *The Great Los Angeles Earthquake*; it falls onto people in *Superman*, and appears as a burning apocalyptic image in *Escape from LA* (see website).

4) Series of disasters

The earthquake initiates a series of disasters such as uncontrolled electric currents, collapsing dams, floods, explosions, fires, leaking pipes, traffic accidents, elevator accidents and nuclear accidents. It results in loss of communication, pillage, lines for food, trapped people. The combination of disasters leads to a catalogue of further catastrophes. If a dam collapses the area is flooded. The flood causes telephone poles to fall over. The water transmits electric current. People in the water experience electric shocks. A disastrous sequence of events such as this occurs in *A View to Kill, Earthquake, The Big One: The Great Los Angeles Earthquake, Earthquake: Nature Unleashed, Superman,* and *Volcano* (see website).

(5) and (6) Faces, Bodies and Objects

In addition to collapsing architecture, the experience of the earthquake has also been conveyed through the representation of facial and physical expressions. The hanging bodies of victims from collapsing bridges and buildings and people taking the foetal position repeatedly appear (see website). In comparison to the colossal display of images of urban and architectural destruction, small objects also represent the shaking of the earthquake in a

functional way. In addition to falling furniture, swinging ceiling lamps were emphasized in almost every film surveyed. A collection of various swaying and trembling objects exhibits a remarkable use of objects as a part of décor and *mise-en-scène* (see website). A trembling padlock on the door, vibrating pieces of chess board, a tiny giraffe model on a computer, the swinging uniforms hung in the locker room of a nuclear power plant, a trembling wire fence, water in the coffee maker, window glasses, a signboard on the road, the keys of piano moving by themselves, all indicate the impending disaster in a subtle way. Here, the film relies on the spectators' mental participation and permits them to imagine the upcoming impact of the earthquake. Consequently, the visualization of the earthquake appears more immersive.

7) Representations

The use of maps, seismographs, computer graphics, analogue models, drawings, even a theme park, in a movie can be classified as a representation within a representation. *A View to Kill* (1985) precedes the use of detailed computer graphics so a table top analogue map is used to illustrate the cruel plan of destroying Silicon Valley (see website). A massive amount of explosives, placed in a mine close to the fault, will produce a man-made earthquake, followed by a flood. The lights on the map indicate the motion of the flood. Since the representation is a three dimensional model instead of a computer animation on a two-dimensional screen the impact of the water covering Silicon Valley appears immense.

8) Absurd moments

Even though an earthquake is a profoundly disturbing subject, films do not avoid exhibiting a sense of humour by depicting the absurd situations that may occur at the moment of the catastrophe. After all, the spectator soon comes to realize, a major earthquake could occur in the middle of an ordinary day. For example, in *Earthquake!*, Stuart Graff's demanding wife Remmy commits suicide with an overdose of pills and appears to have lost consciousness. While her husband is worrying about her and looking for help, an earthquake strikes. Remmy's eyes suddenly open with the shock of the quake; she was only pretending to have blacked out (see website). In another humorous scene, pool players in a bar fight over the original location of the ball that has moved because of the quake. *Escape from LA* and *The Great Los Angeles Earthquake* both include an assassination at the moment of the earthquake. Because of the jolt, the assassins miss their targets.

(9) and (10) Animals and apocalypse

Animal behaviour, in scenes of barking dogs and birds taking flight, frequently serves as a sign of the disaster to come. Apocalyptic images of the corruption of society and a collapsed

world economy after a major earthquake such as in *The Running Man* (1987) are also common indicators. Boiling pools and sea images contribute to the sense of apocalypse.

(11) Moral lessons

Finally, at the level of theme, moral lessons and verbal descriptions of the earthquake act as non-visual representations. In *Innocence* and *Intacto*, for instance, the effect of the earthquake is created in the viewers' mind through dialogue. The normative American family, white, middle class, heterosexual, is united at the end of *The Great Los Angeles Earthquake*, *Earthquake: Nature Unleashed*, and *Volcano*. The reunion of the family in *Earthquake: Nature Unleashed* is noteworthy. The woman scientist is divorced, yet continues to wear her wedding ring. At the last second, she prevents a possible nuclear catastrophe by completing an electric circuit with her wedding ring, saving millions of lives. In the end, as expected, she decides to return to her ex-husband. The wedding ring, a symbol of the family and the heterosexual couple, is the magical tool for stopping the disaster. Bravery, the brotherhood and sisterhood of races, the conflict between science and humanity, family and duty, and punishment for bad policy-makers comprise other moral themes.

The simultaneous use of inside and outside perspectives

The insider perspective enforces an emotional approach with the aid of the identification mechanism. The outsider perspective imposes an informative approach, and reduces the emotions by eliminating identification. There are many variables that determine the implementation of either strategy and their impact is open to various readings in different contexts.

The tools of invisible narration mainly enforce the insider view. For example, continuity editing, the absence of a voiceover, the presence of a human, animal, or anthropomorphic being in the frame, interior shots, low angle shots, eye-level shots, the use of realistic proportions that avoid close-ups or wide-angle lens, and tracking shots following the characters, all enable the spectators to imagine themselves in the scene.

As previously stated, strategies that produce a self-conscious awareness of the narrative will inevitably alienate viewers and align them with an outside perspective. In such cases, a variety of methods and techniques are employed. If there are no human beings, animals, anthropomorphic objects or any kind of prop that offers a metonymic bond with a character within the frame, the *mise-en-scène* does not offer a point of mediation, a child's toy or a piece of clothing for example, that triggers the identification process. This case becomes apparent when a map or some other graphic representation is presented in the film.

An aerial shot will make the characters and setting look as tiny as ants. Moreover, the bird's eye view leads to an enormous foreshortening of vision. Consequently, the choice

of cinematographic distance will lead to an extreme abstraction of shape and size and will reduce the chances of identification. Moreover, since spectators view the event from above, they will not feel threatened by the dangers that the characters face, such as falling bricks, collapsing buildings or dams etc. Similarly, a wide shot creates a greater sense of distance between the objects within the frame, camera and spectators. In this case, even though the foreshortening will not be effective, the reduction in size of characters and setting will hide the details and only inform the audience about the scale of the disaster by mechanically revealing the dynamics between actors and environment.

During an interior scene where the furniture, ceiling and walls collapse and fall down, the unexpected entrance of the objects into the frame creates a shocking impact. An exterior shot that places the viewers at a safer distance and in a distinct location will reduce the imminent risk of falling objects from the top of the frame. In an interior shot, unless the camera is not recording the scene from a voyeuristic position outside a window, characters and viewers are presented from a unified perspective in the same environment. Consequently, an exterior shot is more likely to offer an outside perspective.

An earthquake on screen is often edited as a sequence of short cuts that jump from one event to another. Such shifts in spatial perspective and temporal duration break with the rules of continuity editing, make the narration visible and ultimately alienate the viewer. The speed and suddenness of the shots reduces their emotional impact but increases their informational content by presenting the spectators with a sense of the variety of hazards and the magnitude of the event.

The viewer occupies the position of a voyeur in relation to the main events and objects in the frame, sharing the same space with the characters while remaining invisible to them. Consequently, the impact produced by the objects in between the camera and the core event in the frame is two-sided and enforces both the inside and outside perspectives.

The following frames from *Superman* (1978) and *Earthquake* (1974) illustrate the simultaneous use of the strategies for implementing outside and inside perspectives and show how they can function in a completely unexpected way depending on context.

In Figure 3.7, the camera locates the viewers at the same eye level as the character and in the same setting, thereby producing an extreme level of emotional engagement and identification. In Figure 3.8, the frame does not contain a single living being. The aerial shot reduces the image of the splitting and shifting ground to an abstract representation, minimalist in its grandeur and beauty. Consequently, in Figure 3.8, the visual information – the massiveness of the faultline, the splitting of the earth – has more impact than any emotion that the scene would convey.

The sequence that follows illustrates the importance of narrative context in assigning an inside or an outside perspective to a scene. While the shot of Lois screaming in the car seems to be presented from an inside perspective, the scenes in Figure 29 and Figure 30 (see website) appear to be outside perspectives. Actually, all frames are closer to the inside perspective. The first shot locates the viewers inside the car and, even though the falling telephone poles and the explosion are shot form a distance, they will feel threatened to the

Film on the Faultline

Figure 3.7: A complete inside perspective in *Superman* (1978).

Figure 3.8: A complete outside perspective in *Superman* (1978).

extent that they imagine themselves in the car with Lois Lane. Moreover, the newspaper in the last shot adds a realistic detail to the scene and increases the viewers' feeling of being in the car. As a result, all of the three shots contain aspects of the inside perspective.

However, the majority of the frames captured from the films surveyed exhibit both perspectives at the same time, thus preventing the alienation that might be caused by over-identification. In Figure 3.9, the wide-angle shot makes the characters look tiny. The abstraction and distortion of scale diminishes the human features of these characters. Viewers cannot identify strongly with such ant-sized figures. The tininess of the characters enforces the outside perspective. Even if the Hollywood sign falls over, it will not disturb the viewers who survey the scene from a safe distance. On the other hand, the presence of living beings in the frame and the eye level shot imposes the inside perspective.

At first glance, Figure 3.10 seems like a clear example of the outside perspective since it does not include any living beings and captures the scene from above. Nevertheless, the camera height and angle locates the viewer at a standing position next to the crack, thereby establishing an ominous sense of presence. The spectators feel threatened because of the unstable ground opening just in front of their hypothetical feet.

Another image from *Earthquake* (see website), again induces both perspectives simultaneously. While the presence of the living beings in the frame, the interior shot and the camera angle generate the inside perspective, the presence of the pipes and valves between the viewer and the event produces a voyeuristic effect. Even though the spectators

Figure 3.9: Tiny characters as a consequence of the wide-angle shot in *Superman* (1978).

Earthquakes in Film

Figure 3.10: Location of the camera in *Earthquake* (1974).

share the same interior space, the distance and location of the camera places them at a safer remove and provides them with a hidden and invisible perspective from which to view the scene.

Figures 3.11 and 3.12 show the varying function of the strategies in relation to the context. The character Denise is in a movie theatre during an earthquake. Because of the shaking, the film in the projector burns and abstract shapes appear on the screen. Initially,

Figure 3.11: Denise in the movie theatre, *Earthquake* (1974).

87

Figure 3.12: Film is burning, *Earthquake* (1974).

Figure 3.11 appears to be an example of the inside perspective while Figure 3.12 shows the outside perspective. However, Figure 3.12 represents the point of view of a spectator watching the movie. The issue is complicated by the introduction of a self-conscious gesture since the character is in a movie theatre and since the burning film signifies the essence of the medium. The scene reminds the viewers that they too are actually watching a film. The self-conscious content alienates the viewers and establishes the outside perspective.

Finally, figures 31 and 32 (see website), exemplify the shifting meaning of a given setting in the flow of time. In Figure 31, the map is shot from above, a position consonant with an outside perspective. When a character steps onto it, the illusion is broken and the setting and scale of the image are revealed from a position more in line with the inside perspective.

Conclusion

The research from the survey can be applied in a number of possible directions. Policy makers could use it to assess earthquake risk and damage within a simulated digital environment. Interactive maps on a two-dimensional computer screen, manipulatable by the keyboard and the mouse, provide the most common and accessible form of visual imaging. However, tangible interfaces utilizing three-dimensional space with virtual reality goggles, sensors, and computer vision technology would offer a more intricate-installation based experience to the policy makers and the layman.

A standard map representation involves a high degree of abstraction and contains a minimal level of human presence, and is more likely, therefore, to offer the distanced view afforded by the outside perspective. In this case, it is not easy to imagine the human scale of the disaster because of a lack of those realistic details that stimulate empathy. The zoom in-out option on a digital representation, on the other hand, would give the user

the opportunity to manipulate the insider and outsider perspectives. In a possible scenario, the users could zoom into a satellite map image representing the destruction after an earthquake. At the maximum zoom level, the users can perhaps crawl into the window of a destroyed apartment. In this case, the users will move from an omniscient view of the event to an immersive experience of objects, characters, props that will support identification. This shift from a complete outsider to a complete insider perspective will enable the users to imagine the informative and emotional aspects of the disaster simultaneously.

The objects in between the user and the user's point of attention can activate a voyeuristic point of view. For example, if a user locates herself in an apartment behind the collapsed wall of a room, after zooming in to the maximum point, those parts of the collapsed wall in the frame will implement a voyeuristic look. Consequently, while the zoom-in option enforces the insider perspective, the voyeuristic point of view imposes the outsider perspective while prohibiting alienation.

During the screening of narrative feature films, the viewers can invest in the characters as a consequence of the identification process. A seismic map drawn from still images would not exhibit a narrative structure or present characters in action. However, maps represented in the digital environment, in addition to the possibility of interactivity, possess the capacity to project a sequence of moving images. If users can invent characters, place them in specific habitats, create earthquakes of different magnitudes, and observe their consequences, they would therefore be more invested in the characters and the environment. In this case, the users' relationship with the map will go far beyond the outsider perspective.

In a film, the camera can trace the character's path as the character moves. This connection between camera and character reinforces the identification process. In a digital interactive map, the user's capacity for navigating the space will enforce the development of an insider perspective since such tracing movement will create a bond between the user and the environment.

The maps designed for digital environments can contain artefacts produced in different media. For example, if a two-dimensional hand-drawn animation portraying a moment of destruction during an earthquake is placed on a satellite map in an interactive map design, the visible difference between the flat look of the hand drawn animation and the realistic look of a satellite map will make the users aware of the presence of the medium. An animated insert in a live action movie produces an effect of alienation in the same way. A multimedia collage in a digital map may alienate the users and induce an outside perspective. In order to balance the outside and inside perspectives, the aesthetic of the map can be altered from a collage like representation to a more homogeneous aesthetic.

By applying a survey compiled from slides of films that represent earthquakes, further empirical research will test the accurateness of the thesis about the validity of those strategies based upon the simultaneous use of inside and outside perspectives. The results of the survey will provide further cues for answering the core question for designing maps in the digital media: Do we imagine ourselves in the scene if we can navigate the space?

Acknowledgements

This chapter was shaped as a result of group meetings with Janet Murray, Ann Bostrom, Richard Catrambone, Chessy Gaylor, Gray Gunther, Alison Riggieri, Kacey Wood, and Jichen Zhu. I would like to thank them for their insightful contributions and guidance.

References

Brecht, B. (1957), *Brecht on Theater*, Hill and Wang.
Bryant, D. and Tversky, B. (1999), "Mental Representations of Perspective and Spatial Relations from Diagrams and Models," *Journal of Experimental Psychology: Learning Memory and Cognition*, 25: 1, pp. 137–156.
Bordwell, D. (1993), *Narration in the Fiction Film*. Madison: University of Wisconsin Press.
Burton, T. (1990), *Edward Scissorshands*, 20th Century Fox.
Carpenter, J. (1996), *Escape from LA*, United States: Paramount Pictures.
Chatman, S. (1980), *Story and Discourse: Narrative Structure in Fiction and Film*, Ithaca: Cornell University Press.
Demirkubuz, Z. (1997), *Masumiyet/Innocence*, Turkey: MK2 Diffusion.
Donner, R. (1978), *Superman*, United States: Warner Bros. Pictures.
Elikann, L. (1990), *The Big One: The Great Los Angles Earthquake*, United States: Von Zerneck Sertner Films.
Fresnadillo, J. C. (2001), *Intacto*, Spain: Lions Gate Films.
Geln, J. (1985), *A View to a Kill*, United States: MGM/UA Entertainment Company.
Glaser, P. M. (1987), *The Running Man*, United States: TriStar Pictures.
Honda, I. (1962), *Kingu Kongu tai Gojira/King Kong versus Godzilla*, United States: Universal Pictures.
Jackson, M. (1997), *Volcano*. United States: 20th Century Fox.
Lombard, M. and Ditton, T. (1997), "At the Heart of It All: The Concept of Presence," *Journal of Computer-Mediated Communication* **3: 2**. (on-line serial) Available: http://www.ascusc.org/jcmc/vol3/issue2/lombard.html
Metz, C. (1986), *The Imaginary Signifier: Psychoanalysis and the Cinema*, Bloomington: Indiana University Press.
Robson, M. (1974), *Earthquake*, United States: Universal Pictures.
Schubert, T. (2001) "The Experience of Presence: Factor Analytic Insights," in *Virtual Environments. Presence: Teleoperators & Virtual Environments*, 10: 3, pp. 266–281.
Slatter, M. and Wilbur, S. (1997), "A Framework for Immersive Virtual Environments (FIVE): Speculations on the Role of Presence," in *Virtual Environments. Presence: Teleoperators & Virtual Environments* 6: 6, pp. 603–616.
Stam, R. (1992), *Reflexivity in Film and Literature*, New York: Columbia University Press.

Stonehill, B. (1988), *The Self-conscious Novel: Artifice in Fiction from Joyce to Pynchon*, Philadelphia: University of Pennsylvania Press.
Takács, T. (2004), *Earthquake: Nature Unleashed*, United States: Nu-Image Films. *The Great San Francisco Earthquake* [DVD] 2005 United States: PBS.
Zettl, H. (2007), *Sight, Sound, Motion: Applied Media Aesthetics,* Belmont California: Wadsworth Publishing.

Chapter 4

The Virtual of Disaster: Science, Politics and Tectonics in Roland Emmerich's *2012*

Axel Andersson

When the big quake finally strikes in Mark Robson's classic *Earthquake* (1976), Rose (Victoria Principal) is in a movie theatre watching Clint Eastwood in *High Plains Drifter* (Eastwood, 1973) as the ceiling cracks and starts to fall down. Rose sits in the cinema, inhabiting the same space as a spectator watching the film on screen at the present moment. The moment of projection and reception meet here in a rare cinematic representation of the passage from the virtual to the actual. Suddenly, the imaginary world of the film coincides with the apparent experience of the spectator. The viewer is placed in an impossible situation; we register the first shock waves of the quake from the perspective of the victim. The disaster genre in cinema plays with the fact that a cinematic representation of a disaster is obviously not the same thing as a real disaster. Hopefully, it produces a sufficiently similar set of psychological effects for the audience to identify with the protagonists. A virtual disaster has to appear to be only one step away from its actualization.

The virtual disaster can be contrasted to the virtual *of* disaster. The preposition has the power to change the meaning of the concept. Rather than referring to a cinematic representation of disaster, we are potentially dealing with an inversion of the disastrous situation. The virtual of disaster can thus be what cinema shows us about our "un-disastrous" reality: the outside that greets us after the film is over and the theatre ceiling has not caved in upon our heads. It can also refer to an ethical and political imagination that is born out of the experience of watching a projected disaster. How does this fictitious event make us reflect on our relationship to our fellows? Can we imagine how those who we are close to, and those, further removed still, who hold political power, would react in the event that the worst happened? How would they and we manage to do the right thing in a situation where all societal parameters are twisted or have vanished? Or would they, and we, become monsters like the young National Guardsman (Marjoe Gortne) in *Earthquake* who becomes a law unto himself, shooting a gang of bullies and almost raping Rose who has escaped the crumbling movie theatre?

The virtual of disaster highlights the role of popular culture in providing a space to think about ethical and political questions. The disaster genre in cinema holds a prominent role within a "popular culture" that Lawrence Levine defined as "widely accessible and widely accessed; widely disseminated, and widely viewed or heard" (Levine 1992: 1373). The genre also defines itself as distinct from more prestigious cultural productions. When disaster migrates into the realm of art cinema, the virtual of disaster tends, interestingly, to lose its more overt engagement with politics and ethics and becomes, rather, a meditation on aesthetics. For instance, in Robert Altman's *Short Cuts* (1993) and most recently in Lars

von Trier's *Melancholia* (2011) the "popular theme" of the apocalypse is taken to its most extreme manifestation, total annihilation, at once logical and senseless. Total destruction becomes an event that questions the very existence of the "virtual."

The relationship between disaster, the virtual and politics also raises the question of science. The disaster film often strains the boundaries of the scientifically probable, even as it relies upon the popular conception of scientific knowledge. Its more extreme scenarios, however, are fundamentally improbable and fall within the province of pseudo-science. The film must negotiate a contractual agreement with its audience if the imaginary projection of the disaster is to be perceived as realistic. We are thus being asked to prepare. In the genre's revival in the 1990s, the scientist is usually represented as a heroic figure working to avert the disaster – an alien invasion or apocalyptical climatic change – or to warn the population of the crisis in time. The scientific "voice" usually goes unheard or is considered hysterical until the disaster actualizes the threat and renders such voice the most rational. It is no coincidence that many disaster films deal with the topic of earthquakes since the seismologist is quintessentially the most tragic of scientists who in most cases will arrive too late with his or her prediction. In many ways, a clear seismological dramaturgy has shaped the disaster genre. The scientist, often a seismologist, detects something awry in a seemingly normal situation. He or she must communicate the problem to the public and will be dismissed as an alarmist with an improbable prediction by the authorities; the narrative, however, makes it clear that the scientist is the only one who realizes that the virtual disaster has become actual. The seismologist, furthermore, embodies the ambivalence between spectator and participant, apparent in the movie theatre scene from *Earthquake*. He or she observes the data or the events, just as Rose observed Clint Eastwood on screen, but with the difference that their observations ethically impel them to act. A strong dramaturgical link between the seismologist and the pseudo-scientist exists in part due to the late acceptance of seismology as a scientific "truth." The discovery in the 1960s that our planet actually rests on tectonic plates (Gubbins 1990: 273) re-enforces the notion that the popular imagination seeks and finds more reassuring explanations in the discourse of pseudo-science and the spectacular manifestations of the disaster film.

Roland Emmerich's *2012* (2009) is in many ways the ideal film for an analysis of the relationship between disaster, virtuality, seismology and pseudo-science, as well as the ethical, political and scientific dimensions of the genre. Like *Melancholia*, Emmerich's *2012* appears to show a total disaster, though in keeping with the genre the plot is in the last instance saved from being a purely aesthetic spectacle of the sublime. With its premise that the world as we know it is about to end, *2012* is the culmination of both Emmerich's trajectory as a director of disaster films, notably *Independence Day* (1996) and *The Day After Tomorrow* (2004), and of the genre's revival in the 1990's. Roger Ebert called it "the mother of disaster movies" made by the "father of the extended family," adding that the film "ends the world, stomps on it, grinds it up, and spits it out" (Ebert 2011: 597). *2012* unfolds upon a biblical scale, right down to the deluge and apparent divine retribution. No effects are spared as the world is consumed by fire and then water. No corner of the world

is left untouched, apart from the uninhabited peak of Mount Everest. *2012* comes as close to a total disaster film as possible while remaining within genre conventions and the codes of "popular" culture. There will be a way out, however, the important political and ethical questions will be posed and a redemptive scenario presented. For even though the scale of the apocalypse is enormous, there are no dearth of symbolic messages in the film. The disaster ultimately reveals the essence of humanity.

2012 can only make its disaster probable by relying on a scenario from pseudo-science: a solar eruption has led to a mutation of subatomic neutrino particles in the bowels of the earth leading to the development of an unprecedented nuclear fusion at the planet's core. This is registered by the young geologist Adrian Helmsley (Chiwetel Ejifor) whose task it will be to warn the authorities. Emmerich is on familiar territory here. Much like the satellite technician David Levinson (Jeff Goldblum) in *Independence Day* or the paleoclimatologist Jack Hall (Dennis Quaid) in *The Day After Tomorrow*, Helmsley will also stumble over crucial information about coming events that will have profound implications for the planet as a whole. Interestingly, the real hero of Emmerich's story is not the scientist but a failed science-fiction writer in Los Angeles, Jackson Curtis (John Cusack). We are introduced to Curtis, asleep on the couch of his Los Angeles apartment, as he is shaken awake by a "mini-quake," a tremor that will foreshadow the "big one." A news broadcast about a mass suicide in the "Mayan city" of Tikal in Guatemala is playing on TV. The title of the film is here linked with the alleged Mayan prophecy of the end of times in 2012. The same New-Age eschatology sits perfectly with the destruction of Los Angeles by an earthquake, an apocalyptic fantasy that holds a strong place in the popular imaginary.

Curtis takes his children camping in Yellowstone only to run into Charlie Frost (Woody Harrelson), a paranoid DJ, part crazy hippy, part militant survivalist, who has discovered that the government is withholding information about the impending catastrophe precipitated by the warming of the earth's core and the destabilization of the earth's crust. Charlie quotes Charles Hapgood, a historian of science whose book *Earth's Shifting Crust* (1958) presented the idea that the weight of the polar ice would lead to a shifting of the outer layer of the earth (Palmer 2003: 114). This is the only direct reference to the "pole shift hypothesis" in *2012*, even though the idea of a spinning earth or shifting crust has many proponents in pseudo-science. In 1948, Hugh Auchincloss Brown conjectured that the polar shift might be rapid and could cause catastrophic events on the surface of the planet (Huggett 1997: 119). Immanuel Velikovsky also suggested in *Worlds in Collisions* (1950) that several catastrophes had already occurred because planets passing by the earth had caused it to turn on its axis (Palmer 2003: 117). The most famous of the modern proponents of catastrophic earth crust movements, closer to Hapgood than Velikovsky, is the British writer Graham Hancock who in *Fingerprints of the Gods* (1995) detailed the "traces" of a god-like civilization that had existed prior to the last disaster. Hancock, as Emmerich admits in an interview, played a significant role in the conception of *2012*: "I always wanted to do a biblical flood movie, but I never felt I had the hook. I first read about the Earth's Crust Displacement Theory in Graham Hancock's *Fingerprints of the Gods*" (Jenkins 2009).

2012 escalates as the catastrophic shift of the earth's crust begins much earlier than Helmsley had predicted. Not surprisingly, Los Angeles bears the first impact of this event. A gigantic earthquake confirms Los Angeles as the modern equivalent of Sodom or Gomorra, a city of sin deserving of the same fate as the "brimstone and fire" that the Lord rained down out of heaven (Genesis 19:24). Los Angeles has not only been destroyed in *Earthquake* (1974) but possibly more spectacularly in *Volcano* (Jackson, 1997) where the entire city threatens to disappear under floods of lava. In *2012* Curtis rescues his family from the apocalyptic demise of Los Angeles and heads for Yellowstone in search of a map in Charlie's possession which details the location of the ships, or arks, which are being built for a limited evacuation of a select few. This small opening towards salvation will propel both the narrative of the film and its ethical and political questions. Even though Curtis begs Charlie to come along to search for the arks, Charlie decides to opt for a purely aesthetic engagement with the catastrophe. In facing pure destruction as a sublime event, Charlie forecloses the ethical and political world still inhabited by Curtis. He is blown away as a volcano explodes before his eyes, its plume of ash and fire suspiciously resembling the shape of an H-Bomb. In linking the volcano to the bomb, Emmerich follows a long cinematic tradition. In *20,000 Leagues Under the Sea* (1954), Robert Fleischer changed the ending of Jules Verne's story as Captain Nemo blows up the home base where his dangerous secrets are stored, the island "Volcania," rather than allowing the *Nautilus* to go down in a whirlpool. The explosion produces a sublime mushroom cloud (Andersson 2007: 180).

The disaster in *2012* starts 44 minutes into the film (as compared to 58 minutes in Robson's *Earthquake*) and continues for close to two hours. The film revels in the further spectacular destruction of other cities of vice, first Las Vegas and Washington, DC, the home of political corruption. The statue of Christ the Redeemer in Rio de Janeiro falls, and a highly symbolic crack in the ceiling of the Sistine Chapel opens as the hand of God is separated from that of his creation, Adam, in Michelangelo's famous fresco. The ceiling collapses over the praying cardinals. Man is no longer in contact with his maker and has to fend for himself in the face of the natural violence produced by the unruly planet's shifting surface. Curtis, his two children, his estranged wife and her husband dash as fast as they can towards the site of the construction of the arks in the Himalayas. It slowly dawns on Helmsley, who has briefly met Curtis in Yellowstone, as he heads to the same destination on Air Force One, that those who will be saved have been elected more for the size of their wallets than because of any scientific rationale. In short, the crisis, rather than uniting humanity, permits the rich of the G8 countries to arrange for their nations' survival. Naturally, Curtis and his family do not possess a ticket for the vessels they so desperately hope to join.

Emmerich postulates an event that is more extreme than anything produced by the shifting of tectonic plates. The end result – earthquakes, volcanic explosions and tsunamis – follows a predictable seismological pattern with the difference that the effects occur on a planetary level. The planetary dimension of the disaster inscribes a more direct allegorical value to the actions of the film's characters. It is interesting to note that these kinds of global catastrophes are unusual in disaster films. They traditionally belong to the domain of the

science fiction genre, especially the nuclear doomsday film of the post-war era. Emmerich also explored the planetary dimension in *The Day After Tomorrow* (2004) where global warming leads to extreme weather conditions around the world, causing a new ice age. The ice covers the northern hemisphere, forcing the population and political leadership of the United States to seek safe haven in Mexico in an ironic reversal of the current geopolitical formation. Astronauts observe the spread of the ice across the western world from space. The cinematic language of these sequences recalls science fiction and uses that genre's ability to represent the earth in its totality. In *2012* this earth-consciousness will become properly total, just as in films where the world has to come together in the face of an alien invasion.

2012 thus plays with genres beyond the disaster tradition, linking them in a novel fashion. The planetary consciousness of science fiction is revealed in the opening scene with a reference to astronaut William Anders 1968 "Earthrise" photo. The film ends with another "earthrise" moment in which the blue planet is seen from space. In contrast, conventional disaster films, such as *Earthquake* and *Volcano,* even an art film like *Short Cuts*, begin with aerial shots of more local urban landscapes. Emmerich also introduces fast cuts between different locations around the world, a technique more normally associated with films in the thriller genre such as *The Bourne Identity* (Liman, 2002). The audience is whizzed around the planet, from the "Naga Deng Copper Mine, India" to "Lincoln Plaza Hotel, Washington DC" (two fictitious locations) onwards to the G8 meeting in British Columbia (the real G8 meeting in 2010 took place in Huntsville, Ontario) and on to two more made-up locations: "Cho Ming Valley, Tibet" and "Empire Grand Hotel, London" before showing two real places: "Musée du Louvre, Paris" and "Manhattan Beach, California."

In this case, the thriller convention does not merely set up another type of planetary consciousness (of spies who can move across all political boundaries). Emmerich uses its global scope as a commentary upon contingency. In a classic disaster film like *Earthquake* the quake unites all the characters on screen thereby negating contingency. Similarly, the quake also supplies the occasion for the male protagonist to confront his romantic situation. He often enters a new relationship or rekindles an old one, escaping a dysfunctional marriage, divorce or widowhood, as in *Earthquake, Volcano* and *Dante's Peak* (Donaldson, 1997) as well as in *2012*. The disaster, in short, brings people together and also solves the loneliness of the male protagonist. Every event that unfolds is a step in this direction. No meeting is gratuitous. The disaster film, like the fairy-tale, functions as a chronotope, a term denoting 'the intrinsic connectedness of temporal and spatial relationships' (Bakhtin 1981: 84), in which no random or contingent event disrupts the story's consistency. *Short Cuts* uses this device to remarkable effect. Los Angeles exists as an interconnected organism in which every human relationship can be linked with another in a tight chain without interruptions. None of the characters are physically disconnected, although though they all appear to be trapped, locked in a psychological bubble of varying degrees of narcissism. Altman makes a disaster film without the disaster. There is no need for the quake to resolve the storyline as the disaster plays out in real time as both a social and psychological event. A few minutes

before the film ends there is indeed a small tremor, no more or less than what Californians are used to. The fabled "Big One" never arrives.

In the disaster film, the negation of contingency in inter-human relationships is normally applied on a local, rather than planetary, level. In *2012*, Emmerich provides a completely globalized vision of the same interconnectedness, and turns, for this purpose, to the cosmopolitan scope of the thriller film. As if to underline this point, the majority of the film takes place on various modes of transportation between different places. The characters are in constant movement across continents and oceans as opposed to the small local displacements around a seismological hotspot in films like *Volcano* or *Dante's Peak*. Curtis and his family travel, for example, in a car, in a small propeller plane, a motor home, a large Russian Antonov cargo plane and a truck. Helmsley spends most of the film on Air Force One, commanded by the unscrupulous Carl Anheuser (Olivier Platt) who has usurped the power of the US president, Thomas Wilson (Danny Glover). The president has decided to meet his destiny with his people on the White House lawn. These travels can be seen as preparations for the final journey on the salvation vessels, the arks being the ultimate non-contingent space that houses those privileged enough to repopulate the earth once more. The connectedness of the confined space of the ship also alludes to such maritime disaster films as *The Poseidon Adventure* (Neame, 1972).

The interconnectedness produced by the suspension of a more realistic contingency reveals the degree to which the ethical and the political overlap. If we are all connected on a human level, our politics must serve to safeguard an ethical behaviour in which each and every one's humanity is preserved. It is thus not merely a question of acting ethically in a one-to-one relationship, but also of developing abstract ethical principles. In *Earthquake*, for example, Stewart Greff (Charlton Heston) sacrifices himself for his alcoholic and bickering wife Remy Graff (Ava Gardner) rather than letting her die alone. Remy's death would have made it possible for him to start a new life with his new young lover Denise Marshall (Geneviève Bujold). The shared humanity of a large group of people is a recurrent trope in disaster films, and is visually represented when dust, soot or ash descends upon a heterogenous congregation and makes them appear similar. In *2012* the White House lawn, now a field hospital, serves as the site for this equation. A less subtle example can be found at the end of *Volcano* when the volcanic ash that rains down on the inhabitants of Los Angeles has made all faces grey. The cultural faultlines of race and ethnic difference disappear in the face of the disaster. In *Volcano* this utopia is suspended in the penultimate shot when the rain really comes down and washes the faces clean.

In terms of abstract principles, the members of the post-apocalyptic community in *2012* are selected according to three main criteria. Anheuser, White House Chief of Staff, represents the cynicism of political calculation. He makes sure that the arks are financed by the rich who buy tickets for one billion Euros each. Anheuser's supreme goal is to save the species and, primarily, himself. He is not willing to risk this aim for any ethical considerations. He knows that all cannot be saved and does not pretend to justify that this is a fair situation. Helmsley represents the naive position that those saved will be selected

on rational and scientific grounds, an idea satirized in Stanley Kubrick's *Dr. Strangelove* (1964). Helmsley's reasoning is close to Curtis', with the difference that Curtis' response is more emotional than rational. He represents a humanist, cosmopolitan ideal that holds it unfair to give any special privileges to the rich, the well educated or the genetically superior. Curtis is also prepared to sacrifice himself to save his family and the remaining survivors of the catastrophe. Confronted with Curtis' heroism, Helmsley is won over to his position and urges Anhauser and the other politicians to open the arks (and their hearts) to the mass of waiting refugees.

The people on the arks will form the new civilization and *2012* makes it clear that this new start takes place without original sin. The vessels also set sail for Africa, the site of the birthplace of humanity. Ultimately, the planetary catastrophe purges and redeems humanity from its sins. Similarly Curtis is given a new chance to re-kindle his relationship with his estranged wife. The film situates ethics and politics on an existential level in a fabled realm beyond the ideology of state, political parties and corporate capitalism. As in all disaster films the catastrophe offers an opportunity to perform ethically. In a remarkably large number of these films it also provides the chance to repeat an event in the hope of a better outcome, such as, in the case of *2012*, the beginning of civilization. Curtis' family will similarly be able to start afresh. In this case, the virtual of the disaster serves to reprocess another disaster (the breakup of the family). The most concrete example is *Dante's Peak* that begins with a volcanic eruption and a man and a woman driving a car through the apocalyptic landscape. She, Marianne (Walker Brandt), is hit by a lava projectile and dies. Four years later, the man, the geologist Harry Dalton (Pierce Brosnan), is called to another hot spot, the fictional "Dante's Peak" in the Cascades. This event leads to a re-run of the traumatic episode with Marianne, though this time with a love interest, the mayor Rachel Wando (Linda Hamilton). The second time the trauma is replayed, in an almost identical car ride after a volcanic eruption, the outcome is a positive one. Ultimately, the second trauma will cancel out the first.

The new beginning that the disaster promises highlights the importance of trying to understand its virtual dimension. The "virtual" must be separated not only from the realm of the real but also from that of the potential. The earthquakes in *2012* are not supposed to be "potential" scenarios or depictions of things that might happen. The virtual, as opposed to the potential or possible, has a relationship with the real; the audience has to believe that a disaster, like the global cataclysmic events in *2012*, is not merely abstractly possible but can become actual. For this reason, the realistic portrayal of an unreal situation is of paramount importance in the disaster genre. All the parameters might be fantastic but the projection still has to be believable. It has to look and feel like a real disaster even though it appears rationally to have nothing to do with reality. Emmerich said of *2012*: "Show this film to a scientist and they would probably laugh" (Jenkins 2009). But, more importantly, the film must produce sensory responses in the audience that are experienced with a similar intensity to their interactions with the physical world outside.

In the digital age, we have come to define the "virtual" as something non-existent, a digital simulation or reproduction as in virtual or artificial reality. But the concept of the

virtual is rendered as an inoperative generality if it is merely used to refer to something that does not exist. A five-hundred-year old theological debate regarding the Christian Eucharist is helpful in understanding the conceptual meaning of virtuality. After the split from the Catholic Church, which held that the bread and the wine of the Eucharist *became* the flesh and blood of Jesus, the Lutheran reformers had to find a new relationship to the doctrine of transubstantiation. Martin Luther argued that God's presence was ubiquitous and thus also present "in and under the bread and wine" of the Eucharist (Tappert 1959: 447). The Swiss reformer Ulrich Zwingli went further and suggested that, as the Lord had risen to Heaven and could therefore not at the same time be on earth, the bread and wine were mere "visual reminders" of the Saviour (Stooky 1993: 54). Jean Calvin arrived at a middle path that was to be called "virtualism." In this vision of the Eucharist the ritual contains the same *virtue* (understood through the Latin *virtus* as in "power") as if Christ's flesh and blood *had been* present (Campbell 1996: 328). The ritual of the Eucharist was virtual not in the sense of a mere simulation of a real event (this would have been closer to Zwingli's "memorialism") but in the sense that the "bread and wine convey the power of Christ" (Stookey 1993: 56).

From its inception the word "virtual" has come to mean something that is not, at the same time as it has the power of something that is. Charles Sanders Peirce provided the most famous modern definition of the term: "A virtual X (where X is a common noun) is something, not an X, which has the efficiency (virtus) of an X" (Pierce 1902: 763). Importantly, Pierce's definition clearly separates the notion of "virtual" from that of "potential." That which is potential is similar in nature to that which is simulated, but does not possess the efficiency or efficacy of the thing being simulated. The potential, in other words, lacks the power of the virtual. With this in mind it is possible to argue that the disaster in a disaster film has to be virtual in order to be credible. A potential disaster is too vast and weak a category to produce the necessary suspension of the audience's critical faculties. If the audience feels *as though* (in some way) they are experiencing the same disaster that is projected on screen, then the content of the work, in terms of its ethical and political implications, will resonate. At the same time this does not imply a hysteric inability on the part of the spectator to separate projection from reality; there is no "transubstantiation" from fiction to reality. It is possible, just as in Calvin's "virtualism," to enjoy the power (or efficiency in Pierce's definition) of reality without having to confuse it with the real, or, in Lacan's terminology, the impossible and brutal "Real" (Evans 1996: 160).

The French philosopher Gilles Deleuze provides the most sustained meditation on the virtual after Pierce. Deleuze stressed that the opposite of the virtual was not the real but the actual. In fact, he opposed the possible to the real (Deleuze uses "possible" rather than Pierce's "potential"). The virtual was what is actualizable (Deleuze 1968: 272–273). Deleuze quoted Proust in his definition of the concept: the virtual was "real without being actual, ideal without being abstract" (Deleuze 1990: 96). The virtual is thus linked to the actual in a direct way, as both terms imply their opposites. In discussing cinema Deleuze argued that the "actual image" had a "virtual image" that "corresponds to it like a double or a reflection" (Deleuze 1989: 68). Both modes, virtual and actual, are real. Both are included in the set of

the real but the possible (or "potential") is not. A thing, or condition, could be virtual or actual, and, at the same time, real. A virtual disaster, it could be argued, could actualize itself, but would still retain its strength (efficiency, *virtus*) even though it remained un-actualized. A possible (potential) disaster could only realize itself if it overcame its intrinsic weakness as merely possible. In *2012,* the virtual disaster, the shift in the earth's crust that produces earthquakes and volcanic eruptions, has to pass from the possible to the virtual to be credible. The virtual of disaster in this film, the collective redemption of a divided humanity, also has to be accepted by the audience as a likely outcome of the catastrophic events.

The ethical and political questions raised by the representation of the disaster must also appear to be virtual, about to be seemingly actualized. It can be argued that *2012* succeeds, against the odds, with the first step, especially when contrasted with films whose budget has not made even mildly believable special effects possible, a problem encountered in television films or direct-to-DVD productions like *Megafault* (Latt, 2009*).* But good special effects alone do not create cinematic realism. An engagement with science that is too farfetched will destroy the virtual dimension of the disaster, something which also occurs in blockbusters. Jon Amiel's *The Core* (2003) is so riddled with unavoidable and taxing leaps of the imagination that all political and ethical implications of the narrative lose their meaning. The film clearly lacks the power of the real and therefore becomes an almost absurd spectacle.

Emmerich's disaster films manage, through special effects and an engagement with a scientific and apocalyptic imaginary, to produce scenarios that, despite their factual improbability, appear in the logic of the film as perfectly believable. The success can in no small measure be ascribed to Emmerich's use of well-known collective symbols regarding the apocalypse, and to the way he links these to current preoccupations existing in popular culture. In this sense he is working in a classical fashion, extrapolating from and continuing an investigation of themes already shared within the popular imagination at a certain moment. In *Independence Day*, we thus encounter the familiar alien invasion of the planet. The aliens are after the earth's resources, a theme that recalls the fascination with resource scarcity in the period immediately after the cold war, when resources replaced ideology in the conflicts of a post-political age. *The Day After Tomorrow* dealt with global warming in the context of the immediate future, a film appealing to an era obsessed (with no small amount of enjoyment) with the apocalyptic scenario of rising temperatures. Emmerich used the popularity of New Age eschatology evident in the '2012 phenomenon' (Sitler 2006), which insists that the Mayans predicted an apocalyptic end to the world as we know it in this year.

In *2012*, pseudo-science thus helps to establish the credibility of the disaster. As pseudo-science is based on the logic of predictions, it perfectly mirrors the dramatic structure that the disaster film borrows from the imaginary scenario of modern seismology in which prediction and detection play such a key role, as illustrated, sadly, in the recent conviction of the scientists who have been deemed responsible for not warning the public sufficiently about the chances of a major earthquake in L'Aquila, Italy. A pseudo-scientific proposition, despite the strangeness of its actual theories, differs from madness in that it could possibly be accepted

somehow as real. More than one person has to believe in the prediction for it to pass from individual madness to something vaguely believable (which can, unfortunately, also result in collective madness). Within the disaster genre, this passage from one to the many is a key point in the narrative developments of the films. In *Earthquake,* Walter Russell (Kip Niven) of the California Seismological Institute predicts that Los Angeles is about to be hit by 'the big one', an earthquake of 7.0 in magnitude or greater on the Richter scale. Russell, a junior analyst, is at first dismissed by his boss. His agitation is graphically portrayed in the film and he begins to question his own sanity because his scientific knowledge is questioned. *Volcano* and *Dante's Peak* have similar characters. The stereotypically crazed hippy Charlie in *2012,* however, provides the most powerful illustration of the case. He believes in conspiracies and lives in a motor home, isolated from the rest of society. One more character in the film has to believe Charlie's theory for it to be credited as real. It is of course Curtis who will accept Charlie's crazy predictions as owning the *virtus* or efficacy of something real.

A logical development in the construction of pseudo-science as a virtual knowledge would thus be a progression from the lone voice of the madman to his encounter with another believer, a more extreme version of the development of the seismological drama. The creation of a primary community of believers dispels the negative image of psychological delusion. The opportunity for a possible rather than virtual knowledge, a knowledge wide open for absolutely anything, is revealed. When the primordial knowledge is accepted by a defined group, an actual knowledge, a new scientific standard has been "established." In *2012,* Charlie and Curtis come together in a primary community of believers, which is solidified when Curtis manages to convince his family, including his estranged wife's new husband, of the state of things. Pseudo-science, in cinema and in real life, is virtual science hoping, often vainly, to become actualized. It is thus not the opposite of 'real' science. That would be madness.

The study of pseudo-science has often focused on how the pseudo-scientist attempts to portray himself or herself as a 'lone genius' engaged in a competitive race with the longer-term perspective of institutional science. Pseudo-science thus ends up negating such important Popperian observations about how scientists work in communal processes that aim at a provisional consensus (Charney 2003: 218 and 237). Although this strand evidently exists in pseudo-science, films informed by such theories, like *2012,* provide a revised image of the "lone genius" as dependent on a primary community of believers in order not to be considered as mad. Pseudo-science is also a communal process. As long as pseudo-science does not enter into the scientific mainstream, its basis remains a process of belief rather than one of rational logic. Cinema, however, has the power to posit an imaginary scenario in which the virtual knowledge is actualized, that is, in which it becomes rational. Curtis' conversion to Charlie's Pole Shift theory is gradual. He accepts the hypothesis only when he sees that a number of Charlie's predictions turn out to be true. His family accept the same scenario too when their experience verifies its reality.

The inception of virtual knowledge is always more or less divine, as though the boundary between madness and pseudo-science was impossible to define. Curtis is first introduced

to Charlie as a prophetic voice on the radio as he drives into Yellowstone. Charlie, excited and exalted, recounts how government forces are moving into the area. At the very same moment, army helicopters fly over Curtis' car. Curtis reflects on the uncanny nature of the coincidence that the helicopters passed overhead just as Charlie mentioned them on the radio, but he dismisses the episode as a contingent event. As a disaster film, *2012*, however, possesses a narrative logic, as the audience knows, that actively negates contingency.

A similarly delicate transition between the lone voice and the community of believers also exists in *2012* with the prediction that shapes the virtual of disaster as a political and ethical issue. Curtis is the author of a book, *Farewell Atlantis,* in which he postulates that people will react altruistically in the face of a planetary disaster. Even though he is preoccupied with the ethical and political consequences of the disaster, Curtis' writing echoes Charlie's prophetic voice. To some extent, he is also presented as a marginal character, having failed in his career and his marriage. Helmsley, the geologist, has, however, read *Farewell Atlantis* and appears to be attracted by its message. Much is made of the fact that Curtis has sold so few copies, but at least some people are familiar with the work. He has reached an audience. It is also no coincidence that, despite the genre's dislike of contingency, Helmsley is a geologist who has stumbled across an impending disaster. Helmsley too must make predictions that will have an enormous impact on civilization as a whole, just as the seismologists in more localized natural disaster films (like *Volcano* or *Dante's Peak*) have the destiny of a city or a town in their hands. Unless these characters succeed in reaching an audience and manage to "virtualize" the seemingly outlandish scenario that the majority does not wish to believe (thus endowing the potential with the efficacy of the real), they will fail.

Curtis' predictions will also become important, even though they do not possess the same category of scientific knowledge and cannot be proven to be true in an objective manner. Whether or not people behave altruistically in the face of a disaster depends on their actions. It might appear that, in this manner, contingency enters into the universe of the disaster film, but according to the conventions of the genre, the actions and ethical decisions of the characters follow a pattern. Some are altruistic, some egotistical while others are mad or hysterical. Charlton Heston's character in *Earthquake*, for instance, appears unable to act unethically. Curtis too is an affable character whose actions and beliefs posit humanity's inherent goodness. As a result, the audience become the public and primary community of believers of Curtis' prediction. *2012* would transgress the narrative logic implicit in popular cinema if, for example, the disaster in the film would reveal Curtis as a brutal egotist in a Darwinian world populated by people with similar attitudes.

The two processes of virtualization at play in *2012*, the first concerning the realm of science and the second the realm of ethics and politics, reveal as much about the virtual disaster, and the virtual of disaster, as about cinema as a whole. Cinema is the locus through which the popular imaginary coalesces into a representation of a virtual scenario as long as, for the duration of the film, an audience is willing to play along and at least feign to form a primary community of believers. If this is not the case then the film will merely reproduce an untranslatable individual vision or the regurgitated and stereotyped content

of the cultural industry. In the case of *2012*, the film's preoccupation with forming of a community of believers around an initially unverifiable and improbable scenario mirrors the predicament of the cinematic medium itself. Thankfully it is in a staged environment that the cinematic experience connects to the real. When the movie theatre collapses over the audience in *Earthquake* a brutish and violent reality is shown to interact with the virtual. Cinema is an art of virtualization that keeps its audience close to, yet at a safe distance from, reality. The only slippage in this model is if ideology, as with the humanist concerns of *2012*, after becoming virtual also becomes actualized in the audience. The virtual natural disaster cannot be actualized, but the virtual of disaster can. This results in pure cinematic wish-fulfilment as nearly all disaster films, like *2012*, show positive outcomes for their ethical protagonists.

Evidently, in a film like *2012*, the disaster is itself less important than the ethical and political challenge it raises. The disaster film, as a popular cinematic form, presents the moral implications of those situations that appear to virtually concern us all. The discussion need not be profound or subtle, but it reveals how popular culture approaches universal themes and why, beyond the important economic factors that give power to the cultural industry, it is "widely viewed or heard" (Levine 1992: 1373). Through the virtualization of cinema it is possible to come close not only to the intensity and violence of reality but also to the moral choices such a reality might demand. Every step in which the possible becomes virtual in the process of being projected to an audience is also a step towards its actualization. The victory for the ethical position presents an appealing prediction of the behaviour that the audience of the fictional trauma will display if such a trauma returns as reality.

References

Altman, R. (1993), *Short Cuts*, Los Angeles: Fine Line Features.
Amiel, J. (2003), *The Core*, Los Angeles: Paramount Pictures.
Andersson, A. (2010), *A Hero for the Atomic Age: Thor Heyerdahl and the Kon-Tiki Expedition*, Witney: Peter Lang.
Bakhtin, M. (1981), *The Dialogic Imagination*, trans. C. Emerson and M. Holquist, Austin: University of Texas Press.
Campbell, T. (1996), *Christian Confessions: A Historical Introduction*, Louisville KY: Westminster John Knox Press.
Charney, D. (2003), "Lone Geniuses in Popular Science: The Devaluation of Scientific Consensus," *Written Communications*, 20: 3, pp. 215–241.
Deleuze, G. (1968), *Différence et répétition*, Paris: PUF.
—— (1989), *Cinema 2. The Time-Image*, trans. H. Tomlinson and R. Galeta, Minneapolis: University of Minnesota Press.
—— (1990), *Bergsonism*, trans. H. Tomlinson and B. Habberjam, New York: Zone Books.
Donaldson, R. (1997), *Dante's Peak*, Los Angeles: Universal Pictures.
Eastwood, C. (1973), *High Plains Drifter*, Los Angeles: Universal Pictures.

Ebert, R. (2011), *Roger Ebert's Movie Yearbook 2012*, Kansas City, MO: Andrews McMeel.
Emmerich, R. (1996), *Independence Day*, Los Angeles: 20th Century Fox.
—— (2004), *The Day After Tomorrow*, Los Angeles: 20th Century Fox.
—— (2009), *2012*, Los Angeles: Columbia Pictures.
Evans, D. (1996), *An Introductory Dictionary of Lacanian Psychoanalysis*, London: Routledge.
Fleischer, R. (1954), *20,000 Leagues Under the Sea*, Burbank: Disney.
Gubbins, D. (1990), *Seismology and Plate Tectonics*, Cambridge: Cambridge University Press.
Hancock, G. (1995), *Fingerprints of the Gods*, London: Heinemann.
Hapgood, C. H. (1958), *Earth's Shifting Crust: A Key to Some Basic Problems of Earth Science*, New York: Pantheon Books.
Huggett, R. (1997), *Catastrophism: Asteroids, Comets, and Other Dynamic Events in Earth History*, London: Verso.
Jackson, M. (1997), *Volcano*, Los Angeles: 20th Century Fox.
Jenkins, D. (2009), "Roland Emmerich's Guide to Disaster Movies," in *Time Out*, http://www.timeout.com/film/features/show-feature/9039/roland-emmerichs-guide-to-disaster-movies.html. Accessed August 31st, 2012.
Kubrick, S. (1964), *Dr. Strangelove*, Los Angeles: Columbia Pictures.
Latt, D. M. (2009), *Megafault*, New York: Syfy.
Levine, L. R. (1992), "The Folk Culture of Industrial America: Popular Culture and Its Audiences," *American Historical Review*, 97, pp. 1369–1399.
Neame, R. (1972), *The Poseidon Adventure*, Los Angeles: 20th Century Fox.
Palmer, T. (2003), *Perilous Planet Earth: Catastrophes and Catastrophism through the Ages*, Cambridge: Cambridge University Press.
Pierce, C. S. (1902), "Virtual," in J. M. Baldwin (ed.), *Dictionary of Philosophy and Psychology*, New York: Macmillan, Vol. 2, p. 763.
Robson, M. (1976), *Earthquake*, Los Angeles: Universal Pictures.
Sitler, R. K. (2006), "The 2012 Phenomenon: New Age Appropriation of an Ancient Mayan Calendar," *Novo Religio: The Journal of Alternative and Emergent Religions*, 9: 3, pp. 24–83.
Stookey, L. H. (1993), *Eucharist: Christ's Feast with the Church*, Nashville, TN: Abingdon Press.
Tappert, T. G. (1959), *The Book of Concord: The Confessions of the Evangelical Lutheran Church*, Philadelphia: Fortress Press.
von Trier, L. (2011), *Melancholia*, Hvidovre: Zentropa.
Velikovsky, I. (1950), *Worlds in Collision*, New York: Macmillan.

Chapter 5

Aftershock: The Cultural Politics of Commercializing Traumatic Memory

Jinhua Li

The cinematic representation of disaster can serve to creatively reconfigure a traumatic experience and act as an alternative mode of remembrance. When commercial cinema utilizes the entertainment value of natural disasters for consumption, it often dramatizes one narrative as the representative experience of events over other discursive accounts. It promulgates a single collective discourse of public value and social responsibility, represented in the form of a personal account, as the ultimate expression of a shared traumatic memory. The visual spectacle of earthquakes, volcanic eruptions and tsunamis are digitally engineered to perfection so that the audience may enjoy a virtual experience of the fear, pain, and shock of trauma survivors in a safely contained environment. The re-imagination of natural disasters on screen not only localizes their harrowing impact, but employs meticulously re-enacted scenes of catastrophe as media spectacles whose visual immediacy often weakens the political, socioeconomic, and psychological meaning of the film. Disaster films strategically moderate those private and individualized memories that threaten to rupture the formation of a "collective trauma," whose "cumulative effects […] are of central importance in forging the collective identity of any given group of people" (Neal 1998: 9, 22). By limiting alternative possibilities of seeing, recounting, and memorizing natural disasters, these cinematic discourses exploit the singularity of traumatic memories and transform them as lived, collective experiences for their entertainment value.

The Chinese language film *Aftershock* (唐山大地震/Tangshan da dizhen, 2010) exemplifies the cultural politics of the commercialization of traumatic memories. The natural disaster of an earthquake of historic magnitude in China in 1976 only serves as a cinematic backdrop against which a grand narrative of nation building, national unity, and traditional values takes centre stage. The *petits récits* of the survivors' private memories, which are positioned at the heart of the original novella from which *Aftershock* is adapted, merely provide necessary material for the commercialization of trauma in the film. The disaster becomes not only immediately consumable in popular media, but, more importantly, deeply embedded in the grand social discourse through the experience of mass entertainment. In what follows, I explore the cultural politics of *Aftershock*'s commercialization of trauma by investigating the dynamic between the visual representation of disaster and cinematic tropes of change and personal suffering, the aestheticization of sacrifice, private recollection and the mediation of collective experience, the narratives of pain, desire, and redemption and the discourses of familial values, social responsibility and national solidarity.

Aftershock was adapted for the screen in 2010 by Feng Xiaogang from the Canadian Chinese writer Zhang Ling's award-winning novella of the same name (余震 *Yuzhen*, 2007). As the title of the novella indicates, the original story of *Aftershock* focuses primarily on the traumatic psychological, emotional, and physical aftershocks of the earthquake for the protagonist Xiaodeng as she seeks meaning and reconciliation with her past. The literary narrative switches between past and present, tracing the life trajectories of Xiaodeng and the family that she leaves behind in Tangshan. The plot of the film, however, changes the narrative focus from Fang Deng (Xiaodeng in the original novella) and centres on her family. After losing her husband Fang Daqiang to the earthquake, Li Yuanni is faced with the worst choice a mother could imagine: a slab of concrete traps her twin children at each end, and she has to decide which child she wants to save. If one end is lifted to save the child underneath, the weight of the concrete, and the entire building on top of it, will crush the other. Yuanni makes an impossible choice: she saves her son Fang Da and leaves her daughter Fang Deng to die. Yet Fang Deng survives the collapse, and is ultimately adopted by a couple from the People's Liberation Army who live in another city, while Yuanni remains ignorant of her survival. In the years that follow, all three of the family members must come to terms with the trauma of the earthquake and the consequences of their choices. Fang Deng is emotionally shattered by the memory of the double trauma of the earthquake and of losing her mother, Fang Da is physically challenged with the loss of his right arm, and Yuanni has to live with her decision to abandon her daughter.

Aftershock achieved immediate commercial success and critical acclaim and became Feng Xiaogang's most profitable production to date. With a 600 million RMB (100 million USD) global box office return, *Aftershock* set several records for the Chinese film industry, including the highest premier weekend box office revenue, the first IMAX film in China, and the highest single day box office sale for a domestic film. *Aftershock*'s unprecedented commercial success is predicated upon the creation of an alternative memory, which re-negotiates historical events and submits fragmented individual memories to a selective and stereotyped official narrative. With an ingeniously engineered promotional campaign that emphasizes its status as "a disaster film […] that represents the power of family and love" (Feng 2010, cited in Zhao 2010), the film masks the commercialization of trauma with family values and universal humanity. Beneath the apparently individualized account of a single family, *Aftershock* prescribes a politically correct discourse of faith, camaraderie, and social responsibility as the panacea that heals the private pain. The audience is invited to relive the disaster through a politically mediated and emotionally preconditioned filmic narrative, unconsciously participating in the orchestration of an alternative collective memory superimposed upon individual remembrance. The private act of remembering the suffering and violence of the quake and its aftermath comes to serve the project of a politicized collective memory that hinges upon the rhetoric of unity, change, and renewal.

Earthquake: media spectacle and cinematic trope

Aftershock spared no effort in visually recreating the small city of Tangshan in 1970s China. A widely publicized media campaign called for the donation of household items and old family photographs of Tangshan Earthquake survivors. Apart from the obvious publicity and promotional efforts, such meticulous attention to detail and representational authenticity turned the imagination of the earthquake into a media spectacle dependent on visceral excitement and nostalgic fetishism. Just as the old Tangshan crumbled during the earthquake, new urban planning and reconstruction supplied cinematic tropes of rebirth, modernization and improvement.

Aftershock's tireless pursuit of historical realism in terms of props, costume design, makeup, and architectural studio settings manifests a desire to establish narrative credibility through visual verisimilitude. In other words, when the historical past is presented as true to reality, then the story becomes much more reliable than fiction. As Lowenstein (2005: 5) observes:

> Representation, as that vital but precarious link between art and history, between experience and reflection, holds out the promise, however risky, that trauma can be communicated.

Aftershock exploits such an excessive cinematic fidelity in its representation of the historical past as a visual incentive for the transferability of trauma, in the sense that an audience can vicariously experience trauma as the people who survived the Tangshan earthquake experienced it. If, as Cathy Caruth (1995: 4–5) has written, "to be traumatized is precisely to be possessed by an image or event," *Aftershock*'s visual fidelity effectively conveys the memory of trauma to the audience. Notwithstanding the film's employment of historicity to enhance the visuality of the earthquake, historic authenticity is primarily used as a cinematic trope of change within which the past takes a fossilized form. The ritualistic obsession with the re-creation of a visual replica of Tangshan in 1976 transforms the expositional sequence at the beginning of the film into a meticulous cinematic stage-description, which serves no other purpose than to present a convincing background for the narrative plot.

Here stage props and studio sets coordinate not only to fashion visual coherence and virtual reality, but also to promote the circulation and consumption of history as a visual commodity. Household items from the 1970s that were collected nationwide through the film's official website are used not only as props, but as cultural relics that point to a pre-reform China. A discourse of socio-political change, therefore, serves as a subtext to the imminent disaster. Objects from the Mao-era dominate the *mise-en-scène* in the first 30 minutes of the film, where the earthquake becomes the prime focus of the cinematic narrative. Thus, a subtle yet unmistakable parallelism connects pre-earthquake Tangshan with a pre-reform China. In other words, the "sense of history," as director Feng Xiaogang describes (2010 cited in Zhao), derives from visual simulacra instead of narrative realism.

Aftershock opens with an unusual credits sequence: names of the film's crew fade in like white dots of light against a black background, reminiscent of light specks coming from the cracks of destroyed buildings in an earthquake. The ominously disquieting silence on the soundtrack reinforces the sensations of entrapment, suffocation, isolation and desperation, and builds a suspenseful expectation for the visual spectacle of the earthquake. The credits sequence, a minute in length, deftly preconditions the audience for the necessary spectatorial identification and the crucial emotional engagement with the protagonists.

Before the black background completely fades out, the disembodied whistle of a train suddenly breaks the silence of the previous sequence. The departing train is seen from above, as the camera, assuming an aerial point of view that follows the perspective of a flock of dragonflies, reveals a dusty industrial city suburb, where railway tracks covered in weeds run side by side with traffic lanes. The cinematic point of view creates a widening spatial distance between the dragonflies and the train, a visual analogue that subtly hints at the gruesome fate awaiting pre-earthquake Tangshan: a city stranded in time from which there is no escape.

The nondescript setting could point to any dilapidated industrial city in contemporary China, where socio-economic reform rendered a deadly blow to many cities, especially in the north, that relied almost exclusively on heavy industry. The significance of such a spatial and temporal setting would have remained obscure, but the anonymous setting only temporarily blurs the boundary between past and present. A caption – "July 27, 1976, Tangshan" – is superimposed unobtrusively in the upper right corner of the frame. The image also promises a visually pleasurable encounter and a spectatorial position that is close enough to the event yet safely distant from the disaster. Reaction shots from ground level briefly disrupt the anthropomorphic point of view; people are alarmed and puzzled by the unnatural movement of the dragonflies. As he sits in his truck with his twin children, Fang Deng and Fang Da, Fang Daqiang is the first to register the significance of this strange phenomenon. He murmurs something about a big storm coming, and, as if to confirm his suspicion, the screen turns dark. A roar of thunder echoes on the soundtrack, names of people who lost their lives in the earthquake twinkle against the black background, and the scene suddenly dissolves into the ruins of Tangshan city.

The title of the film appears against this image of post-apocalyptic devastation. Three bold black characters – 大地震 (*da dizhen* big earthquake) – dominate the centre of the screen in cursive script, their thick strokes visually rendered as if they were cracks and ruptures in the earth. To the left, smaller and in printed form, the words 唐山 (Tangshan) appear within a red rectangular shape, reminiscent of a seal stamp. The colour contrast between the two words graphically emphasizes that the film's narrative will focus upon the earthquake rather than the city that suffers it. Visually, the name Tangshan occupies a smaller portion of the screen, like an afterthought or a footnote that inconspicuously specifies the location of the earthquake. This could happen to any city – Tangshan just happens to be the one. The English title, *Aftershock,* nestles, in much smaller font, directly beneath the character 大 (*da*, big), overshadowed and almost negligible.

The design of the title illustrates Feng Xiaogang's (Feng 2010, cited in Zhao 2010) conception of the disaster film, in the way that it highlights the significance of the devastating catastrophe. But it also reveals a narrative incongruity, as the plot moves quickly away from the earthquake and subtly uses the natural disaster as a trope for the socio-political changes that confronted China in 1976. Despite the fact that one third of the film's budget was spent on the finest special effects, despite the extensive media coverage on the effort devoted to the exact reconstruct of the living environment of Chinese families in the period, the earthquake merely serves as a pretext for a tragic event that brings the characters together, a trope of unforeseen and unforeseeable change. In other words, the film could have been about any other disastrous event and the story would still be sustainable. In fact, just as the English title suggests, the emotional and psychological aftershock is placed at the core of the film.

The Tangshan Earthquake is visualized as a seamless and spectacular cinematic event. In the opening sequence, the camerawork maximizes spectatorial identification with Daqiang and Yuanni. The audience, like the protagonists, experience the disaster in psychological real-time. Rather than simply mesmerizing the audience with impeccable special effects, this scene is fluidly orchestrated to create the sensation that the earthquake is not only an unavoidable natural disaster, but, above all, that it possesses a personal significance, a calamity whose magnitude defies sensible comprehension and, therefore, can be conceptualized only through affinity with a screen avatar – the couple whose most intimate moments the viewer shares.

The camera voyeuristically observes the couple improvise sex in the back of Daqiang's truck, a salacious device that rivets the spectators' attention while also foreshadowing the imminent disaster. As the city starts to tremble, the camera quickly returns to the couple just in time to capture their initial reactions. A series of medium and long shots reinforce audience identification throughout the length of the scene. The sequence follows a shot/counter shot pattern, cutting between images of destruction, chaos, and death and reaction shots of Daqiang and Yuanni. The editing intensifies the personal antithesis between the earthquake and the couple. It seems as if the disaster has the vengeful agenda of destroying their happy life. This anthropomorphic perspective is most poignantly dramatized when a gargantuan crane collapses and appears to aim exactly where Daqiang and Yuanni are standing. The couple narrowly escapes its lethal attack by only a few inches.

The earthquake sequence delivers what the film promises: the visual verisimilitude of catastrophe with documentary fidelity. But its significance exceeds the form of a media spectacle to be consumed and discarded in a fast-food style. The representation of the earthquake as an almost sentient force provides the audience with an emotional "safety-valve," through which their fear and horror can be released in controlled doses in the form of commiseration. Thus, in a later scene, when Yuanni despairingly berates God as the reason for her tragedy, the audience returns to a psychological equilibrium by empathizing with her emotional catharsis.

Traumatic memory: the commercialization of pain and the aestheticization of sacrifice

The narrative trajectory of *Aftershock* takes a sharp turn from a disaster film to a family drama. The earthquake is deeply embedded in the unconscious of the surviving protagonists, only to resurface in different forms as they carry on with their lives. In the latter half of the film, Feng Xiaogang enters the territory of family melodrama, familiar from his commercially successful "New Year Blockbusters" (*Hesuipian* 贺岁片).[1] Like his previous hits, *Aftershock* shares the bitter-sweet dramatization of human dilemmas in modern society, the commercialization of the cinematic image, and the consumption of romanticized sacrifice. *Aftershock* continues Feng's stylistic fascination with the concept of family in an increasingly globalized modern society, as well as his signature exploitation of cinema's marketing potential through the commercialization of pain and the aestheticization of sacrifice.

Aftershock devotes two thirds of the film to the life of the surviving members of the Fang family after the earthquake. The healing process of the mother unfolds against the background of the reconstruction and rejuvenation of Tangshan. The Fang family's painful reconciliation is based on the same foundation as post-earthquake Tangshan – the destruction of the old and the preservation of memory. Their story becomes a historical case study of major events in Chinese society in the post-Mao period. Thus, the discourse of trauma is carefully appropriated by the politics of change, in the sense that trauma serves to initiate social reform, but never acts as the centre of cinematic experience or emotional investment.

Aftershock's reorientation from a disaster film to a family drama exemplifies the commercialization of trauma on several different levels. As Ann Kaplan and Ben Wang note, "[t]he culture of consumption now finds in history a new toy, a fashionable consumer item" (Kaplan and Wang 2004: 11). Cinematically, the representation of the earthquake is marketed as a visual sensation, a *tour de force* of modern cinematographic and computer technologies, recreated to reflect historical authenticity. Psychologically, the public is invited to invest emotionally and materially in the film through their participation in the early production process; by donating their collection of old household items, family photos, and personal accounts of survival, they become personally engaged with the spectacular imagery and the cultural implications of the film. Furthermore, Feng Xiaogang, continuing the commercializing practice that he himself introduced to contemporary Chinese cinema, unapologetically utilizes his auteur status as "the most commercially successful mainland Chinese filmmaker ever" (McGrach 2008: 165) to secure good business through overt product placement in *Aftershock*.[2] Because of the sensitive nature of the film, Feng's profuse use of product placement has been questioned by many media critics, who accuse him of "making the audiences watch advertisements when they are crying over the plot (让观众哭着看广告)" (*Xinhua Net*, unpaginated).[3] Thus, the trauma of the earthquake takes the form a mass-media marketing event, seamlessly incorporating pre-sale media coverage, advertising events and promotional campaigns. The film functions as a commodity to maximize capital gains.

Due to the commercialization process, the social and political implications of the earthquake are carefully pushed into the background, while the natural disaster is represented as a consumable emotional incident, a cause for cathartic compassion, and, ultimately, as a topic that is no longer relevant. This narrative and rhetorical erasure is subtly initiated through a short, seemingly irrelevant yet crucial scene that plays a transitional role between the first and second parts of the film. It is positioned after the plot follows the twins' separate lives: Yuanni is able to keep her disabled son Fang Da with her in Tangshan despite the opposition of her mother-in-law, and Fang Deng, adopted by a couple from the People's Liberation Army and renamed Wang Deng, settles in a new life. Fang Deng responds to her foster father's suggestion that he go back to Tangshan and look for her family with the noncommittal reply, "I don't remember." This is the only sentence that Fang Deng utters after her rescue, a clear sign of her anger and determination to forget the pain and trauma of both the earthquake and her mother's abandonment.

Fang Deng's words disclose the narrative meaning of the next scene: the Tangshan Earthquake will be erased from memory because of another social and political "earthquake" of national scale – the death of Chairman Mao on September 9th, 1976, only 43 days after the disaster. A disembodied funeral tune plays in ominous solemnity on the soundtrack even before the camera cuts from the preceding scene, a brightly lit interior that promises healing, rebirth, and a fresh start, to an oppressive aerial shot of Tian'anmen Square. A slow pan reveals that the entire Square is full of mourners in neatly arranged rows, a powerful reminder to the audience of the other tragedy that has not yet been properly mourned or memorialized. The opening scene of the earthquake contained only fleeting and fragmentary shots of haphazardly lain human bodies and of several long rows of tombs, suggesting that death was not the primary visual emphasis; by contrast the massed group of mourners at Mao's funeral occupies the full frame. Amongst many earthquake orphans, Fang Deng is seen wearing the white paper flower on her chest, a customary symbol of mourning for the death of someone close. As the funeral tune reaches its climax, soldiers lower their heads in unison in an expression of mourning and grief. Except for a few stifled sobs, the non-diegetic music dominates the soundtrack. It seems, therefore, that the entire scene (1.40 in length) is disturbingly aphasic on the great loss of the nation's leader, indicating a trauma too deep to register linguistically. Such visual grandiosity, alongside the emotional expressiveness of the music, effectively shifts the focus from the actual earthquake to the social "earthquake", and ingeniously diminishes the pain of the former by comparison.

While this structural effort switches the locus of pain and trauma from the Tangshan Earthquake to the national tragedy of Mao's death, the latter half of *Aftershock* exploits the materiality of commercial products as compensating rewards for Yuanni's romanticized sacrifice. The next scene returns to the same location from the start of the film, now completely rebuilt as a pleasant residential neighbourhood, with only the train tracks as a distant reminder of the past. The new Tangshan of 1986, visualized in rows of new apartment buildings bathed in clear morning sunshine, is represented as a city that has healed. Yuanni, riding a bicycle in the same way as she did ten years previously, buying breakfast for her son

and supporting him on her own, embodies the image of an indestructible woman who is vibrant, independent and hopeful. Metaphorically, Yuanni's survival reflects Tangshan's rise from the ruins. Her determination to live on characterizes the city's modernization after the earthquake.

Over the course of the next three decades, the Fang family inevitably participates in China's socialist market economic reform, the real aftershock to which the title refers. As Tangshan rises from the ruins of the earthquake, China also recovers its footing after the Cultural Revolution through modernization and reform. The Fang family certainly represents the first generation who benefit from China's reconstruction and economic development. The film charts the course of the rising fortunes of both the nation and the family – from the "Open Up" policy in the early 1980s, when Fang Da goes to the south to seek better opportunities, to the large-scale privatization of state-owned enterprises that results in Yuanni's voluntary retirement in the 1990s, and, finally, to China's globalization, which enables Fang Deng to make a living by tutoring English, and her subsequent immigration to Canada after she marries a Canadian lawyer. *Aftershock* visualizes Fang Da's success in great detail through the materiality of product placement. The exquisite restaurant where he treats Yuanni, the fashionable brand of clothes and accessories that he and his beautiful wife wear, the BMW car he drives, all provide quantifiable evidence that Yuanni has access to a carefree lifestyle. Yet in reality, it might have been a different story for Fang Da, because as a college dropout and a physically disabled young man, he stands a slim chance in becoming an executive of a sizable travel agency. Thus, the family's motivational rise to middle-class affluence signifies a desire on the part of the spectator for material compensation, and a commercial demand for the healing power of a fairy tale ending.

Yuanni's sacrifices for her family and her fidelity to Daqiang are unreservedly aestheticized as the film uses the carefully coordinated, tear-jerking moments of her reunion with the long lost daughter Fang Deng to foil the "happy ever after" ending that becomes Yuanni's ultimate triumph in life. Yuanni's adherence to the traditional values of marriage and family is tactfully established when she refuses to remarry, despite the attentions of a sincere suitor and the exhortations of her mother in law and son. Her traditional values are represented in an unmistakably positive light, as Yuanni is portrayed clearly as a noble character. Throughout the film, Yuanni repeatedly expresses her fidelity to her husband, saying that he died to save her, and it is "not a bad deal at all to be his wife in this life." Such devotion and loyalty go beyond conjugal love, and are powerfully reminiscent of the traditional Chinese value of good wifely conduct – stay loyal to one's husband, dead or alive. They also reflect the Confucian ideal of reciprocity, an endorsement of Yuanni's wifely devotion and self-sacrifice. Yet her sacrifices far exceed her responsibility to the family as a mother and wife, and could be seen as punishment for the unspeakable decision to abandon her daughter on the night of the earthquake. Guilt and remorse, therefore, underline Yuanni's ascetic life. Her solitary, self-sufficient, and contented existence encourages a sympathetic identification on the part of a Chinese audience because it presents an idealized picture of a loyal, loving, and constant woman.

Aftershock uses the Tangshan earthquake as a narrative and psychological backstory in order to promulgate the dominant model of national and cultural ideology for the normalization of characters who have been gravely wounded by the natural disaster. Such values characterize the politics of aestheticization of personal sacrifice and the discourse of national re-building. Thus, *Aftershock* engages a much wider audience as it transcends the generic limitations of the disaster film, which are closely associated with visual spectacle and the discourse of pain, and exploits the commercial potential of family drama by focusing on the ultimate reconciliation of the family and the promise of a happy ending. Such an ending in turn confirms the necessary value of Yuanni's redemptive sacrifice and her daughter's painful negotiation with trauma as it alludes to a simple yet deep-rooted Chinese aphorism – good things happen to good people 好人有好报 (*Haoren you haobao*).

Renewal: familial values and national solidarity

Aftershock was commissioned by the Tangshan government as a promotional film about the city and its glorious rise from the trauma of the earthquake. It belongs, according to Zhang, to the subgenre of "mainstream films 主旋律电影 *Zhuxuanlǜ dianying.*" Such films are typically characterized by "a cinematic flatness on the screen" (Zhang 2009: 130), and are often regarded as uninspiring and didactic with stereotyped characterization and stylized cinematography. As Chinese national cinema became increasingly globalized and immersed in the regulative forces of market economy in the first decade of the new century, the production of mainstream films aimed for domestic and international market competitiveness by representing contemporary issues and social concerns to promote Chinese national culture and national solidarity. In the "mainstream films" (*Zhuxuanlǜ dianying*) genre, the main characters often function as representatives of social and cultural values that are recognized and exalted in Chinese tradition, among which the fundamental importance of familial love, national solidarity and universal humanity are repeatedly celebrated.

The central theme of familial values and the bond of kinship is frequently articulated in Feng Xiaogang's various interviews with visual and print media. This thematic emphasis is echoed in both positive popular feedback and critical acclaim (Li 2010; Zeng 2010; J. Wang 2010). Most tellingly, *Aftershock*'s strong government endorsement is evidenced by a highly laudatory article written by Hongsen Wang, Deputy Director of the Film Bureau of the State Administration of Radio Film and Television (SARFT), and published in *People's Daily*, the official Party newspaper.[4] Hongsen Wang was fully involved in *Aftershock*'s planning and production. He points out in his article that *Aftershock* is a "landmark achievement" in the modernization of China's cinematic realism, providing "general guidance" for contemporary Chinese cinema (2010). Thus, *Aftershock*'s realistic portrayal of the earthquake and its aftermath, along with its synthesis of family values and nationalistic discourse, insured that it achieved a carefully maintained balance between popular entertainment and political correctness.

Aftershock's promotional tag line – "23 Seconds. 32 Years" – suggests an incomplete temporal continuum. The earthquake caused a cognitive, as well as a physical, fracture. In 23 seconds, it created a rupture that continues to define the protagonists' lives for the 32 years till the present time. The film creates a cinematic chronotope that de-emphasizes the locality of the tragic earthquake through affirming its spatial absence. Therefore, as discussed earlier, the traumatic memory of the earthquake is exploited as a means to achieve the thematic goal of socioeconomic, emotional, and psychological renewal, which binds the fracture with the healing power of familial love and national solidarity.

The Fang family, along with millions of other Chinese, experiences innumerable seismic shifts in the social structure of the nation whose transformative power is far greater than the destructive force of the Tangshan earthquake itself. In the director's own words, as quoted by John Chong, CEO of the Media Asian Group which financed the film, *Aftershock* tells a story "about the triumph of family and humanity" (Zeno, *Newsweek*). Indeed, the second half of the film carefully steers the emotional tone away from private grief to social solicitude and human empathy. Trauma and bereavement fade from the Fang family's life, while hope and warmth characterize the emotional landscape.

A temporal distance of 32 years separates the Tangshan earthquake from the final reconciliation of the divided family. A Chinese audience could not ignore the fateful coincidence of dates. At 2:28pm China Standard Time on Monday, May 12th, 2008, an earthquake which measured 8.0 on the Richter scale devastated the small towns of Wenchuan and Beichuan in Sichuan Province, taking more than 85,000 lives. Although smaller in magnitude than the Tangshan Earthquake, the Sichuan Earthquake was the worst disaster in China since 1949 in terms of damage and long-term impact. *Aftershock* presents the Sichuan Earthquake as the visual and narrative double of the Tangshan Earthquake; the traumatic aftershocks in the first earthquake find closure, confirmation and consolation in the more recent disaster. The chronicle of the Fang family's journey achieves its final climax at the moment when the concept of the individual family is superimposed upon that of the nation as its patriotic extension.[5] The Fang family is only reunited through the Sichuan Earthquake in 2008, renewing their faith in the strength of familial love and the manifestation of national unity and camaraderie through the disaster relief efforts.

This structural device corresponds with a narrative parallelism that brings the 2008 Sichuan Earthquake to the foreground. If the 1976 Tangshan Earthquake symbolizes destruction, confusion, loss, and despair, the 2008 Sichuan Earthquake serves as an impossible antidote to the trauma of the characters, renewing their faith in family, allowing them to find hope in humanity and unity, and ultimately facilitating the final reconciliation within the family. In the Tangshan Earthquake, Yuanni not only loses her husband, who died trying to save her and their twin children, but also loses her only daughter, both physically and emotionally. When she decides to save her son rather than her daughter, the audience cannot overlook the traditional sexist preference for boys over girls. Yuanni's preference of her son over her daughter is foreshadowed in an earlier scene, when she gives the last tomato left to Fang Da, while both children want it. Although Fang Deng is portrayed as a perfect daughter and elder

sister, loving her parents and always taking care of her little brother, she is abandoned, for apparently no other reason than the fact that she is only a girl and cannot carry the family name. Moreover, Fang Deng is significantly rendered voiceless as she tries to find help while buried under the ruins. She can only hit the rocks to attract the attention of the rescue team, while her brother cries for help loudly and clearly. Yuanni's decision is understandably deemed "correct" according to Chinese tradition, a choice reinforced by the silence of her mother-in-law and sister-in-law, who visit Yuanni after the quake but never mention Fang Deng.

The cinematic representation of the Sichuan Earthquake is mediated through a CNN news report on TV, when Fang Deng's Canadian husband tells her the terrible news. The use of recorded footage creates a narrative distance, a buffer space for the audience, who are encouraged to replace the trauma of Tangshan Earthquake with the spirit of national unity that characterizes the Sichuan Earthquake disaster relief missions. Doubly framed on the TV screen and within the film frame, the visual impact of this far more devastating earthquake is considerably reduced, which suggests, perhaps, that the images of destruction are not the principal focus. Fang Deng, struck by photos of deceased children from the Sichuan Earthquake, decides to go back to China and become a volunteer in the disaster relief efforts. As an earthquake survivor herself, an "insider" in relation to the disaster, Fang Deng relives her trauma emotionally and physically through her humanitarian voyage to Sichuan; on the other hand, her ability to contribute to the rescue mission and devote herself to helping the victims of the earthquake also positions her outside of the immediate tragedy. Arguably, this re-enactment of pain becomes her salvation as it offers a symbolic opportunity to make peace with her past.

When Fang Deng, in a moment of déjà vu, witnesses a mother's painful decision to amputate her daughter's leg in order to free her from under a building, she is confronted, along with the audience, with an apparently identical scenario from her own past: her mother and this woman must sacrifice their daughters, yet, whereas Yuanni has no alternative, this mother *chooses* to make a noble but cruel decision. Upon hearing the mother's decision, Fang Deng's emotionless face nonetheless reveals her epiphany: Yuanni could not have chosen either child without feeling punished for the rest of her life. For her, there was never a choice, only a lifetime of pain. As Fang Deng holds the devastated mother tightly, she has already forgiven Yuanni and come to terms with her past.

The ethical and emotional tenor of such an uplifting narrative development is echoed in the cinematic representation of the Sichuan Earthquake, with its swift, efficient and effective rescues, the selfless and spontaneous participation of civilians, and the unconditional support from all sectors of the country and the rest of the world. Thus, although the two earthquakes are comparable in magnitude and degree of physical destruction, their narrative and symbolic meaning are essentially different. The Tangshan Earthquake is characterized by pain, loss, shock, and dislocation, whereas the Sichuan Earthquake inspires unity, hope, faith, and a shared humanity. The sentiments aroused by the Sichuan Earthquake are given visual form as Fang Deng returns for the first time to the rebuilt city of Tangshan, which is represented as vibrant, prosperous and new. *Aftershock* establishes an intertextual relationship between

the two earthquakes. It imagines the Sichuan Earthquake as a redemptive re-enactment of the trauma of the Tangshan Earthquake, and rediscovers the city of Tangshan as a promise to the ruined towns in Sichuan.

The film's narrative dénouement rewards Yuanni's suffering with the reconciliation with Fang Deng and the restoration of familial unity. In a reversal of expected roles, Fang Deng apologizes to Yuanni for breaking the familial ties and abandoning her family. Fang Deng's repentance and remorse further reinforce Yuanni's noble sacrifice by implying that Yuanni is not to blame for abandoning her daughter. The cherished values of filial piety and the inseverable ties of blood are celebrated and the family is reunited finally in front of the father's grave. When Fang Deng renews her faith in family and love by witnessing other people's loss and reconciles with Yuanni, the audience experiences emotional and psychological catharsis not by remembering the Tangshan Earthquake, but by confirming their own confidence in national unity, socialist spirit, and above all, the entertainment value of Feng Xiaogang's cinema.

Aftershock's unprecedented commercial and critical success once again confirms Feng Xiaogang's auteur status. By combining family melodrama and the disaster film, Feng successfully harmonizes the political mission underlying state-sponsored "mainstream films" with his signature emphasis on entertaining the mass audience. Jason McGrath has claimed that Feng Xiaogang is different from those directors who produce mainstream films with the aim of "educating the audience and instilling patriotism" (2008: 165); in *Aftershock*, however, the political discourse of patriotism is deeply embedded in the singular moments of national tragedy, when nationalism and patriotism are appreciated and demanded.[6] Nonetheless, Feng is still a market-oriented director at heart. With the unreserved support of the Tangshan government and his many retail sponsors, *Aftershock* was always a fail-proof film even before it was made. *Aftershock*'s production involved such key elements as investment attraction, audience engagement, and political endorsement. The film has been hailed as "a successful collaboration between business capital and government capital" (Zhang, cited in Fan 2010). *Aftershock*'s phenomenal success has secured Feng an invisible but highly valuable political capital – his favourable relationship with the government. Thus, *Aftershock* promises a new development in commercial cinema – mainstream drama (主旋律剧情片). As Zhang Ling's novella *Aftershock*, upon which the film was based, is made into a 38-episode TV drama by the same investor in Feng's film, it remains to be seen whether this trend will be carried over to the small screen.

References

Caruth, C. (1995), "Introduction," in Cathy Caruth (ed.) *Trauma: Exploration in Memory*, Baltimore: The John Hopkins University Press, pp. 3–12.

Fan, J. (2010), "电影《唐山大地震》：一部主旋律大片催动城市推介 *Aftershock*: One Mainstream Film Boots City Promotion," *China Youth Online* [Online] July 30th, 2010, http://zqb.cyol.com/content/2010-07/30/content_3350696.htm. Accessed February 24th, 2013.

Kaplan, E. A. and Wang, B. (2004), "Introduction," in E. Ann Kaplan and Ban Wang (eds.), *Trauma and Cinema: Cross-Cultural Explanations*, Hong Kong: Hong Kong University Press, pp. 1–22.

Li, X. (2010), "*Aftershock*: Defusing the History of Trauma with the History of the Soul," "大地震"：用心灵史化解灾难史,"*Jinan Daily*, July 27th, 2010, p. 9. Lowenstein, A. (2005), *Shocking Representation: Historical Trauma, National Cinema, and the Modern Horror Film*, New York: Columbia University Press.

McGrath, J. (2008), *Postsocialist Modernity: Chinese Cinema, Literature, and Criticism in the Market Age*, Stanford: Stanford University Press.

Neal, A. G. (1998), *National Trauma & Collective Memory: Major Events in the American History*, Armonk: M. E. Sharpe.

Wang, H. (2010), "The New Life of Realism Films: Thoughts and Inspirations of *Aftershock*" 现实主义电影重获新生 – 《唐山大地震》带来的思考与启示," *People's Daily* [Online] August 6th, 2010, http://www.people.com.cn/GB/192235/197089/199395/199428/12367146.html. Accessed February 23rd, 2013.

Wang, J. (2010), "*Aftershock*: Highlighting Humanity and Family Love," "《唐山大地震》彰显人性和亲情," *Sanqin Daily* [Online] July 26th, 2010, http://epaper.xplus.com/papers/sqdsb/20100726/n105.shtml. Accessed February 23rd, 2013.

Xinhua Net (2010), "Counting *Aftershock*'s Product Placement," "唐山大地震植入广告盘点." *Xinhua Net* [Online], http://news.xinhuanet.com/fortune/2010-08/12/c_12439970.htm. Accessed February 22nd, 2013.

Zeng, J. (2010), "Feng Xiaogang Says He Sheds Tears with the Audience," "冯小刚称热泪与观众一样多,"*Beijing Times*, July 23rd, 2010, p. A43.

Zeno, A. A. (2010), "China's Spielberg: Making Shock Waves," *Newsweek* [Online], http://www.thedailybeast.com/newsweek/2010/07/30/china-s-spielberg-making-shock-waves.html. Accessed February 23rd, 2013.

Zhang, H. (2009), "Ruins and Grassroots: Jia Zhangke's Cinematic Discontents in the Age of Globalization," in Sheldon Lu and Jiayan Mi (eds.), *Chinese Ecocinema: In the Age of Environmental Challenge*, Hong Kong: Hong Kong University Press, pp. 129–153.

Zhao, Z. (2010), "Feng Xiaogang's Exclusive Talk on Aftershock: Family Love Moves the Time," "冯小刚独家阐述《唐山大地震》 亲情感染大时代," *Sohu Entertainment* [Online]http://yule.sohu.com/20100601/n272501594.shtml. Accessed February 19th, 2013.

Notes

1 New Year Blockbusters, or *Hesuipian* 贺岁片, are commercial films, typically in the genres of comedy or family drama, that premier during the Chinese Lunar New Year, and cater to the festival spirit of the national holidays. Feng Xiaogang established himself as a major director by successfully creating the genre of New Year Blockbusters in 1997 with *The Dream Factory* 甲方乙方 *Jiafang Yifang*. Baidu.com, the Chinese equivalent of Google, calls him "Father of New Year Blockbusters." (http://baikc.baidu.com/view/1678.htm). For a more detailed discussion on Feng Xiaogang's New Year Blockbuster films and the New

Year Blockbuster Films as a genre, see "New Year's Films: Chinese Entertainment Cinema in a Globalized Cultural Market," in Jason McGrath's (2008) *Postsocialist Modernity: Chinese Cinema, Literature, and Criticism in the Market Age.*

2 There are many examples of product placement in *Aftershock*, most of which are not subtle. For instance, in the scene when Yuanni and her suitor have dinner, the camera gives the Jiannanchun (剑南春) wine they drink, a famous brand in China, a close-up. In the scene when Fang Da's employees are frightened when they feel the Sichuan Earthquake, Fang Da says, "Use China Life Insurance (中国人寿), they are better." More information can be found in this online article on Huanqiu.com (http://life.huanqiu.com/chuanshao/2010-07/969459_2.html).

3 This is a comment from an online article in Chinese on Xinhua.net (http://www.ce.cn/xwzx/shgj/gdxw/201007/30/t20100730_21671184.shtml).

4 Wang's article, in Chinese, can be found at http://media.people.com.cn/GB/40606/12228174.html.

5 The belief that the nation is an extension of the individual family can be traced to early classics in Chinese literature, such as *The Book of Rites*, *The Analects*, and *Mencius*. All contain passages that expound upon the importance of cultivating private virtues as a model for public behaviour. The interdependence of "individual family 小家 *Xiaojia*" and "nation as a big family 大家 *Dajia*" has also been repeatedly emphasized throughout the Communist era to promote patriotism and national pride.

6 In his investigation on the tradition of New Year's Films (贺岁片), McGrath observes that "Feng's unapologetic emphasis on entertaining audiences above all else distinguishes his films […] from the state-sponsored 'main melody' (*zhuxuanlü*) films screened in China with the more didactic aims of educating the audience and instilling patriotism" (2008: 165).

Chapter 6

The Just Distance: Abbas Kiarostami and the Afterlife of Devastation

Steve Choe

The earthquake

destroyed

even the ants' grain silo.

<div align="right">Abbas Kiarostami (Kiarostami 2001: 122)</div>

I.

On June 21st, 1990, a 7.3 magnitude earthquake struck northern Iran at 12:30 am. Lasting approximately one minute, its epicentre was located near the Caspian Sea, about 200 kilometres north-west of Tehran. A 30,000-kilometer radius, encompassing the provinces of Zanjan and Gilan, the small cities of Manjil, Rudbar and Lushan, as well as hundreds of towns and villages, was left devastated. Dozens of aftershocks followed. One of them, measuring 6.5 on the Richter scale, burst open a dam in Rasht, the capital city of Gilan province, and razed farmland in the surrounding areas. In all, about 40,000 people were killed and over 300,000 were left homeless.

Iran's spiritual leader, Ali Khamenei, and then president, Hashemi Rafsanjan, travelled to the area and supervised relief operations. They declared the destruction wrought by the earthquakes a "national tragedy" and called for three days of mourning. The League of Red Cross and Red Crescent Societies made requests for survival supplies, including tents, medical supplies, food, and blankets for the homeless. American journalists, who up to then had been prohibited from travelling freely in Iran, were given greater access in light of the international relief efforts. While news about Iran at this time was dominated by the death of Khomeini in 1989, after the earthquake US readers were provided with a more tragic, less overtly demonized, picture of Iran. In a June 24th article in the *Los Angeles Times*, a woman named Zenab Zohori is portrayed as an individual who has just experienced profound loss. "My brother is dead," she laments, "his children are dead. Everyone is dead. My husband's back is broken. I don't know where they have taken him." The *LA Times* correspondent then reports, "A few hundred feet down the road, a family of eight huddled together and wept. A few hundred feet farther along, a crowd gasped as searchers discovered the body of a girl, about 9 years old, under a pile of mud bricks that once formed the front wall of her home" (*LA Times* June 24th, 1990). Many hospitals were destroyed but those left standing became quickly overcrowded with the wounded. Despite the considerable casualties resulting from

collapsed buildings, on June 22nd, 1990, according to the *Guardian*, "At least 6,000 victims, many still alive, were said to have been dug out of the rubble" (*Guardian* June 23rd, 1990).

Abbas Kiarostami was about to celebrate his 50th birthday when the 1990 earthquake ravaged northern Iran. With his son, Kiarostami travelled from Tehran to the devastated area, driving in and around Koker and Poshteh. This was a particularly meaningful location for the director. Four years previously, Kiarostami had filmed *Where is the Friend's Home?* (1987) in these villages. In this feature-length film, Ahmed (Babek Ahmed Poor) seeks out the home of Mohamed Reda Nematzadeh (Ahmed Ahmed Poor), to return a notebook he had taken by accident. Ahmed faithfully undertakes this quest so that his friend will not reprimanded at school the next day. When Kiarostami returned to Koker, he found that the earthquake razed the village featured in his film. Deeply dismayed by the sight of massive destruction, the film-maker took it upon himself to seek the whereabouts of the two young actors.

But as his travels through Zanjan and Gilan provinces continued, Kiarostami saw how people were trying to rebuild despite their experience of massive loss and the ruins that surrounded them. The earthquake profoundly interrupted their lives and tore apart families, but the film-maker saw that "life continued" nevertheless,[1] and that there was an afterlife to the devastation. In an interview conducted years later, he reflected that "Travelling in the area touched me deeply. I had such a close and profound experience of death that it changed my work in an optimistic way" (*Guardian* June 12th, 1990).[2] Despite the massive loss of life and property, Kiarostami was profoundly moved by the life-affirming efforts of the traumatized. And despite the potentially debilitating, overwhelming presence of death, individuals continued to live their lives.

One year later, Kiarostami returned once more to Koker and Poshteh to film *Life and Nothing More ...* (1992), whose plot reconstructs the trip through the devastated areas he had taken with his son. In a 1997 interview, he speaks about the temporal gap between his initial trip and its deferred, cinematic reconstitution:

> When I first went there I was very upset and saddened. Had I really been filming the third day after the earthquake, my camera would have been like other documentary films, capturing only death and destruction. Actually, when I took some distance from it, I realized that though we went to the location to see death, what we found was life. The reflection of life was much stronger than the reflection of death. This is the view I came to by distanciation, by leaving one year's distance between the day of the earthquake and the shooting.
>
> (Hamid 1997: 24)

Kiarostami states that the temporal distance between then and now allowed him to see that what he wanted to film was not images of devastated survivors mourning the loss of their loved ones. Filming for Kiarostami was about the filming of continued life in the midst of death.

One year's time allowed him the right distance to film the delicate image of survival following the earthquake, while obviating the assertion of an exploitative, cinematic gaze. Kiarostami refuses to straightforwardly document the reality of devastation in a manner that would conform to the conventions of the documentary genre. He was not interested in making a film that would transparently convey the actuality of the event, nor a reconstruction faithful to the original. "I don't value the realist cinema and documentary cinema," (Hamid 1997: 24) Kiarostami asserts. Indeed, as one attempts to contextualize *Life and Nothing More ...* – its explicit reference to *Where is the Friend's Home?* and Kiarostami's own experience of travelling through Koker – this contextualization of its story and history only heightens the confusion between fiction and documentary genres. Like *Close-Up* from 1990, *Life and Nothing More ...* occupies a zone of indeterminacy between the two. Indeed, this indeterminacy explains a good deal of dissatisfaction expressed by cinema-goers who sought immediate, documentary images of destruction and mourning. Kiarostami describes this response among local audiences:

> The Tehran audience was extremely unhappy with it – they had come to see an earthquake film, to see the bodies of those who had died in the 1990 earthquake. They had come to cry and mourn. When it was over, they blamed me for being unfeeling and cold-hearted – they hated themselves for having watched a film about an earthquake in which, rather than cry, they had even laughed on two or three occasions. One spectator told me, 'You led us all the way up the cliff, then left us dangling. We never even found out if the children were alive or dead.' Because people pay, they wish to find out what happens in the end.
> (Nayeri 1993: 28)

The audience needed to know that sitting through Kiarostami's *Life and Nothing More ...*, despite its long takes and understated plot structure, will satisfy narrative expectations. If the aim of working through trauma is to arrive at a sense of closure, to achieve mastery over the reality of the past and to restore a lost innocence, the characters in *Life and Nothing More ...* dissatisfy because they seem strangely present, living in the moment while remaining detached from the destruction that surrounds them. Some audiences seem to resent Kiarostami's own emotional distance, for being "unfeeling and cold-hearted," and for the film's lack of melodrama in response to the experience of trauma and the 1990 earthquake.

At the risk of being cold-hearted myself, I want to discuss, precisely, the distances that inform Kiarostami's look and the representation of mourning and loss in *Life and Nothing More* Commenting on this film in *The Evidence of Film*, the philosopher Jean-Luc Nancy writes that "[t]he just distance [*distance juste*] is quite exactly a matter of *justice*" (Nancy 2001: 72). Nancy goes on to clarify that the just distance is not a function of a correct spatial distance, of a medium distance or a long shot in relation to its subject. For the "extreme close-up suits it just as well as the frameless shot that fills the entire screen, the immobile shots just as well as the tracking shots going at the speed of the car." (Nancy 2001: 72) Nancy's use of

the word "*just*" emphasizes the justice that the film image renders to the pro-filmic world as well as to its own ontological possibilities. I would like to propose that Nancy's formulation advances a cinematic ethics grounded, not in categories of space, but principally on the problem of temporality and the comportment of the human viewer towards finitude. To do this, I will look closely at the last two films of Kiarostami's Koker trilogy that immediately followed the devastating 1990 earthquake in Iran, *Life and Nothing More …* and *Through the Olive Trees* (1994).

In writing about the films of Kiarostami, I am constantly reminded of my own outsider status as a critic and thinker of the cinema. In her critical essay, "Perspectives on Recent (International Acclaim for) Iranian Cinema," Azadeh Farahmand takes a "non-romantic approach" (Farahmand 2002: 87) to the auteurism of Kiarostami, arguing that a good deal of the first-world, art house popularity surrounding his films may be explained by national concerns (such as film censorship), the intricate politics of international film festivals, as well as the geopolitics of Iran in the world. Farahmand remains sceptical of the efforts to deify Kiarostami in the West, insofar as the western spectator is always already imbricated in an Orientalizing look. The first-world spectator "can maintain his distance and remain uninvolved, be fascinated, securely appreciate of the exotic locales, as though viewing an oriental rug, whose history he does not need to untangle" (Farahmand 2002: 101). As a Korean-American film scholar, I hope to remain sensitive in the following discussion to my own Orientalizing tendencies in my look on Kiarostami and his films. Indeed, it is precisely the metaphysics of the "distanced" observer[3] that has been so crucial to the theorization of the fetishizing, voyeuristic spectator that I wish to interrogate and ultimately undermine here. While I will not treat Kiarostami's films as ethnographic, that is as authentic artefacts of Iranian culture, admittedly I do run the risk of different kind of essentialism in my belief that his films, to quote Laura Mulvey, "reach out towards key questions about the nature of cinema as a medium" (Mulvey 2002: 260). If the dominant cinema is inextricably linked to a distanced and objectifying look, I believe that Kiarostami's films can teach their spectators of an ontological nearness that surpasses theories of suture or identification in film studies and, according to Negar Mottahedeh, "produce a different relation to time and space in film beyond the commodified image" (Mottahedeh 2008: 157).

II.

Life and Nothing More … starts off unassumingly. In a long take, Kiarostami places the camera inside a highway tollbooth, framing the hands of passing drivers and the tollbooth operator exchanging money. Over the sound of traffic and sirens, a voice on the radio urges individuals to adopt an orphan child as a gesture of solidarity. Most of the drivers quickly pay and continue on, but one pauses to ask if the highway ahead is obstructed. "If it were, we would notify you," the tollbooth operator abruptly responds. The film then cuts to a

medium, frontal shot of the middle-aged driver and his son, Puya, sitting in the back seat. The driver proceeds a bit further and pulls over to ask a man standing on the side of the road if the highway has been blocked. The film does not cut to a reverse shot and the spectator hears his response as an off-screen voice: "The highway is only open for the rescue services." As the car drives further, Puya asks his father, "What are rescue services?" He responds, "They are the things that people send to help the victims of the earthquake." A dialogue between the two ensues. The boy asks about a communications tower and a cement factory in the distance, both standing in the midst of the rubble surrounding them.

Father and son quietly argue about who played in a recent World Cup match, and then argue more loudly about a grasshopper that has somehow entered the car. Puya then lays back to rest and as his eyelids become heavy, they drive through a tunnel, blocking the light and making the image flicker. The credits to *Life and Nothing More …* appear. "The film emerges slowly, little by little," Nancy writes,

> it finds, or finds again, the possibility of the image that, at first, when it emerges from the tunnel, will consist of close ups of ruins, trucks, abandoned objects, mechanical shovels, dust, large rocks that had fallen onto the street. It is at the same time a question of getting out of the catastrophe, of finding the road leading to the villages that have been razed, and of getting out of the dark to find the image and its right distance.
>
> (Nancy 2001: 70)

The just distance between then and now must be discovered. While the devastated settings, characters, and narrative of *Life and Nothing More …* attest to the earthquake that took place three days previously, the images attest to the immediacy of reality as it unfolds in the present, flowing into a highly uncertain future. Their immediacy sets the driver of the car, who is a film-maker and serves as the stand-in for Kiarostami, on the task of *Life and Nothing More …*: to find the "right distance" in the process of creating it.

As in *Taste of Cherry* (1997) and *Ten* (2002), much of *Life and Nothing More …* is shot from inside a moving vehicle, doubling the view of the camera with the car's windshield as life inexorably passes into and out of the frame. Everyday life, insofar as it is possible at all following the earthquake, is documented through the camera/car. The film-maker and his son drive through scenes of razed villages, full of people sorting through the rubble of their destroyed homes. Like the children featured in the Italian Neo-realist cinema, who for Deleuze in *Cinema 2* embody the pure optical and sound situations of the post-war Europe, Puya perceives the destruction that surrounds him with a naiveté that does not make epistemological distinctions between fantasy and reality.

Soon father and son are stuck in a traffic jam caused by a car that has somehow crashed into a large piece of cement. This interruption forces them to seek out an alternative road. Stopping to ask for directions to Koker, they encounter an old woman carrying a gas cylinder on her shoulder. She asks if she could place the heavy cylinder on the roof of their car, and requests that they drop it off at the top of the hill they are climbing. The film-maker asks another despondent

woman if the road they are travelling will lead them to Koker. The woman comes close to the car window and tells them that her whole family – 16 members – was lost in the earthquake. They are buried under the rubble. Driving further on the road, Puya tells his father to stop and help a man who looks tired from carrying a heavy sack on his back. He is from Koker. The film-maker holds up a movie poster and explains that they are searching for the boy who starred in *Where is the Friend's Home?*, filmed and released before the earthquake. The man from Koker recognizes the boy but says that he does not know whether he is alive or dead.

Guided by his photograph reproduced in the poster, the search for the missing young actor attests, recalling Barthes's assertion in *Camera Lucida* of photography's ontology, to a catastrophe that has already occurred. Containing no flashbacks or cross-cuts, the film seems to occupy a continuously unfolding present, one that has broken radically with the past while advancing into an uncertain future. Disaster and loss circumscribe the images, creating a cinematic situation which Deleuze calls "any-space-whatever" (Deleuze 1986: 109). And in this *Life and Nothing More …* seems to treat everyday life following the quake with little sentimentality or melodrama, as if objectively. Its images produce the becoming of time itself, as Nancy notes in *Evidence of Film*, marking the distance between past and present, as well as the inevitable mourning and melancholy that accompanies life's perpetual unfolding. These images do not simply record what happened in northern Iran in 1990, they also continue the flow that is constitutive of the viewer's own vitality. *Life and Nothing More …* proceeds by seeking new relationships between film and physical reality, in the search for the road that will lead to Koker.

Thus the windshield is not only doubled by the camera, but the travelling automobile also parallels the distances covered by the moving image, doubled once more by the movement of life. This movement proceeds as if by accident, yet with a sense of inevitability, through a number of other interruptions. Near the beginning of *Life and Nothing More …* the film-maker stops by a grove of olive trees to urinate. He hears a crying baby, and then sees the child struggling in a hammock suspended between two tree trunks. When Puya calls to his father from the car off-screen, he runs back and they drive off. Later, turning a corner, they see dozens of people burying their dead on a hill across the valley. On the soundtrack we hear a voice singing a sorrowful melody overlaid with the voices of those who mourn before the graves of lost loved ones. And at the very end of *Life and Nothing More …* the film-maker gathers speed to climb a hill, only to fail, and then turn around to have another go at it. It is not clear if such interruptions are to be read allegorically, symbolically, or otherwise. While they seem to promise events that will turn out to be significant for the film's narrative flow, their subsequent insignificance, seemingly without telos, only provides further evidence of life's constant fits and starts, and attests to its continuous discontinuities.

In moments such as these Nancy interposes the problem of rendering justice, one without condition and irreducible to the logic of debt and exchange. He writes that

> It's a question of doing justice to what interrupts meaning, to what cuts off the road, to what separates people from one another, and each one from himself. It's a question of

rendering justice to life insofar as it knows death. To know death is to know that there will be an absolute point of arrest of which there is nothing to know. But to know *that* is to do justice to the evidence of life.

(Nancy 2001: 74)

For here lies Nancy's key point: to live with death as its own possibility of interruption, and to make visible through film this life that continues towards the catastrophic interruption that will be and has been. This temporality, the anterior future, underpins the general ontology of photography for Barthes, a "new *punctum*" that is "Time" (Barthes 1981: 96). In his reading of the visual reproduction of Lewis Payne, who in 1865 attempted to assassinate US Secretary of State William H. Seward, Barthes writes: "But the *punctum* is: *he is going to die*. I read at the same time: *This will be* and *this has been*" (Barthes 1981: 96). Every photograph attests to the mortality of its human subjects, who "will have been," illuminating the ontological specificity of photography. Like the temporality of the photograph, the lived present in Kiarostami's film foregrounds its own future anterior.

Solidarity and universality are the film's goals, realized not through the consolidation of political and national identities, but through the shared sensitivity to the precariousness of life. As the car drives away from the mourners burying their dead, trees pass in front of the camera. And as they do so, the soundtrack shifts to the pleasing, baroque tones of Vivaldi, alleviating the weight of death depicted just moments ago. Earlier in the film, the voice coming from the car radio notes the "purity" of folk and contemporary melodies in Iran, contrasting this purity with the musical mixings that have occurred for centuries between North Africa and southern Europe. One may be tempted to balk at Kiarostami's use of Vivaldi to accompany the scene of mourning, as this southern European music remains foreign to Iran. However Vivaldi, like much of western classical music, as he states in a 1995 interview, "belongs to the world. It's like the sky, and everyone can partake of it. My aim is to create unity between worlds that are usually apart" (Kiarostami 1995: 34). Through the cinema, Kiarostami brings disparate, culturally diverse elements into cinema's own flow and unfolding, continuing despite multiple interruptions, until the film ends. The music continues, over images of destroyed buildings and rubble, while the film-maker stops once more to ask a young man, with bandaged head and hands, whether they are still on the road to Koker.

This unifying flow, this continuous discontinuity, persists throughout *Life and Nothing More …*. Later the film-maker meets a young man, Hossein, who despite having lost an astounding number of 65 family members in the earthquake, nevertheless marries the very next day. Hossein remarks, dryly and without irony, that "perhaps we will die in the next earthquake" – as if to justify his rush to marry before it is too late.[4] The losses suffered by those who survived the earthquake serve only as pretexts to reiterate a crucial life lesson: life's precious fragility. There is no metaphysical realm beyond this existence, no Hegelian "inverted world," no resurrection, but a life in the here and now that goes on until it ends. Life and death are not opposed ontological states, but both "belong to the

world." Kiarostami brings death into the scope of life in a kind of rhythm in a manner that allows mournful wailing to almost seamlessly flow into the Western harmonies of Vivaldi, sutured through the images of trees and the sky. This life lives "beyond mechanical 'life,'" Nancy continues, "it is always its own mourning, and its own joy" (Nancy 2001: 76). Kiarostami's images thus render justice, and provide evidence, to the earthquake survivors having lived, not only through their depiction, but through the objective assertion of death's constant presence in the flow of life. Nancy calls this "the very thought of the film" (Nancy 2001: 76), worked through the very materiality and unfolding of the medium itself.

The distance that is just stands in contrast to the scopophilic, fetishistic camera concomitant with the objectifying gaze, a gaze that inaugurates a unified, sovereign subject into an imaginary relation with what is represented on screen. According to this familiar formulation, which critically describes the viewer's escape into the dream factory of the cinema, the spectator aims to maintain his status as a Cartesian subject, master of the spatial and temporal distances that stretch out before him. Describing this epistemological stance, Heidegger writes of the elimination of time and space in technological modernity, pointing to the airplane, radio, television and film – each of which bring what is faraway, be it bodies, information, or time itself, closer to the modern subject. In his essay on "The Thing," he criticizes this technological goal of bringing near, setting an ontological thing before the modern subject so that it may be scrutinized. Heidegger writes that

> The frantic abolition of all distances brings no nearness, for nearness does not consist in shortness of distance. What is least remote from us in point of distance, by virtue of its picture on film or its sound on the radio, can remain far from us. What is incalculably far from us in point of distance can be near to us. Short distance is not in itself nearness. Nor is great distance remoteness.
>
> (Heidegger 1971: 165)

Heidegger points to how ontological distance is all too often confused with physical distance, as if the sound or the image of the thing, brought into proximity from afar, were ontically identical to it. It is precisely this confusion that allows for the forgetting of the question of Being.

Within our technical episteme, distance is conquered when things, including other beings, life, and death, are brought before the subject as representation, like figures in a picture that stand over against the viewing subject.[5] As Heidegger notes in *Being and Time*, this activity constitutes entities as possessable, as *vorhanden* or present-at-hand, which exist only for the cogitating subject of knowledge. Correspondingly, time is measured according to a strictly spatialized formation of near and far, now and then. The remote past is hypostasized as a narrative of teleological progress, and the faraway future is calculated in advance: temporality appears to the objective observer as measurable and mastered, always already known. This

appropriation of distant things in time and place ultimately aims only to reinforce the ego's own certainty, to fashion worldly things so that the Cartesian subject may reproduce the relation of the self to itself – all this at the expense of worldhood. We may remember that in *Being and Time*, Heidegger critiqued Cartesianism for this fatal disavowal.

In "Of Being Singular Plural," written at the time that he wrote his essays on Kiarostami's films, Nancy asserts that one is not obliged to read Descartes as Heidegger does. The French philosopher believes that Heidegger does not go back far enough to the primordial *Mitsein*, or being-with, that presupposes the question of Being.

> In fact, one must read Descartes literally, as he himself invites us to: engaging *with* him and like him in the experience of the pretense to solitude. Only this thinking *with* achieves the status of evidence, which is not a proof. From its very first moment, the methodological pretense is neither substantialist nor solipsistic: it uncovers the state of the 'at each time' as our stage, the stage of the 'we.'"
>
> (Nancy 2001: 66)

When we read Descartes's mediation on Being, we encounter the performance of his own solitude, staged for the other, for future readers of his *Meditations*. For Nancy, the articulation of the "*sum*" as a consequence of the thing that thinks is also already an articulation of *Mitsein*, and of the simultaneity of the plural and the singular that is constitutive of *cogito*. Moreover, the *ergo sum* "counts as 'evident,' as a first truth, only because its certainty can be recognized *by anyone*" (Nancy 2001: 66). Being-with another is, in other words, simultaneous with the ostensibly isolated, solipsistic "I," for the self of the *cogito ergo sum* is not only represented by Descartes, but an infinite number of others as well.

The performance of the question of Being thus anticipates the arrival of the other and affirms its interdependence with that which is not-yet. To pose this question is to pose a question to another, to one who will respond. As an intersection of singularities, the plural singularity of the "I" that is always already being-with maintains a just distance from other beings, other bodies, regardless of whether they are constituted, according to Nancy, as "inanimate, animate, sentient, speaking, thinking, having weight," or made of "stone, wood, plastic, or flesh" (Nancy 2001: 84). This performance of the *cogito* that is simultaneous with the address to the other is what Nancy calls "world." *Life and Nothing More …* in fact constitutes such a world, bringing together its film-maker protagonist, Iran's ruined landscape, those who survived the earthquake, and the viewer of the film in a relation of mutual coexistence.

It is clear that Nancy's evidence of film does not inhere in its capacity to mimetically represent a given reality, or in film's ability to bring distant things in time and space closer to the viewer in a relationship of mastery. Kiarostami's cinema shows how the right distance spans between people and their environments, between the car and the hills it climbs, between the camera and the survivors of the earthquake, and between the cinema and the spectator.

Towards the end of the film, we see a man setting up an antenna so that a group of refugees, temporarily residing in tents, can watch the World Cup. The film-maker approaches him in his car and asks, "Given that the earthquake has taken so many victims, how can you watch television?" The young man responds, with some optimism, "The truth is that I too am in mourning. I have lost my sister and three cousins. But what can we do? The World Cup is every four years and the earthquake every forty. Yes life goes on. Also, this is the work of God." Smiling a bit, the director asks if the soccer fan is from Koker. He remarks that he is, and then adds that he is from everywhere as well. His antenna receives global images from afar and brings them closer to the earthquake survivors in the refugee camp. Children bet a notebook, referencing a key object in *Where is the Friend's Home?*, on who will win the Cup. Meanwhile the film-maker continues driving to Koker, having confirmed that the boy he is looking for will be there. Here it is only life as it passes, seemingly without telos. Loss and mourning are integrated into the everydayness of life, having the same status as the World Cup or the shooting of a film.

Kiarostami does not condemn the technics of the "small screen." Speaking of the 1998 World Cup Finals, won by France, philosopher Bernard Stiegler calls the broadcast technologies that made this televisual event possible complicit with "a new age of calendarity" (Stiegler 2011: 120). For Stiegler, broadcast television synchronizes millions into predetermined programming grids and time slots, interpellating mass viewers into a global culture industry that demands spectatorial passivity. And yet Kiarostami's camera and his surrogate film-maker do not attempt to determine whether the young man's desire to watch the World Cup reflects a false consciousness, manipulated by the spectacle of television. They do not attempt to expose the interiority, psychological, spiritual or otherwise, of this soccer fan, "*as if there were no such a thing as a pure truth lodged in an 'authentic' interiority*" (Nancy 2001: 64). Kiarostami allows only what the camera itself can show, not the moral soul of the human bodies captured in its frame, but only the exterior of things, allowing them to simply appear without judgement. His images maintain a just distance from the world. "The image, then, is not the projection of a subject, it's neither its 'representation,' nor its 'phantasm': but it is this outside of the world where the gaze loses itself in order to find itself as *gaze* [*regard*], that is, first and foremost as *respect* [*égard*] for what is there, for what takes place and continues to take place" (Nancy 2001: 64). To look, to regard, to guard, to look after, to respect: Kiarostami's look respects the real that unfolds before the camera, while respecting the camera's capacity to look out at the world. Nancy writes:

> A rightful look [*juste regard*] is respectful of the real that it beholds, that is to say it is attentive and opening attending to the very power of the real and its absolute exteriority: looking will not tap this power but will allow it to communicate itself or will communicate with itself. In the end, looking just amounts to thinking the real, to test oneself with regard to a meaning one is not mastering.
>
> (Nancy 2001: 38)

The respect elicited by Kiarostami's cinema in turn respects the spectator. This is why *Life and Nothing More …* dissatisfies those who seek to cry and mourn before his film. Kiarostami's look does not probe the interior psychologies of his characters, nor does he seek to capture on film the exculpation of past trauma through the externalization of inner anguish.

Giving up the desire to "master" his vulnerable subjects, while respecting their right to withhold, Kiarostami's look gives evidence only to the "absolute exteriority" of what appears to the camera, lending evidence to a key capacity, perhaps the most crucial, of the cinema itself. As Nancy scholar Philip Armstrong puts it, quoting his essay on Kiarostami, "In short, cinema is not about making evidence *visible* but 'to make visible that *there is* [*qu'il y a*] this evidence', and it is precisely in this giving and gift of evidence that the possibility of *justice* for Nancy emerges" (Armstrong 2010: 23). In short, *Life and Nothing More …*, like the antennas searching the sky to receive images of the World Cup, looks outwards, respectfully presenting the worldly exteriors presented to the camera.

In a key turning point in the *Life and Nothing More …*, the film-maker and his son pick up Mr. Ruhi coincidently, the old man who played the door maker in *Where is the Friend's Home?*. He explains that he lost everything in the earthquake, but fortunately all of his family survived. The only possession Mr. Ruhi has left, apparently, is a porcelain urinal that he places on top of the car. He positions it like the old woman's gas cylinder from a previous scene, and remarks that the urinal is indispensable, though it may seem that other needs, like food or water, should take precedence. As they drive together to Koker, he says that, "The ones that died are already gone. And the ones that remain, some of them, we need this valuable piece of porcelain." Mr. Ruhi becomes philosophical, and likens the earthquake to a hungry wolf, "devouring those who he passes by, while letting those live who he has not passed. No, this is not the work of God." Throughout the scene, the camera remains at a respectful distance – almost always in long shot – never taking the view from within the car and never revealing Mr. Ruhi's face.

The son asks him why he was depicted as older and walked with a limp in the 1987 film. He responds,

> Yes, I can see why that puzzles you. The limp, they put it on me in the movie. They told me I had to look older and I did what they told me. I do not know what kind of art it is that people have to seem older and uglier. Art means happy and beautiful things that touch you. Art is to rejuvenate the people, not make them decrepit. Well, to continue being alive is also an art. I suppose it's the most sublime art of all, don't you think?

Mr. Ruhi speaks, somewhat softly, in voice-over as the vehicle drives through ruins left by the earthquake. He then continues, "Most people don't appreciate the value of youth, not until they arrive at old age. They don't know how to enjoy it. And they don't appreciate the value of life until death comes to them. If they gave us the opportunity to live our lives all over after we died, surely we would know to take better profit of it."

When they finally reach Mr. Ruhi's village, some buildings still stand while most have been reduced to rubble. The old man's house has been left untouched by the earthquake. The film-maker looks at the area, while Puya wanders off on his own, collecting two figurines from destroyed homes. He meets a woman filling a metal jug with water. Off screen, his father shouts and tells him to stay close. As she washes her clothes, she tells Puya that three of her children survived, and that her eldest daughter, who was at her father's home at the time, was taken by God. Puya repeats Mr. Ruhi's comparison of the hungry wolf and the earthquake, naively telling her that her daughter was "lucky to have died. Thus she is liberated from her school duties." Continuing to wash her clothes, Puya tells her the story of Abraham and Isaac. "I believe if people die and resurrect," he concludes, "they will appreciate life better. And I also believe that all the children that have survived will appreciate life more." Off screen, her father calls him once more.

In a poem published in 2001, Kiarostami ponders the great mystery posed by life's finitude: "The more I think / the less I understand / the reason / to fear death so much" (Kiarostami 2001: 158). The 1990 earthquake seems to compel the film-maker to take up this profound consideration for the survivors. Death is the futural possibility that grants to life its own continual passing, as well as its transient preciousness. Kiarostami's representation of life always keeps something in reserve, as if to hold back, for it is precisely this possibility of pure absence that cannot be represented through cinema's signifying codes, contingent on the metaphysics of presence and visibility. The earthquake reminds the modern spectator of the limits of his capacity for representing the reality of life. If life in *Life and Nothing More ...* eludes the conventions of the melodrama, it is because of its inability to show life's future anterior. Only distance does justice to this temporality. In other words, the memory and anticipation of death, which inform the past and future of the image, makes possible an elusive temporal excess, bringing forth an art of distance between film and reality, reiterated in the art of worldly living, of being singular plural. Echoing a point made by Levinas in *Time and the Other*, the relationship to the futurity of death models the relationship to the alterity of the other. In this, being-towards-death is already a hospitality to the other, a comportment that anticipates the arrival of guest, like Mr. Ruhi and his porcelain urinal.

> "What is aura, actually? A strange weave of space and time: the unique appearance of semblance of distance, no matter how close it may be."
> Walter Benjamin (Jennings et al. 2005: 518)

III.

Off-screen voices throughout *Life and Nothing More ...*, like the film-maker's when he calls out to Puya or Mr. Ruhi's over the long shot of the moving car, remind the viewer of the frame of the image by indicating the presence of speaking individuals beyond its

The Just Distance

borders. Like the limits to life imposed by the destructive power of the earthquake, the voice-over limits the presumptions of the sovereign gaze by pointing to a reality not perceived by the camera. This unseen reality is withheld from the viewer. In an interview with Mehrnaz Saeed-Vafa and Jonathan Rosenbaum conducted in May 2000, Kiarostami remarks that

> Basically anything seen through a camera limits the view of a spectator to what's visible through the lens, which is always much less than we can see with our own eyes. No matter how wide we make the screen, it still doesn't compare to what our eyes can see of life. And the only way out of this is sound. If you show the viewer it's like peeking through a keyhole, that it's just a limited view of a scene, then the viewer can imagine it, imagine what's beyond the reach of his eyes.
>
> (Saeed-Vafa and Rosenbaum 2003: 114)

The spectator does not see the origin of the voice (Mr. Ruhi's speaking mouth) or only locates it later (the father's mouth telling his son to stay close). Their unlocatability does not attest to the omniscient authority of the voice-over, but rather serves as a reminder that the cinema provides the human filmgoer with only an incomplete perception of the diegetic world.

The view offered up by Kiarostami's camera does not serve the narcissistic demands of the idealized, transcendental spectator. The voice widens the scope of the perceived world, including unseen others into the film. Although he has discussed the aesthetics of the image frame on numerous occasions, in a 2003 interview Kiarostami describes this incomplete reality in a manner most relevant to the present discussion:

> In films, there are forever actualities and occurrences outside of the frame, which are directly related to, if not an integral part of the film, and when we limit our frame we inevitably lose many of them. It is these omitted actualities and occurrences that scream out to me, like a guilty conscience, saying: 'We exist! Give us the recognition we deserve by virtue of our being, and realize us.' And in my opinion, it is this very recognition that transforms cinema's architecture into a real architecture, and distances the cinema from that which portrays only bits and pieces of pictorial information.
>
> (Moussavi 2004: 94)

Kiarostami takes it upon himself, "like a guilty conscience," to represent the absence of the reality that falls outside the frame, and to record the voices that sound outside the reality presented in the image. Sensitivity to the periphery of the world that continues beyond the frame of the image seems to be heightened by the total, unbiased destruction wrought by the earthquake. Nancy writes that "the earthquake is present here as a limit of images, as the absolute real" (Nancy 2001: 70), suggesting that the earthquake itself delineates the frame of

Kiarostami's film, enabling and delimiting the view offered by his cinema. The withholding of bits and pieces of reality throughout *Life and Nothing More …* is experienced, not only as lack, and even less as spectatorial frustration with what cannot be known. One is rather reminded, once more, of one's own finite humanity. And in this, the spatial limits imposed by the image frame correspond to the temporal limits of lived life.

This is what makes the final shot of *Life and Nothing More …* particularly significant. For it expands the field of vision as far as possible, zooming back to an extreme long shot to include everything. In doing so however, the vast distance between camera and pro-filmic reality breaks apart the ontological differences that are conventionally maintained between human figure, automobile, and landscape. In the final scene the film-maker protagonist drives his car up the side of a steep hill on a zigzagging road. On his way up a man carrying a gas tank tells him to accelerate at the bend. The car then builds speed but before it reaches the second turn, it stalls and falls back down. The man carrying the tank offers to give the car a push. The car then backs up in order to gain momentum and finally makes it to the top. There the man climbs into the passenger seat. Reiterating earlier moments from the film when an old woman placed her gas cylinder on the car roof, as well as Mr. Ruhi and his porcelain urinal, he places his gas tank on the roof and the car continues to climb. As the closing credits appear, Vivaldi plays over the soundtrack, and the spectator is left with the demonstration of reciprocity as the final gesture of *Life and Nothing More …*. Between the car and the mountain, the film-maker and the man carrying his gas tank, and between the film and spectator, distances enable exchanges between entities that point to the continuation of life following the earthquake. At the same time, the extreme long shot of the camera and the vast span of distance between it and the mountain allows the yellow car to merge into its yellow and green surroundings, underscoring their shared cinematic phenomenology. The man and his gas cylinder become mere specks, almost disappearing into the natural *mise-en-scène*.

Like *Life and Nothing More …*, an extended long shot culminates *Through the Olive Trees*. And again, the vast distance between camera and landscape elicits a just distance. Produced two years later, *Through the Olive Trees* revolves around the actors who played the young couple married one day after the earthquake. The young man, we remember, lost sixty-five familiar members and casually spoke of his own future death in the earlier film. In *Through the Olive Trees*, this past encounter is treated as fictional, like Mr. Ruhi's disclosure of his fictional limp in *Where is the Friend's Home?*, and woven into the reality of the present. As life continues following the destruction wrought by natural disaster, so it is with the life of film, marking distances of time from one to the next. Once more, Kiarostami creates a temporal distance by self-reflexively bracketing the drama of the past. As yet, far from remaining unfeeling, it is precisely the distance that enables the ethical relation between subject and world. From one to the next, *Through the Olive Trees* carries the lesson of the just distance learned from the earthquake while developing it further. Once again, it is the cinema the reveals the just distance in the ethics of everyday life.

Through the Olive Trees begins in the self-reflexive spirit that signals the difference between film and reality. A bearded director wearing a light jacket addresses the camera and

explains that he is "Mohammed A. Keshavarz, the actor who plays the director." Dozens of women are lined up behind him, standing before a rebuilt school. The director explains that he is there to choose a young actress for his next production. He turns around and walks among the women, asking their names. One of them asks in return if they will see the film he is making. Another retorts that his previous productions had not been broadcast on television. Despite knowing that they will probably not see themselves on the screen, the women implore him to continue filming. The director asks his female assistant to note their names, and as they crowd around her, the film credits appear.

This opening sequence foregrounds the constructedness of the film drama, distancing the spectator from its illusory reality. In an interview Kiarostami clarifies that the self-reflexive foregrounding of film in *Life and Nothing More …* should not be taken straightforwardly as a kind of Brechtian distanciation device that foregrounds the illusion of the cinema. These moments of *mise en abyme* do not derive "from the theory of Brecht only," Kiarostami explains, "I came to that that through experience. We are never able to reconstruct truth as it is in the reality of our daily lives, and we are always witnessing things from far away while we are trying to depict them as close as we can to reality. So if we distance the audience from the film and even film from itself, it helps to understand the subject matter better" (Hamid 1997: 24). This is the distance that Kiarostami took when he reconstructed his visit to Koker and Poshteh, and whose reconstruction is the subject of *Through the Olive Trees*. Later in the film we see how Hossein struggles with his lines in his scene from *Life and Nothing More …*. A reverse shot of the director and his crew reveals their mounting frustration.

These reconstructions do not function to debunk the illusion of the cinema, to simply reveal the truth of the cast, crew, and camera behind the fiction. For Kiarostami, these moments of self-reflexivity serve only as pretexts to new fictions, new lines of flight towards as yet untold stories, multiplying the stories by continuing as the cinema continues. As Nancy puts it:

> Film on film or film in film is not something he is interested in; his work does not revolve around any *mise en abyme*. In it, the theme of lies leads only to the truth, and appearances intervene only to underscore the manner in which looking and the real together are mobilized. This comes out in the whole fable of *Close-up*, and also the one in *Through the Olive Trees*, unveiling a number of artifices and lies needed to make *Life and Nothing More*, but in such a way that this unconcealment introduces a new story, neither more nor less effective than the first one, just showing another angle of what is real and therefore many-faceted.
>
> (Nancy 2001: 26)

In contrast to Brecht's formulation of *Verfremdung*, of alienation or distanciation, which aims to lecture its audience about the ideology of the escapist drama, "culinary through and through" (Brecht 1992: 37), Kiarostami utilizes this self-reflexive moment at the start of

Through the Olive Trees merely as a pretext. For the scene functions at once to unconceal the metaphysics of the fiction narrated in *Life and Nothing More …*, not to expose a conclusive truth, but also to multiply the narratives, from one film to another. These distanciation effects should be understood in light of the justice that remains so important for Nancy. The just distance, one that respects the other, is not a technique, or an aesthetic device whose effects are to be predetermined before filming takes place.

While the film revolves narratively around the relationship between Hossein and Tahereh, it nevertheless is concerned with once again finding and maintaining the just ontological distance between individuals, and between humans and the phenomenal world. The final shot of *Through the Olive Trees* is an extreme long shot, and an extended long take á la Bazin, of the couple as she is pursued through trees and then a green field. Already reduced to two white dots, Hossein reaches Tahereh and says something to which the spectator is not privy. The oboe concerto by Domenico Cimarosa softly intones on the soundtrack while birds continue to chirp. Their interaction remains secretive, and like the shots and off-screen voice of Mr. Ruhi in *Life and Nothing More …*, the camera establishes a distance that embeds their bodies within the landscape, while the shot's duration allows the spectator to live with this concluding scene until the very end, and in a way to be-with Hossein and Tahereh.

The representation of this relationship throughout the film is inextricably bound to the interdictions placed on the representation of heterosexual relations in post-Revolutionary Iranian cinema. In his essay, "Veiled Vision/Powerful Presences: Women in Post-Revolutionary Iranian Cinema," Hamid Naficy theorizes what he calls the "averted gaze," prevalent in the representation of women in post-revolutionary Iranian film. In contrast to the direct, objectifying gaze, linked to the fetishization of women and reproduced by dominant cinema, the averted gaze downplays scopophilic desire, in conformity with Islamic moral and aesthetic proscriptions implemented in June 1982 by the Ministry of Culture and Islamic Guidance.[6] According to Naficy, "With few recent exceptions, men and women on the screen do not look at each other with desire; in fact, the look, which in the pre-revolutionary era was often direct and highly cathexted with sexuality, has been desexualized" (Naficy 1994: 144). The averted gaze implicitly frustrates viewers' desires to see women as sex objects, or exotic non-western others, or even perhaps, to intrusively gaze upon private expressions of mourning following the earthquake. As Naficy observes, "The unfocused look, the averted look, the fleeting glance, the desexualized look, and the long-shot – all instances of inscription of modesty in cinema – problematize the western cinematic theories which rely on audience implication through suturing because they impede audience identification with characters on the screen" (Naficy 1994: 145). Throughout *Through the Olive Trees*, Tahereh constantly looks away from the direct gazes of both Hossein and Kiarostami's camera. That is, except for one stunning moment, after the first rehearsal and sitting in the passenger seat of a car, when she briefly and reluctantly meets Hossein's gaze, as if to acknowledge her power over the viewer's intrusive look. Otherwise her eyes remain affixed to the pages of a book or are directed anywhere other than the male gazes looking at her.

While the search for a just distance seems to inform the exchange of looks between men and women in Kiarostami's films, it is in the final scene of *Through the Olive Trees* where the averted gaze seems most relevant to the gentle intrusion, and the just distance, of the final long shot. Far from being debilitated by Iran's interdictions on the cinematic representation of women, Kiarostami realizes a freeing relationship precisely because of these interdictions, a more ethical gaze that respects Tahereh's decision, whatever it may be. In this, the camera also respects the fragility of her being, taking from her image and giving to the spectator the bare minimum of narrative information for the scene. Far from solely objectifying Tahereh, turning her into a potential exotic female object to be fetishized, Kiarostami's camera celebrates her singular life. According to Hamid Dabashi, Kiarostami "proceeds by altering the reality he rejects morally and aesthetically via a camera that must learn to keep a strategic distance – thus his (in)famous long shots that his critics cannot stand – from what it must represent. The distancing representation is a strategic mechanism Kiarostami has mastered" (Dabashi 1995: 86). Rejecting the morality of a distanced, objectifying look, the film-maker finds a distance that does justice to the world, and specifically the world of heterosexual desire, represented in the cinema.

As in the final shot of *Life and Nothing More…*, this just distance is pronounced as the human figures disappear into their natural surroundings. Tahereh and Hossein become smaller and smaller as they move further away from the camera, their bodies lose the distinguishing features that mark them as human. They become two specks of white within as vast expanse of green, and through this Kiarostami once more creates a kind of unity between realms that are commonly made distinct. As the film ends, the beauty of this final shot may compel the viewer to think once more about the earthquake that devastated this area. Here, as one sees the blooming and continued life of the surrounding greenery, the afterlife of devastation, one is reminded once more of the transience of all earthly life, human and non-human.

References

Armstrong, P. (2010), "From Appearance to Exposure," *Journal of Visual Culture*, 9: 1, pp. 11–27.

Barthes, R. (1982), *Camera Lucida: Reflections on Photography*, trans. Richard Howard, New York: Hill and Wang.

Brecht, B. (1992), "The Modern Theatre is the Epic Theatre: Notes to the Opera *Aufstieg und Fall der Stadt Mahagonny*," in *Brecht On Theater: The Development of an Aesthetic*, trans. John Willet, New York: Hill and Wang.

Dabashi, H. (1995), "Re-Reading Reality: Kiarostami's *Through the Olive Trees* and the Cultural Politics of a Postrevolutionary Aesthetics," *Critique: Critical Middle Eastern Studies*, 4: 7, pp. 63–89.

Deleuze, G. (1986), *Cinema 1: The Movement-Image*, trans. Hugh Tomlinson and Barbara Habberjam, Minneapolis: University of Minnesota Press.

—— (1989), *Cinema 2: the Time-Image*, trans. Hugh Tomlinson and Robert Galeta, Minneapolis: University of Minnesota Press.

Farahmand, A. (2002), "Perspectives on Recent (International Acclaim for) Iranian Cinema," in Richard Tapper (ed.), *The New Iranian Cinema: Politics, Representation and Identity*, London: Tauris.

Hamid, N. (1997), "Near and Far," *Sight & Sound*, 7: 2, pp. 22–24.

Heidegger, M. (1977), "The Age of the World Picture," in *The Question Concern Technology and Other Essays*, trans. William Lovitt, New York: Harper & Row.

Heidegger, M. (1971), "The Thing," in *Poetry, Language, Thought*, trans. Albert Hofstadter, New York: Harper & Row.

Jaggi, M. (2009), "A Life in Cinema: Abbas Kiarostami," *Guardian*, June 12th, 2009.

Kiarostami, A. (1995), "Real Life is More Important than Cinema," *Cineaste*, 21: 3, pp. 31–34.

——— (2001), *Walking with the Wind: Poems by Abbas Kiarostami*, trans. by Ahmed Karimi-Hakkak and Michael Beard Cambridge: Harvard University Press.

Levinas, E. (1987), *Time and the Other*, trans Richard A. Cohen, Pittsburgh: Duquesne University Press.

Mottahedeh, N. (2008), *Displaced Allegories: Post-Revolutionary Iranian Cinema*, Durham: Duke University Press.

Moussavi, G. (2004), "Wow! There Is a Whale in My Net," *Metro: Media & Education Magazine*, 139, pp. 92–96.

Mulvey, L. (2002), "Afterward," in Richard Tapper (ed.), *The New Iranian Cinema: Politics, Representation and Identity*, London: Tauris.

Naficy, H. (2002), "Islamizing Film Culture in Iran: A Post-Khatami Update," in Richard Tapper (ed.), *The New Iranian Cinema: Politics, Representation and Identity*, London: Tauris.

——— (1994), "Veiled Vision/Powerful Presences: Women in Post-Revolutionary Iranian Cinema," in Mahnaz Afkhami and Erika Friedl (eds.), *In the Eye of the Storm: Women in Post-Revolutionary Iran*, Syracuse: Syracuse University Press.

Nancy, J-L (2001), *The Evidence of Film*, trans. Verena Andermatt Conley, Bruxelles: Yves Gevaert.

Nayeri, F. (1993), "Iranian Cinema: What Happened in Between," *Sight & Sound*, 3: 12, pp. 26–27.

Simmons, M. (1990), "Iranian Tolls Climbs to 36,000," *Guardian*, June 23rd, 1990.

Stiegler, B. (2011), *Technics and Time, 3: Cinematic Time and the Question of Malaise*, trans. Stephen Barker, Stanford: Stanford University Press.

Tempest, R. (1990), "Aftershocks Rock Iran; Toll Mounts: Disaster: Main Quake Killed 40,000, Some Officials Say. Town of Roudbar, Center of Devastation, Is Flattened and Nearly Lifeless," *Los Angeles Times*, June 24th, 1990.

Notes

1. The French title of the film is *Et la vie continue*.
2. Kiarostami describes this experience in the original press book, published by the Farabi Cinema Foundation in conjunction with the release of *Life and Nothing More* ….

3　This notion of the distanced observer stands in contrast to Noël Burch's approach to Japanese film in his 1979 book, *To the Distant Observer*. I align myself more closely with Burch in his approach toward Japanese film as textual.
4　Kiarostami's comments on Iranian customs relating to mourning and marriage in the interview later in the book throw further light on Hossein's decision. See p. 279 [Ed.]
5　I am thinking here, of course, of Heidegger's 1938 essay, "The Age of the World Picture."
6　For a concise summary of how film culture was "Islamized" after 1979, see Hamid Naficy's essay, "Islamizing Film Culture in Iran: A Post-Khatami Update."

Chapter 7

Towards a Natural History of the Cinema: Walter Benjamin, Film and Catastrophe

Allen Meek

> Every year several million people are killed quite pointlessly by epidemics and other natural catastrophes ... The victims of the Yellow River floods in China amount sometimes to hundreds of thousands. Nature is generous in her senseless experiments on mankind. Why should mankind not have the right to experiment on itself?
>
> <div align="right">Arthur Koestler, *Darkness at Noon*, p. 157</div>

Technological advances since the industrial revolution have allowed the state and corporate capitalism to assume the force of a natural catastrophe in their impact on human populations. It is in this context that mediated catastrophe, as a defining feature of modern visual culture and of contemporary political identity, must be understood. What it means to belong to, or to identify with, a particular group has been redefined by iconic events such as the Holocaust. Catastrophe forms an intrinsic part of modern theories of aesthetics and politics and their application to film and mass media. Scholars such as Susan Neiman and Gene Ray have discussed the genealogy of intellectual responses to catastrophe that begins with the Lisbon earthquake of 1755, culminates in Auschwitz and Hiroshima, and is reawakened after the September 11 attacks. In each case it is not only the nature of the event but the challenges it posed for contemporary worldviews that is at stake. In our era, when catastrophe is indelibly linked to film and media images, we need new strategies to make sense of world shattering events. This chapter adopts Walter Benjamin's theory of natural history for this purpose.

The Lisbon earthquake sent shock waves through European culture and influenced subsequent philosophical debates that shaped the deepening separation of the arts and sciences as explanatory frames for human history. These directions in modern intellectual culture underlie today's widespread use of trauma as a model for cultural memory. Trauma, originally a medical term denoting a physical wound, is now applied to the psychological survival and cultural memory of entire nations and ethnic groups. The extension of trauma to the level of history can be seen as a symptom of an increasingly biological conception of political identity. Media images of catastrophe serve as relays for marking and policing the boundaries of the body politic.

Walter Benjamin, who first formulated a modern aesthetics of shock, catastrophe and ruins, is a pivotal figure in this trajectory. Throughout his analysis of Baroque tragic drama and his massive study of the Paris arcades, Benjamin repeatedly conjoined the forces of nature with those of human history. He refused the Enlightenment separation of science and aesthetics and insisted on the interpenetration of natural life and the texts, artefacts

and constructions that compose our human environment. Catastrophe is not only a natural occurrence but is endemic to social and political change. Benjamin's final meditations in "On the Concept of History," which invoked history as an endless series of catastrophes, directly influenced Theodor Adorno's famous post-war pronouncements on the fate of culture after Auschwitz. Over the past few decades the cultural prominence of the Holocaust has seen Adorno's "traumatic" conception of history taken in new directions with reference to subsequent events such as the Vietnam War and 9/11.

Cinematic reconstructions and news media coverage of war, genocide and natural disaster all lend weight to the increasingly prevalent conception of collective memory as cultural trauma. But Benjamin's vision of history and film remains distinct from these dominant discourses. In Benjamin's conception of natural history, culture registers the material effects of historical change in a similar way to a landscape altered by an earthquake, storm or flood. But for Benjamin this is never a scene only of devastation but also of radical openness and potential transformation. Only through destruction is the way opened for the liberation of human experience.

In his short text "The Destructive Character" (published only a month after his radio talk on the Lisbon earthquake) Benjamin wrote of a Nietszchean will to open up new spaces and pathways: "destruction rejuvenates, because it clears away the traces of our own age" (Benjamin Vol. 2: 541). When today we speak of "disaster capitalism" and the ruthless exploitation of the vulnerable after a catastrophe, Benjamin's utopian vision may seem only to mock the plight of millions. But it is perhaps only by grasping the political opportunities made possible by these "states of emergency" that the darkest implications of cultural and biological survival can be illuminated and challenged.

After a "natural disaster," such as an earthquake or tsunami, the human environment appears violently displaced from history as a purposeful moving forward in time. Life returns to a pre-historical condition in which society is directly subject to geological forces whose origins predate the human species. The survivors are literally thrown out of historical time for as long as it takes for institutions, services and public discourses to revive and reconstruct social identity. Natural forces are supra-national, traversing the global environment and impacting communities geographically distant from each other. The narratives formulated by public figures and media professionals that respond to these catastrophes tend to place them within a frame that is national and always ideological.

Instead of reaffirming charity and resilience, we must examine images of catastrophe for the ways that they rearticulate social relations. Reduced to a state of nature, survivors are left open to interventions by health specialists, aid workers, insurance companies, and various agents of urban planning, development, demolition and construction. The task facing cultural criticism is to grasp how the natural overcoming of political borders and territories can expose the structures that include and exclude human populations on the basis of citizenship and that define the limits of political agency.

The Lisbon earthquake of 1755 is often seen as shattering the Enlightenment faith in history as progress. Benjamin sees similar shock waves destroying the "aura" of the art work

and the "dwelling" of the city, but now the disruptive forces are technical reproduction and industrial urban construction. This perception of catastrophe as implicit in human progress allows us to see Benjamin's criticism as an early attempt to grasp the biopolitical nature of modern power later theorized by Michel Foucault and Giorgio Agamben. The use of biological conceptions of race, health and evolution as part of the monitoring, surveillance and management of human populations has also made possible new forms of genocide. The Nazi "final solution" used industrial age technology for the total domination and annihilation of human life. But Benjamin already saw that the urban environment and mass media were shaping modern life with the intensity of a force of nature. For Benjamin it is film that is the medium most adequate to grasping this new historical relation between technology, politics and experience. Before returning more specifically to Benjamin's theory of film, this chapter will consider the origins of his ideas in the philosophy of catastrophe.

Philosophical shock

Benjamin's conception of natural history forms part of his critique of European Enlightenment philosophy. His geological metaphors for cultural change rearticulate earlier philosophical attempts to reconcile natural disaster and human reason. The disruptive impact of the 1755 Lisbon earthquake was felt throughout eighteenth century Europe. Those who registered the shock in their writings included Voltaire, Rousseau, Goethe, Kleist and Kant (Regier 2010: 357–359). As Susan Nieman explains, before the Lisbon earthquake natural catastrophes were interpreted as manifestations of divine providence and moral retribution. The inability to explain the physical causes of the events enhanced the sense of mystery and awe that surrounded them. After the destruction and death it was time to repent for one's sins. With the advance of the natural sciences the physical universe became more intelligible. But with this new understanding also came the Enlightenment conception of progress, including economic rationalization: "Rising expectations that the social and natural worlds would be equally transparent thus made Lisbon the shock it wouldn't have been without them" (Nieman 2002: 247). Fifty years before Lisbon a massive earthquake destroyed Port Royal, Jamaica but "No conceptual damage occurred"(241). The colonies remained a deviant space excluded from the progressive rationalization that defined the centre.

Responses to the Lisbon earthquake tended either towards a new pessimism about human suffering or towards an upholding of the explanatory power of science over theology (Regier 2010: 358). Responses to natural disaster were no longer dominated by religious interpretation but became "the object of attempts at prediction and control" (Nieman 2002: 250). The need to incorporate the shock of the events into an aesthetic of the sublime also demanded spatial and psychological distance, thereby insuring the reestablishment of the rational subject capable of analysing his feelings. In this way both science and aesthetics allowed the catastrophe to no longer be seen as an expression of divine wrath but to be submitted to the power of human rationality (Regier 2010: 366–368).

Gene Ray argues that the Lisbon earthquake, about which Immanuel Kant wrote a scientific treatise, resonates in the formulation of the sublime in his later *Critique of Judgment* (1790). As Ray puts it, "[T]he sublime moves the mind like the tremors or deep shudders of an earthquake" (29). The response to this shock, however, is the reassertion of reason and the reconstitution of the individual subject as free moral agent. Kant seeks to overcome the shock of Lisbon disaster with a philosophical optimism about historical progress: "human reason and dignity could still claim to be superior to nature" (Ray 2005: 31). Ray proposes that the twentieth century saw the transferal of the aesthetic category of the sublime from natural disasters – such as the Lisbon earthquake – to man-made catastrophes such as Auschwitz and Hiroshima. Previously "encounters with the power or size of nature defeated the imagination and moved it to terror and awe"(19) but today the modern application of industrial technologies to the ends of mass destruction and genocide has overtaken the natural sublime. As Nieman comments, "Before contemporary warfare nothing but an earthquake could kill fifteen thousand people in ten minutes"(Nieman 2002: 255). Instead of historical progress, reason has produced a reduction of human freedom and consciousness and a devaluation of life itself: "If Lisbon marked the moment of recognition that traditional theodicy was hopeless, Auschwitz signaled the recognition that every replacement fared no better" (Nieman 2002: 281).

In his meditations on culture "after Auschwitz" in *Negative Dialectics* (1960), Adorno proposes that philosophy receives a shock when the murder of millions of people cannot be assimilated into its conceptual categories (Adorno 1973: 364). Just as Voltaire in *Candide* had mocked the philosophical rationalization of human suffering by showing how the Lisbon earthquake merely offered new opportunities to exploit and torment its victims, so Adorno argued that to attempt to "make sense" of Auschwitz would be comparable to reproducing the music used in the Nazi camps to drown out the screams of the victims. Instead it is necessary to employ forms of "negative presentation"(Ray 2005: 22) that testify to the impossibility of directly representing, dramatizing, narrating or exploiting the horrific events. Adorno reformulates the Kantian sublime as a traumatic undermining of the individual ego comparable to a "tremor or shudder"(Ray 2002: 32) or shock wave. Unlike Kant, Adorno does not claim that human suffering can be redeemed or resolved through rational explanation or the contemplation of sublime spectacle.

Ray's account, which moves from Kant's Enlightenment response to natural catastrophe to Adorno's critical theory of the technological destruction of humanity, does not discuss the distinctive articulation of these problems by Benjamin. Benjamin's essay "On the Concept of History," was a direct and profound influence on Adorno's reflections on culture after Auschwitz. In contrast to Adorno's "traumatic" conception of history after Auschwitz, however, Benjamin sees the "moment of danger" as both a threat of destruction and an opening for the new. In several texts from the 1920s and 1930s Benjamin uses the disruptive impact of natural catastrophe as a metaphor for the possibilities of technological invention and political revolution. Film serves as the privileged example of a new medium that embodies the potential for cultural transformation. Film explodes the perception of social

space that is confined by social class, occupation and domesticity, allowing us to discover open spaces among the ruins.

Benjamin develops the theme of catastrophe in ways that complicate the opposition between the natural and man-made. His images of history resonate, just as had Kant's *Critique of Judgment*, with his interest in the Lisbon Earthquake. Just as an earthquake reveals geological strata as fundamentally unstable, so culture is continually transforming, particularly due to technical revolutions. But in order for these technical capabilities to achieve their full potential they must coincide with radical social and political change.

In a political revolution, as after a natural disaster, social relations and human environments are destabilized and subject to reorganization, often extending instability and change over long periods of time. But for this reason such situations are also opportunities to break with confining cultural hierarchies and oppressive social orders. Benjamin's account of catastrophe and revolution may ring hollow after the extreme human destruction wrought by totalitarian states and confronted by the humanitarian and ecological disasters of today's world. But we also need to be sceptical about the labelling of contemporary catastrophes as "traumatic" by public figures, aid workers and media professionals. The mediated consumption of catastrophe is embedded in broader relations of power, assigning the roles of victim, perpetrator, witness and bystander that are in turn defined by political boundaries and symbolic hierarchies. Benjamin's writings suggest ways to grasp the interpenetration of nature and culture that refuse the hierarchies of suffering that are built on the division between the human and non-human.

Natural history

The conception of "natural history" developed by Benjamin and Adorno in the pre-World War II period may prove to be more useful to understanding the politics of catastrophe than Adorno's more widely discussed comments on the trauma of Auschwitz. Benjamin developed a critique of the nature/history opposition in his *Origins of German Tragic Drama*, particularly through his insights into the image of the ruin. According to both classical aesthetics and Enlightenment philosophy, human culture develops according to the logic of historical progress in which the natural world is transcended and sublimated. In his excavation of the Baroque aesthetics of German *Trauerspiel*, Benjamin discussed a counter-aesthetic in which history was represented in the form of material decay and ruination, which departed from the classical ideals of harmonious beauty and eternal value embodied in the art work. Eric Santner explains:

> [T]he Benjaminian view that at some level we truly encounter the radical otherness of the "natural" world only where it appears in the guise of historical remnant. The opacity and recalcitrance that we associate with the materiality of nature – the mute "thingness" of nature – is, paradoxically, most palpable when we encounter it as a piece of human

history that has become an enigmatic ruin beyond our capacity to endow it with meaning, to integrate it into our symbolic universe.

(Santner 2006: xv)

Under Benjamin's influence Adorno developed a philosophical critique (culminating in *Negative Dialectics*), in which the conception of both nature outside the progressive movement of history, and of history as embodying the natural order of life, are rejected. Susan Buck-Morss has explained how Adorno formulated the non-identity or "double character" of nature and history as concepts (Buck-Morss 1977: 54–57). When the natural world is posited as simply the ground of, or background to, the trajectory of human history then nature comes to be imagined as a mythic force. The actualities of human experience, including suffering, are relegated to a silent presence behind the procession of "historically significant" persons and events. At the same time, history, by establishing itself as the factual record of what has happened, comes to be accepted as "natural." The mythic force of nature is then attributed to the march of human progress. These are forms of reified thought that ultimately serve established forms of power. The perception of the existing social and political order as natural is a foundation of ideology. Instead criticism must attempt to understand history in its materiality and thereby see it, like nature, as undergoing a ceaseless process of change.

The image of the earthquake understood in terms of natural history allows us to see it as a force that disrupts the existing social order and reveals the myth of historical progress. The ruins that it leaves in its wake allow us to see the materiality of the social order for what it is: impermanent, transitory, and therefore potentially open to the making of a new and different world. This new order, however, is not always liberating but more often grasped as an opportunity for the powerful to make new advances. As this power re-establishes itself it re-inscribes the caesura between history and nature, justifying its victories as a triumph over natural adversity while re-establishing itself in terms of the "natural" order of things. Catastrophe provides an opportunity to once again pass across "the threshold where life becomes a matter of politics and politics comes to inform the very matter and materiality of life" (Santner 2006: 12).

After the Lisbon earthquake European Enlightenment thinkers developed a fundamental distinction between natural and man-made disasters. The legacy of this distinction, Suvendrini Perera has proposed, leads to a consigning of the suffering of certain human populations outside the realm of the political. Yet natural disasters need to be understood in terms of "both their discursively constructed status and their geopolitical imbrications and effects" (Perera 2011: 36) – including evaluating which deaths "count" and which do not. The notion of deaths that are "unavoidable-though-regrettable"(36) decrees the cost for colonized peoples as they are forcibly assimilated into a progressive narrative of European global dominance.

After Lisbon, Nieman comments that "earthquakes are only a matter of plate tectonics. They threaten, at most, your faith in government building codes or geologists' predictions"

(Nieman 2002: 246). But, as Perera shows, modern biopolitics has incorporated natural disaster into the domain of political management and the further destruction of human lives, environments, and social infrastructures. Naomi Klein has called the contemporary forms of this dominance "disaster capitalism." The other's catastrophe presents an economic and political opportunity for those who know how to take advantage – all of this was already made clear in Voltaire's account in *Candide* of the aftermath of the Lisbon Earthquake. The discourses of humanitarian aid and Western corporate media construct this global scenario of bystander or benefactor and helpless victim. Benjamin's vision of historical change may help us to explore alternative possibilities.

Catastrophe and revolution

In October 1931 Benjamin gave a talk, broadcast on German radio, on the Lisbon earthquake. He began with a brief scientific account of the causes of earthquakes, describing the earth's crust as "in a state of permanent turmoil; the masses of matter it contains are constantly shifting and striving to achieve equilibrium" (Benjamin Vol. 2: 538). After briefly mentioning Kant's fascination with this catastrophe, Benjamin goes on to quote at length from an eye-witness account. According to this description, after the withdrawal of a twenty meter high wave that submerges the city, the Tagus river was completely drained of water, while the ships in the harbour could be seen "tossed about as if they were playthings of a mighty storm"(540). These images of massive waves, wreckages and swirling waters reappear in several other texts of Benjamin's.

The eye-witness account of the earthquake forms part of Benjamin's ongoing formulation of history as catastrophe, culminating in the final text he completes before his death in 1940: "On the Concept of History." Almost a decade earlier, in diary entries from 1931, he records a conversation in which he replaces the concept of history as a riverbed, in which one can discern the traces of stages of development, with the image of a whirlpool in which "the prehistory and posthistory of an event […] swirl around it" (Benjamin Vol. 2: 502). Such an approach to history would be "determined by its firm rejection of the possibility of an evolutionary or universalist dimension in history"(502). In the famous image from "On the Concept of History," the angel sees history as "one single catastrophe, which keeps piling wreckage upon wreckage and hurls it at its feet" (Benjamin Vol. 4: 392). The catastrophe shatters the perception of the progressive moment of time and of history as the accumulated sediment left behind by that movement. Instead everything is in flux: past, present and future are constantly reconfiguring in a vortex, so that even the stability of the ground under one's feet is suddenly experienced as "a state of permanent turmoil"(Benjamin Vol. 2: 538).

This turmoil caused by natural forces has its equivalent in historical situations that for Benjamin, as for many of his generation, were most dramatically acted out in the Russian Revolution. Instead of nature it is now technological and political change that disrupts social and cultural life. In 1927 Benjamin visited Moscow and produced a series of short essays on

the state of post-revolutionary culture. One of the themes that emerges in these essays is the disappearance of private space. Technological media are central to this transformation: all books are censored, reviewed and debated on political grounds. Aesthetics is dominated by concerns about content and formal experimentation is looked on with suspicion. Mass literacy is the top priority. The film industry is even more strictly controlled than publishing. In Russia film actors are disappearing, replaced by "the people," and the goal is the education of the rural peasantry.

In response to a critical review of Eisenstein's *Battleship Potemkin* in a Berlin literary journal, Benjamin argues for the necessity of understanding film in political terms. Art is embedded in historical consciousness:

> But just as deeper rock strata emerge only where the rock is fissured, the deep formation of "political tendency" likewise reveals itself only in the fissures of art history (and works of art). The technical revolutions are the fracture points of artistic development; it is there that the different political tendencies may be said to come to the surface.
>
> (Benjamin Vol. 2: 17)

This comment predates by several years Benjamin's formulation of history as a whirlpool, his talk on the Lisbon earthquake, and the fragment on "The Destructive Character." Could it be that it was film, or more specifically Eisenstein's montage, that initially provoked Benjamin's "seismic" theory of history? *Battleship Potemkin*, of course, is a film about the Russian Revolution. Benjamin's natural history of the cinema has its origins in his visit to post-revolutionary Moscow and his perception of the radical openness made possible by the destruction of the old political order. Film, proposes Benjamin, is a dramatic example of a fracture point in art history. He goes on:

> Film is the prism in which the spaces of the immediate environment – the spaces in which people live, pursue their avocations, and enjoy their leisure – are laid open before their eyes in a comprehensible, meaningful, and passionate way. In themselves these offices, furnished rooms, saloons, big-city streets, stations, and functions are ugly, incomprehensible, and hopelessly sad. Or rather, they were and seemed to be, until the advent of film. The cinema then exploded this entire prison-world with the dynamite of its fractions of a second, so that now we can take extended journeys of adventure between their widely scattered ruins.
>
> (17)

This passage was later reworked in the often cited essay on "The Work of Art in the Age of its Technical Reproducibility." The new spatial mobility made possible by film is a product of its technical possibilities and is not bound to questions of content or form.

As in Kant's aesthetic of the sublime, in Benjamin's account of the cinema the spectator moves from a state of shock and disturbance to one of calm rationality. The difference in Benjamin is that the cinema spectator who "can set off calmly on journeys of

adventure"(Benjamin Vol. 3:117) among the debris could be said to have now developed the "protective shield" (Benjamin Vol. 4: 317) against shock that Benjamin derived from Freud's theory of trauma. The viewer, as we say today, has become "desensitized."

Benjamin, like Kant before him, wants to claim a certain analytic distance on the part of the spectator. This distance, for Benjamin, also allows an opening for new perspectives on the urban environment. As Johannes von Moltke has suggested, Benjamin's aesthetic of ruins returns us to the temporal dimension of this traveling so that, like the urban flâneur, the cinema spectator receives fresh insights into the past through the break-up of dominant spatio-temporal organization: "If the cinema offers new modes of temporality, including the reversibility of time, ruins invite their visitors to travel along related temporal vectors into the past" (Moltke 2010: 398). The radical fragmentation of cinematic space potentially resituates the spectator as an historical agent. In the cinema of the Russian Revolution, the technical features of the new medium find themselves in an historical situation that is adequate to their potential, because film is able to capture the momentum of the proletariat as a political collective. The subject of the film is no longer the bourgeois individual but the mass revolutionary movement.

The world of objects, in Western Europe confined to the interiors of houses and apartments, in Moscow erupt onto the sidewalks. The bewildering, labyrinthine nature of the city as it appears to the foreign visitor, the "whole exciting sequence of topographical deceptions to which he falls prey could be shown only by a film" (Benjamin Vol. 2: 24). Such radical openness is the antithesis of catastrophe: it breaks out of social confinement, it overflows the boundaries of social constraint and class. Benjamin's description of Moscow precisely echoes his account of film:

> Employees in the factories, offices in buildings, pieces of furniture in apartments are rearranged, transferred, and shoved about. New ceremonies for christening and marriage are presented in the clubs, as if the clubs were research institutes. Regulations are changed from day to day, but streetcar stops migrate, too. Shops turn into restaurants and a few weeks later into offices.
>
> (Benjamin Vol. 2: 28–29)

This social flux is also a symptom of the abolition of private life that can now be seen in a more sinister light. Benjamin also comments that bourgeois private life has given way to the life of the army camp (30).

Urbanism

Another radio talk given by Benjamin that also evokes history as catastrophe is his talk on "The Railway Disaster at the Firth of Tay." Benjamin discusses this train wreck, which took place in a violent storm, with reference to the historical development of iron as a building material, anticipating concerns that would become central to Benjamin's massive research

undertaking the *Arcades Project*. The development of iron construction is the foundation of the railway system. As Wolfgang Schivelbusch has explained, the massive social disruption and reorganization that is driven by industrial technology also gives rise to new conceptions of human perception and consciousness. And with the railway accident comes the first formulation of psychological trauma.

The historical emergence of the Paris arcades was premised on the capabilities of iron construction (Benjamin Vol. 3: 32–33). Benjamin notes that Baron von Hausmann, whose reshaping of Paris involved the destruction of sections of the old city to allow the establishment of the large boulevards, gave himself the title of *artiste démolisser* (demolition artist). Benjamin associates Hausmann with the dictatorship of Napoleon III, with imperialism and the suppression of urban revolution: "He wanted to make the erection of barricades in Paris impossible for all time"(42). The "whirlpool" of history is manifest in Benjamin's historical reconstruction of nineteenth century Paris as a constantly shifting mass of constructive and destructive forces. The *Arcades Project* was also conceived as carrying the montage principle from film into cultural history. In the image of the ruin natural catastrophe becomes joined to processes of social and technological change. The earthquake or storm is only part of a collision of historical forces such as the construction of cities and the management of human populations.

In Benjamin's essay "The Work of Art in the Age of its Reproducibility" the camera operator is compared to a surgeon who penetrates the patient's body (Benjamin Vol. 3: 115). This biological body is also a social body that inhabits a physical city. Thus the image of demolition and the ruin again comes into play in Benjamin's description of camera movement: "with the close-up, space expands; with slow motion, movement is extended" (117). The camera is said to explode social space so that "now we can set off calmly on journeys of adventure among its far-flung debris"(117). Technology destroys existing forms of art, perception and social relations. The catastrophic aspect of its interruption is also a moment in which the forces of historical change swirl and reconfigure, revealing relationships that up till now could not be perceived or had remained unconscious. As technology and science penetrate established human cultural practices, they seek to govern and bring under control new domains of human experience. For Benjamin every catastrophe is a moment of danger in which the potential of technology for openness must be seized.

Cultural trauma and biopolitics

In recent cultural and media theory, Benjamin's conception of shock as registering the impact of modern urbanism is often put aside as trauma is assimilated into a contemporary politics of memory. Benjamin's and Adorno's critique of natural history, along with Foucault's and Agamben's theorizations of biopolitics, demand that we understand trauma in terms of larger polarities such as nature/culture, citizen/non-citizen and human/non-human. Modern media, including film, relay catastrophic events to mass audiences within

interpretive frames that participate in these larger biopolitical divisions. "Trauma" often serves as a (misleading) name for this inscription of human experience as "bare life." Victims of war, genocide, terror and disaster may be seen as "disposable" by those who decide their fate, but media transmit images to viewers who subconsciously understand that "their" fate may yet become "ours." "Their" suffering becomes "our" trauma. Media images in themselves do not usually cause psychological traumas because, as Benjamin pointed out, modern viewers have developed a protective shield against shock. But such images play a central role in biopolitical discourses that undermine citizenship as an active engagement with social change. For example, after 9/11 psychological research defined media viewers in terms of their vulnerability. When media audiences are vulnerable to traumatization, specific political agendas can be advanced.

Catastrophes, political crises and economic shocks attract intense media coverage and foster mass anxiety that leads to demands for the restoration of social order and stability. In such situations public figures, intellectuals and media commentators construct "trauma narratives" that seek to make sense of disruptive and disturbing experiences for large groups of people. For this reason such situations also offer important opportunities for political leadership and new political initiatives. What Frank Ferudi (2007) has called "therapy culture" has tended to replace narratives of political engagement or protest with those that emphasize emotional and psychological vulnerability. Moments of catastrophe and crisis allow mass media to construct narratives of national consensus and communities of mourning. Through ritual performances such as commemorative ceremonies and funerals, the media orchestrate a collective and communal emotional response. The notion of victim has been extended to the larger society.

Those who suffer are also pathologized, their experiences turned into trauma narratives that circulate as a form of symbolic capital in various medical, legal, political and mediated contexts (Kleinman and Kleinman 2009: 295). The victim of political violence becomes a patient requiring therapy. Just as mass media images remove violence and suffering from social and political contexts and assume exchange value in the media market, health discourses impose universal standards on human suffering in a diverse range of situations and locations in order to decide who is more deserving of aid.

The conceptualization of cultural trauma is embedded in the intrinsic relations between sovereignty and violence. The imagined communities of the modern nation and world religions are bound to narratives and images of sacrifice: soldiers who give their lives for their country, or martyrs for their beliefs. But the actual victims of violence and terror witnessed through media representations are often those who have, by one means or another, been deprived of the rights or securities of citizenship and reduced to the condition that Agamben has called "bare life." So claims to identify with forms of human suffering are undermined by contradictions in the different political status of viewer and victim.

Suvendrini Perera has discussed these philosophical issues with reference to the Indian Ocean tsunami of 2004. Following Gene Ray's linking of the Lisbon earthquake with Kant's conception of the sublime, she argues that natural catastrophes in the so-called third

world are consumed as sublime spectacle in the West. After the catastrophe comes the traumatic aftereffects to be observed, discussed, analysed, managed in the discourses of aid organizations and international media networks. Perera poses the question:

> how does the biopolitics of trauma, as a set of institutionalized practices for managing and ordering the life and health of populations, play out across the necropolitical terrain of global inequality and in relation to those it locates as bare life?
>
> (Perera 2011: 33)

Perera considers how trauma is "geopoliticized"(37) in the global imaginaries of western dominated aid organizations and media.

The representation of catastrophe and human suffering in contemporary visual media is an everyday affair. Clearly not all of these images and stories can be "traumatic" for the public that witnesses them. Only particular images and stories related to the collective identity of specific groups earn the name of cultural trauma. Benjamin noted that photography and film served as a means to insulate human perception from the shocks of modern urban society. The mass media are "shock absorbers" and so the elevation of trauma to a privileged cultural status suggests that rather than the direct transmission of reality we are instead seeing a symptom of other needs and desires. Trauma is serving as a form of "deep memory" in a period of rapid social change and proliferating media technologies and information networks (Meek 2010: 9).

Benjamin's vision of history as catastrophe and the disruptive potential of film allows us to imagine both "natural" disasters and moments of radical social, cultural and political change as situations where the hierarchies and borders that organize human life and experience can be challenged. Such a vision demands that we also acknowledge that the most sinister forms of political transformation are also likely. But only by confronting this can we avoid the humanitarian and national narratives that see catastrophe as an opportunity to advance biopolitical control. Benjamin's conception of film can help us to see natural history as a politics of life.

References

Adorno, T. (1973), *Negative Dialectics,* trans. E. B. Ashton, New York: Continuum.
Agamben, G. (1998), *Homo Sacer: Sovereign Power and Bare Life*, trans. Daniel Heller-Roazen. Stanford University Press.
Benjamin, W. (2002), *The Arcades Project*, trans. Howard Eiland and Kevin McLaughlin, Cambridge, MA and London: Harvard University Press.
——— (1999), *Selected Writings Volume 2 1927–1934*, trans. Rodney Livingston and Others, Michael W. Jennings, Howard Eiland, and Gary Smith (eds.), Cambridge, MA and London: Harvard University Press.

―― (2002), *Selected Writings Volume 3 1935–1938*, trans. Edmund Jephcott, Howard Eiland, and Others, Howard Eiland and Michael W. Jennings (eds.), Cambridge, MA and London: Harvard University Press.

―― (2003), *Selected Writings Volume 4 1938–1940*, trans. Edmund Jephcott and Others, Howard Eiland and Michael W. Jennings (eds.), Cambridge, MA and London: Harvard University Press.

Buck-Morss, S. (1977), *The Origin of Negative Dialectics: Theodor W. Adorno, Walter Benjamin and the Frankfurt Institute*, New York: Free Press.

Furedi, F. (2004), *Therapy Culture: Cultivating Vulnerability in an Uncertain Age*, London and New York: Routledge.

Kant, I. (1952), *Critique of Judgement*, Trans. James Creed Meredith, Oxford: Clarendon Press.

Koestler, A. (1973), *Darkness at Noon*, Trans. Daphne Hardy, London: Hutchinson.

Klein, N. (2007), *The Shock Doctrine*, Camberwell, Vic: Allen Lane.

Kleinman, A. and Kleinman, J. (2009), "Cultural Appropriations of Suffering," in *Cultures of Fear: A Critical Reader*, Uli Linke and Danille Taana Smith (eds.), London and New York: Pluto Press, pp 288-303

Meek, A. (2010), *Trauma and Media: Theories, Histories, Images*, London and New York: Routledge.

Moltke, J. v. (2010),"Ruin cinema," in Julia Hell and Andreas Schönle (eds.), *Ruins of Modernity*, Durham and Indiana: Duke University Press, pp. 395–417.

Neiman, S. (2002), *Evil in Modern Thought: An Alternative History of Philosophy*, Princeton and Oxford: Princeton University Press.

Perera, S. (2011),"Torturous Dialogues: Geographies of Trauma and Spaces of Exception," in Mick Broderick and Antonio Traverso (eds.), *Interrogating Trauma: Collective Suffering and Global Arts and Media*, London and New York: Routledge, pp. 31–45.

Ray, G. (2005), *Terror and the Sublime in Art and Cultural Theory: From Auschwitz to Hiroshima to September 11*, Basingstoke: Palgrave Macmillan.

Regier, A. (2010), "Foundational Ruins: The Lisbon Earthquake and the Sublime," in Julia Hell and Andreas Schönle (eds.), *Ruins of Modernity*, Durham and Indiana: Duke University Press, pp. 357–374.

Santner, E. (2006), *On Creaturely Life: Rilke/Benjamin/Sebald*, Chicago and London: University of Chicago Press.

Schivelbusch, W. (1986), *The Railway Journey: The Industrialization and Perception of Time and Space in the 19th Century*, Lemington Spa: Berg.

Voltaire (1947), *Candide, or, Optimism*, Trans. John Butt, Harmondsworth: Penguin.

Chapter 8

Seismic Energy and Symbolic Exchange in *When a City Falls*[1]

Kevin Fisher

When a City Falls (2011) began as an attempt by Gerard Smyth, a resident of Christchurch, New Zealand, to make a short documentary about the everyday experiences of his fellow citizens as they grappled with the aftermath of the earthquake on September 4th, 2010. However, unrelenting aftershocks with continued destruction and trauma, followed by the deadly second earthquake of February 22th, 2011, would expand the project into a feature length film. The impromptu nature of the documentary, as an accumulating response to a rapidly transforming series of events for which it could not possibly have planned, is a key ingredient in the spontaneity and immediacy of its realism.

As director, Smyth plays two roles: videographer chronicling his quotidian interactions around the city, and collector/compiler of other footage sourced largely from amateur videographers and CCTV/security cameras. Smyth's own style of videography embodies the neo-realist demand that "there must be no gap between life and what is on the screen" (Zavattini cited in Williams 1980: 28). Indeed, the camera is Smyth's constant companion as the film is spatiotemporally structured around the rhythms of coming and going from his house and returning to familiar sites and people. In their analysis of *When a City Falls*, Austrin and Farnsworth observe that as an extension of the film's social world, "there is no necessary sequence to the shots […] It is an effective capture of the city as a sensorium by a filmmaker moving through a mobile camera recording in the streets, homes, and parks of the city" (2013: 80). It is in this context that the participatory and performative elements of the film also become pronounced. The hand-held camera is rarely a removed observer, but more often a direct interlocutor, what Jean Rouch has described as a "catalyst" (2003), aware of its influence within the situations it documents. For instance, the filmmaker arrives at a building just in time to halt its demolition and phone the owners who have not been notified. It turns out that while "all the paper work is in place" (according to the Earthquake Commission officer) the wrong structure was set to be demolished. Here, as elsewhere in the film, local, situated knowledge crucially intervenes. In related fashion, the camera is also a means for Smyth to perform his own belonging to the place he documents. In one exemplary scene, he sobs audibly behind the camera while approaching the collapsed bell towers of the Cathedral of the Blessed Sacrament where, he states, he was once an altar boy.

Yet the film is not largely autobiographical. The integration of amateur video footage from multiple sources promotes the sense of a self-documenting social record of events, which

Austrin and Farnsworth describe as "paraethnographic" (2013: 79). Smith never narrates over his own footage or that of others, thereby raising his own voice to a higher power. When he speaks it is with people who also speak for themselves. The film's multiplication of partial views creates a potent cocktail of realist strategies, which at the same time, according to Austrin and Farnsworth, presents an "oligopticon," mirroring within its own internal structure the diversity of media practices mobilized around the earthquake of which it is a part:

> These range from blogs to mp3 downloads to the personal images and videos that have flooded Christchurch Facebook pages. Together they create potentially innumerable, dynamic sociotechnical assemblages, and hence discourses.
>
> (79)

Curiously, however, Austrin and Farnsworth overlook the film's most distinct discursive aspect. *When a City Falls* almost totally neglects the political controversies surrounding the earthquake and recovery that rage within the other media platforms they mention. For example, critical discourses on the government's management of the "recovery" in print media and on the Internet have frequently made comparison to Naomi Klein's analysis of the Bush administration's response to Hurricane Katrina in New Orleans. Parallels have been drawn between the establishment of the Canterbury Emergency Recovery Agency (CERA), rushed through the New Zealand parliament in April 2011 with no real consultation with the Christchurch City Council or the people of Christchurch, and the function of the Federal Emergency Management Agency (FEMA) post Katrina; as well at the construction of their respective disaster zones as states of exception in which normal democratic rights, governmental processes, and market restrictions were suspended. Indeed, the list of institutional 'reforms' pursued in the wake of the earthquakes also replicates many on the post Katrina agenda, including the disestablishment of elected local government bodies, rezoning of urban areas for redevelopment, redistricting of public schools, introduction of privatized charter schools, and University restructurings.[2] Although rationalized in terms of the need to more effectively provide relief and hasten recovery, many argue that such measures have been most responsive to the exigencies of ideological and market opportunity. As Chris Trotter observes:

> It's almost as if, perceiving the region's capacity for resistance to be dangerously compromised, the Government has seized the opportunity to conduct a malign, constitutional experiment upon its exhausted population.
>
> (2012)

Chair of the Canterbury Arts and Heritage Trust Lorraine North describes how the process of "recovery" in Canterbury has felt to many like a repeat of the disaster: "Citizens

are in a state of shock and many avoid the CBD altogether, grief-stricken at how much of their city has been destroyed – not by earthquakes, but by order of the Canterbury Earthquakes Recovery Authority (CERA)." (2012) This type of slate clearing, according to Klein, has become routine within the exploitation of disaster: part of "a second Tsunami of corporate globalization […] as pillage follows war" (395). In Canterbury, as in the other locations described by Klein, a state of precariousness becomes the "new normal" as perpetual fear of aftershocks, job losses, demolitions, and social restructurings become intertwined.

So why does *When a City Falls*, which Smyth promotes as the "people's story" of the Christchurch earthquakes, avert its political context? The film's reluctance to interpret, narrate, or politicize has been applauded by many reviewers, as if to do otherwise would have adulterated the unvarnished reality of the events it documents. I want to suggest that, beyond adherence to any implied criteria of documentary realism, the film is invested in preserving something more seductive and elusive: what Jean Baudrillard describes as the "wave" of "symbolic power" unleashed by the "the bursting energy of catastrophe […] of seismic energy […] in the age of simulation" (1991). Ten years later Baudrillard would again invoke symbolic power with regards to the 9/11 attacks, whose objective, he argued, was "to defy the system by a sacrificial gift to which it can only answer with its own death and collapse" (2002: 409). Whether "naturally-occurring" or anthropogenic, both disasters enact on a macro-social scale the logic of "symbolic exchange" expressed in archaic practices of potlatch and gifting analysed by Marcel Mauss and formulated into a theory of "general economy" by George Bataille. In *The Accursed Share Volume One: An Essay on General Economy* (1991), Bataille describes potlatch as follows:

> More often than not it is the solemn giving of considerable riches, offered by a chief to his rival for the purpose of humiliating, challenging, and obligating him. The recipient has to erase the humiliation and take up the challenge; he must satisfy the *obligation* that was contracted by accepting.
>
> (1991: 67)

He provides the following specific examples of the types of exchanges involved:

> As recently as the nineteenth century a Tlingit chieftain would sometimes go before a rival and cut the throats of slaves in his presence. At the proper time, the destruction was repaid by the killing of a large number of slaves. The Chuckchee of the Siberian Northeast have related institutions. They slaughter highly valuable dog teams, for it is necessary for them to startle, to stifle the rival group. The Indians of the Northwest Coast would set fire to their villages or break their canoes to pieces.
>
> (65)

As Bataille points out, in such practices "it is easy to recognize […] a particular aspect of terrestrial activity regarded as a cosmic phenomenon" (20). For example, "the sun gives without ever receiving": a phenomenon of which humans were conscious "long before astrophysics measured that ceaseless prodigality; they saw it ripen the harvests and they associated its splendor with that act of someone who gives without receiving" (28). The association of the sun's expenditure with that of the human gift-giver reflects the general economic principle that "the living organism, in a situation determined by the play of energy on the surface of the globe, ordinarily receives more energy than is necessary for maintaining life" (21). The expenditure of energy is never confined to its utility so that "beyond our immediate ends, man's activity in fact pursues the useless and infinite fulfillment of the universe" (21), which must remain enigmatic except perhaps for some divine agent. Indeed, as "acts of God," earthquakes, floods and famines powerfully evoke the cosmic dimensions of symbolic challenge whose justification is beyond human comprehension; and must devolve either to meaninglessness or religious explanation.

Bataille writes that, by contrast, in modernity: "Minds accustomed to seeing the development of productive forces as the ideal end of activity refuse to recognize that energy, which constitutes wealth, must be spent lavishly (without return)" (22), "willingly or not, gloriously or catastrophically" (21). Accordingly, modern political economy "assigns to the forces it employs an end which they cannot have" (21) – one defined by utility. In the modern world, disaster constitutes a symbolic challenge precisely by exposing the limitations of those systems incapable of productively redirecting its expenditure of energy. Hence, as Baudrillard asserts, "it is precisely this symbolic power, the bursting energy of catastrophe that we want to harness … [to] intercept the energy behind earthquakes" (1991). Indeed, as he continues, the premise that "catastrophes could become the main source of energy in the future" expresses the deepest ambition of modern political economy, although he characterizes such a project as "sheer madness; it would be just as mad to win energy from road accidents, run over dogs, from everything that perishes and breaks down" (1991).

This speculative hypothesis regarding the earthquake underscores Baudrillard's general critique of the underlying impulse of modern political economies to convert symbolic power into productive energy. The desire to contain the spiralling values of unregulated symbolic exchange (as in the situation of Potlatch) requires a coded system of equivalences grounded upon the inherent use value of objects and corresponding needs of subjects – this is the definition of regulated economic exchange. However, Baudrillard argues that such use values and needs are not the natural precursors, but rather the *naturalized* ideological products of economic exchange, "resurrected in advance" (1994: 6). As Victoria Grace elaborates: "The ideological form of economic exchange value (EV) is to assume that EV obtains its value from use value (UV), whereas in fact, Baudrillard has argued, UV is an artefact of the social institution of a codified system of EV" (2000: 13). As she also points out, Baudrillard's related insight was to observe the same structure of "precession" operating at the level of the sign, so that "rather than assuming that the meaning of the Sr [signifier] obtains in the Sd [signified], Baudrillard argues that the Sd is an artefact of the social

institution of a codified system of representation" (13). Taken together, these integrated systems of economic exchange and representation constitute a "whole metaphysic" whose precession of objective reality he traces from industrial production to post-industrial simulation.

The coordinated deception of equivalence, use value, and need that informs economic exchange risks exposure in catastrophic events such as earthquakes, which dramatically pose the question of what exchange could stabilize the value of an entire economy, society, or world threatened with destruction? For, as Baudrillard argues:

> There is no equivalent of the world […] it cannot be exchanged for anything. [Similarly] the economic sphere, the sphere of all exchange, taken overall, cannot be exchanged for anything. There is no meta-economic equivalent of the economy anywhere, nothing to exchange it for as such, nothing with which to redeem it in another world. […] The illusion of the economic sphere lies in its having aspired to ground a principle of reality and rationality on the forgetting of this ultimate reality of impossible exchange.
>
> (2001: 3–4)

The catastrophe draws those it affects, unwillingly and perhaps unknowingly, into a confrontation that re-enacts the logic of Potlatch. Accordingly, pre-modern societies often responded in kind to natural disasters by sacrificing the lives of animals or humans, which – as irreversible and irrecuperable – likewise have no equivalent. By contrast, in the modern world insurance companies discretely calculate the monetary value of human lives. It is thus, writes Baudrillard, that "[t]he earthquake threatening us also provokes a breaking open of spaces in an intellectual sense; the blasting apart of almost inseparable things" (1991). In the symbolic challenge it poses to prevailing systems of politics, economics and thought, the disaster forces open what feels like a radical possibility for reconstituting objects, social relations, people … the world. Indeed, catastrophes are demonstrative of Baudrillard's assertion that "a critique of general political economy [in both its classical/modern and hyperreal/postmodern modalities] […] and a theory of symbolic exchange are one and the same thing" (1972: 136). This is because symbolic exchange openly enacts what political economy systematically disavows: namely the production (or "precession" [1972]) of the objects, subjects and values that the latter pretends to discover as always already existing in a state of nature. Moreover, the value accrued by objects through symbolic exchange is predicated explicitly on destruction of the use value from which their exchange value is held to follow naturally and logically within systems of economic exchange.

When a City Falls enacts the ambivalent confrontation between symbolic exchange and economic exchange within the age of simulation. On one level, the reluctance of the film to address the political contexts of the earthquake recovery can be understood as its refusal to submit the event to *any use* – to reduce its symbolic value to use value *qua* political

capital. Hence the seduction that the earthquake holds for the film as documentary: to capture and protect this moment that feels so real and so authentic. Yet on another level, in its rejection of what it perceives as the media circus and simulation of politics surrounding the disaster in favour of the real "people's story", the film succumbs to the temptation of a nostalgic retreat to the utilitarianism of an idealized pre-neo-liberal, pre-hyper-real New Zealand. Baudrillard describes how – as if laying in wait for this reflex – "capital […] uses political economy as a simulation model […] in the framework of an apparatus where it loses all self-determination, but where it retains its efficacy as a referential of simulation" (1976: 124). Not surprisingly, as the juggernaut of hyper-reality spirals further from any anchorage in utility or objective reality, it stimulates a growing appetite for such mythic referents, which in turn become its most important productions. It is instructive to point out that Klein's critique of the neoliberal exploitations of disaster falls prey to the same temptation in her desire to restore the meaning of disaster within the social welfare state:

> Not so long ago, disasters were periods of social leveling, rare moments when atomized communities put divisions aside and pulled together. Increasingly, however, disasters are the opposite: they provide windows into a cruel and ruthlessly divided future in which money and race buy survival.
>
> (2007: 413)

The problem from a Baudrillardian perspective is that the seeds of hyper-reality are already sown irrevocably within both Marxist and capitalist variants of the pre-neoliberal, classic political economies for which both Klein and Smyth are nostalgic. Specifically, the "use value" of resources and "needs" of individuals/communities to which they appeal are, according to Baudrillard, the naturalized ideological products of economic exchange.

The problem of how to preserve symbolic power without turning it into its antithesis is closely related to the problem of its representation. As already indicated, the illusion of the thing-in-itself whose essential use value grounds its exchange value for a subject possessed of innate needs is paralleled in Baudrillard's critique of the Sausurrean theory of the sign; the signifier produces the signified and referent that are presumed to pre-exist it independently, yet are related only by arbitrary convention. In this respect, *When a City Falls* is instructive regarding a more fundamental tension between symbolic exchange and representation. As Baudrillard remarks:

> the symbolic, whose virtuality of meaning is so subversive of the sign, cannot, for this reason, be named except by allusion, by infraction. For signification, which names everything in terms of itself, can only speak the language of values and of the positivity of the sign.
>
> (1972: 161)

The positivity of the cinematic sign has been historically associated with its transparent indexicality, which raises direct problems for any cinematic documentation that attempts to also preserve the symbolic nature of an event.

Notable in this regard is the film's treatment of the September 4th, 2010 earthquake, which occurred in the early hours of the morning and consequently (in contrast to the February 22nd, 2011 quake) yielded very little usable footage. The sequence is quite distinct from the remainder of the film in the way it uses the cover of darkness to amplify the power of sound and diminish the clarity and distinctness of the world. Rumbling becomes audible over a black screen as the telephonic voices of emergency workers register the initial shock. When images come, they are fleeting: the torch-lit face of a child surrounded by darkness followed by shaking surveillance camera footage as streetlights fail and the screen is plunged once more into total darkness. Telephone voices return: "what the fuck was that"? Because, as Michel Chion explains, "there is no auditory container for film sounds, nothing analogous to this visual container of the images that is the frame" (1994: 68), sounds can become "acousmatic": divorced from any decisive visibly objective source or referent (71–73). The Mayor of Christchurch, Bob Parker, later remarks: "I've heard earthquakes – you can hear them coming […]It's spooky." Acousmatic sound acquires an especially promiscuous power relative to the earthquake, which seems to come from everywhere and nowhere at once. By utilizing sound to express the enveloping presence of a phenomenon that defies visual containment, *When a City Falls* militates against what Chion describes as the persistent "audiovisual illusion of a redundancy that doesn't exist (for example, the sound seems to duplicate what the image already says)" (2009: 232). It is worth noting that this "coefficient of misapprehension" (2009: 232) that informs the audio-visual illusion is structurally similar to Baudrillard's account of "precession," insofar as sound disguises its constitutive power over the image behind qualities that seem to already belong to the image itself. The use of acousmatic sound to trouble this illusion contributes to the symbolic force of the earthquake by disrupting the determination of objects, signifier and referent preserved and reified through clear and distinct visual representations.

If the prioritization of sound over image in the treatment of the September 2010 earthquake alludes to symbolic exchange by infraction, the representation of the second large earthquake of February 2011 exemplifies what Baudrillard describes as "present day photographic, cinematic and television images […] thought to bear witness to the world with a naïve resemblance and a touching fidelity" (1987: 14). Paradoxically, however, it is this fidelity that heightens the film's deceptiveness. As Baudrillard writes: "It is precisely when it appears most truthful, most faithful and most in conformity to reality that the image is most diabolical. […] It is in its resemblance […] that the image is most immoral and most perverse" (1987: 13–14).

This perversity lies in the fact that the documentary image strives for greater adherence to a world whose objective, pre-signified existence it produces as its fundamental fiction. Hence, for Baudrillard, it is "its pretention to be the real, the immediate, the unsignified, which is the maddest of enterprises" (1987: 33).

This is particularly evident in the film's use of CCTV footage; the medium seems to disappear and the spectator is left with the illusion of watching things as they were, and "as if we were there" in the absence of any mediating agency (Baudrillard 1994: 28). The sequence of the February 22nd earthquake begins with a shot from a CCTV camera mounted to the side of a building. A man walks into the frame just as the shaking begins and a building topples directly behind him. In the lengthy montage that follows, additional CCTV footage from multiple locations is intercut with amateur video from a variety of sources. In this way, the most objectifying and subjectifying modalities of video – the indifferent disembodied gaze associated with the surveillance of state, corporate, and institutional agencies and the imperiled embodied vision of individuals – are forced into a synthetic correlation. The abstract "reality" of subject and object is reified at the very moment when the forces that might destabilize them strike. The montage concludes with an extreme long shot of the city, a lingering image that gives new meaning to the term "establishing shot" insofar as it works to verify the referent by capturing in real time the totality implied by, yet absent from, the preceding sequence of viewpoints. In alternating between a range of sources and locations, the montage also recapitulates fictional disaster films such as *Earthquake* (1974) and *Shortcuts* (1993), which similarly deploy montage to forge a sense of simultaneity and unity of experience among a collection of strangers who are unaware of the social fabric in which their lives are intertwined. John Key, the Prime Minister of New Zealand, insists at the beginning of his speech to the Latimer Christchurch Earthquake Memorial Service: "we all remember where we were when we heard the news." In the Canterbury earthquakes, as in the aftermath of 9/11, the mediated simulation of the social is extended in the reimagining of national community.

The representation of the February earthquake is also marked off from the rest of the film by its hyperbolic protraction within screen time. Thus, the montage not only multiplies types of footage and viewing positions but also extends the duration of the event. At no other moment in the film does editing work this way, the prevailing rule being the contraction of screen time relative to story time in the service of narrative progression. In Hollywood cinema, such temporal protractions are often associated with spectacle, subjective sequences and other forms of narrative ellipsis. The temporal prolongation of the earthquake exerts a similar power of suspension over narrative, securing the reality of the event beyond the contrivances of story and fiction.

This reality effect is also amplified by the way the frequent recurrence of earthquakes in Canterbury defies prevailing structures of narrative containment. Massively destructive earthquakes of the scale experienced in Canterbury are narratively plotted in films such as *Earthquake* (1974) and *Shortcuts* (1993) as singular events accompanied (if at all) by foreshocks or aftershocks of substantially lesser intensity. This in turn maps onto the conventional structures of classical film narratives in which tensions build, climax and dissipate, allowing for the inevitable recovery phase that the ongoing Canterbury earthquakes have so frustrated. Instead, in *When a City Falls* the frequency and oscillating severity of aftershocks breed uncertainty about whether these are separate earthquakes or foreshocks

(and foreshadowings) of a larger future event. This is conveyed in the prescient remarks of the mother of an affected family immediately before the film cuts to the montage of the February 22nd quake: "They say there's not going to be another 7.1 earthquake for 16,000 years or whatever, but there could be one in 5 minutes time also."

If the simulation of the metaphysics of production naturalizes itself behind the cloak of common-sense expectation and predictability, the second major earthquake of 22 February struck a serious blow to such well-worn shibboleths as "lightning never strikes twice in the same place." The narrative must thus accommodate an expansion of the realm of the possible that verges on the metaphysical, evoking the maxim from Paolo Cuehlo's *The Alchemist*: "Everything that happens once can never happen again. But everything that happens twice will surely happen a third time" (2006: 184). The second quake thus effectively obliterated any expectation that shocks would follow a declining pattern, promoted the expectation of an ongoing series of large quakes, and raised the spectre that both were in turn only foreshocks of some yet larger event. As Leanne Curtis of CANCERN (the Canterbury Communities' Earthquake Recovery Network, a citizens' advocacy group) observes: "It's not like they [the after/foreshocks] get smaller. […] Most of us believe we're in for another big one about every six months" (Bergman 2012: 2).

The feelings of precariousness verbalized by subjects in the film are corroborated in cinematic terms through the routine inclusion of amateur videos and interviews associated with various human-interest stories during which aftershocks spontaneously occur. The temporal spacing of these events within the screen time of the film assumes a homologous relation to their intervals at the level of story, commuting their unsettling effect to the spectator and disrupting the film's ability to narrate the "recovery." The film's restaging of chance as always beyond calculation provides a regular infusion of symbolic energy into the social world, which blocks the return to "normal" modes of exchange and signification. However, in another sense, the cinematic rendering of these events as superadditive to whatever documentary contrivances or intentions were at play in the moment, promotes them to an extra-representational status, apparently "more real than real" (Baudrillard 1994: 81). Such vehement assertions of the autonomous reality of the quakes mark their function as a simulation model within hyper-reality.

The treatment of the earthquake in *When a City Falls* exemplifies Baudrillard's critique of "disenchanted simulation" that "replaces all illusions with just one, its own, which becomes the reality principle" (Baudrillard 1990: 83). Hence Baudrillard's refusal of "any pedagogy of the image" (83), the core of every defence offered up on behalf of documentary. Ironically, it is in its very attempt to redeem cinema through strict adherence to physical and socio-historical reality that the documentary impulse perfects its fraudulence: "In this very way, we enter, beyond history, upon pure fiction, upon the illusion of the world. The illusion of our history opens on to *the greatly more radical illusion of the world*" (Baudrillard 1992: 122). For Baudrillard this "radical illusion of the world" is nurtured paradoxically through the very threat of its destruction, and for this reason has a special relationship to films about disaster and catastrophe. For the fundamental wish that informs narratives about the destruction

of civilization and the extinction of human life is for a view of the world *as it really is,* without the mediation of the sign: "In a word, we dream of our disappearance, and of seeing the world in its inhuman purity" (1987: 26). However, Baudrillard also observes that even those disaster films that permit survivors, such as *The Day after Tomorrow* (2004), do so in order to "[bring] about a regression of the human race" in order to fulfil a similar wish (26). Indeed, this second scenario is closer to that of *When a City Falls*, where the desire is not for self-destruction but the destruction of false selves and a false image of the world.

Here we might enquire what specific "illusion of our history" opens onto this "illusion of the world?" The questions of social and referential realism certainly converge around this point. The answer resonates with the deepest aspirations of Kiwi nationalism: a romanticized belonging to place simultaneously at the centre of international attention.[3] Indeed the population has been primed for this by over a decade of location tourism (New Zealand as Middle Earth) and nation branding (100% Pure New Zealand) that promote the intranational and international consumption of New Zealand as simulacrum. As Brendan Hokowhitu intimates in his critique of *Whale Rider* (Niki Caro 2002), the simulation of the New Zealand landscape as "brute matter" and "terra nullis" also corroborates fantasies of its reclamation by an innocent and universalized Kiwi pragmatism that elides the problematic history of settlement and colonization (2007: 24). In *When a City Falls* the decimation of the colonial infrastructure in Christchurch similarly creates a clean slate that provides the stage for a thinly disguised fantasy of resettlement.

In the aftermath of the September and February quakes, *When a City Falls* visits a range of suburbs, named in captions, ranging from wealthy to poor. In these places Smyth encounters a varied assortment of people who present a demographic sample of children, the elderly, mothers, fathers, Māori, Pākehā, Pacific people and Chinese, who all remain unnamed (unless incidentally). The film thus constructs the earthquake as common denominator for a universalized humanity and Kiwi populace to whom destruction has been meted out indiscriminately and without prejudice. All now equally belongs to this place in the natural inauguration of a new social order that transcends and trumps all prior differences. This fantasy of a "pan-indigeneity" must therefore sacrifice all reference to the divisive aspects of the earthquake response, such as the unequal distribution of relief from portable toilets to tanked-in water. As a result, it reproduces the myth identified by Naomi Klein that "disasters do not discriminate" (2007: 406). The film, thereby, avoids the structural inequalities within the response to the earthquake that would impose upon its idealized community some answerability to the political past.

The fantasies indulged by the film enact a parody of what Baudrillard describes as the power of seduction within symbolic exchange. "Seduction is what tears you away from your own desire to return you to the sovereignty of the world" (Baudrillard 1983: 142). However, the sovereign world enacted through symbolic exchange can be quickly diverted into the affirmation of a "real world," which is itself an artefact of economic exchange. This is why, paradoxically, "seduction lies in the transformation of things into *pure appearance*,"

(Baudrillard 1990: 70) whereas economic exchange and hyper-reality produce the illusion of an immanent world behind all appearances. Thus, rather than restoring illusion to reality, seduction undermines the illusion of objective reality:

> For if production can only produce objects or real signs, and thereby obtain some power; seduction, by producing only illusions, obtains all powers, including the power to return production and reality to their fundamental illusion.
>
> (1990: 70)

Symbolic exchange is thus not about the return of the real but about the assertion of rival illusions. However, as Baudrillard acknowledges, this does not exclude a "cold seduction" (1990) to the illusion of "social beings, who, in the rupture of symbolic exchange, autonomize themselves and rationalize their desire, their relation to others and to objects, in terms of needs, utility, satisfaction and use value" (1972: 142). *When a City Falls* becomes ensnared in precisely this trap as the symbolic exchange unleashed by the earthquakes is diverted by the film into nostalgia for a "real" world defined by the reassertion of the equivalence of exchange value and use value characteristic of classical political economy. In this respect, the film is symptomatic of what Baudrillard describes as:

> [C]urrent revolutions [which] index themselves on the immediately prior phase of the system. They arm themselves with a nostalgic resurrection of the real in all its forms; in other words with simulacra of the second order: dialectics, use value, the transparency and finality of production.
>
> (1984: 56)

In the New Zealand context this takes shape through a re-materialization of the spirit of Kiwi ingenuity in the form of outdoor toilets ("it looks as though it shouldn't work but it does"), makeshift accommodation, homemade public water dispensers, pot belly stoves ("they told us to get rid of 'em") and free book dispensaries. It is as if the earthquake opens a time travel portal to a pre-globalized, pre-neo-liberal, pre-hyper-real New Zealand in which real people solve real problems with real objects – which, fortunately, have been lying around all the while waiting for us to rediscover them and thereby our true selves and needs. Even social networks magically shed their virtuality, as a Facebook group organized by University of Canterbury students materializes into a real community of helpers.

Such is the power of "use value fetishism" that, as Baudrillard warns, "people do not rediscover their objects except in what they serve; and they do not rediscover themselves except through the expression and satisfaction of their needs – in what they serve" (1993: 145). The social realism of *When a City Falls*, prefaced on the return to a real society, is likewise no less a function of hyper-reality. That is, in order for this disaster to serve its ultimate purpose – to remind ourselves of who we all are as "Kiwis" – it must at the same

time move through the circuits of simulation as image and be transubstantiated into what Baudrillard describes as the indifferent exchange value of code:

> While these images glorify the event, they also take it hostage. They can compound *ad infinitum* and simultaneously act as a diversion and neutralization. […]The image consumes the event, in the sense that it absorbs it and prepares it for consumption. Indeed, it gives the event new vigour, but as an image-event.
>
> <div align="right">(2002: 140)</div>

This "new vigour" of the earthquake as "image-event" is predicated upon the film's simulation of symbolic exchange, which neutralizes and annuls its potentially subversive power. According to Baudrillard, the subversive power of symbolic exchange lies in its capacity to reverse utility and the reifying function of precession. He writes that "reversibility, cyclical reversal and annulment put an end to the linearity of time, language, economic exchange, accumulation and power. […]Neither mystical nor structural, the symbolic is inevitable" (1993: 2). The inevitability of the symbolic is expressed most forcefully in death, which defies utility and has no equivalent in terms of exchange value, yet must still be incorporated within the ritualized patterns of exchange that define the social fabric. It is in this respect that the level of death and destruction associated with the February quake presents an amplification of symbolic challenge. The "feeling […] that someone has been looking after us, that we are big time blessed," as one ambulance dispatcher puts it in response to the miraculous lack of fatalities in the September earthquake, is confronted with the improbability of a second event with such a large toll of death and destruction. This reversal of fortune seems to give rise to others just as the earthquake precipitates aftershocks. Indeed, in scientific terminology, aftershocks themselves undergo reversion to foreshocks following the February earthquake, in relation to which they become prelude rather than postscript, cause rather than effect. We are even told by a seismologist that at the epicentre of the second earthquake the vertical force of the shock reversed that of gravity, momentarily suspending the conditions that hold the physical world together.

The reversal of cause and effect is closely related to symbolic exchange for Baudrillard insofar as it threatens to expose the ideological operation of precession that produces cause *from* effect, for example, in the occultation of use value from exchange value or referent from signifier. It is in this way that symbolic exchange asserts the radically generative, magical power of signification by the same stroke that it counteracts the "laws" thought to inhere in the physical world according to the metaphysics of production.

However, symbolic power, once diverted into the reification of a world of objects reduced to their base materiality and defined by their use value, can only overflow into a transcendental realm. This occurs in *When a City Falls* in terms of paranormal phenomena, reports of which were said to have increased dramatically after the first major quake in September (Sachdeva 2011). It is only after the fatalities of the February quake, however, that the film

becomes invested in such occurrences. In one case, a Lyttleton woman relates how she was led mysteriously to her father's body by his familiar whistling after he had been crushed to death by falling rocks while walking in the Port Hills. Here the whistle precedes the whistler, and indicates the location of its deceased causal source. In another instance, during video footage of a meeting of Māori kaumātua (leaders), a strong aftershock strikes, as if on cue, immediately after a participant begins to speak in Te Reo Māori. Sir Tipene O'Regan, a respected Ngai Tahu leader, wittily responds: "your words have great force," drawing laughter from the others. The incident recalls that most infamous historical coincidence of Māori ritual speech and seismic event when the tohunga Tuhoto Ariki purportedly effected the 1886 Mt. Tarawera eruption with a spoken makutu (curse), destroying the Pink and White Terraces (Conly 2006). In another example, after the February earthquake the statue of the Virgin Mary in the Cathedral of the Blessed Sacrament reversed its position in the window, from facing inwards towards the church to looking outwards over the city; under her gaze, Christchurch appears to be a sanctified zone through its destruction and hence deliverance from the scheme of utility.

Jonathan Smith points out that, for Baudrillard, "two orders of metaphysical precession generate two forms of magic" (2007: 7). While the cold seduction of hyper-reality delivers: "a mechanical form based on simulation, wherein before-the-fact models 'conjure up' referents," symbolic exchange exemplifies "a more ancient form" in which "the world, its reality, is made up only of signs" that "do not refer to any sort of 'reality' or 'referent' or 'signifier' whatsoever" (cited Smith 2007: 7). To the degree that *When a City Falls* is symptomatic of the forms of precession associated with hyper-reality it is confined to the simulation of symbolic exchange. It is here that *When a City Falls* exhibits a fundamentally conflicted relationship between the forms of symbolic exchange it attempts to resuscitate and the mode of simulation it exemplifies. Indeed, it is only on these terms that the film gets to have it both ways: to indulge its "unashamed parochialism" (Littlewood 2011) and also be consumed more broadly as a mirror of national culture and universal humanity.

When a City Falls diverts the energies of symbolic exchange to impose a moral, nationalist, and humanitarian obligation to participate in what Baudrillard describes as "the panic-stricken production of the real and the referential" (1994: 7). This simulated symbolic challenge takes shape as a veiled antagonism towards the spectator, which comes to the surface at times. For instance, early in the film while touring a particularly devastated street near the epicentre of the first earthquake, Smyth's camera dwells on a hand painted sign that reads: "rubberneckers fuck off." In cinematic terms, the sign enacts an ambiguous double address: to the unwanted outsider within the diegetic world of the film and to the spectator, for who it both is and is not intended. One might ask what constitutes a "rubbernecker": one who looks for too long, too closely, too pruriently, or too critically? *When a City Falls* certainly indulges all these modes of looking, save perhaps the last. The sign also has a double origin: represented though not written by Smyth both a film-maker and a resident of Christchurch, whose intent has been described by one reviewer as "not so much [to] document [...] as bear witness" (Littlewood 2011). A reciprocal disavowal is thus accommodated in the cinematic

mediation of the sign. On our side, we as spectators may watch, but only on condition that we respect an inner limit within the simulation beyond which is enshrined an autonomous reality from which we are prohibited, the precise effect of which is to conceal the fact that we have participated in its very conjuring. This is simulated symbolic exchange. A similar dynamic is apparent in the shots where Smyth approaches traumatized and injured people in the streets following the second earthquake; some address the camera pleading for help or for information about loved ones. The overriding sense is that, as spectators, we do not belong here, like voyeurs at a roadside accident or crashers at a funeral. Yet compelled to respond in some way, the least we can do is affirm the symbolic power of the loss, which through the reflex of cultural and documentary conventions becomes converted unnoticed to the exchange value of the real.

References

Bataille, G. (1985), "The Notion of Expenditure," in *Visions of Excess: Selected Writings 1927–1939,* Minneapolis: University of Minnesota Press.

———. (1991), *The Accursed Share: An Essay on General Economy, Volume One: Consumption,* trans. Robert Hurley, New York: Zone Books.

Baudrillard, J. (1972), *For a Critique of the Political Economy of the Sign,* trans. Charles Levin, St. Louis: Telos Press.

———. (1983), *Fatal Strategies,* trans. Philip Beitchman and W. G. J. Niesluchowski, New York: Semiotext(e)/Pluto Press.

———. (1987), *The Evil Demon of Images,* Sydney; Power Institute of Fine Arts, University of Sydney.

———. (1988), *Jean Baudrillard: Selected Writings,* Mark Poster (ed.), trans. Charles Levin, Stanford: Stanford University Press.

———. (1990), *Seduction,* trans. B. Singer, London: Macmillan.

———. (1991), "Paroxysm: The Seismic Order," *Merve Verlag* .http://www.egs.edu/faculty/jean-baudrillard/articles/paroxysm-the-seismic-order/. Accessed 20 January 2015

———. (1992), *The Illusion of the End,* trans. Chris Turner, Cambridge: Polity Press.

———. (1993), *Symbolic Exchange and Death,* trans. Iain Hamilton Grant, New York: Sage Publications.

———. (1994), *Simulacra and Simulation,* trans. Sheila Faria Glaser Ann Arbor: University of Michigan Press.

———. (2002), *The Spirit of Terrorism and Requiem for the Twin Towers,* trans. Chris Turner, London: Verso.

Bell, A. (2007), "Becoming Pākehā: Dominance and its Costs," http://sweetasconference.blogspot.co.nz/2007/05/becoming-pkeh-dominance-and-its-costs.html.

Bergman, J. (2012), "New Zealand Earthquake, One Year On: Christchurch Stuck in Postquake 'Fog,'" *Times*. February 21st.

Chion, M. (1990), *Audio-Vision: Sound on Screen,* New York: Columbia University Press.

———. (2009), *Film: A Sound Art,* New York: Columbia University Press.
Coehlo, P. (2006), *The Alchemist,* trans. Alan R. Clarke, New York: HarperCollins.
Conly, G. (2006), *Tarawera: The Destruction of the Pink and White Terraces,* Wellington: Grantham House.
Fox, A. (2011), "Calls for Aggressive Demolitions in Christchurch," http://www.stuff.co.nz/business/industries/4725440/Call-for-aggressive-demolition-in-Christchurch.
Grace, V. (2000), *Baudrillard's Challenge: A Feminist Reading* Routledge New York.
Hokowhitu, B. (2007), "Understanding Whangara: *Whale Rider* as Simulacrum," *New Zealand Journal of Media Studies,* 10: 2, pp. 22–30.
Hopkins, J "Cera Bill Threatens Democracy," http://www.stuff.co.nz/the-press/opinion/4885510/Cera-bill-threatens-democracy Accessed 20 January 2015.
Klein, N. (2007), *The Shock Doctrine: The Rise of Disaster Capitalism,* New York: Metropolitan Books.
Littlewood, M. (2011), "*When a City Falls* Film Review," http://www.stuff.co.nz/timaru-herald/entertainment/film-reviews/6049239/When-a-City-Falls.
North, L. (2012), "History Comes with a Price," http://www.stuff.co.nz/sunday-star-times/latest-edition/7685947/History-comes-with-a-high-price.
Sachdeva, S. (2011), "'More Ghosts' after Earthquake," http://www.stuff.co.nz/oddstuff/4318133/More-ghosts-after-earthquake. Accessed 20 January 2015.
Sears, C., Wilcox, L. and Johnson, J. (2012), "NeoLiberalism Unshaken: A Report from the Disaster Zone," *Excursions* 3: 1. pp. 1–25 http://www.excursions-journal.org.uk/index.php/excursions/article/view/63/110. Accessed 20 January 2015.
Smith, J. (2007), "Jean Baudrillard's Philosophy of Magic," *International Journal of Baudrillard Studies,* 4:2, http://www.ubishops.ca/baudrillardstudies/vol4_2/v4-2-jsmith.html.
Smyth, G. (2011), Promotional Website for *When a City Falls* http://whenacityfalls.co.nz/.
Trotter, C. (2012), "Canterbury Democracy Hammered," http://www.stuff.co.nz/the-press/opinion/columnists/chris-trotter/7649879/Canterbury-democracy-hammered.
Williams, C. (1980), "Realist Positions," in Christopher Williams (ed.), *Realism and the Cinema,* New York: Routledge & Kegan Paul.

Notes

1 An earlier version of this chapter appeared as an article in *The New Zealand Journal of Media Studies* titled "The Canterbury Earthquakes and the Production of Reality in *When a City Falls*."
2 For a detailed account of the relationship of the earthquake response to restructurings at the University of Canterbury, see Cornelia Sears, Leonard Wilcox and Jessica Johnston (2012) "NeoLiberalism Unshaken: A Report from the Disaster Zone" *Excursions* 3(1).
3 See for example, Avril Bell, Becoming Pākehā: Dominance and its Costs http://sweetasconference.blogspot.co.nz/2007/05/becoming-pkeh-dominance-and-its-costs.htm

Chapter 9

Landscapes in Conflict in Contemporary Chilean Film

Antonia Girardi/Translated from Spanish by Stephen J. Clark

Among so many other good things, a defect stands out in Chile. We are victims of frequent and strong earthquakes that at times shake us to the core. The quakes cause such damage that it seems to me that those who have not witnessed them will have a very hard time believing them. And it's even difficult for me to talk about them for by doing so I put the truth in jeopardy and cast doubt upon the certain.
<div align="right">Julio Vicuña Cifuentes, *Popular Ballads of Chile*. Santiago, 1912</div>

All of that inert, voiceless world, that world whose mission has been to remain fixed and silent throughout its entire existence, suddenly springs to life in a dramatic fashion; immobility appears to be exacting a sort of revenge against the mobility of mankind, which finds itself stuck, with no clue about what to do next.
<div align="right">Benjamin Subercaseaux. *Chile or a Mad Geography:*
The Country of the Restless Earth. Santiago, 1940</div>

A long beach with devastated landscapes exposed to the ravages of the south wind. Gray sands, beached tree trunks, an immense sinking. The sea and the river rose one league inland. The planting fields on the coast are now sand banks covered in rubble.
<div align="right">Luis Oyarzún, Toltén January 21st, 1961</div>

Its presence is felt, from the beginning of the twentieth century, in the poetry, essays, chronicles or popular narratives of Chilean literature. The earth shakes. Each of its oscillations leaves a mark. From day to day, from season to season, one reckons with the possibility of the most unexpected disaster. A telluric imaginary, buried under layers and layers of historical experience, rumbles and stirs. In the words of the philosopher Luis Oyarzún, "[T]he Chilean subject falls prey to philosophising about earthquakes: the soles of his feet tread on uncertain ground. Nothing is lasting or definitive. Suddenly the earth roars and the abyss abruptly places us all on the same plane."[1] One writes, just as one films. With the earth torn asunder, a new discursive position opens up like a bleeding wound. Whether from the heights of the rugged peaks upon which we have been cast by the force of the sea or on the surface of the earth, one confronts with all one's senses, as in a crucible of new experiences, the productive warmth of that abyss. Suddenly, what used to be in the background abruptly moves to the foreground – the silent treasure of peaceful landscapes, dissimilar stages upon which the great actors of the nation's history meet or where the constructive landmarks of its modernization stand tall and proud.

Chillán, 1939, 7.8 / Valdivia, 1960, 9.6

The idea that the landscape can assume the role of a character is hardly new. It is already evident in the chronicles of the *conquista*, in Darwin's travel writings in Chile, in naturalist painting, or in early twentieth-century theories on the telluric foundation of Latin American identity. All make reference to a subjectified territory where superimposed layers of utopian and dystopian narratives animate the Earth's surface. As Miguel Rojas Mix points out in *Imaginary America*, cartography returns as fiction. The coastline is transformed into shapes and silhouettes, the sea is plagued with monsters. Chile, a land at the uttermost end of the Earth, embodies – in the manner of a temperamental, violent or ungovernable subject – another sort of apocalypse: the end of time. After successive attempts to establish the modern, Humanity, always more or less at a disadvantage, struggles, with the repeated efforts of a Sisyphus, against a powerful organic entity. The Spanish philosopher Ortega y Gasset remarked as much, a few days after the Talca earthquake of December 1st, 1928:

> If I were Chilean, this is how I would perceive the misfortune that in these days tragically renews one of the most painful features of your destiny. Because this florid Chile shares the destiny of Sisyphus in that it lives just as he did, in a high mountain range, and like him, it seems doomed to suffer the repeated collapse of that which it has created time and again.[2]

Ortega y Gasset refers to the misery and misfortunate of the days after the quake when everything returned to a state of collapse, erasure, ruin. In the same breath, he speaks of a mythical time, a tragic destiny, where obliteration and recreation are no longer the exception but the rule: the rule which sustains the territory [*el territorio*], upon which its convulsive tectonic plates rest, but also the moral code upon which is inscribed the impossibility of a truly American, ultimately Chilean, philosophy.

As previously noted, Chileans lose themselves in philosophical thoughts about earthquakes. The ground under their feet is uncertain: the earth shakes, buildings come tumbling down, entire cities disappear. At the same time, however, as much as it emerges in fragments, historical modernity never completely arrives, and thus must be reformulated time and again. Luis Oyarzún, who as a philosopher never abandoned historiography, revealed in his personal diary that this productive problem is linked to a sort of telluric aesthetic [*estética de lo telúrico*]. The creative energy of philosophy takes hold through an aporia, as Gabriel Castillo will later express in his research on the Chilean essay.[3] According to Oyarzún, "One could say that the Spanish American subject seeks a new language in his powerlessness."[4] He writes from London, New York, Caleu, Río Piedras, Lima, Washington, Til Til or Santiago. His texts are always carefully dated and located, no longer sent from the academy but from what can be imagined as a "hollow space." They sketch a cartographic outline, an aerial perspective, of a Latin American way of thinking that is not rooted in the allegedly clear and distinct terms of an institutionalized form of national discourse,

a virtual carbon copy of European ideology. Rather, they maintain a kind of resistance that distrusts words and remains sceptical with regard to their expressive value. Poetry is, for Oyarzún, one of these oblique paths, opposed as it is to mimetic clarity. Its reflexive turns of phrase undo meaning, break the material links of language in order to mould it anew, as in a foundry. Cinema, in its power to mythify or conjure, to direct or deconstruct discourses of identity, will be our path. In this context, the earthquake becomes the specific catalyst for the representation of the territory [*del territorio*], giving rise to a wild variety of paradoxical images and visions which gradually become sedimented, one quake at a time.

Images of the 1939 Chillán Earthquake is a clear example of the Sisyphean courage exhibited in the audio-visual transcription of Chile's seismic reality. The documentary is composed of two newsreels from the era that have been restored and spliced together by the National Film Archive. The film aspires, above all else, to provide a record of the route taken by the presidential motorcade through the disaster zone and to enumerate the countless efforts undertaken to remedy the situation. Intertitles and newspaper clippings comment, like notes in the form of a marginal discourse, upon the disruptive potential of the images. These "Notes on the Earthquake," as they are called at the beginning of the film, begin with President Pedro Aguirre Cerda's train ride from Santiago :

> Partial trains are organized to lend aid to the affected region. At the break of dawn, his Excellency, the President of the Republic, Pedro Aguirre Cerda, and his wife depart with numerous technicians and doctors. Along the way, they take note of the pleas of the victims' relatives.

The careful calligraphy of the first title card is directly followed by a close-up of the president's face that fills up the screen, as he delivers a speech through the window of the train. A procession of images unfurls according to a strict cartographic logic, city by city, from north to south, images that, despite attempting to capture the extent of the damage, only manage to glimpse the losses, framing them merely as a backdrop to the official visit. However, as the film progresses, it seems that these precarious moving images, discontinuous and only partially accompanied by sound, dare to compete with the title cards that initially assumed complete authority for narrating the film. Almost at once, the institutional – and human – scale ceases to be the sole frame of reference, and, for a few brief moments, the film leaves a space for a landscape-based and experiential treatment of the disaster. Gradually, one begins to notice, not only the names of the towns, the distribution of food, the movement of the sick (sanitary, engineering and logistical measures), but also the length of the cracks on the walls, the impossible textures that the great ruined edifices take on, the image of train tracks, directionless and useless, twisted into a knot. Then as if the film were awakening from a dark slumber, the narration returns, giving way to a string of newspaper headlines that describe the catastrophe in a tragic tone. The intertitles slip in uplifting messages that appeal to civic pride while the multitudes are filmed in slow, sweeping pans as they listen enraptured to the president's address. The epic tone continues but the feeling remains that a fissure has

opened up, that the quake has not only opened cracks in the earth, but has brought about an entirely different dimension in the filmic treatment of disaster, and, ultimately, in the human and natural realm. Those unexpected yet hypnotic panning shots over the ruins, that sea of bodies mixed up with the rubble, the twisted train tracks that signify the metaphorical derailment of the project of modernity, will reverberate indefinitely in the unconscious of the nation's cinematography.

The formal and narrative dilemmas raised by the telluric imaginary [*lo telúrico*] continue to pose problems by *putting the truth in jeopardy and casting doubt upon certainty*. Even as they claim to record reality and gather the documents upon which History is founded, films like *La Repuesta* (1961) negotiate these murky waters. The documentary, by Sergio Bravo, an experimental film-maker from the University of Chile, and the Spanish historian, Leopoldo Castedo, depicts the Valdivia earthquake in May 1960, which registered 9.6 on the Richter scale, and to record the desperate attempts to control the overflowing Riñihue River. Yet it presents a difficult enigma for the viewer to unravel. The narrator claims that "*It's an uncorrupted account, based on the truth, ripped from the headlines,*"[5] citing the famous epic poem by Alonso de Ercilla as the colophon to the film. On screen, the images, as faithful and as true to the facts as they might be, are far from believable or humanly comprehensible. Castedo's epic narration, the experimental and disturbing score by the composer Gustavo Becerra, and the daring images filmed by Bravo, all take a different track. Regarding the telluric imagination [*lo telúrico*] in Chilean cinema, the historian Joaquín Hernández points out that nature is understood in opposition to technology as an antagonistic centrifugal force. The engineering feat that was supposed to contain the overflowing Riñihue is registered in heroic tones, a titanic achievement in terms of the historical patrimony. Castedo's recorded voice is so confident in its eloquence and in the brilliance of the engineers that it becomes removed from the material effects of the earthquake. Deaf, dumb and blind to the disaster, the narration ignores the disorder conveyed by the montage of images of the violent landscape. It invokes the process of modernization that resulted in the channelling of the waters as the ultimate triumph of reason. What we actually see, however, is the inevitable and irreversible transformation of the land, as, with increasing autonomy, it impacts upon our sensory experience.

The films that I am interested in here have little to do with the sound and fury of natural forces. They are not concerned with those grandiose and massive human enterprises projected upon vast areas of the natural landscape, nor with the rise and fall of modern utopias set against the backdrop of sleepy countryside. They share a similar focus on the telluric, climatic and geographic conditions that offer a reconsideration of the possible audio-visual modes of addressing the landscape – the importance of the wide shot, the exploration of off-screen space, certain uses of the zoom. The shot must do justice to the enveloping and overflowing nature of the setting. The emphasis is no longer placed upon the dramatic potential or performative efficacy of the characters in physical space. The regime of the visible is liberated from the yoke of action. The filmic event is reoriented towards the sensible world. Consequently, the domain of linguistic experimentation becomes a privileged

site when it comes to reading the film. Such a reading would not produce a utopia, nor make of the movies, to paraphrase Raul Ruiz, a homeland that welcomes everyone in general, but no one in particular.[6] Rather it would create an "other" space, a heterotopia – an isolated place that would activate, from within its own enclosed and local nature, other (hi)stories temporalities and spaces. We find ourselves, in Foucauldian terms, faced with films in which the decline of master narratives, the weakening of the subject as protagonist, or the crisis of the action-image, as conceived by Gilles Deleuze, inscribes itself literally on the skin or on the paper upon which physical space is transformed.

Seismographic impressions in *Tres semanas después*

(Constitución 2010: 8.8)
A static and tightly framed shot on the strip of land where the waves break. The cadence of the sea and the music suddenly interrupted by the unexpected. In full focus, like an abstract landscape painting, the fragment torn from a continuous façade of destroyed homes is exposed horizontally, full of rubble and with a diffuse collection of muffled sounds.

Three weeks after the 8.8 earthquake that rocked the south-central area of Chile on February 27th, 2010, the film-maker José Luis Torres Leiva journeyed through the affected area. Over a period of eight days, he recorded the aftermath of the disaster, experiencing the reality on the ground at first hand. Talca, Curepto, La Pesca, Rancura, Iloca, Duao, Constitución, Cobquecura, Pelluhue, Dichato, Talcahuano and Lota, sit next to or near the sea. They have ceased to exist as cities, transformed by the earthquake into the monstrous remnants of a wrecked landscape, a vast landslide, a great submarine graveyard. Without a doubt, the situation recalls Julio Vicuña Cifuente's response to the 1906 Valparaíso earthquake: *it puts the truth in jeopardy and casts doubt upon certainty*.

Tres semanas después was first shown at the 2010 Documentary Festival in Santiago (FIDOCS). Critics hailed the film as a "visual meditation on the landscape following a catastrophe,"[7] an overwhelming portrait containing "the most terrible and devastating tracking shot in the history of Chilean film."[8] The viewer is swept away by the visual and sonorous litany of this tracking shot, lulled by the incessant sounds of the sea and the sight of the countless ruins that sweep by in succession, which lend themselves naturally to endless recombination. Our sensitivity is also subjected to the rarefied experience – all the more violent because often suppressed – of protracted long takes. In direct opposition to the media circus that followed the disaster, the film contains no interviews and no narration whatsoever. Through minimal camera movement, static framing, and montage, *Tres semanas después* creates a deconstructed surface through the strength of its own compositions. Torres Leiva gazes with bewilderment, face to face with the catastrophe. A heavy calm hangs over everything. The earth no longer trembles. Colours, waves of sound, the texture of things seem to have absorbed the earth's energy [*la energía telúrica*] as they vibrate undaunted on their way to our retinas.

As if the experience of the earthquake not only required the implementation of urgent political, logistic, and sanitary measures, but also that the victims return time and again to contemplate the abruptly shaken earth, there appears the figure of the seismograph. A viewing machine that registers the earth's oscillations in its own code, the inscription of a visual authorship that at that same time as it undertakes the writing of the disaster, dares to film those layers of the present that tend to remain exposed. Thus, faced with the unforeseeable, *Tres semanas después* presents a view of the catastrophe that distances itself from the universe of victims and heroic actions, from the testimonies and the official visits of engineers and government bureaucrats. Unlike the newsreels of the past, like *Imágenes de terremoto de Chillán*, or contemporary TV reports, *Tres semanas después* treats the viewer as a participant in a journey in which the landscape [*el paisaje*], regarded with the perspective of critical distance, appears as the singular protagonist. One must learn to discover, amidst the rubble of earthquake after earthquake, how to reconfigure the concept of landscape through audio-visual means, which, in turn, leads to the transformation of the cinematic space surrounding the protagonists of the film. The national territory [*territorio nacional*] is slowly submerged in waste, a chaotic jumble of images, an infinity of fragments, a catastrophic vision, which, upon being reframed and put in motion once again, functions with the randomness of a kaleidoscope that is disassembled piece by piece.

Torres Leiva imposes another cartographic layer over the landscape that he films in the regions most affected by the earthquake. But while the projected images are far from pastoral or naturalistic, they also do not correspond to the catastrophic or dystopian imagery that at times has characterized Latin American film. This is not "*los nuevos cines*" [of the 1960s and 1970s], whose epic characters were engulfed in the precariousness of open space and left on their own to confront the antagonistic forces of nature. *Tres semanas después* displays a sort of sensorial empathy towards the land, an agency that operates from the realm of the unknown. The experience of the devastated territory cannot be contained within consciousness, within any text or dialogue, least of all the dramatic media onslaught following the quake and the destructive tsunami. *Tres semanas después* proposes a new perspective [*una nueva mirada*] from which to contemplate tragedy: a view from the outside – an outside that is concrete, specific yet not unique, territorially inscribed under the figure of "*la zona*," yet not entirely identifiable. *There is no possible narrative*. This wounded territory resists all measurement. It mounts an abstract rebellion: a hypnotic flow of nameless images, impossible to attribute to a specific location, like close-ups from Mars (a Mars that in reality is closer than we think, from Concepción to the coast). Without predicative images to illustrate that which is real, such a documentary cinema begins to conceive of setting no longer generically, in terms of scenario or symbolic background – pure visuality – but rather as image, structural principle and rhetorical ground.

I refer, with the distinction between image and visuality, to the possibility of finding an analogous mechanism to define the difference between landscape [*paisaje*] and territory [*territorio*]. For Serge Daney, the *sine qua non* of the "image" is its alterity.[9] The

act of looking [*mirar*] transcends the optics of vision and refers to the contemplation of a particular and concrete other. Something similar might occur with landscape. If the visual is the mist that hides and numbs the disjunctive power of images, a procedure of power befitting the homogeneous effect of clichés and stereotypes, territory, setting or milieu (as given, transparent and standard in terms of dimension) would conform at the same time to another type of fog. In this context, it is a matter of perceiving, as Torres Leiva does in *Tres semanas después*, landscapes or "images of the disaster" that realize this tension. That is to say, he films natural or cultural spaces in a particular way that insists upon off-screen space; by way of saturating or emptying the frame, he rarefies the figure/ground delimitation. The visual [*la mirada*] is denaturalized and, thereby, acquires definition and agency beyond scenography. Once this point is reached, the strictly scopic potency of the gaze [*la mirada*] appears; as if when faced with the decline of the big picture, before the desolate view of the wide shots, a fantasmatic subject took over and began to run blindly through the [visual] field.

Torres Leiva pushes the gesture of the partially autonomous camera to the extreme, to the point that one longer knows to whom this gaze belongs. Neither the director nor the spectator realize it completely. One can no longer tell who appears in the film, nor the material effects of the disaster. The camera moves slowly and persistently as if at the unhurried pace of geological time; it plumbs, like a relative but independent consciousness, the long *durée* of this affected space plunged into crisis. The image *endures* in the tracking shots or, frame by frame, in the expanded time of the still shots that are formalized like a series of portraits, in the close-ups of wrecked highways or the waves of the sea. One witnesses the pure optical and aural display of actions that belong less to their producer and more to the concrete and temporally encoded space that envelops them. Peter and Christa Bürger consider [that] the history of subjectivity is marching towards the disappearance of the *I*: "The *I* is not the subject of its thoughts but rather its milieu […] in a disconcerting way the boundaries between the inner and the exterior are blurred." In a similar vein, one might say that in *Tres semanas después*, alongside the rhetorical categories of the time-image, the very substance of the gaze [*la mirada*] takes on the form of a Deleuzean desiring-machine. It becomes an immanent landscape, composed of flows and irradiations. The film marks the crossroads between the clichéd image of the death of the subject and the eclipse of a consciousness that contains within itself a form in pursuit of a new subjectivity, one which, uprooted from the body, chooses landscape as its preferred medium.

On being framed or detained by the gaze [*la mirada*], the territory [*el territorio*], the disaster zone around Constitución, becomes landscape [*paisje*].[10] An apparently neutral surface, common to every film and every culture, finds itself in sudden conflict. The earth trembles: the background, that which is taken for granted, is called into question. As a result, a new subject, no longer sensible or practical, acquires form. From the spatial, temporal, aural, structural and tactile rarefaction of the image, the scopic field of the narrative itself assumes the dominant role. The twists and turns of unusual perspective create a paradoxical logic of the frame. By means of deframing (décadrage),[11] the image is redirected towards a

completely different dimension. The shots, in their human scale, merge together with the chromatic warp of fine planes of detail, to the point that the panoramic vista of the sea dissolves into an ocean of rubble amidst the steep cliffs of deformed buildings.

Seismographic cartographies: dismembered maps in *Cofralandes* and *Mapa Fílmico de un país*

It makes sense to think of cartography in terms of cinema and tectonics. Traditional geographers, however, would view such a notion with suspicion. They consider maps as scientific images of the world, an inert register of the morphology of landscape. Some treat the clarity and eloquence of maps as a teleological discourse that personifies power, yet fail to take into account that, in terms of the *status quo*, all geographical prophecies have been institutionally realized and accomplished. J. B. Harley notes that

> The social history of maps, unlike literature, art, or music, appears to have few genuinely popular, alternative, or subversive modes of expression. Maps are pre-eminently a language of power, not protest. Though we have entered the age of mass communication through the medium of maps, the means of cartographic production, whether commercial or official, is still largely controlled by dominant groups. Cartography remains a teleological discourse, reifying power, reinforcing the status quo and freezing social interaction within charted lines.[12]

The exercise of cartography to which we refer stands, in the case of the audio-visual products discussed here, as an operation that has reached its limits. Although not completely subversive, it has installed itself within an institutional framework by occupying the margins. A map like this is at once meaningful and delirious. It goes beyond the limits of the beaten track, as implied by the etymology of the word *delirium*. It exceeds the limits of geographic space by way of specific technical determinations in order to venture into a territory that can at once be written and read in terms of the form and the method of an essay.

"Last night the ground shook, sometime around four or four-thirty. I couldn't get back to sleep, and I kept thinking about the country house, I can see it right now, that house, in Limache. Then I fell asleep." The first part of *Cofralandes* (Ruiz 2000–2002), a documentary series divided into four chapters, begins with these words, spoken off-screen. What kind of *dérive* are we embarking on? What sort of material will we encounter and what will happen at the end of the line? It's hard to know for sure. Apparently, [from this] chance arrangement of "puzzle pieces," one could assemble a particularly seismic discourse of cartography that dwells deep within contemporary Chilean documentary film and its wild variety of forms. Later in the film, Ruiz speaks in his own voice: *And I wanted to say Chile, and who knows what came out*. *Cofralandes* is Raul Ruiz's own "Chilean Rhapsody," an attempt to give an account of his impressions of the country. The film is full of paradoxical impressions, typical

of a dream world, a sort of Garden of Eden. In this space, anything can happen, as in Violeta Parra's song, the "City of Cofralandes":

There is a city very far away.

The poor head over there.

The walls are made of bread.

And the pillars are made of cheese.

Raúl Ruiz often made use of his *exile privilege*, as Charles Tesson calls it, to "see that which those who stayed can no longer see."[13] In 2000, as on other occasions, Ruiz travelled to Chile to direct an audio-visual project to be financed by the Ministry of Education. The film leads us to believe that everything happens because of the fragility of the order of cause and effect, due to a series of random events, as unexpected as an earthquake. Raúl meets his friend Bernard, a trained anthropologist, at a Chinese restaurant in Paris; Bernard convinces him to embark upon a trip to Chile, by impersonating a certain Arnaud who was supposed to do a report on the country. They meet two more foreigners by chance – a German who draws landscapes on public transport, his pencil guided by the vagaries of the road or the mood of the driver, and an English sociologist who travels through Chile studying suicide rates that drop as soon as he sets foot in the country. "*Who knows what*" this is all about? Is it a documentary or docufiction? An audio-visual portrait of the country? Or a dismembered map, a space of inversions, coexistences and permeabilities that traces the landscape of Chileanness in secret code – as in the lines of the traditional song, "The Divided Body": "*a finger in Paraguay, an ear in Great Britain.*"

We know nothing "about the terms of the contract between the director and the governmental office, nor about the objectives of the project, but we suspect that they might correspond to the then president's political intentions of producing cultural monuments for the Bicentennial and the 30th anniversary of the coup that overthrew Allende."[14] But if the final product appears dubious with respect to its institutional objectives, it is not simply because the cultural monuments recorded, like the Sandwich Museum, for instance, do not fit within the "repertory of memorial works." The map formed by the constellations of these landmarks does not follow a rectilinear design, consistent in the demarcation of its borders. Instead, it registers a range of impressions concerning the vibrations of the land [*del terretorio*], seismic impressions of this "jewelry box behind the Andes."

So, it would seem that, in tandem with seismic activity, the audio-visual rhetoric of the film warps the space-time continuum by exposing the tension between the regional and the global. *Cofralandes* wraps up the world in a single gesture. It contains an endless number of views and vistas, urban and rural, interior and exterior, documentary and fictional. The film unfolds through a kaleidoscopic montage of fades and dissolves. Its sound design far exceeds the range of music and speech recorded on separate tracks. Traditional songs, easily recognizable parts of the Chilean countryside, fragments of dreams narrated

off-camera, red double-decker buses like those in London, dogs running along the beaches of Antofogasta, grand Parisian-style boulevards, a sandwich museum in the heart of old Santiago, cobblestone streets like in the Basque Country, the country house from Ruiz's childhood in Limache invaded by an army of old Santa Clauses [*viejos pascueros* in the local dialect], radio recordings of the 1973 coup: all of this is mixed together with no apparent direction or meaning. Perhaps, as Pablo Corro explains, Ruiz's film is to be understood in the sense of a rhapsody, a "musical piece, formed by fragments of other works or with bits of popular tunes." It goes without saying, then, that in *Cofralandes* the telluric [*lo telúrico*] does not appear in an obvious way. Ruiz films neither the earthquakes, nor the rubble, nor the immediate aftereffects. He captures the fantasies of a country that witnesses its own image being displaced, a culture that cannot find itself other than by way of the broken lines on a map, whose traces exist only in the record of oscillations imprinted on the streets of Santiago, in fugitive statistics, in forested landscapes, and finally, in the qualities of the spoken word.

Tres semanas después induced a hypnotic and contemplative state through the insistent flicker of fragmentary images or the arrangement of slow tracking shots that transported attention away from the immediacy of the disaster towards an other delayed temporality, shaped more by duration than by the untimely occurrence of the events. *Cofralandes,* on the other hand, embarks on a journey into sound, a cinematic *flânerie*, that breaks with the limitations of linear storytelling. Ruiz follows the proposal of the Noble Prize winning poet, Gabriela Mistral, for an *Audible Map of Chile*:

> Visual maps, as well as tangible ones, have already been made; what's missing is a map of resonances that can make the world "listenable." But this will come, and sooner rather than later; it will pick up the mix of noise and din from a region […] alighting with the "angelic" palps of the radio upon the Brazilian or Chinese atmosphere. It will be given to us truthfully like a mask, untouchable and effective, the sonorous double, the symphonic body of a race that works, suffers and fights.[15]

In a whisper, sometimes even babbling unintelligibly, Ruiz tells the confusing story of his dreams, the fragmented and digressive chronicle of the voyage through Chile undertaken with Bernard, the list of things that remind him of the Chilean flag or that the hand can grasp. He's sketching the outlines of a cartographic portrait, a speculative map of Chile.

Ten years later, the website www.mafi.tv , in that same spirit of *"who knows what,"* will serve as the portal for a permanent cartographic reformulation, the *Filmic Map of a Country*. The banner of the site does not refer to Chile, but, more indirectly, to *a country* [*un país*]. This map is constructed from an infinite number of views, fragments torn from an exposed national reality. Upon entering the site, one can browse a mobile display of images by following distinct pathways: location, film-maker and date. A series of micro documentaries are viewable, as in a news website, under various categories: *Politics, Entertainment, Lifestyle, Technology, Ecology.*

The films must follow precise technical specifications: a single shot, static camera short duration, clearly recorded sound. Each piece must be a documentary *about contemporary Chile*. The project has been created and curated by Christopher Murray, Ignacio Rojas, Antonio Luco y Pablo Carrera, as well as their frequent collaborators, Maite Alberdi, Iván Osnovikof, Bettina Perut, José Luis Torres Leiva and others. The brief description of the project, which also serves as the call for contributions, states that the objective is "to capture fragments of the national reality, in order to create a filmic map of our present situation through an authorial gaze [*mirada*] that is reflexive and of high visual quality." Without a doubt, an analogy can be drawn with the *Vistas Lumière* whose camera operators mapped the world. In the discrete, "un-manipulated" character of these pieces, one can observe a [similar] collective critical operation. Here, notwithstanding the winking of the website's logo, the space of early cinema and digital film come into alignment. The *Filmic Map of a Country* differentiates itself in this way from the torrent of images that circulate daily on television, on news and miscellaneous programs, even on YouTube or in other undiscovered latitudes of the Internet. In this case, the critically reflexive character of the images, although inscribed by the authors of each piece at the moment of formulation, is not displayed in its totality until all of the clips are set into motion together. The tectonic density of the website is then revealed.

The micro-documentaries on the *mafi.tv* website may resist the "cut." Yet, only through the concept of montage is it possible to inscribe these supposed fragments of Chile within a global panorama. The current state of the nation completely exceeds measurement according to the institutional categories referred to earlier. The experience of navigating through the *Filmic Map of a Country* could be compared to the motion of a seismograph, the machine that measures the variability of the earth. In *Cofralandes* too one encounters a precarious and fragmented pattern of images. Both texts seek to illustrate and illuminate a zone of reality defined along the lines of a cartographic identity. They recount its distinctive features, geographical accidents, linguistic and idiosyncratic aspects. They do not ignore the geographic, cultural or political universe in which their images are installed. Yet, at the moment that they begin to translate the space that they intend to encompass, other forms of representation systematically infiltrate what, for the sake of convenience, may still be referred to as documentary film. Raúl Ruiz and the film-makers of mafi.tv break ties with descriptive and linear thought and turn towards montage. Their films function as critical devices for the reconfiguration or reinterpretation of the very land itself [*mismos territorios*]. It is almost as if the map of this undefined country, formed by telluric cycles that transform it into ruins and force it into a state of permanent reconstruction,, were to fall from on high, shattering into a thousand pieces, multiplying its perspectives and incidental angles.

J. B. Harley has stated that "*seeing was believing in maps*."[16] The image of a text that is both cartographic and seismographic requires an ever more radical distancing from the colonial mindset to which Harley refers. Seeing – in the digital age, in the age of *docuficción*, of audio-visual websites on the Internet, of immediate and simultaneous images of

earthquakes and tsunamis that spring up on Twitter and Facebook – is transformed into something problematic. Seeing will no longer mean believing in the accuracy of the filmic image, nor in its phenomenological or indexical properties. The 1:1 scale of Borges's immeasurable map no longer reflects the indexical qualities of light.[17] Now, to see is to believe in the power of circulation and montage to create stories and transport us from past to present.

In this respect, the metaphorical allusion to a "telluric cartography" also carries a methodological significance that affects how one negotiates these circuits of images. According to Harley, "all cartography is an intricate and controlled fiction." Ruiz's visions of Chile, on the other hand, are far less controlled in their endless *dérive*, as are the intimate and secret relationships that burst into view in the intervals between the downloaded images on mafi.tv. The lines on these "maps" do not tamely survey and grid a topographic space. They are "maps" that shake, shudder and tremble [*tiemblan*]: they test, invent, imagine and inhabit a territory [*un territorio*] – like the divided body in *Cofralandes* or Mafi, the filmic map [*mapa fílmico*] composed of a patchwork country. At this point, it would not be too extravagant to take a momentary detour from the map to the Atlas.

The atlas of images, Abby Warburg's *Mnemosyne Atlas,* assumes the task of carrying "the world on its shoulders." It consists of movable sheets, like fluctuating tectonic plates, that are placed in provisional positions. The atlas functions by virtue of the concept of montage as a reading machine (a legibility machine), which, in the words of Didi-Huberman, will disclose itself "under its utilitarian and harmless appearance […] as a double object: dangerous and explosive yet inexhaustibly generous."[18] Thus, in both *Mafi* and *Cofralandes*, the atlas serves a paradoxical function, split between its specific and dispersive meanings. One may employ it as a cartographic and seismographic apparatus [*dispositivo*] to locate oneself within a specific territory, to learn something about Chile, for instance – something about *waltzes* and *recollections*, about *museums* and *clubs*, about *current events*, about *politics, ecology,* or *show business*; something about the magnitude of each earthquake, whether it register 8.8 or 9.6 on the Richter or Mercalli scale. The truth is that one forgets what one was looking for in the first place and, as if among the rubble, one wanders aimlessly.

In the end, what is an earthquake? A shaking of the earth's crust, an apparatus [*dispositivo*] for metamorphosis, a violent movement that inscribes fissures on the earth's surface, an event that disrupts the experience of time. It is also a traditional Chilean cocktail, *el Terremoto*; a mixture of white *pipeño* wine, pineapple ice cream, cognac and a touch of *fernet* or bitter liquor.[19] *El Terremoto* takes its name from the 1985 quake, 7.8 on the Richter Scale, whose epicentre was located in the coastal region near Valparaíso. Inti Brontes, the cinematographer of *Cofralandes*, often sets up his shots behind clear glasses of wine and litres of beer. The spectator, intoxicated by his camerawork, as if under the effects of a strange illness, loses the capacity to comprehend the world according to the causal order of things. Inebriated perhaps by *Terremotos,* we linger and lose ourselves in order to find, once more, another order in an open constellation of inconceivable correspondences.

References

Berque, A. (2000), *Médiance: de milieux en paysages*, Paris: Belin.
Bonitzer, P. (1978), "Desencuadres," *Cahiers du cinema,* 284, January.
Burger, Christa and Burger, P. (2001), *La desaparición del sujeto. Una historia de la subjetividad de Montaigne a Blanchot,* Madrid: Akal.
Castillo, G. (2003), *Estéticas nocturnas*, Santiago, Pontificia Universidad Católica de Chile, Instituto de Estética.
Daney, S. (2003), *Cine, arte del presente*, Buenos Aires: Santiago Arcos.
Deleuze, G. (1987), *La imagen-tiempo*. Barcelona: Paidós.
Foucault, M. (1984), "Los espacios otros," *Architecture, Mouvement, Continuité,* October 5th.
Harley, J. B. (2001), *The New Nature of Maps: Essays on the History of Cartography*: Baltimore: Johns Hopkins University Press.
Mistral, G. (1957), *El Mercurio*, October 21st, 1931 in Alfonso M. Escudero (ed.), "Recados contando a Chile," Santiago de Chile: Ed. del Pacífico.
Oyarzún, L. (1995), *Diario íntimo*. Edited and with a prologue by T. Leonidas Morales, Departamento de Estudios Humanísticos Facultad de Ciencias Físicas y Matemáticas Universidad de Chile, Santiago de Chile.
Rojas Mix, M. (1992), *América imaginaria,* Barcelona: Lumen.
Ruiz, R. (2000), *Poética del cine,* Santiago: Sudamericana.
Subercaseaux, B. (1940), *Chile o una loca geografía*, "El país de la tierra inquieta," Santiago: Universitaria.
Vicuña Cifuentes, J. (1912), *Romances populares y vulgares de Chile*, "Los terremotos de Chile," Barcelona: Imprenta Barcelona.

Notes

1. Edwards Bello, Joaquín. *Recuerdos porteños* en http://blog.latercera.com/blog/muronacional/entry/recuerdos_porte%C3%B1os_por_joaqu%C3%ADn_edwards.
2. Speech by José Ortega y Gasset, December 4th, 1928, before the Chilean National Congress. José Ortega y Gasset, "Discurso en el parlamento chileno" en Obras completas, tomo VIII, Madrid, Revista de Occidente, 1965, p. 380.
3. Gabriel Castillo, *Estéticas nocturnas*. Santiago: Pontificia Universidad Católica de Chile, Instituto de Estética, 2003, p. 147.
4. Luis Oyarzún, *Diario íntimo*. Edited and with a prologue by Leonidas Morales T. Departamento de Estudios Humanísticos, Facultad de Ciencias, Físicas y Matemáticas, Universidad de Chile, Santiago, 1995, p. 58.
5. *La araucana* is Alonso de Ercilla's (1533–1594) epic poem about the Mapuche Indians' resistance to the Spanish conquest.
6. Raúl Ruiz, *Poética del cine*. Santiago: Sudamericana, 2000, p. 33.
7. http://www.cinechile.cl/pelicula-887.
8. Christian Ramírez, Fidocs 2010: Heridas muy abiertas, El Mercurio June 6th, 2010.
9. Serge Daney, *Cine, arte del presente*. Buenos Aires: Santiago Arcos, 2003. p. 269.

10. For the French cultural geographer Agustín Berque, landscape is always in tension between the given facts of the setting and the view, between the ecological and the phenomenal, between objectivists and subjectivists in a dialogue of the deaf. Berque creates the term *médiance*, signalling that the landscape cannot be tackled theoretically unless one assumes that its identity is forged in a network of such contradictions. We might say that landscape, defined as the given setting + the continuous action of *médiance*, is conjugated with the attributes of a trajectory which approaches an existential experience of space in film by conjuring up the power of framing as a selection of relationships.

11. A term developed by Pascal Bonitzer and based upon Gilles Deleuze's concept of out-of-field in the time-image, as well as the theories of Noel Burch in the 1970s.

12. J. B. Harley. *The New Nature of Maps*: *Essays in the History of Cartography,* Baltimore: Johns Hopkins University Press, 2011, p. 79.

13. Cahiers du cinéma, p. 347, May 1983, « Lettre d'un cinéaste ou le Retour d'un amateur de bibliothèques», Charles Tesson.

14. Pablo Corro, "Cofralandes I, Hoy en día (2002), Raúl Ruiz" en *Retóricas del cine chileno: Ensayos con el realismo*. Santiago de Chile, Editorial Cuarto Propio, 2012, p. 104.

15. Gabriela Mistral, *El Mercurio,* October 31st, 1931, quoted in "Recados contrado a Chile" Santiago: Editorial del Pacifico, 1957, p. 139.

16. J. B. Harley, *The New Nature of Maps: Essays in the History of Cartography*, p. 9.

17. Jorge Luis Borges, "Del rigor en la ciencia," *El hacedor,* Madrid: Alianza, 1997, p. 40.

18. Didi-Huberman, Georges. *Atlas ou le gai savoir inquiet*. L'œil de l'histoire 3, Paris: Les Editions de Minuit, 2011, p. 12.

19. http://es.wikipedia.org/wiki/Terremoto_(bebida).

Chapter 10

The Earth Still Trembles: On Landscapes Views in Contemporary Italian Cinema

Giorgio Bertellini

The Italian city, ancient or modern, is prodigiously photogenic.

André Bazin, 1948[1]

L'Aquila, capital of Abruzzo, in central Italy, is a long way from the Rockaways and Staten Island, but its struggle to recover from an earthquake may provide a cautionary tale for New York, post-Hurricane Sandy.

New York Times, December 1st, 2012[2]

In recent years Italian cinema seems to have developed a special interest for the narratives and characters of migration. In early September 2011, from their observation post at the Venice Film Festival, Jacques Mandelbaum and Philippe Ridet of *Le Monde* referred to this production trend in Italian cinema as something akin to a genre in and of itself [*un genre en soi*].[3] This pronouncement was made public even before Emanuele Crialese's travel drama, *Terraferma*, received the Jury Award at the Lido. While discussing the festival presentations of Francesco Patierno's *Cose dell'altro mondo*, Barbara Cupisti's *Storie di schiavitù* and Ermanno Olmi's *Villaggio di cartone*, Mandelbaum and Ridet explained their assessment in terms of poetic justice: given that geopolitically Italy has been one of the European countries most exposed to the phenomenon of migration, its national film productions have responded accordingly.[4] As a result the wealth of recent films and the amount of critical attention to film works on migration narratives and characters, particularly from North Africa, Asia and Eastern Europe, was somewhat unsurprising.[5]

While films about migrant subjects are obviously no news in Italian cinema, particularly given the role of mass migrations in Italian history, over the past 20 years the attention has shifted to the phenomenon of migration *to* Italy – with glaring exceptions such as Emanuele Crialese's *Nuovomondo* (*Golden Door*, 2006). The late 1980s and early 1990s have seen the codification of a "genre" engaged in the revelation of immigrants' daily dramas and the denunciation of Italians' racism. The phenomenon has connected Italy's national cinema with the film-making production of other nations which also find themselves along the path of world migrations. A possible list of films working in this direction would include Michele Placido's *Pummarò* (1990), Gianni Amelio's *Lamerica* (1994), Carlo Mazzacurati's *Vesna va veloce* (1996), and Matteo Garrone's *Terra di mezzo* (1997), among others. Although these productions are not always comparable, Amelio's Oscar-nominated title was exemplary of

a work that, while focusing almost entirely on Albanian settings and landscapes, began to convey insightful and unpleasant ideas about Italy, its ruthless business schemes, historical amnesia, and corrupting televisual environment.

While keeping this poetic trend in mind, in this chapter, I am not primarily concerned with a genealogy or a recent phenomenology of Italy's "migration cinema." Instead I am more interested in considering one of the mirroring effects of immigration, namely the spatial recasting that the movement of people, and of course of languages and customs, has had on the *familiar* Italian landscape. I do not wish to speak of landscapes metaphorically, as in "social landscapes," but would rather stress the strong relationship between fictional narratives and their actual spatial and geographic locations, as well as the living bond that characters forge with the sites that they inhabit. I argue that, in recent years, Italian cinema has begun to critically re-explore the rendering of Italian places and landscapes and has, as such, reactivated one of the nation's most important cultural patrimonies, that of spatial experience, in relationship to the corrosion of civic solidarity and responsibility. In brief, while showing the plight of foreigners on screen and presenting their struggles to settle in the domestic sphere, Italian cinema has also ventured into various forms of Rossellinian voyages in Italy, sometimes in the company of outsiders and their views. Since the 1990s, but particularly in the 2000s, these spatial explorations, whether explicitly or not, have produced remarkable insights into the nation's self-assessment and self-understanding, and they have done so through a "poetics of space," that is an interest in the peninsula as a shared place, or home, subject of collective responsibility and not just the object of cultural representation and aesthetic delectation. As such, these films have contributed to a filmic output that is sharply distinct from the Italian cinema of the 1980s and that, in various ways, showcases and reflects upon a growing sense of territorial *degrado*, or dilapidation of one of the nation's most precious treasures.

Going out

In the 1980s, Italian films displayed such an insular and solipsistic character that it was as if directors had progressively become incapable of getting their characters outside themselves and out in the world.[6] Many film-makers agreed with this view. In an attempt to address this disturbing trait, Nanni Moretti created a fictional scene in his confessional *Caro Diario* (1993) – a film within the film – where a few affluent characters sit in an elegant living room and refuse to venture outside while commiserating with each other on their lives' ugly and selfish decisions. By contrast, Moretti proudly claimed his difference by riding his Vespa around Rome. As if suggesting that he never stopped actually looking at the world, Moretti-the-director has the camera follow closely Moretti-the-character riding his scooter himself through the city's outer suburbs, over well-known bridges, and into private courtyards. To many, the film provided a refreshing cinematic solution and a remarkable poetic statement.

In the same year, the question of the corruption of the landscape, iconically represented by landfills, building abuse, and impending natural disasters, was already at the centre of Daniele Lucchetti's *Arriva la bufera* (*Here Comes the Storm*, 1993). The film featured an inept magistrate who is transferred to a symbolic Southern outpost that, as in the one-horse towns of many westerns, is utterly indebted to the patronizing generosity of a single family-clan, represented by the three sisters who exert total control over the garbage collection business. The family's corrupting power over the town and its territory is ultimately revealed by the surprising but unbreakable rapport between one of the sisters and a shrewd and corrupted local lawyer, an expert in milking funds from the European Community. What further granted the film a most sinister spatial dimension were the repeated views of the surrounding landscape dotted by incinerators and a threatening volcano, bound to explode and to bring a human and environmental disaster to the whole area. *Arriva la bufera* belonged to a group of films that appeared to look at familiar sites through a different, "migrant perspective," and that as a result paid attention to rarely explored locations, including cities' racial ghettoes, suburban spaces, the *provincia*, and the countryside.[7] Consider the mysterious and almost unrecognizable Naples of Mario Martone's *L'amore molesto* (*Nasty Love*, 1995), the marginal Roman locations in Matteo Garrone's *Ospiti* (*Guests*, 1998), or the obsessively limited views of the capital in Bernardo Bertolucci's *L'assedio* (*Besieged*, 1998). These films' anti-touristic approach was novel, risky, and refreshing, but not widely appreciated at home and abroad. It is worth remembering that the blockbusters of the long 1990s have been films, from *Nuovo Cinema Paradiso* (1989) and *Mediterraneo* (1991) to *Il Postino* (*The Postman* 1994), *Il ciclone* (*The Cyclone*, 1996) and even *La Meglio Gioventù* (*The Best of Youth*, 2003), which managed to intertwine politically charged narratives of family, friendship, and solidarity with enchanting views of the country's most recognizable Italian cities (and islands).[8]

It is not this postcard-like rendering of the nation that I am interested in discussing. To be exact, it is the notion of Italy as an inhabited place that I wish to focus on, one that features dramatic events that we could group under the category of "disaster," whether occurring suddenly, as one-time incidents, or extending over a period of time. It is a narrative that Italo Calvino mobilized as early as 1957 in his short novel *La speculazione edilizia* (*Building Speculation*), but which has marked Italy's natural and cultural history for decades.[9] Narrated in the first person, the novel is the story of an intellectual with film aspiration who improvises himself as real estate entrepreneur along his native Ligurian Riviera. His motivation is not greed, but a pressing desire to feel attuned to the new, pervasive consumeristic ethos that has replaced the political passion that he, like most Italians, had felt until a decade earlier. His confrontation with his building impresario, a vulgar but cunning man, brings to the fore the disorientation of leftist intellectuals who are unable to translate older values of democratic solidarity and respect into modern, commercially viable initiatives. Bourgeois amorality, with its utter disrespect for the landscape and decent aesthetic standards, prevails, resulting in the protagonist's utter sense of alienation. It was a feeling that Italian directors captured in a number of films of the same period, mostly set in the new suburban quarters outside of Rome, from Fellini's *La Dolce Vita* (1960) and, most

eloquently, Antonioni's *L'Eclisse* (1962) to Pasolini's *Mamma Roma* (1962) and *Uccellacci e Uccellini* (*Hawks and Sparrows*, 1966).

Several public events that occurred in Italy, but which held a broader European significance, have spurred a renewed interest in landscape preservation. They included the first *National Conference on Landscape*, held in 1999 in Rome at the Cultural Heritage Ministry, and the 2000 *European Convention on Landscape*, signed in Florence in October 2000, and known as the Florence Convention.[10] The ensuing interest has translated into the emergence of an epistemological recasting of the notion of landscape and its extension to all major disciplinary perspectives. The Florence Convention directly addressed the dichotomy and confusion, common in ordinary language, between environment, which pertains to the biological perspectives of ecology, and landscape, which instead concerns subjective forms of representation, the connotation of "landscape," by insisting on their convergence. Landscape is neither just a natural nor a cultural phenomenon; rather, it refers to the shared site or home of natural resources, social communities, and aesthetic values. As such it demands an ethics of governance and a civic responsibility that crosses all disciplinary divisions and that considers landscapes as living spaces – or spaces of life – inhabited by individuals and communities and housing a shared historical memory and identity. As Luisa Bonesio, one of the key exponents of this intellectual movement known as geophilosophy, put it, "Responsibility toward places is as vital as the respect for human and cultural diversity."[11]

Such an epistemological turn has also informed the emergence of a new philosophical paradigm, consisting of periodicals (i.e. *Tellus: rivista di arte, geofilosofia e letteratura,* 1990–), a publishing series (*Terra e mare: collana di geofilosofia*; Diabasis 2007–), and a number of foundational texts that encompass philosophy, law, history and sociocultural criticism.[12] In a related area of cultural production, there are also significant photographic and journalistic works aimed at reporting on the transformation of the Italian territory into spaces of neglect, exploitation, and abusive appropriation. Since the pioneering photographic reportage of Luigi Ghirri and Gianni Berengo Gardin, the recent contributions of photographers and artists variously associated with the Milan Provincial Government's project *Archivio dello Spazio* have drawn public attention to how the peninsula has lost its agricultural lands, forests, and watercourse and basins to unregulated residential and infrastructural exploitation.[13] On the journalistic side, a new genre of works have variously identified, and denounced, a "party of concrete," namely a coalition of interests vested in the systematic exploitation of the national territory, particularly the South and the peninsula's coastlines.[14]

Italian film criticism has also paid increased attention to the settings of Italian film stories. The scholarly trend of including geographic considerations in the study of a nation's artistic production, whether literary or filmic, has informed a number of important studies. It has informed quite explicitly the essays of an anthology, *Atlante del cinema italiano: corpi, paesaggi, figure del contemporaneo* (2011), edited by Gianni Canova and Luisella Farinotti. In the introduction of the anthology, one of the editors polemically acknowledges the solipsistic character of the Italian cinema of the last decades, prisoner of "its inward looking tendency, in a sort of obsessive return to the usual places or, worst, within the confines of the domestic

walls."[15] When Italian cinema allegedly pays attention to the national landscape, it does so by selecting the usual suspects – romantic Venice, laborious Milan, the easily corrupt North East, lazy Rome, and the sunny Neapolitan coastline. The familiar tourist paradigm remains dominant and the consequence is a failure of engagement:

> Consumed by a drive to entertain at any cost and forced into a false picturesque, the landscape is utterly *ignored* by contemporary Italian cinema, which instead transforms it into a postcard *even when* it is not the setting of vacation narrative.[16]

In a few cases, however, Italian cinema has showcased dramatic instances of social and environmental corruption. The countryside, whether in the North of Daniele Gaglianone's *Nemmeno il destino* (*Not even Destiny*, 2004) or in the South of Matteo Garrone's *L'imbalsamatore* (*The Embalmer*, 2002), is not the site of a vacation from an impossibly stressful urban life. Instead, it is the *locus* of post-industrial ruins and consumeristic dystopia, where constructions and cement, whether operating or abandoned, rule unchallenged.

Italy, in concrete

Even an arbitrary look at a good number of recent films reveals the extent to which places and spaces have become key evidence of an unchallenged logic of profit and civic disregard that, by defeating any sense of *publica utilitas*, is causing environmental and anthropological devastation or *degrado*. This tendency does not just express itself straightforwardly, that is, by foregrounding illegal building practices, (failed) garbage collection, or senseless environmental exploitation. It also assumes more inventive forms, by articulating, for example, a need to recuperate a physical sense of place and the semblance of a personal life, both socially and existentially grounded. Fictional narratives, but especially non-fictional ones and fictionalizations of popular reportages of criminal activities or natural disasters, have revealed a new form of ecological dramaturgy, whereby characters, but especially viewers, are called to share authors and film-makers' sensibility in the nation's territorial well being.

A range of public discourses, scholarly, journalistic, and critical, have developed a cogent view of altering landscapes, atlases, maps, and cartographies as part of the nation's key dramatic narratives. In terms of its widespread popularity (and critical acumen), it is impossible to ignore the best-selling *Gomorra* (2006). Roberto Saviano's work placed the Camorra in a global context of commercial exploitation and in a national one of environmental disaster. At the centre of his eloquent analysis (and of Camorra's business success) is a very tangible matter – concrete. In one of his most suggestive passages, Saviano revealed the inspiration for his insights by quoting the famous opening of Pasolini's 1974 *Corriere della Sera* article:

> I know and I can prove it. Successful Italian businessmen come from cement. They're actually a part of the cement cycle. I know that before transforming themselves into

fashion-model men, managers with yachts, assailants of financial groups, and purchasers of newspaper companies, before all this lies cement. […] the constitution should be amended to say that it is founded on cement.[17]

As eloquent and articulate as Saviano has been, the trajectory from Pasolini to the present comprises other voices, images, and stories. They have become particularly cogent around the tragic earthquake that in 2009 devastated L'Aquila, but they have also included reflections and narratives not strictly linked to natural disasters. Thus, in addition to Matteo Garrone's much-analysed cinematic adaptation of Saviano's novel in *Gomorra* (2008), a range of other films of various success have focused on the representation of Italian landscapes and living spaces as sites of a broader natural and anthropological defacing. They have done so by focusing on two narrative vectors, one quite conventional – the contemporary state of the Italian *family* – the other much more cogently associated to *work*, or lack thereof, namely the frighteningly low employment perspectives that Italians, particularly young people, face today. Ultimately, even when foregrounding questions of violence, political engagement, and national history, these narrative strands have revolved around the same pervasive dimension of unregulated commercial exploitation. The confrontation between *publica utilitas* and private interest has tragically tilted towards the latter to the point that the Italian cultural patrimony, made of its urban and countryside landscapes and its cultural traits and customs, has been priced, sold to the highest bidder, and used for further exploitation – often without many noticing.

This must be the place

Several productions openly convey how difficult it is in today's Italy to imagine a *place* to work and lead a normal and safe existence, and not one on the constant brink of financial disaster or violent reprisals. While superficially feasible, the alternatives are not ultimately positive. At the heart of these narratives are questions of unemployment or underpaid employment, leading to escape, personal defeat, inauthenticity or moral corruption. In social and urban landscapes where possibilities for honest and creative employment are denied, not even the return to nature is ultimately possible or believable, even when idealized within romantic narratives.

Alessandro D'Altri's *La febbre* (2005) features a 30-year-old architecture student, played by actor and novelist Fabio Volo, caught between the financial stability of secure employment as a municipal land surveyor in his native Cremona and his somewhat juvenile dream of opening a nightclub. The emotional and narrative tension of the film results from the conflict in values represented by the material pressures of holding onto his job in the local administration, even while witnessing illegal money-making schemes, and the courage and freedom of his girlfriend, who follows her dream of studying literature in the United States. In the end it will persuade him to make a key romantic decision: to move into his

own farmhouse to dedicate himself to his newly found passion, the manufacturing of art objects. After Volo's girlfriend returns home, the final sequence shows their long embrace in a digitally sutured combination of medium, long, crane, helicopter, and satellite shots. This suggestive zooming back reveals the short distance of the farm from the provincial centre, thus suggesting that the apparent happy ending represents merely a temporary escape that exudes a sort of juvenile utopia, or fever. The urban entanglements and cement blocks that Volo so heroically escaped, it seems, are just a few fields away.

When work is narrativized as an honest and fulfilling activity, it still turns out to be a risky business, in either environmental or criminal terms. This is what happens to Margherita in Paolo Genovese and Luca Miniero's *Viaggio in Italia: una favola vera* (2007). Margherita tricks her divorced parents (Licia Maglietta and Antonio Catania) into travelling by car from Milan to Stromboli, following the same emotional and tourist routes of Rossellini's *Voyage to Italy* (1954) and *Stromboli* (1950). Once they get to the Aeolian island, she confesses to them that she is not really getting married as she had told them. Her only professional option is to take the job of onsite scientist in charge of studying the volcano's perpetual eruptions. A similar combination of occupational destiny and proximity to danger confronts the volcanologist Concettina, a minor character in the aforementioned *Arriva la bufera*, as well as Rita, an officer in the Guardia di Finanza and protagonist of Cristina Comencini's *A casa nostra* (At Our Home, 2006). Not only does Rita fight every day against corrupt financiers and brutal criminals, but she also constantly witnesses the life-changing choices people make in Italy between unlawful means to quick wealth and the lawful showcase alternatives that result in endless financial struggle. By virtue of widespread unemployment and occupational immobility, several characters around her make key decisions about money and morality, either by accepting a low-paying salary as teachers or lending their body and name for illicit traffics. While the criminal plot has a positive resolution, the broader tension between the unlawful means to quick wealth and the lawful alternatives resulting in constant financial struggle identifies the familiar environment referred to in the film's title. In Italy, honest professions, the film appears to suggest, come with mortal risks.

These films, and others like them, show how scarce and limited are the dramatic choices that certain characters, particularly younger Italians, must make in their legitimate ambition for a steady job and a normal life. Italy is not a welcoming country, even to foreigners armed with the best intentions. In Giorgio Diritti's *Il vento fa il suo giro* (*The Wind Blows Around*, 2006), an entrepreneurial French shepherd moves to a small village, perched on the Occitan Alps of Valle d'Aosta, with his family and his goats. The majority of the locals in the village are struggling financially, but nonetheless are proud and distrustful. Their dialect may sound foreign to most, but their intolerance of diversity is quite familiar. Furthermore, memories of Italy's economic inhospitality continue to haunt those who left it for new countries of adoption. In Claudio Cupellini's *Una vita tranquilla* (*A Quiet Life*, 2010), a *camorrista* (Tony Servillo) long believed to be dead has instead reinvented (and saved) his life as a talented chef in a German restaurant only to find himself re-inhabiting the same brutal world he had once left behind.

The correlation between work and place has become a key point of access to the motivations and destiny of the central characters in these recent Italian films. The struggle to hold on to a decent occupation, the hazards involved in keeping a job and earning a decent living, and the rapport that people establish with places and sites are storytelling motifs that return with regularity. What they convey, particularly through an insistence on macroeconomic failure, is a sense of social decline and degradation of social spaces and natural environment. As such, Italian cinema has absorbed lessons and discourses that have recently risen to national consciousness about the defacement of the national territory.

Cementing views

The notion that places, landscape views, and geographic sites may themselves tell stories of danger, corruption and defacement has not been conjugated solely in the present tense. When reading Salvatore Settis' learned and passionate *Paesaggio Costituzione Cemento. La battaglia per l'ambiente contro il degrado civile* (2010), one realizes the *longue durée* of the battle for the preservation of the Italian landscape and the continuous efforts to exploit it from a legal, economic, and cultural standpoint.[18] Settis writes:

> Since the first decades following Italy's state formation, the preservation of the landscape (and that of the cultural patrimony) found it extremely difficult to be accepted, for one sole reason: it implied a hierarchy of values according to which public interest prevails over, and limits, the rights of the private property.
>
> (Settis 2002: 217)

Eventually, as Settis reminds us, the "preservation of the landscape" was written into the Italian Constitution (Article 9), which represented a world's first. The Article read as follows: "The Republic promotes the development of culture and of scientific and technical research. It safeguards natural landscape and the historical and artistic heritage of the Nation." Further, adopting both a historical and a critical framework, Settis defines the notion of landscape (*paesaggio*) as a nation's natural living site and, as such, as its civic and ethical patrimony. He has also masterfully analysed the systematic slippage of the meaning of the term *paesaggio* into the related notions of environment (*ambiente*) and territory (*territorio*), whose different conceptual character rely on statistics and quantitative measurements (i.e. of pollution and natural resources). The legal confusion that has ensued over time has affected both the actual Italian landscape and our understanding of its civic and ethical cogency. The urgent battle for Settis centres on recasting the Italian landscape, not just as an aesthetic object and certainly not as a tourist experience, but as an actual place to live with dignity as a community in opposition to its mystifying split into *paesaggio-ambiente-territorio* or its disintegration into different disciplines and legal responsibilities (Settis 2002: 308). Such *publica utilitas* ought to prevail against the seemingly unstoppable commercial

and political speculations (Settis 2002: 217). The activities of several associations (Italia Nostra, Fai, Legambiente, WWF, patrimoniosos.it, stopalconsumoditerritorio.it), who are engaged in promoting and divulging knowledge of hundreds of stories of destruction, land poisoning and contamination, have led to a grassroots popular movement that is committed to political resistance and solidarity for the common good.[19] Through the juridical notions of living community (*comunità di vita*) and environmental ethics (*etica ambientalistica*), Settis sets out to articulate a broader awareness of what he calls the "anthropic poisoning," a form of territorial alienation and environmental unease. As we have seen, Italian cinema has been quite sensitive to environmental anxiety, which it has rendered as existential malaise, social disaffection, professional hazards, while pointing to the national body's subjugation to corporate logic and political opportunism. In a few, most remarkable instances, certain films have addressed the question of environmental unease with impressive eloquence by adopting registers ranging from allegory and documentary to the sensual and the material.

Consider Mario Martone's *Noi Credevamo* (2010), released around the 150th anniversary of Italy's state formation. Two-thirds of the way into the film, two key characters, the Mazzinian Domenico (Luigi Lo Cascio) and the young Saverio, (Michele Riondino), are walking across the Cilentian countryside, their homeland, south of Salerno. Suddenly, shots of the forests and valleys include a view of a contemporary landscape feature, namely an abandoned and possibly illegal concrete structure, made of cement floors and naked pillars. It is a telling historical anachronism that reveals the film's value system, opposing political ideals of unification and solidarity with their later most glaring defeat, indexed iconically by corruption, wasteful constructions and civic indifference to the natural landscape. This is not an insight limited to one or two long shots; Martone articulates his point further. Under a contemporary structure of reinforced concrete, Domenico and Saverio, the aging ideologue and the faithful young acolyte, rest and talk. The commoner Saverio asks his older and worldly travel companion whether after liberating Rome and Venice, he would take him to see the rest of Italy, particularly its Northern regions, which he assumes are quite beautiful. The latter nods. But their conversation, right under the anachronistic concrete structure, is marked by hypocrisy. Domenico fails to tell his young political partner, with whom he is facing death at every turn, not only that he personally knew his father, but also that the old man did not die a hero, as the son believes, but was killed by a jealous patriot. Martone, in other words, skilfully uses the contemporary corruption of the landscape to tell the story of the mortal sin of duplicity and betrayal that marked the Risorgimento and even some of its best figures.

The themes of civic betrayal and territorial despoliation are explicitly addressed in Sabina Guzzanti's filmed polemical documentary *Draquila: l'Italia che trema* (*Draquila: Italy Trembles*, 2010), about the reconstruction practices following the 2009 earthquake in L'Aquila. *Draquila* was part of a growing cinematic and journalistic attention to the event. Suffice it here to mention the Rosi-like documentary *Sangue e Cemento* (*Blood and Cement*, 2009), an adaptation of the eponymous 2009 book by investigative journalist and opinion leader Marco Travaglio, and the first-person account of the events, *L'Aquila 2009: la mia*

verità sul terremoto (*L'Aquila 2009: My Truth on the Earthquake*) by Giampaolo Giuliani, a scientist affiliated with the local Laboratori Nazionali del Gran Sasso who had allegedly forecast the rise of telluric activity in the area.[20]

For *Draquila*, Guzzanti and her crew interviewed victims and experts, visited L'Aquila's historical centres, the tented camps, the prefabricated housing quarters, the populations temporarily relocated in distant hotels, and even the few "lucky" families who got to occupy the newly erected apartments. What she discovers is a strange pattern of land reclamation. The Italian government's *Department of Civic Protection*, the Italian FEMA, which reports directly to the office of Prime Minister Berlusconi, reclaimed urban and non-urban areas, not for the impaired local communities but for shady business practices with private firms (including possibly mafia cartels), which glaringly capitalized on the misfortunes of the area and its inhabitants.

Within this scandalous, yet apparently lawful design, the first step was the denial of access which took different forms, including barring L'Aquila's former inhabitants from entering their private homes and former neighbourhoods and ultimately preventing them from visiting their city. This was not a prohibition solely motivated by safety. At issue there is a broader segregating strategy: citizens' political exclusion from the decision-making process regarding rebuilding, housing, and planning of the areas hit by the earthquake. The strategy was so glaringly authoritarian and anti-democratic that under an alleged military rule basic civic rights were suspended: even former members of the local government were denied the right to assembly and self-expression. In this regard, *Draquila* performed a reporting service rarely duplicated or anticipated by news agencies or media networks. In its revealing audio-visual coverage, Guzzanti's film uncovered the extent of the state occupation. The government adopted a particularly alienating business model according to which the citizens who had lost their home or the right to gain access to their home were given the opportunity to move to new apartments. These flats, however, were not just allocated, but were basically leased to their occupants and came with a heavily scripted lifestyle, inclusive of standardized interior layouts, furniture and ornaments – often, and in the best corporate tradition, with the printed logos of the *Dipartimento di Protesione Civile*. All these bequests were regularly catalogued and were to be returned in perfect condition, to the point that a woman confessed not to feel at home in her own house – a comment that resonates with Settis' discussion of a widely felt contemporary sense of out-of-placeness.[21]

Under the executive jurisdiction of the Prime Minister, the new Civil Protection National Department (*Servizio Nazionale della Protezione Civile*), established in 1992, was able to bypass standard legal restrictions. A series of legislative measures, including Law 401 (November 2001), extended the mandate of the re-named *Dipartimento di Protezione Civile* from disaster relief (whether natural or man-made) to intervention in "*grandi eventi*" (Law 401, Article 5, comma 1). Such events included Papal visits and international sport competitions (i.e. the Mediterranean Games or the Swimming World Cup) although there was nothing extraordinary, unforeseen, and catastrophic about them. Instead, they were exceptionally useful to a new regime of rules, rights, and sovereignties. During these 'grand

events', in fact, the State bypassed annoying overseeing practices while granting building rights – actually all sorts of commercial rights – to private firms. More than a case of private interests in public affairs (and public territories), this amounted to an act of massive expropriation.

Draquila does not just show how the alleged politically exploited reconstruction of L'Aquila and its neighbouring regions turned out to be the setting of a prison film narrative without final escape, where citizens simply played the role of convicts opposed to unreachable gatekeepers like Guido Bertolaso, the Chief of the *Dipartimento di Protezione Civile*. *Draquila* also makes a broader argument by showing that the earthquake may have been a rare natural occurrence (albeit one foreseen and publicly discussed by local scientists in the weeks prior) but that the ensuing alliance of private business and government agencies followed quite an established pattern. It was a practice that Palermo mayor Massimo Ciancimino mastered in the destruction of the Sicilian city's historical centre – another most significant example of landscape disfiguration. Similarly, Berlusconi adopted it when he razed the Milanese hinterland to construct new, celebrated quarters with opportunistic political skills, impressive speculative scheming, and opaque financial backing – as British cultural historian John Foot, and journalists Marco Travaglio and Elio Petri, variously discussed in their 2001 volumes about the Milanese links between real estate ventures and the growth of private television.[22] With L'Aquila, the Italian government has instituted a practice of environmental manipulation – in the sense of both physical and media environments – according to an illiberal politics of land reclamation and new towns that has famous precedents in Fascist Italy and, more cogently, attuned to the civic degradation of a sensationalized celebrity culture, promoted by both private and public television networks, that idolizes personal fame and disregards any consideration for public welfare. As a show business person, Guzzanti was particularly attentive to those public well-covered events where the visiting Prime Minister Berlusconi appeared to talk to selected local citizens, all seemingly loyal and appreciative of the state assistance, for the benefits of the evening news celebrating his commanding and reassuring leadership – and reversing negative job approval ratings.

Draquila's macropolitical conclusions are more than troublesome. Through its quasi-military powers, the *Dipartimento della Protezione Civile* has become an in-state corporate entity of sorts, legally capable of taking over a city, relocating its citizens, and leasing them new housing units by awarding building projects to private entities, apparently in exchange for kickbacks and political favours. The communal Italian territory and its landscape have become, as Guzzanti's documentary reveals, one of the most precious currencies for private profit. Earthquakes do not just bring environmental ruin and degradation: they become unique opportunities for what seem to have become standard business practices centred on seizing, speculation, and exploitation of the national territory. Just like hurricanes, to follow the comparison made in the pages of the *New York Times* article quoted at the opening of this essay, they provide a test for a country's civic culture and, ultimately, appreciation for collective responsibility and political leadership – or lack thereof. This was quite evident in

Spike Lee's 2006 documentary, *When the Levees Broke: A Requiem in Four Acts*, about the devastation of New Orleans, Louisiana, due to the failure of the levees during Hurricane Katrina in late August 2005.

Conclusion

In this chapter I show how contemporary Italian cinema has articulated a sustained interest in the representation of national landscapes and physical environments as revelatory settings of the decline of contemporary Italian life. After abandoning the solipsistic tendencies of the 1980s, films, books and public discourses have exposed those natural disasters and man-made abuses that have contributed to the defacement of the nation's geo-cultural patrimony. The notable works of Roberto Saviano and Salvatore Settis have engaged their readers with an environmental ethics that calls for citizens' participation as careful observers of the dynamics affecting our environment and customs.

Italian cinema can play a vital role in awakening us from this spatial and anthropological *degrado*. It can contribute to and stimulate a much-needed form of *environmental literacy* that is a sensibility to the long history, unique forms, and shared values of a land that Italians should always be able to call home. It is a literacy that by definition also represents an environmental ethics [*etica ambientale*]. Films like *Draquila*, *Noi credevamo*, *Arriva la bufera*, among others, have contributed to the articulation of such an environmental literacy.[23] One does not need to listen only to well-written characters or lucid narrators-directors, though. Consider once more *Draquila*. In the film Guzzanti brings her crew and microphones to the house of a retired historian, Professor Colapietra, the only inhabitant of L'Aquila who resiliently stayed put after the earthquake. In order to do so, he had to rebuff the insistence of the workers of the Protezione Civile who wanted to save him from possible new earth tremors (and himself). Known for his research on the city's long history, Professor Colapietra was quite adamant about his right to remain in his beloved, although deserted city, at home among his cats and his books. As if inviting Guzzanti and her spectators to constant engagement with one's own natural and cultural space, he was eloquently outspoken about the dangers that he had been able to deflect. Had he not decided to obey his own internal sense of justice and destiny – the professor implied – he would have had to face much more than housing displacement. Without feeling the need to explicitly refer to what one can only guess would have been a more devastating civic loss, he tersely noted: "Once they catch you, you're finished" ("Una volta che ti prendono, sei finite").

An earlier version of this chapter appeared, with the same title, in *Italian Culture*, 30: 1 (March 2012), pp. 38–50. I am grateful to *Italian Culture* for granting permission to republish the essay. I also wish to thank Norma Bouchard and Joseph Francese, for key critical feedback on that earlier version, and Alan Wright for suggestions on the present one. This is, once again, for Amelia Cocconi.

References

Ardizzoni, M. and Ferrari, C. (Eds.) (2010), *Beyond Monopoly: Contemporary Italian Media and Globalization*, Lanham, MD: Lexington Books.

Bazin, A. (1967), *What Is Cinema?* Vol. 2. Trans. Hugh Gray, Berkeley: University of California Press.

Bertellini, G. (2013), "Film, National Cinema, and Migration," in I. Ness and M. Schrover (eds.), *Encyclopedia of Global Human Migration*, Malden, MA: Wiley-Blackwell, Vol. 3, pp. 1504–1509.

Bignami, A. (Ed.) (2010), *I Cacciatori di Aquilani*, Milan: Feltrinelli.

Bonesio, L. (Ed.) (1996), *Appartenenza e località: l'uomo e il territorio*, Milan: SEB.

—— (1997), *Geofilosofia del paesaggio*, Milan: Mimesis.

—— (2007), *Paesaggio, identità e comunità tra locale e globale*, Reggio Emilia, Diabasis.

Calvino, I. (1963), *La speculazione edilizia*, Turin: Einaudi, first appeared in *Botteghe Oscure*, no. 20 (1957).

Cigognetti, L. and L. Servetti (Eds.) (2003). *Migranti in celluloide. Storici, cinema ed emigrazione,* Foligno: Editoriale Umbra.

Cincinelli, S. (2009), *I migranti nel cinema italiano*. Rome: Edizioni Kappa.

Clementi, A. (2002), *Interpretazioni di paesaggio: convenzione europea e innovazioni di Metodo*, Rome: Meltemi.

Diamanti, I. (2011). "Quei film sugli immigrati nel Paese di *Terraferma*," *La Repubblica*, September 12th.

Dickie, J., Foot, J. and Snowden, F. M. (Eds.) (2002), *Disastro! Disasters in Italy Since 1860: Culture, Politics, Society,* London: Palgrave Macmillan.

Erbani, F. (2010), *L'Aquila dopo il terremoto: le scelte e le colpe*, Rome: Laterza.

Foot, J. (2001), *Milan since the Miracle*, Oxford: Berg.

Galt, R. (2002). "Italy's Landscapes of Loss: Historical Mourning and the Dialectical Image," in *Cinema Paradiso, Mediterraneo* and *Il Postino'*, *Screen*, 43: 2, pp. 158–173.

Ganeri, M. (2010), "The Broadening of the Concept of 'Migration Literature' in Contemporary Italy," *Forum Italicum*, 44: 2 (Fall), pp. 437–451.

Giuliani, G. (2009), *L'Aquila 2009: La mia verità sul terremoto: La storia mai raccontata di un disastro annunciato, dell'uomo che avrebbe potuto salvare 300 vite umane e delle istituzioni che non gli hanno creduto,* Rome: Castelvecchi.

Kimmelman, M. (2012), "In Italian Ruins, New York Lessons," *New York Times*, (December 1st): C1.

Mandelbaum, J. and Ridet, P. (2011), "L'immigré, vedette américaine de la Mostra de Venise," *Le Monde* (September 10th).

Marzocca, O. (1994), *La stanchezza di Atlante: crisi dell'universalismo e geofilosofia,* Bari: Dedalo.

Miccichè, L. (1998), *Schermi opachi: il cinema italiano degli anni '80,* Venice: Marsilio.

Pasolini, P. P. (1974), "Cos'è questo golpe? Io so," *Il Corriere della Sera* (November 14th).

Preve, M. and Sansa, F. (2008), *Il partito del cemento. Politici, imprenditori, banchieri. La nuova speculazione edilizia,* Milan: Chiarelettere.

Romney, J. (2010), "Italian Cinema: The Food of Love," *Sight & Sound* (May).
Russo Bullaro, G. (Ed.) (2010), *From Terrone to Extracomunitario: New Manifestations of Racism in Contemporary Italian Cinema*, Leicester: Troubador Publishing.
Sansa, F. (2010), *La colata. Il partito del cemento che sta cancellando l'Italia e il suo future*, Milan: Chiarelettere.
Saraceni, G. (2008), *Luoghi della giustizia: appunti di geofilosofia del diritto*, Naples: Edizioni Scientifiche Italiane.
Saviano, R. (2006), *Gomorra. Viaggio nell'impero economico e nel sogno di dominio della camorra* (Milan: Mondadori), trans. Virginia Jewiss *Gomorrah*, New York: Farrar, Straus and Giroux.
Sesti, M. (1994), *Nuovo cinema italiano: gli autori, i film, le idee*, Rome: Theoria.
—— (Ed.) (1996), *La "scuola" italiana: storia, strutture, e immaginario di un altro cinema, 1988–1996*, Venice: Marsilio.
Settis, S. (2002), *Italia S.p.A. L'assalto al patrimonio culturale*, Turin: Einaudi.
—— (2010), *Paesaggio, Costituzione Cemento. La battaglia per l'ambiente contro il degrado civile*, Turin: Einaudi.
Spunta, M. (2008), "Esplorazioni sulla via Emilia e dintorni: la fotografia italiana degli anni '80 in dialogo con la scrittura di paesaggio," in G. Minghelli (ed.), *The Modern Image*, special issue of *L'anello che non tiene*, 21–21: 1–2 (Spring–Fall), pp. 158–187.
—— (2009), "The New Italian Landscape: Between Ghirri's Photography and Celati's Fiction," in A. Chantler and C. Dente (eds.), *Translation Practices. Through Language to Culture*, Amsterdam: Rodopi, pp. 223–238.
Travaglio, M. and Veltri, E. (2001), *L'odore dei soldi. Origini e misteri delle fortune di Silvio Berlusconi*, Rome: Editori Riuniti.
Travaglio, M. (2009), *Sangue e cemento. Le domande senza risposta sul terremoto in Abruzzo*, Rome: Editori Riuniti.

Notes

1 André Bazin, *What is Cinema?* Vol. 2. Trans. Hugh Gray, Berkeley: University of California Press, 1967, 28.
2 Michael Kimmelman, "In Italian Ruins, New York Lessons," *New York Times*, (December 1st, 2012): C1.
3 J. Mandelbaum and P. Ridet, "L'immigré, vedette américaine de la Mostra de Venise," *Le Monde* (September 10th, 2011).
4 A few days after the publication of the *Le Monde* piece, *La Repubblica* published an article by sociologist Ilvo Diamanti who furthered the discussion on film representations with statistics about the immigration phenomenon. Cf. Diamanti, "Quei film sugli immigrati nel Paese di *Terraferma*," *La Repubblica*, September 12th, 2011.
5 I have reflected on the century-old relationship between Euro-American cinemas and migrations in G. Bertellini, "Film, National Cinema, and Migration," in I. Ness and M. Schrover (eds.), *Encyclopedia of Global Human Migration*, Malden, MA: Wiley-Blackwell, 2013, III, pp. 1504–1509.

6 On the cinema of this period, see Lino Miccichè, *Schermi opachi: il cinema italiano degli anni '80,* Venice: Marsilio, 1998, and, in relationship to the 1990s, see Mario Sesti, *Nuovo cinema italiano: gli autori, i film, le idee,* Rome: Theoria, 1994, and Sesti ed., *La "scuola" italiana: Storia, strutture, e immaginario di un altro cinema, 1988-1996,* Venice: Marsilio, 1996.

7 On this genre, see Sonia Cincinelli, *I migranti nel cinema italiano,* Rome: Edizioni Kappa, 2009, which examines such titles as Corso Salani's *Occidente* (West, 2000), Roberta Torre's *Sud Side Story* (South Side Story, 2000), Giorgio Diritti's *Il vento fa il suo giro* (The Wind Blows Round, 2005), and Mohsen Melliti's *Io, l'Altro* (I, the Other, 2007). Unfortunately, the volume, which is divided into chapters devoted to individual films, does not engage in a comprehensive and systematic assessment of shared poetic traits and critical urgencies.

8 For a fruitful analysis of some of these films, see Rosalind Galt, "Italy's Landscapes of Loss: Historical Mourning and the Dialectical Image in *Cinema Paradiso, Mediterraneo* and *Il Postino*," *Screen,* 43: 2 (2002), pp. 158–173.

9 John Dickie, John Foot, and Frank M. Snowden (eds.), *Disastro! Disasters in Italy since 1860: Culture, Politics, Society,* London: Palgrave Macmillan, 2002. Calvino's novel first appeared in the no.20 issue of the periodical *Botteghe Oscure*. Einaudi (Turin) published it in volume in 1963.

10 The *European Landscape Convention* "promotes the protection, management and planning of European landscapes and organizes European co-operation on landscape issues." The convention came into force on March 1st, 2004 (Council of Europe Treaty Series no. 176). http://www.coe.int/t/dg4/cultureheritage/heritage/landscape/default_en.asp.

11 Luisa Bonesio, *Paesaggio, identità e comunità tra locale e globale,* Reggio Emilia: Diabasis, 2007, 9.

12 Ottavio Marzocca, *La stanchezza di Atlante: crisi dell'universalismo e geofilosofia,* Bari: Dedalo, 1994; Luisa Bonesio (ed.), Appartenenza e località : L'uomo e il territorio, Milan: SEB, 1996; Id., *Geofilosofia del paesaggio,* Milan: Mimesis, 1997; Guido Saraceni, *Luoghi della giustizia: Appunti di geofilosofia del diritto,* Naples: Edizioni Scientifiche Italiane, 2008; and Alberto Clementi, *Interpretazioni di paesaggio: Convenzione europea e innovazioni di metodo,* Rome: Meltemi, 2002.

13 *Italian Atlas007, Landscape at Risk. The Portrait of a Changing Italy,* Rome: Ministero per I beni e le atttività culturali/PARC, Direzione generale per la qualità e la tutela del paesaggio, l'architettura e l'arte contemporanee/Milan: Electa, 2008. For data, see Lorenzo Bellicini, "Italy's 'Artificial Landscape: Facts and Figures," in *Italian Atlas007. Landscape at Risk,* 20–22. On contemporary relations of landscape photography with landscape literature, see Marina Spunta, "Esplorazioni sulla via Emilia e dintorni – la fotografia italiana degli anni '80 in dialogo con la scrittura di paesaggio," in Giuliana Minghelli (ed.), *The Modern Image*, Special Issue of *L'anello che non tiene,* 20–21: 1–2 (Spring–Fall, 2008–2009), pp. 158–187 and Id., "The New Italian Landscape: Between Ghirri's Photography and Celati's Fiction," in Ashley Chantler and Carla Dente (eds.), *Translation Practices. Through Language to Culture,* Amsterdam: Rodopi, 2009, pp. 223–238; Marina Spunta, "'Il Profilo Delle Nuvole': Luigi Ghirri's Photography and the 'New' Italian Landscape," *Italian Studies,* 61: 1 (Spring 2006), pp. 114–136.

14　See for instance Marco Preve and Ferruccio Sansa, *Il partito del cemento. politici, imprenditori, banchieri. La nuova speculazione edilizia,* Milan: Chiarelettere, 2008, which focuses mostly on the Ligurian shoreline.
15　Luisella Farinotti, "In-vece di un'introduzione. Atlanti, cartografie, enciclopedie visive: Mappe dell'immaginario cinematografico italiano," in Gianni Canova and Luisella Farinotti, *Atlante del cinema italiano: Corpi, paesaggi, figure del contemporaneo.* Milan: Garzanti, 2011, p. xvii.
16　Maria Buratti, "Borghi e sobborghi. Il paesaggio extraurbano tra stereotipia e perdita d'identità," in *Atlante del cinema italiano,* 89 (italics in the original).
17　Roberto Saviano, *Gomorra. Viaggio nell'impero economico e nel sogno di dominio della camorra,* Milan: Mondadori, 2006, pp. 236–237, trans. Virginia Jewiss *Gomorrah,* New York: Farrar, Straus and Giroux, 2007, p. 216. Pasolini's article, titled "Cos'è questo golpe? Io so," *Il Corriere della Sera* (November 14th, 1974), reprinted as "Il romanzo delle stragi," in Pasolini, *Scritti Corsari,* Milan: Garzanti, 1975, pp. 88–93 and Walter Siti and Silvia De Laude (eds.), *Saggi sulla politica e sulla società,* Milan: Arnoldo Mondadori Editore, 1999, pp. 362–367.
18　Salvatore Settis, *Paesaggio, Costituzione Cemento. La battaglia per l'ambiente contro il degrado civile,* Turin: Einaudi, 2010. See also his earlier *Italia S.p.A. L'assalto al patrimonio culturale,* Turin: Einaudi, 2002.
19　For examples of these activities, Settis refers also to Ferruccio Sansa, *La colata. Il partito del cemento che sta cancellando l'Italia e il suo future,* Milan: Chiarelettere, 2010.
20　The full title reads: *L'Aquila 2009: La mia verità sul terremoto: La storia mai raccontata di un disastro annunciato, dell'uomo che avrebbe potuto salvare 300 vite umane e delle istituzioni che non gli hanno creduto,* Rome: Castelvecchi, 2009.
21　A number of contributions (and film reviews), included in Alessandro Bignami ed., *I Cacciatori di Aquilani,* Milan: Feltrinelli, 2010, expand upon the same uneasiness. See also the booklet included in the *Draquila*'s DVD box set.
22　See John Foot, *Milan since the Miracle,* Oxford: Berg, 2001, pp. 85–107 and Marco Travaglio and Elio Veltri, *L'odore dei soldi. Origini e misteri delle fortune di Silvio Berlusconi,* Rome: Editori Riuniti, 2001.
23　Inattentiveness in these and other films is the danger, as exemplified by the symptomatic failures of the sympathetic, yet unemployed film-maker in Carlo Mazzacurati's *La Passione* (*The Passion*, 2010). Although by profession he is supposed to know how to look and pay attention to the world around him, his disregard for much-needed hydraulic repairs to his vacation condo, located in the heart of the Tuscan hills, ends up damaging the *affresco* of the adjacent church, and provokes the local administrators to voice a simple, but most eloquent complaint: "This is a proper village, a community, not an automatic teller machine!"

Chapter 11

Cinema in Reconstruction: Japan's Post 3.11 Documentary

Joel Neville Anderson

The sheer scale of damage wrought by a massive natural disaster, whether witnessed remotely or experienced first-hand, throws all standards of knowledge and belief into vertiginous disarray. Human life appears powerless before the indifferent force of nature. Causality and justice no longer seem to apply. This gap in comprehension, in which a ceaseless present engulfs past and future, is analogous to the fragile connection to memory and identity that a snapshot photograph can offer its viewer – a wedding portrait or an elementary school group photo, for instance. The dynamic of remembrance and recollection is further complicated if such photographs themselves appear in films involving natural disaster as is the case in a number of documentaries made in the aftermath of the Tohoku earthquake and tsunami of March 11th, 2011. How might cinema bridge the divide between memories of life before the quake and the barren reality that follows? Can film offer new ways for victims of disaster or sympathetic onlookers to conceive of cataclysmic events and to begin the work of reconstruction?

The invisible faultlines that determine the extent of damage in any large natural disaster are cultural, economic, and industrial as much as they are geological. The cinematic responses to Japan's historic earthquake, tsunami and subsequent nuclear catastrophe similarly reflect their time and place of origin. They are representative of a visual culture and consumer society unique in character but global in scope, and speak to how such events are now largely perceived and remembered, due in part to the availability of rapid mobile communication technology, transferable cinematic forms and the popularization of light, transportable image-capture devices. In what follows, I explore the roles that old and new forms of documentary media played during and after the Tohoku earthquake – amateur photo/video reportage, salvaged family photographs, traditional documentary film, and emerging personal cinema – and analyse the various modes of address, manipulation, exchange, and construction found in such material.

The recent proliferation of mobile photo, video, and text media raises the question of whether documentary film, as we know it in its popular or subversive forms, remains important in contemporary discourse. The circulation of digital imagery through the increasingly commercialized channels of online services now supplies a potential platform for previously unheard voices. Post-3.11 documentaries by Toshi Fujiwara, Yuki Kokubo, Yojyu Matsubayashi, Koichi Omiya and Lucy Walker offer rich texts for investigation of the nature of contemporary documentary media and its function in the wake of disaster. In content, form and style, these films are especially reflexive and also exploit the medium's

potential for the presentation of intercalated subjectivities. In addition to the pervasive depiction of "amateur" image-making and the preservation of domestic photography, these works often employ footage compiled from a wide variety of professional and non-professional sources, and, in some cases, have generated collaborative relationships between the film-makers and their subjects that severely complicate the notion of a film's primary author. The visualization of self and community occupies an important place in these films as well, as is evident in the widespread framing of photographs discovered in the landscape and salvaged from the rubble, or of a camera shielding the face of a "character" on screen. Such features exhibit a concern for the ways that photography and cinema offer a special means of perceiving and conceiving of the quake and its aftermath.

Given that these films themselves rely on advances in digital video, while the material photographs that they show, saved from the muddy fields of a past laid to waste, have been largely produced using superseded chemical processes, their relation, as presented by the films, proposes a clear irony. The ontological tension between digital and analogue photography is not without relevance here, as is the comparison between the efficacy of still or moving images as documentary evidence. This chapter, however, does not provide a definitive response to these problematic issues, nor does it present an exhaustive survey of post-3.11 documentaries; rather, it views this moment in Japanese non-fiction film as an opportunity for discovering something new and noteworthy about the cinematic medium itself as our technological means of storytelling, documenting and witnessing continue to change.

The magnitude 9.0 quake, one of the five strongest documented in world history (*Associated Press* 2011), struck off the north-eastern coast of Japan, triggering a massive tsunami and claiming nearly 16,000 lives while leaving more than 3,000 missing (National Police Agency of Japan 2012). The Tohoku earthquake (also referred to as the Great East Japan Earthquake or the Sendai earthquake) has become known colloquially as 3.11. The earthquake and flood instigated meltdowns at the Tokyo Electric Power Company's (TEPCO) Fukushima Daiichi Nuclear Power Plant and emergency shutdowns at the Fukushima Daini plant, provoking the worst nuclear accident since Chernobyl. The surrounding areas were evacuated while concern for radioactive contamination spread throughout the entire country and beyond to Japan's neighbours and trading partners. Japan's status as a first-world country also insured that a multitude of images from the scene of destruction became instantly accessible. The protracted devastation provided a convincing portrait of what a twenty-first-century apocalypse might look like, especially in light of recent quakes in China, Haiti, Iran, Laos, New Zealand and Turkey. The resulting energy crisis, which produced power shortages in metropolises to the south, provoked a national outcry against the Japanese government and nuclear power industry. Frustration with traditional news outlets and the limited safety information that government officials made available to people in communities potentially affected by radiation led to the mobilization of social media to relay citizen reports and organize public demonstrations, as well as innovations such as the development of an online crowd-sourced radiation measurement network.[1] Anti-nuke demos protesting reliance

on nuclear power surprised many who had not witnessed such popular action since the country's student movements of the 1960s. The international community had already been alerted to the power of social networking services (or "SNS" in Japan) in the months before the Tohoku earthquake. Social media had been implemented with considerable success in the recent revolution in Egypt as a crucial means of organizing political action and reporting clashes with the military to a global audience, leading to the ousting of President Hosni Mubarak on February 11th, 2011. Such inventive, effective, and immediate actions in the face of social and natural disaster further call into question what traditional short or feature length documentary "film" has to offer in the contemporary environment of image and information saturation.

Audiences outside Japan will be most familiar with British film-maker Lucy Walker's *The Tsunami and the Cherry Blossom* (2011), which was nominated for a US Academy Award for Best Documentary (Short Subject). The film has been described by its makers as a "visual haiku." It packs significant rhetorical content into its forty minute running time, and introduces, in a condensed format, many of the qualities possessed by the feature length films that I will discuss. True to its title, *The Tsunami and the Cherry Blossom* can be divided into two parts. Walker's film first documents the damage wrought by the earthquake and tsunami and the state of affairs during the initial stages of recovery by using pre-recorded material and interview footage; it then switches to a more poetic mode through the use of symbolic imagery (primarily the cherry blossom of the title), reflective interviews, and lyrical nature photography and cinéma vérité footage. The film opens with raw, low-quality video footage shot from a hill overlooking a town in the process of being engulfed by the tsunami. This extended clip presents a shocking human perspective of the tsunami, a rapidly progressing dark glacier of waste. Those who have made it to the hill cry out in disbelief as the wave covers the town. They shout encouragement to people seen helping elderly people from the nursing home below up to higher ground, running to the edge of the surging current as it advances towards them. In this moment of extreme danger, the film cuts to white, as we hear the ethereal acoustic and electronic tones of Moby's emotional score. The camera toys with rapturous sun flares as the film crossfades to soft-focus images of cherry blossoms shot from below in high-definition video. A water-colour painting of a cherry blossom tree, glimpsed from over the shoulder of an anonymous figure, is framed in mid-composition before the image fades back to a white screen that presents the film's title.[2] A young relief worker, the film's first interviewee, recounts her experience as she surveys her heavily damaged town from the same hill that the opening scene was shot from: "I can't believe it happened in real life." The sequences that follow mix interviewees' accounts of survival with footage of the devastation from a variety of professional and nonprofessional sources. They incorporate images captured by *keitai*-wielding (cell phone) citizens on the ground, aerial shots from helicopters, and TV news with overlaid text announcements. Waves barrel through town streets, floating houses collide, and flames ignite on the surface of the dirty water. In the aftermath, the unseen, unspeaking camera crew interviews citizens surveying the damage to their homes, recuperating in shelters, or volunteering help. Walker returns

to brief portions of interviews throughout the course of the film, punctuated by montage sequences of landscape views as well as close-ups of items carried away from domestic spaces by the water and now strewn amongst the remaining detritus – toys and paintings, as well as dust-caked photographs and photo albums, even an unspooled roll of 35mm still photo film draped over a tree branch. Pausing from his task of sifting through layers of wreckage, a relief worker makes a brief comment: "I always save photos and gravestones, hoping the families will come along and find them."

About halfway through the film, the focus shifts to a dialogue on the ephemerality of life (*mono no aware*) through the traditional symbol of the *sakura* (cherry blossom). A couple, who now live at a local shelter, yet return to their home during the day to begin repairs, notice the opening buds of a cherry tree in their yard. Leading the camera crew outside, they delight at this harbinger of spring. The soft-focus shots of cherry blossoms and the music which accompanied the film's opening title sequence return before a cut to a *torii* gate (of Shinto shrines, emblematic of Japan's indigenous animistic spiritual tradition), and decimated homes seemingly dropped from the sky onto a barren landscape, a painting of a cherry blossom tree standing upright among cluttered architectural remains, the twilight sky, military trucks driving along a road cleared through the wreckage, empty town streets, the sky (now at dusk), and a time lapse shot of a blooming cherry blossom. A strong link is established between the disaster and the cherry blossom through the poetic associations of montage, a connection that the following sequences develop further. Interviewees comment that the trees are traditionally believed to be house spirits, and serve as a symbol of the *samurai* warrior class, in addition to being invested with personal memories as a mark of the season. Images of people viewing cherry blossoms in peaceful public spaces are interspersed with reminders of the disaster, such as students from Minamisoma City asking for donations, announcements of subway service cutbacks to conserve the national power supply, an out-of-order escalator, and cherry blossom festivals cancelled out of respect for victims of the earthquake. This culturally significant flowering tree, which attracts many domestic and international tourists every spring as it blooms from southern to northern Japan, opened shortly after the quake in the Tohoku region, which would have received numerous sightseers if it were not for the desecrated landscape and the danger of radiation. As many observed who visited the north in the spring of 2011, the cherry blossoms were particularly beautiful that year.

Following a sequence in which interviewees comment on the special memories brought back by the reappearance of the cherry blossom each year, an extended montage presents images of families, friends, and people of all ages in parks taking pictures of the trees in full bloom, using all manner of photographic devices, from smartphones to hand-held digital point-and-shoots and prosumer SLRs. A chorus of disembodied voices accompanies these images and provides a stunning discourse of poetic associations. An older man, stopped on his bicycle, takes a picture with a flip-phone, two young women squeeze together to share a camera viewfinder, a young girl in an Elmo T-shirt lowers her phone after taking a shot, a toddler poses in front of a handy cam, and an unlikely trio, an old man and two teenage

girls, hold their camera phones towards the sky in unison. A man says, "I understand why everyone takes photos of cherry blossoms. It's not that you want the most beautiful pictures, but you want pictures you took yourself. It doesn't matter if the pictures are blurry or out of focus." A young girl states: "It looks different when you see it in the newspaper than with your own eyes. We take our own pictures because we want to keep what we've seen." The film asserts the very practice of photography as a transformative tool of reflection and personal visualization throughout this sequence, just as the importance of the medium in preserving memory and identity was depicted in the attempts to salvage family photographs. It should be noted that photography plays a particularly important role in everyday life in Japan, and, although not a large country geographically, domestic tourism is very popular. That photography would figure prominently in times of emergency and their representation should come as no surprise.

The film ends once more at the site of the disaster now seen from the point of view of a witness who seeks to remember and record the event. With a camera framed over her face, and shot in close-up, the young relief worker from the beginning of the film gathers an image of the scene of destruction. The shutter clicks and the lens is lowered, revealing her expression; youthful and determined, as she looks out at the town, a new coastline encroaching in the distance: "The utility poles are being put back up and the cables are being reconnected." Then, in close-up, she adds: "I want to take pictures of the town as they're rebuilding it." By communicating her ambitions, this compelling association of image-making and preservation along with the process of reconstruction implicates not only the film-making process, but also the myriad contemporary means of creating and experiencing documentary media.

The proliferation of personal photographic and cinematic media serves as a potential antidote to the authorized practices of film and news professionals, and offers those directly affected by the catastrophic events of 3.11 a means of telling their stories to distant observers and fellow sufferers alike. While increasingly conglomerated media companies can hardly claim to have produced a more democratic climate of journalism, followers of the news experience stories through nonprofessional mediators more and more. Even for those who did not experience the quake and its aftermath first-hand, the event was widely reported and recorded on amateur video on cell phones or other consumer video devices. While cellular service was disrupted in the affected areas, information spread through brief accounts punched into smartphone keypads or pixelated snapshots dispatched via blips of social media, and broadcast on Japanese news and international outlets. Aside from these new means of data accumulation, which change how traditional media institutions respond to quickly developing stories, such first-hand "accounts" also find their way into personal media streams, increasingly hybridized between professional and non-professional reporters and commentators.

John Burnham Schwartz reproduces this experience of first exposure in the chilling foreword to *March Was Made of Yarn: Reflections on the Earthquake, Tsunami, and Nuclear Meltdown*.[3] Schwartz relates a seldom described but increasingly felt mode of media

exposure when he imagines someone unaware of the events of March 11th stumbling upon a "random clip on YouTube – digital, of course, and hauntingly crude. A 'home movie,' it used to be called" (Karashima and Luke 2012: xiii). What was the first piece of information from Japan's triple disaster that you experienced? A headline or a note from friends or co-workers may have preceded the initial exposure, presenting a warning or producing an expectation. Schwartz sets the scene on a seemingly normal afternoon at Sendai Airport; his literary proxy watches the video as an unidentifiable rumbling sound grows louder and louder. Soon after, the tsunami's wave appears:

> A wall of water is surging past the terminal. It is a meter high – then, very quickly, two— washing baggage carts, a boarding ladder, a yellow car along its path.
>
> Inside the terminal, screams can be heard now, above nature's roar of destruction. People are running, though there is no place to go.
>
> The footage does not so much end as stop.
>
> The stories begin.[4]

Many will relate to such an experience of horror and disbelief. In the weeks following the disaster, one could watch similar "home movie" clips as they surfaced alongside professional live news coverage and the barrage of disturbing developments regarding Japan's largest earthquake on record. Schwartz references an actual event of the flooding of one of Japan's major regional airports. The small act of taking a picture of that which is about to disappear, recording a video as final testament to a person or place, or rescuing a dirty photo album carried away by the waves is understandably imbued with new courage in the face of massive earthly devastation. Yet an image, as the product of disparate cultural investments, subject to overexposure and appropriation, can easily enable the fetishization of disaster. In addition to the agency of images, a camera also grants its handler a potentially dangerous state of agency. While photographic instruments of mediation provide people with the ability to index memories or anchor the imagination of personally unlived realities, in the wrong hands the camera can justify intrusion into lives and cultures. A film addressing mass trauma such as *The Tsunami and the Cherry Blossom* may communicate an inspirational message of rebirth and hope, but can the medium contribute substantively to the process of reconstruction?

The films discussed here foreground, in their alternating focus on people and place, how personal history is situated in a social and natural landscape. They engage with problems of cinematic form in the diverse idioms of nonfiction film, and their aesthetic choices carry political intentions. The films' recurring depictions of amateur photography – still and cinematic – spotlight photography's dual character as means of remembrance and creation, and provide a set of axial concepts about documentary's role in a crisis, thereby expanding its function as surrogate eyes and ears on the battered and broken ground. How can cinema bridge the phenomenological, conceptual and emotional divide between memory and

experience? How is recording, collecting, and presenting images of disaster justified? What replaces the stark disparity felt upon looking at a photograph in the world when looking at a photograph in a film?

Koichi Omiya's *The Sketch of Mujo* (2011, "Mujo Sobyo") offers many helpful examples. Premiering in Tokyo in June, 2011, it is regarded by many as the first documentary to be created (or completed) in the quake's aftermath. Like many of the documentaries that explored the jagged wastelands left by the quake and tsunami – left mostly empty and lifeless due to fear of radiation – the film is something of a road movie. Omiya travels from place to place in Kesennuma, Miyagi prefecture, accompanying a doctor who can often be heard off camera and appears onscreen during a number of interviews. They encounter people gauging the damage to their homes and communities. Omiya, thus, presents viewers with an episodic survey of survivor accounts. The distinctive trucking shot of the 3.11 documentary, in which devastation unfurls laterally through flattened landscapes of rubble captured from a moving vehicle, is well-established in *The Sketch of Mujo*. Abé Markus Nornes relates this "common visual trope" to those of post-war Japan in a report from the Yamagata International Documentary Film Festival held in October, 2011:

> A key challenge for all these filmmakers is communicating the scale of the disaster before their very eyes. How does one express the incomprehensible vastness of the destruction and the suffering it implies? Half a century back, just west of here, crews of filmmakers faced the same dilemma – not to mention a similar landscape – in the ruins of Hiroshima and Nagasaki. Back then, their strategy was the pan. They scanned the disaster from a fixed point. The first films about the atomic bombings are filled with such shots. Today, they have replaced the pan with the truck. Or more specifically, the car or bike.

Nornes locates one explanation for the difference in the technology being utilized in each historical moment: film cameras in the case of Hiroshima and Nagasaki, light consumer grade video cameras following 3.11. He notes that, while most of the 3.11 documentaries themselves feel like rough sketches, eschewing a tripod even when not filming from a moving vehicle, *The Sketch of Mujo*'s, along with work by Yojyu Matsubayashi and Toshi Fujiwara, contains "strong photography and clean, creative sound editing."

From the first scenes of the film, family photography plays an important role, and its recovery from a partially destroyed house provides the film with its initial moments of reflection and hope for new beginnings. Returning to the remains of her home, an elderly woman retrieves a photo album, and flips through the pages with her husband. "We walked a lot didn't we?" she comments. He replies: "Yes, we did. Yes, I remember." Over the pages of the album, we see a young boy grow up. "It's our history." She nods, and smiles painfully: "I guess […] It's a new beginning. It all begins from here. We are coming to an end though. But I hope the young people will try to rebuild it." The camera holds its view on the old woman as she looks into the distance and her emotions bubble up. "Just look at this […] What can

I say […] I wonder […] just how […]" Omiya cuts to a ravaged landscape that serves as her motivated perspective. Twisted train tracks leading nowhere.

Later, Omiya arrives at a home damaged by the tsunami but miraculously intact, given that a large boat ran aground just feet away when the flood waters subsided. A teenager and her grandmother, both wearing protective medical face masks, are found inside cleaning. Photographs speckled with mud, mostly saved from storage on the second floor, are laid out together and framed in shaky high and low angle close-ups. They depict a young woman, perhaps this maternal guardian from years earlier. The grandmother describes the photos as "priceless," but then expresses her intentions to leave the area since her family no longer relies on fishing for its livelihood, and disasters such as this one, whether large or small, will inevitably occur again. "But I love the sea!" the young woman protests, and the camera pans over to her. "Yes. We all love the sea. That's why we live here." replies the grandmother. "I love the sea. I'd want to stay here, you know." She laughs shyly, seemingly embarrassed, and the film cuts back to the same view of the girl, now looking off in contemplation. She speaks as if asked, "What do you love about the sea?": "When the sun shines on it, the sea just looks gorgeous. And the fish! I love jogging by the sea. Near the sea." In close-up, she continues: "You really should live near the sea." She looks back to her grandmother, then down, nods in self-assurance and looks off into the distance, then down again, noticeably conscious of the camera. The camera zooms in for a closer view before cutting to a shot of ocean, seagulls perched on partially submerged concrete architecture jutting out of the water.

Far from employing the "Ken Burns effect" to project the viewer into a photograph by panning over the image and zooming in on its subjects, all of these films approach photos as elements of the landscape, as personal objects. In scanning the image of salvaged family photos, the viewer is led to wonder if the subjects depicted here were also swept away by the waves; if the owners will ever find them again, or if they have survived themselves. To varying degrees, the use of the filmed photograph supplies a placeholder for the many lives lost or scarred by the quake, an alternative to more explicit images of death and injury. The amateur footage that opens *The Tsunami and the Cherry Blossom* functions very differently, interwoven as it is as an element of the film's diegesis. Even in the case of Walker's film, where the external footage edited into the larger work is more or less continuous, with cuts that appear natural and conceivably result from the actions of the original cameraperson, one can't help but wonder what precedes and follows that which one is given to see. Are the film-makers panning and scanning within the frame to censor gruesome imagery, or to draw attention to other aspects of the image than those intended by the original photographer? Either way, the material has been reframed. For a photo found on the ground or hanging out to dry, there is little consideration of what has been cut out. Rather, the focus is on what has been lost. These photo-objects serve as symbols for the themes of their respective films and informs their approach to the politics of the filmed photograph. "What is the source of this photo? "What has become of its subjects and owners?" In Omiya's case, such questions remain unanswered.

The instances in which these nested images recur are too numerous to list completely, but the effect is most overwhelming towards the end of *The Sketch of Mujo*. The film's coda begins

with a hand-held close-up of photos strung to the wall of a school gymnasium: children playing outside, a couple in traditional wedding garb, a pre-teen offering the peace sign to the camera. This sequence, nearly four minutes long and completely silent, is composed of two panning shots over the wall of abandoned photographs: skiing trips, class photos, candid portraits of friends, family, and lovers, pictures of communal meals, outings in parks, festivals and baby pictures. Most of the photos are in good physical condition and have minimal water damage. Eventually the camera arrives at a sign asking people to claim any of their photos. If the viewer has failed to grasp the purpose of this solemn procession of images it should now become apparent. The camera passes over more photos and turns to follow a row of boxes holding salvaged goods towards the centre of the large space, revealing the expanse of the gym lined with other such containers, the walls covered with similar collages of photographs. A handful of people wander the space, looking through the collections of belongings before the scene cuts to black.

The episodic structure of *The Sketch of Mujo*, in which various encounters serve as portraits that form an overall picture of post-3.11 conditions, is comparable to the allusive function of filmed photographs. Omiya's documentary possesses a minimalist aesthetic, limiting the editing of interviews and dispensing with narration and composed music, save for the chants and bells of a Buddhist priest whose interview opens and structures the film. On the role of the documentary film-maker in the wake of disaster, Omiya comments: "I saw that the only way to be of any help was to listen to what these people had to say and to accept their words and emotions." He adds: "I know every documentarian has his own agenda and good documentaries are calculated to draw out certain words from the interviewees, which in turn are calculated to resonate with the viewers. But for this film, I wanted to forego all calculation. To just be there, with these people, in the here and now" (Shoji 2012). Locals openly contemplate their next steps in life and tough fishermen, many of whom have lost their homes, careers, and families, break down crying on screen; the film-maker stands by as witness. The issue of composing a story from the wreckage of broken lives is fraught with complexity. How should one approach the obvious vulnerability and pain of subjects in an interview? How does one choose to present the face of a stranger in a salvaged photograph whose fate is unknown? What can be said of the fixed stare of the camera on the young woman who loves the sea, as it zooms in to scrutinize the expression hidden beneath her face mask? Is there cruelty in the cut to sullied ocean waters? Is there undue irony in the shot of the train tracks which cut short the interview with an elderly woman, who could only gesture, at a loss for words, towards the possibility of others rebuilding in the future?

Omiya has a strong personal connection to Tohoku, having been born in the region, where his parents still live.[5] Yet some critics of 3.11 documentaries have pointed to the stereotype of Tokyo urbanites driving northward and sticking cameras out the window and in the faces of the aging rural population. Although a drive of less than 300 kilometres, there is no small opportunity for culture clash, as many Tokyo dwellers can have difficulty understanding the Tohoku dialect (*Tohoku-ben*). Critics object that documentary film-makers should not function as "disaster tourists" whose presence only exacerbates the crisis and contributes

to an already chaotic environment. Toshi Fujiwara comments: "These people have lost their homes, their family members, an entire lifestyle. If you don't know what to shoot, then don't shoot. Go home. Leave them alone in peace."[6] His film, *No Man's Zone* (2011, "Mujin chitai"), rethinks the intervention of the documentarian and the function of the interview. The "no man's zone" of Fujiwara's title, reminiscent of documentaries produced following the Chernobyl disaster, refers to the evacuation area within a 20-kilometre radius of the Fukushima Daiichi plant that was deemed a radioactive hazard by authorities. He memorializes this soon to be lost landscape while visiting those who will not or cannot leave. But rather than show these people to the audience, more often his camera visually interrogates the landscape itself in a manner that recalls the experimental film-makers from the period following Japan's student movements of the late 1960s, who offered pointed social critiques through abstract, yet highly materialist means (Japan's "landscape theory," or *fukeiron*, and the political art projects in film and photography associated with it).

Appropriately, this film contains a relative paucity of images of filmed photographs. Aside from incidental, undamaged photographs displayed in the homes that Fujiwara visits, the only notable instance of a photograph receiving special attention from the camera occurs when a sheet of paper, printed with the image of a landscape, is used to point out the effects of the tsunami. A close-up frames the scanned picture on a table beside glasses of beer as a former nuclear power plant worker, using a brightly decorated pencil to point out where the water stopped and where people were killed, recounts driving away from the tsunami with his grandson. The truth is not reached here by delivering a raw account to the camera, nor through poetic organization of images and sound. The text speaks of itself in a detached commentary and openly considers its own intentions and hesitations, expressing a distrust of the images it reveals. In fact, the filmic image itself is treated as an object of criticism.

The voice of the film's disembodied narrator, the Armenian-Canadian actress Arsinée Khanjian, pronounces scripted text in an English monotone not unlike the commentary of the essay films of Chris Marker, notably *Sans Soleil* (1983), where Japan and the relation of photography to memory also feature prominently. *No Man's Zone* opens with a black screen:

> Images of destruction are always difficult to digest. While facing them we become desperate to find a clue or understand. To decode. [Titles begin to appear] To measure the size of the damages. Maybe as an excuse to cover our secret fascination with them. They become stimulants, often consumed as drugs. Today, perhaps, we have become simply addicted to all images of destruction.

Khanjian's narration gives way to the image of a battered coastline and the sound of crashing waves. A slow pan away from the shoreline reveals a landscape that now resembles a landfill littered with surviving portions of houses, boats and cars. The score's single theme begins shortly thereafter, Barre Phillips' bass accompanied by a mournful female vocal. For the next twenty minutes, and intermittently throughout the rest of the film, the testimony of

interviewees is presented only as voiceover, their image absent, while the battered landscapes unfold on screen. This formal innovation serves to shield the film's subjects from its viewers – or, to protect its subjects from the film itself. The imposed bond between their voices and shots of the ravaged landscape would seem to lend new agency to their words by contrast with a more diverse and illustrative form of montage.

Many of the interview subjects are elderly retirees who have spent full careers in the nuclear industry. They recall the area's transition from agricultural to industrial production as they emotionally process the plant's devastating effect on the land and their recent or impending ejection from their homes. While images of muddy debris appear in a steady stream of landscape views (stationary compositions, although trucking shots appear elsewhere in the film), an unseen elderly woman recollects the details of farm life: "During the agriculture off-seasons, I also worked in construction. Both men and woman worked in these constructions. Roads and also wave breakers on the beach. I got in the river to collect small stones and sand to make concrete. Back then, there were no machines, just manual labor. To live only on farming was hard." A shot of upended heavy machinery, treads in the air, accompanies her final comments. On the whole, however, the placement of images feels disconnected from the interviewees' statements. They seem to function as divergent media streams converging on a common endpoint.

The cumulative effect of the human voice on the stricken landscape in *No Man's Zone* is taken up by the director in an interview with Chris Fujiwara: "It's about the slow decomposition of a local community which has been taking place over the years, all the values that used to be important, the sense of community, the respect for history and communal as well as family heritage, all disappearing."[7] The formal condensation of this idea contributes to a radical reflection on power as visualized in the landscape. Toshi Fujiwara grounds his sharp critique of the state-corporate complex in a natural setting. He thereby raises the stakes for asserting a personal apprehension of images and their creation. The idea of power as reflected in and articulated through landscape has long been a subject of study in visual culture, yet this depends upon the non-fixedness of the perception of the environment. In his preface to the second edition of *Landscape and Power*, W. J. T. Mitchell writes:

> If one wanted to continue to insist on power as the key to the significance of landscape, one would have to acknowledge that it is a relatively weak power compared to that of armies, police forces, governments, and corporations. Landscape exerts a subtle power over people, eliciting a broad range of emotions and meanings that may be difficult to specify. This indeterminacy of affect seems, in fact, to be a crucial feature of whatever force landscape can have. As the background within which a figure, form, or narrative act emerges, landscape exerts the passive force of setting, scene, and sight. It is generally the "overlooked," not the "looked at," and it can be quite difficult to specify what exactly it means to say that one is "looking at the landscape."
>
> (Mitchell 2002: xii)

Fujiwara's camera interrogates the landscape as if searching for an invisible hegemonic force, here synonymous with the spectre of radiation pervading the exclusion zone. While this digital video image betrays no trace of radiation damage, one is reminded of Vladimir Shevchenko's *Chernobyl: A Chronicle of Difficult Weeks* (1986), in which the developed film appeared speckled, and his audiotape garbled during moments flying over the clean-up area. One almost expects to see the flash of gamma rays that were recorded by the remote-controlled endoscope video camera TEPCO utilized to peer into its failed Fukushima reactors and gauge damage. Natural space bears an imminent threat.

As we imagine the lives that have been lived on this soil, as well as the turmoil of the quake and tsunami itself, unseen but for the aftermath, the landscape is rendered allegorical, and highly anthropological. Fujiwara's narrator even relays the cameraman's initial reluctance to perform a handheld shot while walking over the debris. He thinks it is disrespectful, and is afraid that he might step on a dead body, a gruesome reality that is barely mentioned in other 3.11 documentary projects.

As an alternative to Fujiwara's aesthetic, Yojyu Matsubayashi's *Fukushima: Memories of the Lost Landscape* (2011), ("Soma kanka Daiichibu Ubawareta tochino kioku") offers an intimate variation on the film-maker-subject dynamic, heeding the call for a more personal perspective. The film offers explanatory intertitles throughout that provide context from the film-maker's perspective; it opens in Matsubayashi's Tokyo apartment, the camera shaking from the tremors as the film-maker rushes about his small living space watching the TV news as it airs updates from Tohoku. Three weeks after the quake, he travels to Minamisoma, where, like Fujiwara, he films within the 20-kilometre "red zone" prior to the April 20th mandatory evacuation deadline. He joins the volunteers and stays in emergency evacuee quarters in a local school. With the approval of city councilperson Kyoko Tanaka, he trails her as she patrols the neighbourhood, cares for evacuees, and tends to her own family as it manages the crisis. The film takes on the form of a video diary, documenting not only the accounts of local people, and day-to-day volunteer work, but also an increasing trust between the film-maker and Mrs Tanaka and her husband Kyuji.

Like *The Sketch of Mujo*, *Memories of the Lost Landscape* includes scenes of the salvaging of family photo albums, which are developed as important themes of reflection and remembrance throughout. In their first outing together, Tanaka spots a stray photo album and dutifully retrieves it. She sets it aside for safekeeping after recognizing the family it belongs to from the pictures it contains. Matsubayashi pitches in to help with her duties, though, realistically and refreshingly, he mostly follows orders. His questions are not those of a prying interviewer, but of someone just keeping up to speed with the tasks at hand. Matsubayashi is in his early thirties, while Tanaka is approaching old age, but he hustles to keep up with the sprightly community organizer, camera at the ready. By the end of the film, Matsubayashi, describing his relationship to the Tanakas, speaks of them as family. The contract between interviewer and interviewee has become an intimate connection, and authorship of the finished work blurred.

Similarly, in Yuki Kokubo's *Kasamayaki*, the roles of documentary film-maker and earthquake survivor continue to merge. The creators and preservers of images forge a strong bond. In *Kasamayaki*, the cracks brought into relief by the quake run specifically along family lines. The film's title, which can also be translated as "made in Kasama," refers to the style of pottery originating from Kasama, Ibaraki, where the film-maker's parents live in a community of artists. The film documents an attempt at reconciliation between the daughter and her parents. I had met Kokubo, in New York, prior to her second trip back to the area to visit her parents, to help them prepare for their community's annual craft festival, and of course, to film. My research on documentary media created in the aftermath of the 3.11 quake largely evolved as I watched her film come together.

The film, still in post-production, resembles a meditation on the healing power of creativity. Kokubo's film seeks to heal wounds hidden by time that have been brought to the surface by the shock of the earthquake and the thought of impending danger from Fukushima. As a young child, Kokubo came to New York with her parents, who hoped to find success in the city's vibrant art scene. When they decided to return to Japan to make a living through pottery, she was left in the city as a teenager. In this highly personal form of documentary, the distancing effect of the filmed interview situation functions as a means of removing oneself from the bounds of interpersonal tangles. The same apparatus that lends a place of privilege to the cameraperson in impersonal situations can also open up, in this case, a new space between close family members, a space for confrontation, open conversation. Kokubo frames her mother or father – facing the camera or working at a sculpting table or pottery wheel – with the film-maker speaking from behind the lens or beside the camera, often conspicuously caught in a mirror. Kokubo's parents' pottery practice and their past New York art projects are likened to the process of creating the film. Each involves a therapeutic act of creation, though using vastly different tools. Kokubo and her father visit a once familiar area that has been wiped away by the tsunami. They borrow a geiger counter to measure radiation around the couple's home, but receive discouraging results. The quake, the film's inciting incident, looms large over the drama portrayed yet the earthquake, tsunami, and even the nuclear disaster are perceived as entirely inevitable occurrences by the family. The former are natural phenomena intrinsically linked to cultural history and the latter an unfortunate symptom of its modern identity.

This project, perhaps more than any of the others discussed previously, answers a call for renewal and reconstruction. For Kokubo, this is accomplished through cinema. The medium is here conceived as a constructive device that is capable of spurring change; its exercise, however, involves a fair share of destruction as well. The camera acts a wedge, driving new realizations of self, family, and community out of its subjects.

Kasamayaki offers a useful insight into the role of documentary following times of crisis. By placing a strong emphasis on craft and the nature of creative labour, the film insists upon the persistent impulse for preserving and producing images as seen in other 3.11 documentaries. It asserts that art in general, and photography and film in particular, can present ways of processing a natural disaster such as the Tohoku earthquake. Here, a creative disposition is

seen as something of a burden, one which requires a distance from others to allow one's process to develop. Yet it also provides an opportunity for renewal. As Kokubo's mother comments: "People who make things pull themselves up by creating. You can renew yourself by creating."

Matsubayashi presents a potential collaborative solution in *Memories of a Lost Landscape*. Following the mandatory evacuation of their Minamisoma home, the Tanaka couple were given the opportunity by the government to temporarily return in order to retrieve some of their belongings. Before boarding a police-escorted bus with other residents, Kyoko and Kyuji are given special radiation protection suits, footwear, hairnets, and medical face masks. As the couple excitedly prepare to leave, Matsubayashi films a security personnel member pointing a video camera at him, the two lenses facing each other in mutual surveillance. Matsubayashi, filming alongside a crew of news cameras, watches the couple get on the bus and drive away. Before leaving, Matsubayashi had given Kyuji quick instructions for operating a simple digital still camera with a video recording function capable of capturing up to 30 minutes of footage.

Matsubayashi then edits the images shot by Kyuji into his film. The "home movie" footage begins with a remarkably steady shot from the back of the van as it enters the evacuation area. The camera, positioned above the hairnets that cover the heads of the other passengers, points out the window at the passing scenery. The townsfolk comment on the sorry state of nearby houses as the van passes by. The unseen camera operator, now inside the Tanaka home, slides open a closet door. The next shot, a view out of the window, reveals mounds of collected debris. The camera then moves back outside where, plastic trash bags of belongings in their hands, the suited neighbours are gathering for the return bus. As they get back in, they assist one another by adjusting the layers of their thin protective plastic suits in order to reduce the risk of contamination. Back on board, they chat happily together.

The film then reverts to Matsubayashi's footage, as Mr and Mrs Tanaka, upon returning, are swarmed by reporters. They remove their protective suits and prepare to leave with their belongings. Matsubayashi pushes through this circle of cameras and microphones and films Kyuji as he is asked by reporters to hold up what he chose to take out of the exclusion area. He proudly removes their grandson's prized card collection and jokes good heartedly: "They want to see my grandson's treasure. Do you give me something if I show you this?"

Many thanks to Tara Najd Ahmadi, Deanna Kamiel, Yuki Kokubo, Fumiko Miyamoto, Nikki Morse, and A. Joan Saab for guidance and comments during the research and composition process, as well as to the editors of Cinespect *and the staff at Japan Society, New York.*

References

Associated Press, March 14th, 2011, "New USGS Number Puts Japan Quake at 4th Largest," *CBS News*, [Online], http://www.webcitation.org/5xgjFTgf4. Accessed April 5th, 2011.

Fujiwara, C. (2011). "A Conversation with Toshi Fujiwara about *No Man's Zone*," *No Man's Zone* press packet. Doc & Film International.

Fukushima: Memories of the Lost Landscape (Dir. Yojyu Matsubayashi, 2011, "Soma kanka Daiichibu Ubawareta tochino kioku").

Karashima, David and Luke, Elmer (Eds.) (2012), *March Was Made of Yarn: Reflections on the Earthquake, Tsunami, and Nuclear Meltdown*, New York, NY: Vintage Books.

Kasamayaki (Dir. Yuki Kokubo, 2014)

Lim, D. (March 14th, 2012), "Post-Traumatic Filmmaking in Japan," *New York Times*, [Online]. http://www.nytimes.com/2012/03/18/movies/films-on-the-tsunami-at-yamagata-documentary-film-festival.html?pagewanted=all. Accessed November 9th, 2012.

Mitchell, W. J. T. (2002), "Preface to the Second Edition of Landscape and Power: Space, Place, and Landscape," in W. J. T. Mitchell (ed.). *Landscape and Power*, Chicago: University of Chicago Press.

National Police Agency of Japan, Emergency Disaster Countermeasures Headquarters (October 31st, 2012), "Damage Situation and Police Countermeasures Associated with 2011 Tohoku District – off the Pacific Ocean Earthquake," [Online] http://www.npa.go.jp/archive/keibi/biki/higaijokyo_e.pdf. Accessed September 17th, 2012.

No Man's Zone (Dir. Toshi Fujiwara, 2011, "Mujin chitai").

Nornes, A. M. (2011), "Yamagata:halfway" *Kinejapan listserv*, October 9th. E-mail.

Shoji, K. (June 24th, 2011), "First Tohoku Documentary Captures Tsunami Aftermath," *Japan Times*, [Online] http://www.japantimes.co.jp/text/ff20110624a4.html. Accessed November 11th, 2012.

The Sketch of Mujo (Dir. Koichi Omiya, 2011, "Mujo Sobyo").

The Tsunami and the Cherry Blossom (Dir. Lucy Walker, 2011).

Notes

1 See SAFECAST Japan <http://blog.safecast.org/about>.
2 As Walker's film is made for Japanese and English-speaking audiences, the title is presented in both languages. Unless otherwise noted, in the description of the films that follows Japanese dialogue is relayed through its subtitled English translation.
3 David Karashima and Elmer Luke's collection of short fiction and nonfiction literature created in reaction to the quake.
4 Karashima and Luke, 2012: xv
5 Shoji, Kaori, http://www.japantimes.co.jp/text/ff20110624a4.html.
6 Dennis Lim, "Post-Traumatic Filmmaking in Japan." http://www.nytimes.com/2012/03/18/movies/films-on-the-tsunami-at-yamagata-documentary-film-festival.html?pagewanted=all .
7 Chris Fujiwara, "A Conversation with Toshi Fujiwara about *No Man's Zone*."

Chapter 12

Ordinary Extraordinary: 3.11 in Japanese Fiction Film

Eija Niskanen

When Yoji Yamada, the renowned veteran of Japanese cinema, directed *Tokyo Family* (*Tokyo Kazoku*), his 2012 remake of Yasujiro Ozu's 1953 classic *Tokyo Story*, he felt compelled to include the events of 3.11 in this quintessential Japanese family drama. The youngest son, the black sheep of the family, met his girlfriend when volunteering in Minomisoma, Fukushima Prefecture. Furthermore, when paying his respects to a recently deceased friend, the main character, an elderly father figure, learns from the widow that her mother drowned at Rikuzentaka, one of the worst hit villages of the 3.11 tsunami. As film critic Mark Schilling states, while the Ozu original looked hopefully towards the future in the midst of post-war reconstruction, the Yamada version seems to reflect the unknown future of Japan in 2011, when the triple disaster hit a country already in economic slump.

By the autumn of 2011, an increasing number of documentary films on 3.11 began to appear (see Chapter 11). A special section of the Yamagata International Documentary Film Festival was devoted to films made in the wake of the Great East Japan earthquake and tsunami, and a screening project, "Cinema with Us," was organized and toured around the country. The most prominent documentaries included the controversial *3:11 A Sense of Home*, as well as such titles as *Fukushima: Memories of the Lost Landscape*, *The Tsunami and the Cherry Blossom*, *Radioactivists*, *Women of Fukushima*, *Fukushima Hula Girls*, *Nuclear Nation*, *Fukushima Now!* and *Becoming an Ancestor*. It took some time, however, for the subject to emerge as a theme in fiction films. Understandably, the events are a challenging and controversial topic to depict in commercial cinema. They awaken traumatic memories, trigger powerful emotional responses and raise difficult political questions. While documentaries on 3.11 seem appropriate, the creation of a fictional film about the real disaster poses a number of critical problems. How can a film-maker stay truthful to the topic and the suffering of the victims, while at the same time remaining faithful to his or her personal and cinematic vision? This might be one reason – besides the obviously lengthy production period of a feature fiction film – why several fiction films dealing with 3.11 were released in 2012, one year after the disaster. On the other hand, fictional films offer a safer channel to discuss traumatic events, as a documentary film-maker is always caught in the dilemma of intruding upon people's suffering. In this essay, I will survey the different approaches both in terms of narrative and style that Japanese fiction film directors have taken in dealing with 3.11. How to depict disaster, in this case the triple catastrophe of earthquake, tsunami and nuclear accident, as well as the ensuing actions and reactions in the immediate aftermath of events, in the context of a fictional film?

Hollywood disaster movies, which often dwell on fictional scenarios of global destruction on an apocalyptical scale, offer mayhem and easy solutions, with heroic characters and a very nationalistic, US-centric response to these threats. Of course, a long tradition of monster films that revels in spectacular fantasies of disaster and destruction exists in Japanese cinema. The Godzilla and Mothra movies are the most noteworthy examples. In recent years, a number of films have also been released in Japan about imaginary threats: *Japan Sinks/Nihon chinbotsu* in 2006 follows in the footsteps of Hollywood special effects disaster blockbusters, while *Pandemic/Kansen retto* (2009) perhaps derived its idea from the SARS epidemic that caused panic and fear throughout the Asian region. This time, however, "the Real Thing" occurred and many artists, writers, film-makers and other creative talents were led to consider their response to the events that unfolded during 2011. The cinematic reaction to 3.11 is further complicated by the combination of natural and man-made factors that led to the disaster, including the negligence of TEPCO, the owner of the Fukushima Dai-ichi nuclear power plant, and the ineffectual efforts of the government to manage and control the threat of radiation.

Ryuichi Hiroki's *River* (2011) was one of the first fictional films to deal, though somewhat indirectly, with the topic. The film opens with a long travelling shot, in the style of a documentary, of a girl walking on the streets of Akihabara. She stops and sits on the railing at the crossroads, looking and listening, perhaps waiting for someone. The soundtrack registers the direct sounds of a typical Akihabara street scene – people chatting, pedestrian traffic lights clinking on and off and cars passing. The peaceful everyday atmosphere of the place is suddenly broken by the piercing sound of screams, but the scene remains unchanged. No one, including the girl, reacts to the screams. A photographer named Mami takes an interest in the lonely figure of the impassive girl. Gradually the girl, Hikari, tells Mami the reason for her recent visits to this particular place: her boyfriend Kenji was one of the victims of the 2008 Akihabara massacre. An ordinary *freeta* (a part-time worker at an undertaker company) suddenly stabbed numerous people in Akihabara. These screams, therefore, are a mental echo of the tragedy, the traumatic memory haunting Hikari's mind as she returns to the scene of the crime three years later.

Hiroki had initially planned to make the film to evoke only the murders, but after 3.11, he felt compelled to change the script to reflect also upon the enormity of the more recent tragedy. Hiroki's hometown, Koriyama, a city of 330,000 residents, is in Fukushima prefecture, an area which today still registers high radiation rates. The choice to include an implicit reference to 3.11 also makes the film resonate on two levels: the recent Akihabara massacre is combined with the new, larger national tragedy of the triple disaster. Hikari's grief over the death of her boyfriend is therefore associated with the recent mourning of the nation over the Tohoku victims. The violent rampage of a sociopath is equated with the terrible consequences of the natural disaster and its political fallout. The state of the nation, its moral and social malaise, can somehow be gauged by connecting these two seemingly random events, in a manner that recalls the implicit critique of contemporary Korean society in *Memories of Murder* by Bong Joon-ho (which itself is reminiscent of Kurosawa's gangster and cop films).

Hikari runs into a young man, Yuji, who seems to have known her boyfriend. Yuji tries to divert Hikari from her eternal mourning by pointing out what is currently taking place in Northern Japan. But he too is escaping from reality: his parents live in the region hit by the tsunami, but he has not been in contact with them since leaving for Tokyo years ago. He no longer has the courage to visit them. Yuji, no matter how lost himself, gets Hikari to take an interest in the world around. The film closes beautifully with a series of tracking shots similar to the one it opened with, as Hikari walks the Akihabara streets. Her walk is cross-cut with similar tracking shots of countryside as seen from a train window, then shots taken from a car window of the tsunami-ravaged landscape in Tohoku. The camera then centres on Yuji, standing in the middle of this scenery, tracking in close-up around him as he looks at the desolated landscape. He searches for his home, but finds an abandoned house with a message written on the wall. He continues walking in several, long tracking shots, and starts crying once he realizes the vastness of the destruction. This ten-minute sequence in Kesennuma finally cuts back to Hikari, who is sitting on a boat, passing through the canals in Tokyo. She looks at a few things left behind by Kenji, her memories of him. The camera is centred on Hikari's face for several minutes, with just the background of the nightly river surface reflected in blues and greens: "Thank you, Kenji," she says. She seems to let go of the past, while Yuji is stuck with facing his – and the nation's – tragedy. Those left behind after the two tragic events share a common feeling of guilt and uneasiness: how to continue living after the disaster? How to overcome the loss and return to life in the trivial everyday world once more?

Women on the Edge/Giri giri no onnatachi (Kobayashi Masahiro, 2011) provides a less successful or satisfying take on the disaster than *The River*. Kobayashi aimed for a topical, disaster-flavoured take on the genre of the family drama. A dysfunctional family's secrets are brought into the light of day against the background of 3.11 in a manner that does not seem to connect the family disputes with the disaster in any significant way – the drama could have been played out in any place and time in Japan since the 1980s. The post-3.11 setting does not lend any dramatic, thematic or psychological insight into the family story – which does not even unfold on screen but, as the dialogue reveals, occurred a long time ago. Although the sisters observe the minimal damage caused by the earthquake to their house, and take a short walk through the rubble, their attitude to each other or the past is in no way changed or challenged by the national disaster. In that sense the dramatic motive for the siblings' reunion could have been anything; quite often in films and stage plays this function is given to the death of a family member. The story of three sisters returning to their abandoned Tohoku family house neither presents an intriguing family drama, nor manages to connect 3.11 to the personal level of the sisters' lives. *Women on the Edge* forms a disappointingly meaningless relationship with the events of 3.11; though right there, in the centre of the disaster area, the three sisters continue as if nothing had vanished. Perhaps Kobayashi intended to say that even in the midst of tragedy there are people who could not care less, but portraying all three of his main characters in such a manner is an odd dramatic choice. Hence, though Ryuichi Hiroki, Sion Sono and Atsushi Funabayashi (as we shall see)

managed to convey something substantial about 3.11 by changing their pre-quake scripts to include the events, Kobayashi does not develop his original stage play for the screen in any significant way.

Makoto Shinozaki, a film-maker and professor at Rikkyu University, dwells on 3.11 in *Since Then/Are kara* (2012), which premiered at the Tokyo International Film Festival in 2012. The film is a collaboration between the director and his students at the Film School of Tokyo. *Since Then* begins with an apparently everyday scene: a woman is trying on comfortable walking shoes while a shop attendant serves her. It soon becomes evident through their dialogue that the scene takes place in Tokyo in the immediate aftermath of the quake. As all the trains have stopped running, the customer switches her high heels for more comfortable shoes in order to manage the long walk home. The scene is based on several true incidents; for example, many Tokyoites bought a bicycle to ride home and, amidst the huge crowd on the long trek home after the quake, I myself saw a young woman walking in cute household slippers, carrying her high heels in a plastic bag. Shoko, the manager of the shoe store, is worried about her boyfriend Masashi, who she has been unable to contact on his mobile phone. Masashi is somewhere north of Tokyo near the disaster area. During the next few days, among the continuing aftershocks, she finally reaches Masashi's brother, who claims that Masashi has become mentally unstable and has been taken to a hospital. Shoko should leave him alone. Suddenly Masashi appears at Shoko's apartment. The couple must find a way to deal with their shock and to continue to live together.

Since Then captures the feeling of everyday life in the days after the quake extremely well. Constant aftershocks punctuate the long periods of waiting, the fruitless attempts to resume a normal routine, to go to work, go shopping or go to a movie, As a shop assistant says, it is weird to just to carry on as normal in such an extreme situation. Anxiety about the unknown, in this case Shoko's concerns about Masashi, totally consumes her everyday actions. *Since Then* does not aim to cover 3.11 or to take a political stand. Rather, it offers a slice of life view of a few, supposedly, normal weeks in the life of a single Tokyo woman, an unforgettable experience which turned out to be extraordinary as a result of the earthquake. Her boyfriend's mental breakdown suggests a thematic parallel with the sudden disturbance in the complacent state of the nation.

Sono Sion has confronted the topic of 3.11 in two of his recent films. *Himizu* (2011) and *Land of Hope/Kibo no kuni* (2012). As the director has stated, the endlessly monotonous normality of Japanese life during the last decades has suddenly been transformed into an unbearable and insupportable abnormality, a subject he had to address in his films. *Himizu,* (the Japanese word for a small mole) is based on a manga by Minoru Furuya, which originally had nothing to do with the tsunami or nuclear radiation. Sion rewrote the script with 3.11 and Fukushima acting as a kind of mental landscape for the main characters and events. In the manga, as in the film adaptation, a schoolboy, Yuichi Sumida, is forced to live in unusual circumstances; abandoned by his parents, he must run the family's boat house on his own. He is determined to live as normal a life as possible, an impossible hope given the extraordinary events he must confront. This theme seems to resonate with the events

of 3.11; it is impossible to continue life as normal when disaster strikes. The roots of the film in the manga are visible in its uneven comingling of elements of each plot: the events at Fukushima are presented alongside the twisted story of a father who forces his son to dig his own grave. The simple black-and-white lines that marked the rain in the manga are represented in the film by the scenery in the disaster area.

Himizu opens with a schoolgirl standing in the rain, addressing the camera directly as she recites a poem by François Villon, "All Things Except Myself I Know." Its lines, besides displaying Sion Sono's fascination with classical European culture, allude to the girl's obsession with Sumida and the common difficulty of knowing the human psyche:

I know flies in milk
Specks against white
I know, I know it
I know a man by his clothes
Even I know that much
I know fair weather from foul
I know that
I know the apple by the tree
That I know
I know who labours and who loafs
I know all
All save myself

A British critic has made a superficial comparison to Resnais's *Hiroshima Mon Amour*, yet the two films could not be more stylistically or morally different in tone.[1] "All Things Except Myself I Know," however, resonates, like an inverted echo, with the repeated statement of the Japanese lover at the beginning of *Hiroshima Mon Amour*: "You know nothing" or "You will have seen nothing." The Villon poem also contains a cinematic reference to Sion's previous film, *Love Exposure*, where a similarly obsessed young woman recites Saint Paul's first letter to the Corinthians.

The girl continues to read Villon's poem as the image changes to a long, lateral tracking shot of the devastated Tohoku landscape. Mozart's "Requiem" accompanies the moving camera and reaches a crescendo, to be replaced by a ticking clock, as the film's title appears on the screen. A dissolve reveals a middle-aged man walking in the midst of the rubble while the distorted sound of a howling wind increases in intensity to an ominous rumble. The camera tracks in close-up around the man as he looks at the destruction with a pained expression on his face. The camera surveys the wasteland as if from his point-of-view. A teenage boy then walks into the frame. As he picks his way through the wreckage, the hiss and click of a Geiger counter becomes audible on the soundtrack. It gets louder and louder

as the boy approaches a broken washing machine. He opens the lid, finds a gun inside, puts it to his head, and fires. The screen goes black and cuts to the same boy, Sumida, suddenly jolted awake; in the background, the TV broadcasts a news item about the evacuation from the radioactive zone around Fukushima. The opening sequence is hence marked as Sumida's dream.

Interestingly, the tracking shot is the most common cinematic tool used in both fictional and nonfictional films that take 3.11 as their subject; it appeared as the central visual strategy in Hiroki's *The River*, and returns once more at the outset of *Himizu*. It seems that, as a means of representing the totality of the destruction, the tracking shot, with its continuous passage through time and space, makes visible the extent of the physical and conceptual void at the heart of the disaster zone. At the same time, the tracking shot has been associated, throughout film history, with the contemplation of memory or trauma, as in the films of Alain Resnais and Andrei Tarkovski.[2] The cast and crew of *Himizu* filmed the dream sequences in a day at one of the areas worst hit by the tsunami. The main location, the boathouse set, in Ibaraki prefecture in Tohoku, was also badly affected by the disaster. Filming took place in May 2011, only two months after the tragic events. *Himizu* is set in the same time period: after killing his father, Sumida makes a voice recording that is dated May 7th.

Sono Sion draws an equation between parental abuse and violence and the government's negligence towards the residents of Fukushima. Sono directs challenging questions against those socially and morally responsible for the welfare of the family and the nation. Sumida's everyday world is far from safe or secure, let alone beautiful. His mother disappears completely, while his father returns occasionally to berate him, beat him up and steal money. He owes a huge debt to yakuza loan sharks who threaten to kill Sumida if the money is not paid back on time. At school, the teacher reminds the students that, for the first time in a generation, Japan has encountered a catastrophe of such magnitude. Based on former historical experiences, he claims, the Japanese will rise again. Sumida responds defiantly that "not everyone will rise." The teacher urges him to fight and to triumph over ordinariness. But Sumida's biggest dream, shared and supported by his infatuated classmate, Keiko, is to be ordinary, to lead an ordinary life. The more the ideal of "ordinariness" escapes him, the harder he tries to force things to become ordinary. As documentaries such as *Nuclear Nation* show, the most cherished wish of those who had to evacuate the area surrounding the nuclear power station was to return home, for things to be as they used to be – a wish unlikely to ever be fulfilled. Sumida's hopeless desire for normality and mediocrity is ironically juxtaposed with the most extraordinary circumstances that the Japanese people faced in the immediate aftermath of 3.11. The extremity of his subsequent actions also exposes the hypocritical façade of conformity and denial, Sion implies, upon which contemporary Japanese society is based.

In the original manga, Sumida finds support among his schoolmates. In the film, he forms a bond with a community of outcasts, evacuees from Fukushima, who are camping by the boathouse. They worry about him, care for him, and act as a surrogate family. One of their number, Yoruno, a former businessman, goes out of his way to pay Sumida's father's debt to

the yakuza. Sumida, a sullen and serious presence throughout the film, rarely smiles, except in those scenes where he joins in the evacuees' drinking parties. Slowly and begrudgingly, Sumida also forges a relationship with Keiko, the girl from the opening scene. She too is an unwanted and unloved child of a dysfunctional family – her parents have built gallows in their large middle-class home and want her to commit suicide in order to collect the insurance money.

Himizu connects Sumida and Keiko's burgeoning romance and violent coming-of-age story with the mental and physical suffering and anguish caused by the 3.11 disaster. Sion also points to the larger societal causes for the nuclear accident in a scene where Yoruno and a pickpocket break into an apartment in order to steal a stash of drug money to repay the loan sharks. They are interrupted when the occupant, a neo-Nazi, arrives home. On the television, a scholarly commentator explains the reasons why the Japanese rely on consensus and have not abandoned nuclear power like many other countries. The fascist thug (a swastika hangs on his wall) shouts back at the screen: "You stupid, nuclear is the best!" The scene makes an explicit reference to the connections between the extreme Right and the construction industry and big business – it is a known fact that yakuza-hired clean up crews have been used at the Fukushima Dai-ichi.

Sion is insistent in his position that the current generation in control of Japan has caused the disaster that the nation now faces. Yoruno acts as the director's mouthpiece when he states that Yuichi Sumida is the future, while he himself, the yakuza and everyone else belong to the past. The film's patricidal theme – Sumida eventually kills his father – can be viewed as a passionate condemnation of the ruling class and as a clarion call for the younger generation to save Japan from self-destruction.

Keiko assumes this role in *Himizu*. In the end, like the insistent female lead of *Love Exposure*, she becomes Sumida's guiding light. She convinces him to give himself up. The film ends with Sumida and Keiko running madly along the road to the police station, towards a camera that is tracking backwards. Keiko screams with fanatical encouragement: "Yuichi, don't give up!" – "Sumida ganbare!" The "ganbare" slogan has been repeated ad nauseam after 3.11, with catchphrases like "Tohoku ganbare" and "Nippon ganbare" appearing on posters, by the roadside, on television. The final scene cuts once more to the tracking shot of the landscape devastated by the tsunami, as Keiko and Yuichi's shouts of "Ganbare," "Don't give up!" continue on the soundtrack. The conclusion explicitly relates Yuichi's personal tragedy with the catastrophe that struck Tohoku and the crisis that Japan must confront. The sincerity of *Himizu*'s message is conveyed by the extremity of its expression.

The radiation threat

Two films deal directly with the meltdown of the nuclear power plant and the radiation threat, although they take a different approach to the topic: *The Land of Hope* (Sion, 2012) is about the people in whose village the power plant exists, while *Odayaka* (Uchida, 2012)

is set in the metropolitan area of greater Tokyo where rumours and fear about the radiation spread.

After *Himizu*, Sono Sion completed another film on the theme of the Fukushima disaster. In *The Land of Hope/Kibo no kuni* (2012), however, he does not recreate events, but draws a parallel future where the same events are repeated. In the near future, in 20XX, in Nagashima prefecture, a massive earthquake occurs. Two neighbouring families wait for the electricity to be switched back on. Suddenly, the self-defence forces arrive, dressed in protective radiation suits. They declare that an emergency has taken place in the nearby Nagashima Dai-ichi nuclear power plant. They draw the 20-kilometre evacuation line right through one family's garden, who are forced to leave immediately, while the other side is considered "safe": "What about this? This side is safe, what?" the people shout as they point to the other side of the line. The events unfold in a fictional location called Nagashima, a combination of the three Japanese areas exposed to nuclear radiation, Nagasaki, Hiroshima and Fukushima. The protagonists of the film, the Ono's, are based on a real-life Fukushima family who had the 20-kilometre evacuation zone line drawn through their garden. The Ono's are a family of farmers who keep milk cows in their barn; their occupation binds them to the land. They can no longer make a living after the nuclear accident if forced to evacuate and leave their land and animals behind. The decision splits the family; the younger generation, the son Yoichi and his pregnant wife Izumi, move to a nearby town, which still has high radiation levels, though not as extreme as on the farm. Yoichi finds a job at a construction site, while Izumi becomes more and more worried about the effects of radiation on her unborn child. Although *The Land of Hope* is much more traditional and sentimental than Sion Sono's previous films, Izumi behaves like one of his typically over-determined female characters. She becomes extremely obsessed with exposure to radioactive contamination and covers the apartment completely in plastic, sealing the windows and venturing outside only in a protective suit. Her actions make her the target of neighbourhood gossip. She finally persuades Yoichi to move further away from Nagashima prefecture to somewhere safe and clean.

Meanwhile, the Suzukis, the couple who lived next door, have been evacuated. They leave their dog behind to be fed by the elderly Ono's. Another couple, Mitsuru and Yoko, frequently returns to the village to look through the ruins for Yoko's missing parents. Yasuhiko, the patriarch of the family, worries about his cows and his wife Chieko, who suffers from dementia. Yasuhiko considers it impossible to move elsewhere because of her condition. Chieko is seen wandering alone by the sea, believing falsely that she is on her way to the traditional village summer festival. Ultimately, Yasuhiko makes a tragic decision: he takes his hunting rifle, kills all the cows, whose milk is no longer good for sale, lets the neighbours' dog free, and shoots Chieko, before turning the rifle on himself. The breakdown of families, businesses and small farms – issues all too familiar from the Fukushima disaster – are the central focus of the film.

The Land of Hope ends with two striking scenes: Mitsuru and Yoko walk slowly, one step at a time, in the snow by the sea. The director commented in an audience Q&A at the film's premiere at the Busan Film Festival: "My point with the characters walking one step by one

step is my wish for the Japanese people to go forward slowly."[3] Sion explains how this scene expresses his critical attitude towards the accelerated development of post-war Japan: the nuclear accident is the logical outcome of such thinking. Mitsuru and Yoko see two children who appear out of nowhere in a place where they should not be. Perhaps they are ghosts, spirits of children killed by the tsunami. The last shot is of two dogs, one of which is the dog that Yasuhiko spared – a common sight in Fukushima, where abandoned dogs and other domestic and farm animals roam the empty villages and roads.

The final scene is both hopeful and frightening: Yoichi, Izumi and their new-born child, drive away from the radiation-contaminated region. They stop by the sea and sit on the beach with other travellers, as the child roams on the ground. Yoichi sits a little further off, looking at the scene with a satisfied smile. Suddenly, the sound of a Geiger counter is heard from his bag. He looks at it; the radiation levels are high. The leak from the Nagashima Dai-ichi plant has spread even further. There is nowhere in Japan to escape.

According to Sion, the film depicts "the unending unordinariness [that] we're living now." The fictional Nagashima resembles Fukushima: the main characters' home village contains a gate with the sign: "Bright future in the atomic village." Such signs are typical in Futaba, the home of Fukushima Dai-ichi power plant, and other villages that house the nuclear industry. As in Fukushima, the 20-kilometre no-go zone marks an arbitrary dividing line that bears little or no relation to the actual limits of the area contaminated by radiation. Sono Sion highlights the absurdity of the situation by creating a literal wall that cuts through the landscape – in reality, police roadblocks on the highway are all that indicate the 20-kilometre exclusion zone. *The Land of Hope* was intentionally shot around Fukushima, but many scenes were filmed in rural regions around Japan that resemble the disaster zone. Fifty nuclear reactors still remain operational in Japan. By locating the plot in the near future and in an imaginary place, Sion strongly suggests the next Fukushima could occur anywhere in Japan. Nagashima is anywhere and everywhere in Japan.

Odayaka/Odayakana nichijou, by Nobuteru Uchida, premiered at the Tokyo FilmEx 2012 film festival. The film begins with the earthquake and then focuses on the story of two women. In the days spent waiting for her husband to return from work, Yukako starts to study the effects of radiation. Saeko is left to tend for her daughter when her husband decides to leave her. Her predicament recalls a story in Haruki Murakami's *Underground*, a collection of reports and testimonies from survivors of the Aum Shinrikyo gas attack in the Tokyo subway; after the tragedy, a man realizes that he wants a divorce, as if the shock of such a traumatic event suddenly opened his eyes to the void at the heart of his own life. Saeko, like Izumi in *The Land of Hope,* soon begins to worry about radioactivity. In an attempt to protect her daughter, she buys a Geiger counter and measures the radiation at the day-care centre that the child attends. She tells the head of the centre not to give spinach to her daughter as it carries radioactive particles. Her actions start irritating the staff and the other mothers, one of whom is married to an electricity company worker – the company is never explicitly identified but the reference to TEPCO, the owners of the nuclear plant at Fukushima, is clear. Everyone downplays the threat of radiation and acts as if the government knows what

they are doing. They treat Saeko as a madwoman who is creating unnecessary problems and panic. Secretly, however, they are just as anxious. The electricity company worker's wife asks for foreign fish at the supermarket. Her worst fears are confirmed when she receives a phone call from her husband who, it is hinted, "will be sent up there" – the Dai-ichi power plant – to help with cooling down the nuclear reactors.

The neighbourhood actions against Saeko and Yukako, who has befriended her, become more and more extreme; they receive anonymous threats in the mail and stones are thrown at their windows. Similar treatment is offered to an evacuee from the disaster area whose car, easily targeted because of its Fukushima license plates, is plastered with nasty leaflets and smashed up. While *The Land of Hope* addressed such bullying and intimidation as a side issue, in *Odayaka* it becomes the main focus of the plot. The film exposes the ugly side of the Japanese nation during and after 3.11, a stark reality that was ignored in the foreign media in favour of positive stories about the stoicism, calmness, and law-abiding behaviour of the Japanese people in the face of the disaster.

Rebuilding

Atsushi Funabayashi dealt directly with the aftermath of the Fukushima disaster in the documentary *Nuclear Nation* (2012). *Cold Bloom*, his recent fiction film, is set in Hitachi in the prefecture of Ibaraki after 3.11. It does not directly depict the disaster, but the mood and the theme of the film pointedly address the difficulties of rebuilding and recovery after the event. The main characters work in a small factory that makes parts for larger companies. After the global financial crisis and the post-3/11 situation small businesses and entrepreneurs in Tohoku face the constant threat of redundancy and closure if they don't receive orders from manufacturers.

Shiori, a young woman who works in the factory, is the central character of *Cold Bloom*. Her husband Kenji is also employed at the same place. He is sent to the larger Kitami Company to oversee the installation of machine parts. Negligence with security and safety measures causes his death, a situation that corresponds with the accidents of 3.11. Takumi, who was involved in the accident, carries the guilt for Kenji's death, but Shiori must continue to work with him. Leaving is presented as one option. When the former boss, Kimura, quits to start a new business in Osaka, the factory is left for Shiori to manage. Takumi also leaves to find a new job far away from the struggling Fukushima region. *Cold Bloom* reflects the topical issue of negligence by large companies towards their contractors and employees. Japan's industrial structure, as revealed in the film, is actually based on the work of small enterprises whose products have made the economic miracle possible.

Cold Bloom is structured around a year. When Kenji dies, the cherry flower trees are about to blossom (the film's Japanese title, *Sakura Namiki no Mankai no Shita ni*, literally means "under the cherry trees in full bloom").[4] Over the course of a year, until the next season of blossoms, Shiori must deal with her ambivalent feelings of loss and rage and her

growing infatuation with Takumi. At the same time, the film confronts the difficult subject of guilt, responsibility, forgiveness, and rebuilding in the wake of the disaster. What does life mean after the loss of a loved one or the trauma of a catastrophe like 3.11? How does one carry on after such a disastrous event? Kenji's speech about the significance of cherry flowers in Japanese culture is repeated twice as a flashback – for him they represent "hesitation." Indeed, the atmosphere of the film is marked by the feeling of transience that is associated with the short-lived cherry blossom flowers. Their bittersweet memory, never saccharine or sugary pink, surfaces through the bleaker scenes in the cramped and dark factory, the industrial landscape, and the wide and windy seashore.

Japanese directors have taken multiple approaches to filming the events of 3.11. Films like *Himizu* or *The Land of Hope* take place, at least in part, at the scene of disaster. Others, as is the case with *Odayaka*, present it from a distance, depicting the fears of people in Tokyo. In *The River,* Hiroki connects it with an earlier tragedy, the 2008 Akihabara incident, while Funabayashi locates *Cold Bloom* in North-Eastern Japan a couple of years after the events. Cinematic style varies as well, even within the work of a single *auteur*. *Himizu* could be viewed as an expansive variation, set in the days and weeks after 3.11, on Sion Sono's previous masterpiece *Love Exposure*. But its overt violence and obsessive characters are juxtaposed against the sombre tracking shots through the disaster zone. By contrast, the sentimental drama of *The Land of Hope* adopts a more mainstream approach. *River, Since Then* and *Odayaka*, on the other hand, concentrate, on an economical scale, on a local or private response to the disaster.[5]

All these films are haunted by an absence – of what was, of what has disappeared and of what will never come to be. Their common theme is loss, be it the illusion of safety and security, the last remnants of parental care, the death of a lover or husband, the loss of home or community. Though not visually present, the disastrous moment lives on. An invisible pall – like the threat of radiation – settles over all things. The ordinary course of everyday life falls under the shadow of an extraordinary reality: 3.11.

References

Cold Bloom/ Sakura Namiki no Mankai no Shita ni (Dir. Atsushi Funabayashi, 2013).
Himizu (Dir. Sion Sono, 2011).
Odayaka/Odayakana nichijo (Dir. Nobuteru Uchida, 2012).
Villon, F. (1906), "All Things Except Myself I Know." The World's Wit and Humor, Vol. X, French, The Review of Reviews Company, New York, pp. 15–17.
River (Dir. Ryuichi Hiroki, 2011).
Schilling, M. (2012), "'River' From Akihabara's Senseless Killings to Tohoku's disasters," *Japan Times*, March 9th.
Schilling, M. (2013), "Tokyo kazoku (Tokyo Family)," *Japan Times*, January 11th.
Simmonds, E. (2012), "Earnest but Morose Drama Set against the Backdrop of the 2011 Tsunami," http://film.list.co.uk/article/42580-himizu/

Since Then/Are kara (Dir. Makoto Shinozaki, 2012).
The Land of Hope/Kibo no kuni (Dir. Sion Sono, 2012).
Women on the Edge/Giri giri no onnatachi (Dir. Masahiro Kobayashi, 2011).
Q&A for *The Land of Hope* with director Sion Sono took place at the 2012 Busan International Film Festival on October 5, 2012. AsianWiki, editor Ki Mun.

Notes

1 Emma Simmonds, "Earnest but Morose Drama Set against the Backdrop of the 2011 Tsunami," http://film.list.co.uk/article/42580-himizu/
2 See the essays in this volume by Joel Neville Anderson, Antonia Girardi and José Luis Torres Leiva for a fuller discussion of the significance of the tracking shot in the representation of the earthquake.
3 Mun, Ki. Sono Sion interview at Busan International Film Festival, October 5th, 2012. AsianWiki.
4 See the discussion of *The Tsunami and the Cherry Blossom* by Joel Neville Anderson in Chapter 11.
5 [Ed.] Since the completion of the essay, a number of films have been released that display a more ironical take on the disaster. *And the Mud Ship Sails On/Soshite dorofune ga yuku,* (Hirobumi Watanabe, 2013) satirizes con-men who scam money from the victims on 3.11. In *Au Revoir L'ete/Hotori no sakuko,* (Koji Fukuda, 2013), an anti-nuclear group invites a Fukushima evacuee to join their demo, but the boy's parents worked at the nuclear power plant.

Chapter 13

Earthquake/*ΣΕΙΣΜΟΣ*

Yuri Averof

I first went to the island of Kefalonia in 2000 to work on the Hollywood production of *Captain Corelli's Mandolin*. At the time, my girlfriend Rea was working as a researcher for the film and we were to spend almost six months living in a small house, built on the slopes of the Agia Dynati mountain that split the island into two.

Captain Corelli's Mandolin starred Nicholas Cage in the role of Captain Corelli, a carefree Italian officer stationed on the island, and Penelope Cruz, as Pelagia, the daughter of a Greek doctor. My job was "marine assistant," teaching the actors to row and fish, and making sure the crew was safe while in and around the water.

In the film, the entire Italian army was massacred by the German Alpine Forces, after they refused to surrender their arms in 1943. Pelagia saved Corelli's life and helped him to escape. Ten years later, in 1953, she survived one of the world's most powerful earthquakes that killed over 500 and destroyed most of the island's buildings.

To reconstruct the island of the 1940's, the art department Rea worked with had to build the town of Argostoli and Pelagia's village from scratch. In Argostoli, only two buildings and one crooked bridge survived the earthquake. The production of the film decided to shoot in the town of Sami, which had also been completely wrecked and was rebuilt with wide streets and pre-fabricated cement houses. Sami was dressed up as the main set for the film, draped in wonderful Venetian style architecture, the crew cladding the main hotel and other buildings to blow up during the main action scenes. Postcards of the set, named "Old Argostoli," were sold over the summer and many tourists visited, relishing the charm of past centuries.

Even if the film had not included a powerful earthquake sequence, the impact of this earthquake is to be seen and felt everywhere across the island. In Faraklata, a mountainous village overlooking the bay of Argostoli, the entire village was abandoned after the 1953 earthquake. It is still possible to enter abandoned untouched homes, as in most villages across the island.

Rea and I became attached to Kefalonia. The following year, Rea went on to work on a BBC production about the real story of Captain Corelli, and in 2003, we were still not finished and decided to film a documentary about the impact of the earthquake on the island.

Our starting point was the discovery of two unique collections of amateur films. The first belonged to a Greek Australian called Stathis Raftopoulos from the island of Ithaca – which is separated from Kefalonia by a narrow channel of water.

Born on Ithaca in 1921, Raftopoulos moved to Melbourne in December 1934 following his father Spiro who had gone to Australia in 1922 and his grandfather who had emigrated in 1895. Stathis maintained a very strong attachment to Ithaca and between 1950 and 1954, his company, Dionysos Films, was the sole distributor of Greek films in Australia.

In 1953, he returned to Ithaca as an amateur film-maker, to film the 16mm documentary A *Tour through Greece*. This was the film we saw. We were at once overwhelmed by its power. The images captured the carefree rhythms of life on the island before the disaster struck, the moment of the earthquake itself, and how life changed after this moment. This was Greece as we had never seen it before and were moved by the spontaneity, the freshness, the beauty and the colours of the images. It was not just footage of the island; it was *someone* looking at it, with his own unique gaze. We later found out that when Stathis screened his film in December 1954 in Melbourne, the audience complained that "the camera was shaking and the images were out of focus." More than 16 police officers were called to calm the angry crowds and the film's sponsors demanded their money back.

The second collection we found belonged to a Kefalonian called Apollon Psomas. In the 16mm footage of Kefalonia his father shot a few days after the earthquake, groups of people stand silently in front of ruins, holding signposts with the names of what used to be their villages. In other reels, he had recorded Kefalonians in New York, picnicking in Central Park. Here too, they held signposts in their hands, with the names of the destroyed towns and villages of Kefalonia. They were a few of the 100,000 islanders who emigrated following this immense natural disaster.

Rea and I were taken back by the power of the images. In Psomas' films, the Kefalonians were much more than silent subjects in observational documentary footage. With their makeshift signposts and intense gazes, they were consciously and actively participating in the creation of a narrative. The visual sense of "time" and "place" was unnerving – as was the intensity of "loss" and "memory."

How could we make a film about this experience? How to depict the total transformation of their homeland from one day to the other? How to express the deeper, hidden layers of such momentous change?

Then we met a Greek poet and novelist called Stratis Haviaras. At the time, he was living in Massachusetts and was a curator in the Harvard College Library and founder of the Harvard Review. We learnt that in 1953 he had experienced the earthquake's aftermath: he had travelled to the island seeking work as a builder. We decided to work together on a voice-over for the film, that could bring together the footage we had discovered and interviews with the earthquakes' survivors. The voice-over was written in the first person, reflecting Stratis' personal story. Here is an excerpt:

The profound shudder and shock of the previous decade had come in the form of war: the Italian invasion, the German invasion and occupation, brutality and atrocities, rubble piling on top of rubble and bodies. My mother had survived the concentration camp in Germany,

but my father's remains were still unidentified in a mass grave near Corinth. Our house in a refugee settlement in the Argolid, demolished in further reprisal by the German army, left me homeless.

At twelve I was roaming the country looking for work. I was small and not strong enough to carry large masonry stones, sacks of cement, buckets of lime and mortar. I carried stones, cement and mortar on a ramp two and three stories high. Exhausted, I often spent the night in the street, or found shelter in ruins and houses under construction.

After the liberation, a tragic civil war raged for five more years, finishing off what the foreign fury had left standing, leaving the survivors scarred and divided for twenty-five more years.

And yet times change. Change transforms all. And what defies change faces extinction. Far from having vanished, the world of our fathers and mothers and more distant ancestors, painfully transformed itself – from what we called a place of destitution, destruction and death, to a place of sufficiency and remembrance.

I first sailed to the Ionian Islands in 1953, shortly after the violent earthquakes that ruptured their undersea foundations and ravaged cities and villages.

Late at night on the Patras waterfront, waiting to board the liner for Cephalonia, I met others like me, builders from all over the country, some carrying tool bags on their shoulders, all somber, silently hopeful for work and signs of life.

With Stratis' voice and the amateur films, we now had two distinct, personal levels of narrative within the film. A third layer was brought in through testimonies with those who had experienced the earthquake. This is how one of the film's characters, Dionysis, remembered the earthquake:

War does not bring such devastation. A bomb falls, it destroys five or six houses but not all of them. Here, everything was destroyed. Everyone was terrified. The women and children were screaming, running towards the sea.

There was a rumor that the island was going to sink. We called on St. Gerasimos to protect us. We believed in the saint and said that if the island sinks, we will sink with our saint.

Efthymis and Ilias, two peasants from town of Lixouri remembered the earthquake differently:

– Efthymis	*Before the earthquake, large families lived in tiny houses built of clay. My father shared one pair of trousers with his three brothers to go to town. They didn't have a second pair.*
– Ilias	*After the earthquake, my pocket was filled with money. I started working at once, hurling up houses and this was the beginning of my new life and salvation.*

– Efthymis	*Life changed. Money poured in. We filled our wardrobe with suits.*
– Ilias	*Now the village has everything the city has. Each house has two fridges and three televisions!*
– Efthymis	*The earthquake was the salvation of Kefalonia. It put an end to many bad things.*

Ultimately, through the three levels of the narrative (voice-over, amateur archive footage and testimonies) the documentary explores the passing of time and our fervent desire to hang on the past. For Georgia, who returned a few years later to the island,

[T]he past exists only in memory." For an elderly sister and brother whose life was transformed, *"the past is a film, it is how we wanted to build our life"* and for Stratis Havarias, the film's narrator, *"we cling to precious objects and memories as though our life would be incomplete without them. And this seems to be but one of life's many devices, with which it perpetuates and preserves itself on this greater island, earth.*

Σεισμοσ is available through http://www.anemon.gr/films/film-detail/earthquake

Chapter 14

Home in a Foreign Land

Nora Niasari

> Exile is not, after all, a matter of choice: you are born into it, or it happens to you.[1]

In the aftermath of the February 2010 earthquake in Chile, its victims faced the consequences of an event beyond their control. Thousands of affected residents were exiled from their homes and permanently displaced. It was not a matter of choice; they were trapped between two worlds, the world they once knew (the past) and the world they were unprepared for (the present). In this collision of past and present worlds, what is the meaning of "home" for disaster victims? While producing the documentary, *Talca Interrupted* in Chile, my personal experiences as an Iranian-Australian film-maker have been essential to exploring this question.

As a first-generation migrant from Iran, I was forced into exile as a child in Australia. Following my parent's divorce, my mother made it clear that if we retuned to Iran, we would not see her again. Despite being alone in a new country, it was not a difficult choice to stay. Growing up in Australia, I was often treated differently by other kids; stereotyped as a Wog or a Muslim, teased about my lunch and my mum's "funny" accent. During the Muslim backlash in my high school after 9/11, I began to think twice about being "proud" of my culture.

> Exiles look at non-exiles with resentment. *They* belong in their surroundings, you feel, whereas an exile is always out of place. What is it like to be born in a place, to stay and live there, to know that you are of it, more or less forever?[2]

Australia's short history is filled with stories of exile and displacement. During the eighteenth and nineteenth centuries, the country was colonialized by Anglo-Europeans who subsequently pushed the indigenous owners of the land into permanent displacement. All human beings desire a sense of belonging to a place. But what happens when that place is destroyed and taken away from you?

Following my studies in architecture and film-making, my projects have often questioned how people define their place of "home" through architecture and the moving image. In 2009, I travelled to Beirut for a short documentary film, "Vehicles of Memory," which focused on taxi drivers circling the now empty city centre, "Martyrs Square." They recalled their memories of their beloved city before the destruction of the Lebanese Civil War. After the damage from the war, the banality and emptiness of Beirut's new downtown area left the locals feeling like foreigners in their own city. A place that was once familiar, no longer felt like home.

The following year, I finally returned "home" to Iran after 16 years of absence. In my grandmother's house, the aroma of her cooking alongside the warmth of my family was indescribable. The liveliness of Tehran and its cultural richness was everything I had imagined. But after a few days of interacting with locals, I realized I was being treated like an outsider. People would ask me why I had not returned home sooner, they assumed it as a choice or a luxury, "Is it because you like Australia more than Iran?" It was not a question of national pride or heritage. Due to my father's presence in Iran, I was prohibited to return until the age of 18. Like many other exiled migrants, I had no choice.

When I returned to Australia, I watched news of the Chilean earthquake on February 27th, 2010. There were images of mass debris and destruction, residents mourning, people who had lost their homes, their livelihoods. It was a tragedy that stood in the shadow of a much larger catastrophe, the Haiti earthquake. The Chilean story slowly slipped under the radar in the international media but I wanted to know more.

Later that year in Chicago, I met local architect Paul Tebben who was running a post-earthquake reconstruction workshop in Talca, Chile. I joined the workshop in February 2011, one year after the earthquake. We arrived in Talca on a Sunday, the streets were mostly empty and after a short walk to the city centre, it was clear that a majority of the city's basic operations were at a standstill. It seemed like the earthquake happened just yesterday. The residents described it as memory loss; they could no longer recognize their city.

> Sometimes I reach a corner and I'm completely disoriented. I have difficulties remembering the facade of the block; there is absolute memory loss. I can't remember what was there.
> (José Luis Gajardo, Architect)

We walked through countless abandoned homes filled with furniture, objects and broken walls from a previous life. Cars and pedestrians motioned past with little to no recognition. On this day, there was one exception; an older man slowly approached the edge of a destroyed house, he silently gazed at the rubble. He stood at the intersection of life and death in this urban cemetery. Among the traffic of the city, he grieved the life of his house or perhaps the people who once lived there.

This was only one of 6,500 homes that were damaged or destroyed in the earthquake. Due to the lack of international media coverage of the situation in Chile, I was motivated to give the residents a voice. During the next two weeks, I interviewed residents who had lost their homes for my documentary, "Talca Interrupted." The majority of residents no longer had a visible façade to their home, instead, a high fence of corrugated iron with a spray-painted house number, #1030, #987, #1432. To the government, they were ultimately considered a number among a thousand numbers.

I quickly learnt that not all residents were lucky enough to stay on their block of land. Many people did not own the land they lived on or lost their paperwork in the muddy heap of their destroyed homes. They were subsequently relocated into temporary shacks or

shared accommodation. One example was a single mother, Sandra, who was trapped in her house with her children on the night of the earthquake. She made a lucky escape but recalled this truly horrifying experience:

> There was a very loud sound at 3AM. I held my kids in my embrace and prayed … If God is to take us, let him take us all together; and if He is to save us, let him save us all together.
> (Sandra Velasco)

Sandra was born and raised in "Casa Antunez." She lived in the same house and the same neighbourhood for 40 years until the night of the earthquake. But she was not the only one who had connections to this house. Sandra's cousin, local architect Jose Luis, gave me a personal tour of their damaged adobe home. This typical long, narrow Chilean house was built in 1927 by Jose Luis' great grandparents. He also grew up in this house. As a child he laid the bricks that formed the path into the courtyard. When we saw the house from the street, it gave no sign of destruction through its façade; it blended perfectly into a normal state of pre-earthquake existence. In opening the doors, you could see the entire foyer covered in remnants of the once standing house.

Casa Antunez was a space of collective memory. Each room had a unique story to tell through its materials, aromas, colours and sounds. It had lived through numerous earthquakes with four generations of family and twenty-eight family members. After interviewing some family members individually and filming house tours before the demolition, I realized that the film-making process was encouraging them to say goodbye and grieve their home instead of turning their backs to the past. Each family member projected different dreams for their childhood home, which they did not share with one another.

Following the irreversible damage to the house, it became a space of collective conflict. The decaying home became a metaphor for internal family relations. While some family conflicts existed before the time of the earthquake, the deterioration of their collective home prompted the family to examine their relationships to one another and ultimately their sense of belonging to this sacred site.

> The house is a site of both deep harmony and hatred […] The house can neither be taken for granted nor be taken to be just a site of memory, for it is a threatened physical place that may experience successive possessions, dispossessions, and repossessions.[3]

While Jose Luis purchased the land and made the decision to demolish the damaged house, Sandra and other family members had other dreams for its future life, to rebuild it exactly the way it was before. They sought to preserve and relive their past whereas Jose Luis dreams to move on and build a better future for his neighbourhood.

Three years after the earthquake, the fate of this now empty land remains a question for Jose Luis and his family. Ultimately what they now share are feelings of exile and displacement

from their roots because they no longer have a physical reference point to their past. All that remains now is one number, #1425.

A family home can hold physical and psychological associations as it contains memory, history, geography, materials and an incomparable sense of place and belonging. In documenting one family's process of reconstruction in the aftermath of an earthquake, it is clear that feelings of exile as a migrant are comparable to the loss of one's home in a natural disaster.

> Anyone prevented from returning home is an exile.[4]

In Talca and other Chilean cities, solidarity movements and community partnerships have assisted to strengthen hopes for a better future after the February 2010 earthquake. When the past is often irrecoverable and the future is uncertain, maintaining traditions, family bonds and collective histories can salvage one's sense of identity and create a new sense of "home" in a foreign land.

Notes

1. Edward Said, "Reflections on Exile," in *Reflections on Exile and Other Essays*, Cambridge, MA: Harvard University Press, 2000, p. 146.
2. Edward Said, "Reflections on Exile," in *Reflections on Exile and Other Essays*, Cambridge, MA: Harvard University Press, 2000, p. 143.
3. Hamid Naficy, *An Accented Cinema: Exilic and Diasporic Filmmaking*, Princeton University Press, 2001, p. 169.
4. Edward Said, "Reflections on Exile," in *Reflections on Exile and Other Essays*, Cambridge, MA: Harvard University Press, 2000, p. 143

For more details about Nora Niasari's documentary Talca Interrupted please visit www.talcainterrupted.com

Chapter 15

Moving: An Interview with Park Kiyong

Zhou Ting-Fung

A current visiting fellow at the University of Auckland, Korean film-maker Park Kiyong sat down with *The Lumière Reader*'s Zhou Ting-Fung (an editor on *Moving*) to discuss the conception and making of his documentary response to the Christchurch earthquakes.

His previous feature films, *Motel Cactus* (1997) and *Camel(s)* (2002), are meticulous, minimalist observations of human disenchantment. Oscillating between monotonous despair and precarious expectancy, it is only by coincidence that the characters in Park's films stumble, for a brief moment, upon the possibility of hope, and though these moments might linger, they ultimately unravel and reveal themselves as nothing more than sad lament. His characters are resigned to their unhappiness.

Park's latest film is a documentary, *Moving*. It is made up almost entirely of a single interview with an immigrant Korean couple in Christchurch, who speak openly and affectingly about the extraordinary hardship of their life in New Zealand, their loss during the earthquake, and their spiritual struggle in coming to terms with that loss. Diverging from his previous films, *Moving* ends on a note of resilience, a thematic echo about that which sustains a migrant's existence: the hope for a better life.

Kiyong was in New Zealand on a sabbatical of sorts, having spent the last ten years as the executive director of the Korean Academy of Film Arts.

* * *

ZHOU TING-FUNG: What gave you the idea to make *Moving*?

PARK KIYONG: I first visited Christchurch in November 2010. I was there to do research for a film project I was trying to develop into a feature film. It was to be loosely based on the true story of a Korean family who had killed themselves earlier that year. The reason for this tragic suicide was unclear: possibly an outgrowth of many problems, ranging from financial difficulties to the sort of relationship crisis that many other immigrant families also experience. There were also vicious rumours about the evil Koreans behind the scene.

The family suicide was a compelling shock for not only the Koreans in Christchurch, but also for many, both immigrants and non-immigrants, all over New Zealand. So, I was there to dig up a heavy, dark immigration story. But as I explored the city, ironically,

I was completely smitten by its charm: the so-called Garden City of the South Island. Even though scarred with damage from the previous earthquake in September, it still looked graceful and charming in its austerity.

I was more than excited bouncing around with the idea of telling this terrible, shocking story set in such a tranquil and serene location. I returned to Auckland with enthusiasm. About three months later, on February 22nd, 2011, a massive earthquake, one of the worst disasters in New Zealand history, devastated my future would-be-filming-location.

While shattered by the enormous scale of the damage and casualties caused by the February earthquake, I remembered what I'd been told before by the local Koreans. Two earthquakes hit the Christchurch-Koreans in 2010. A physical one, the September earthquake, and a mental one, the family suicide incident. Now, they were overwhelmed by a third, incomparably more destructive than the previous ones. I decided to return to Christchurch.

This time, I wanted to see with my own eyes what had happened to the tranquil city that I'd fallen in love with. Above all, I wanted to find out how the devastating disaster had affected the lives of the Korean immigrants. I believed they would speak not only for the 4,000 Koreans in Christchurch, but for the whole immigrant community, and possibly everybody who has lived through the earthquakes in Christchurch.

I called my friend, a journalist for a local Korean newspaper. I called him every week, to find out what the situation was. Then in early April, he gave me a sign that it would be okay for me to come down.

I thought about how I should approach this story, how I would construct the documentary. I didn't want to make a conventional documentary about the earthquake, I wanted to try something new, and I had this vague idea to make a film essay. But I knew it depended on who I could interview. I didn't know who I would interview because all the interviews were being arranged by my journalist friend who was down in Christchurch. I only had this very vague idea.

I was disappointed when I first arrived in Christchurch because everything had been cleared out. The red zone, the downtown area, was barricaded and I couldn't get in. All I could do was walk around this barricade and look into the downtown area, which was seriously damaged.

When the interviews started, the interviews that my friend had arranged turned out to be very dull. Either very short or very dull. Almost everybody told me the same story. All they said was, we were doing something, and then the whole building was shaking, so we ran out, and that was it.

ZTF: You mentioned that what attracted you was Christchurch, this location or place. When you approach a film, do you usually start with an idea of a place?

PK: I think I could say that I start with the idea of a place. My first feature film as a director, *Motel Cactus*, the whole idea for that film started with a motel room and my second feature film, *Camel(s)*, also started with the location. One day I was passing by, I was actually driving on the highway, I saw this newly developed resort area by the west coast (of Korea). I knew about it, but I had never been there. I was just passing by on a winter afternoon, and I was curious about it, so I made a U-turn and spent a few hours there, just wandering around. I was very much intrigued by the location and I wanted to make a film there, so that's how that started.

I think it was quite similar with Christchurch. Of course, if there hadn't been an earthquake in February, I might not have made *this* documentary, but I still would have made *something* in Christchurch. I find Christchurch very interesting, in many ways. I like Christchurch—I had this feeling, this strange feeling, about the place.

Christchurch is the only place I visited in the South Island, so I can't compare it to the other cities in the South Island, like Dunedin or Invercargill. But the cities I visited in the North Island, Wellington, Tauranga, Napier, didn't interest me very much. Nothing was really special.

Even Napier was not really special, even though there's the Art Deco architecture …

ZTF: I'm very fond of Napier.

[Ed. Napier was the site of another large earthquake in 1931. The town centre was rebuilt in the Art Deco style.]

PK: I like Napier. But it was not as exciting as I expected. Firstly, it was too small, everything is contained in one block. And this Art Deco architecture – it's interesting, but not *that* interesting.

For Christchurch, maybe it's because I like European cities. I felt Christchurch was the most interesting. Its architecture, its atmosphere, everything – the Avon River, it's not really a river, it's a stream, but anyway, I found everything to be interesting. It stayed with me.

Also the name of the city, Christchurch. The city attracted so many Koreans, especially Christian Koreans, because of its name. They believed that because of its merciful name not a single person was killed even when struck by the dreadful September earthquake

ZTF: The film itself is very minimalist, very simple in its construction. Why did you decide to make the film in this way?

PK: Well, I didn't decide to make it in this way. It just happened. When I say I didn't want to make a conventional documentary, the reason I say this, or the reason I thought in this way, was because I wasn't sure I could make an interesting conventional documentary. I was a one-man band, and it was my first documentary, so I wasn't very sure about the construction, structure-wise, and also dealing with interviews. I believe in the opinion that one's style is the result of one's production circumstances and attitude of mind during the production. Since it was a one-man band production, I had to find my way of making this film, and *Moving* is possibly the best out of that condition. After I shot the interviews and images in Christchurch, until I came back to Auckland to edit, I wasn't really sure how this documentary would end up. I still wasn't sure about the interviews, but as soon as I decided I would only use the last couple, the structure came very naturally.

ZTF: I think it was very daring of you to have shot all these different interviews, and then to have decided to focus the entire documentary on just this one couple, and not just that, but to clearly have the documentary as a single seemingly uninterrupted interview. What gave you the courage to make that decision?

PK: Well I can't say it was courage; it was just a matter of choice. As I said, I was not sure about the story, but as the interviews were going on, I became worried, because the interviews were very dull. I can't make a documentary, a film, out of dull interviews. As the interviews went on, I was thinking, in my mind, what should I do? After day four or day five, I complained to my friend. I said, "I need to talk to you seriously." Until then I hadn't said anything to him about the interviews. So, we sat down at a Korean Restaurant for dinner, and I told him, all the interviews so far were unusable. He was shocked. He's not a film-maker, so I can't blame him. He thought that whoever he arranged, I could interview them and use them in the film. He thought nothing was wrong, that everything was going okay. I told him, "I'm in trouble." When I told him that, he said, "No, *we* are in trouble, because I told these people that

they would be in a film! If I go back and tell them that they won't be in a film, *I'll* be in trouble."

I told him: "You must find somebody else, because all the people I've interviewed so far are not interesting. They're good people, but their stories are not interesting." So he made some calls, and he found this young woman, a single mother. She was divorced recently. She was not willing to give an interview, but he pushed her very hard, because he thought a single mother was more interesting … The next afternoon, he brought me to her house, but she didn't want to give me an interview. We tried to persuade her for an hour, but she just wouldn't do it. She told me, you can't film me, but if you really want me to tell my story, you can record [the audio], but only my voice can be used.

So I did the interview with only [audio] recording. Of course, I couldn't use it. It's a documentary, I can't use this. Her story was much more interesting than the others, but still, not what I wanted. I complained to my friend again, and he was desperate to find somebody interesting for me. Then he found this couple. Actually, he didn't find this couple – he knew them before – but because their situation was so harsh, he didn't dare to ask them to talk in front of a camera. But as things were becoming quiet and I was becoming harsher on him, he thought, okay, why not give it a try? So he contacted this couple and surprisingly they agreed. I interviewed the couple on the day I came back to Auckland

ZTF: What attracted you to this couple? Do you think their experience is representative of the migrant experience, or do you think it is the exception, given how harsh what they describe is?

PK: Well, when I thought of making this film in Christchurch about Korean immigrants' experience of the earthquake, in terms of style, I didn't want to make a conventional documentary. At the same time, content-wise, I didn't want to tell a conventional story about Korean immigrants living in Christchurch and affected in this way by the earthquake. Of course, I had no answers because I didn't know who I would be interviewing.

The Jungs stood out of a few Koreans I have interviewed for the film. They were kind, strong, and ready to tell me about their life in Christchurch before and after the earthquake. As soon as they started to talk, it was obvious that they would be my heroes.

What attracted me to this couple was not only that they experienced this very difficult time as immigrants in Christchurch, but also, I think I should say, their ability for storytelling. Both of

	them [Jung Jin-suk and Lee Kyung-mi] are very good storytellers. They know how to tell stories. They were very open-minded, and didn't hesitate to tell me anything. When you listen to somebody, somebody's story, you immediately realize if this will be a good story or a bad story. And that's what happened to me when I was interviewing. As soon as the interview started, I knew it, "Oh this is it. This is the couple." I had to wait until the interview was over to be sure, but I was right. The interview was over after an hour and a half or two hours, and I was sure. As soon as I got out of their house, I smiled to my friend, and he was also very sure, because he was there.
	He was also listening to the interview, and he's a journalist, so he has a sense of what makes a good story. So he also knew that this was the best one, and he smiled back at me. So we knew that this was the story.
ZTF:	We've been circling around this idea of style, and what makes a conventional documentary. When I watch this film, it's almost like you've reduced the storytelling down to a single element, which is just someone talking – the sit down interview. Of course, sit-down interviews are very common in conventional documentaries, but you've used it to a very different effect, because you removed everything else. You've chosen not to use any photographs of their past life, you haven't asked them to take you to any particular locations that might serve as a narrative reference. As an audience, we only have what they say to make sense of the story. Why did you make the choice to do it like this?
PK:	Firstly, their two restaurants were in the red zone. I had no access to them. Actually, the morning of the interview, they did go to visit one of the restaurants, but even if I had known about it beforehand, it wouldn't have been possible for me to follow them because it was very restricted. Even if I was lucky, and I could have followed them and shot their restaurant, I'm not sure I would have used the footage. I didn't ask for any photos, and I didn't think of shooting the other parts of their house, because as I was listening to their story, I was pretty sure that their story tells everything. In their story was their past life, their present, and their future, everything. The characters were in the story, so there was no need for me to show other things, or other elements to add to that. Everything was there.
ZTF:	Why do you think that in many other documentaries, the director doesn't trust their subject in this way, just to be able to tell the story without relying on other elements, particularly in the editing?

PK: I don't know. All I can say is that this is my way of making a film. I don't know how this started, but my attitude towards film-making is to tell the story with [...] as [little] as possible. I don't know how this developed, but it's just [...] how I do it. In this way, I feel comfortable. If I add things – of course, every time I make decisions, I'm worried and I'm frustrated that this won't be enough. Later I might regret that I made the choice. But that's how I make films, I guess.

ZTF: So this is your first documentary. As you mentioned before, you've made two narrative feature films, *Camel(s)* and *Motel Cactus*. What were the challenges of making a documentary, coming from a narrative background? Do you think *Moving* is linked to your previous work?

PK: Well, I think there is a strong link to my previous work, even though it is a documentary. In what way? I think in terms of style. As I said before, so far I've made films in the way that makes me feel comfortable. This documentary also developed in that way.

I've made films, not only feature films, but also short films, without a script before, but it is quite different. Although *Camel(s)* didn't have a script, I had actors who I could make the story with. But with this documentary, I had nothing, all I had was this location and these images, and I wasn't sure how these images would work. Also, with the interviews, I also wasn't sure how they would be combined with the other images. Actually, until two or three weeks after I had come back to Auckland and had started editing, I wasn't sure if I could make this film, if I could finish it at all. Everything was uncertain.

That was the biggest challenge for me, having no script, nothing.

ZTF: Coming back to your previous two films, in relation to this film. Your two narrative films, I think they are very erotic films, very sexually charged. But sex, as you've portrayed in those films, isn't fulfilling. It doesn't seem to fulfil what these characters are looking for, and ultimately we're left with a sense of frustration, or maybe that engaging in sex doesn't adequately address the loss they are trying to fill. Thematically, do you think there's a link to *Moving*, which is about the migrant experience?

PK: I think so, because one of the reasons I was attracted to this couple is that they are failures. They're not successful. If they were successful, I wouldn't have been attracted to them. I like failures. My previous films, my narrative films, are also about failures. Failures in life, or failures in love, or failures in their relationships.

What I found interesting about this couple was that they were almost successful – successful migrants. Before the earthquake, they were a typical migrant success story that you might see in the newspapers, or on a TV programme. I wouldn't have made a film about them if the earthquake hadn't hit them.

They interest me because they are failures. They lost everything.

ZTF: What interests you about the idea of failure, or people who are failures?

PK: There are many more failures in the world than successful people. Normal people are failures in some way or another. There are very few successful people.

ZTF: So for you, film isn't a medium for escapism?

PK: Well, I like hard-working people. I like successful, hard-working people who have earned their success after years of hard work and trying very hard. I like that. As a person, I like these sorts of stories. But as a film-maker, these kinds of stories don't interest me. That's not my kind of film.

ZTF: *Moving* itself is very simple. It's just interviews with images of Christchurch undergoing reconstruction from the time you were there. In these purely visual sequences, my reading of the film was as if you're progressing through the possibilities of shot language. We start with something that is static, with static objects and no movement at all. Then in the next image, you introduce movement, and then human subjects and then eventually you introduce camera movement, with the long sequence from inside a car, and then you explore lighting as a visual element, by cutting abruptly from day to night. Did you plan to deconstruct the film in this way in your choice of images, and what do you see as the relationship between the visual sequence of images and the interviews?

PK: I didn't plan it, because I wasn't sure of anything. When I came back to Christchurch in late April of 2011 for shooting, the city had almost calmed down and most of the debris was cleaned up except for the downtown area. But that most heavily earthquake hit area was fenced around and off limits. I knocked about in the city for hours in search of interesting earthquake stories and strong disaster images, but all were in vain. Everyday – I was in Christchurch for one week – I'd wake up at 6 o'clock and sit in my hotel room drinking my first coffee, and I'd be thinking, "Oh shit, what am I going to do today? What will I do with this film?" Because I wasn't sure about anything, and the only thing I could do besides meeting my friend and going to the interviews, the only

other thing I could do was to go out with my camera and just find whatever there is, to find something interesting. So that's what I did, I walked around. As you know, downtown Christchurch is relatively small, so I was just circling around this downtown area. I couldn't go inside, so I was just walking around the red zone area every day. And if something interesting appeared, I'd just set my camera up and shoot it.

I became very friendly with the guards and soldiers because they would see me everyday, and they would ask me, "What are you doing here?" Shooting these motionless images. I told them, "Oh, this is my hobby."

I had come too late, and there wasn't much I could do with my tired legs, disappointed heart and little DSLR camera. The best I could do was to contemplate the devastated scenery across the fence over and over for long until I could come up with something; it could be a feeling, a story, or anything. I was so desperate that I had remembered reading what Paul Cézanne had done many and many years ago when drawing landscape paintings: "I just watched until my eyeballs were about to pop out from my head. Scenery thinks by itself within myself. I am the sense of the scene. Even the fragrance of an object could be seen."

As I went on shooting, I slowly got confidence that I'd be able to make a film with these images. I didn't have a concrete plan, but I thought that I should use long takes. For images that interested me, I would go on shooting, ten minutes for each image, each shot. I knew I could use a few minutes from this ten-minute shot. I became quite confident about this, but I was not sure how I would combine it with the interviews. That happened only later, when I was editing.

ZTF: When you got into the edit then, what determined your decision making process? Which images to use, how long to hold them for, and in what order you would put the images?

PK: I don't think there was any … rational reason [for this], it just happened.

I tried all kinds of things: this image, that image, here, there. And if this image feels comfortable, or right to me, in this part, then that's it. Something like that. There was nothing [like] a so-called plan. It just happened through the editing process.

It shaped up naturally to become an essay film as I combined their interviews with the lengthy scenery shots. I do not know how to define the boundary between an essay film and a documentary,

	I do not think it necessary, but actually *Moving* is a personal essay on what I have seen and felt in Christchurch then.
	The driving sequence in the film also happened in this way. Because everything was so motionless and still, I thought I needed something moving. So I asked my friend to drive me around and I shot this driving sequence. But because my friend was constantly talking, I couldn't use the sound. His daughter was in the back seat complaining, so I couldn't use the sound. The only way I could use these driving shots was the opposite – which means to use music. That's how it happened, naturally, moving in that direction.
ZTF:	The music in the film – you've used a lot of Erik Satie, and also one piece of original music composed by Jessica Tsai. It lends a different feeling to the images, it makes them somehow poetic and somewhat surreal. I think the music is the only overtly expressive element you've used in the film. How did you come to the decision to use music?
PK:	While in Christchurch, it rained everyday. I think there was only one sunny day. Most of the time, it was windy and rainy, dark and wet. Of course, while I was shooting I was very unhappy with this, because it was very uncomfortable to work alone in the rain. I had to hold an umbrella and also try to shoot. It was very very difficult. I complained, to myself and to the weather.
	Because everything was shot in this bad weather, everything was quite dark. When I was thinking of music, I didn't really think of using music much. For my previous narrative films, I had used music, but I had never thought that a film must use music. I always thought about making films without music, and of course, that is completely possible. For this documentary, in the beginning, I wasn't thinking of using music, because this is a documentary.
	But the so-called style [of the film] developed through the editing process, and very naturally, I thought of using music, and very naturally, I thought of Satie, because Satie is one of my favourite composers.
	Also, it is one of the few pieces of music I have on my laptop. I didn't have that much choice.
ZTF:	Speaking of style, let's talk about the forklift sequence. We start with the forklift being very loud, dismantling this building that has been damaged by the earthquakes. It's very noisy, but eventually, the music comes in, and then the forklift fades out, until all we hear is the music, and then silence. Very abruptly, the diegetic sound of the forklift returns. What inspired this sequence, and

PK:

ZTF:

PK:

ZTF:
PK:

what did you want to communicate with the surreal juxtaposition of image and sound?

The film is about the experience of the earthquake, but I didn't have any footage of the actual earthquake. I only had these shots of damaged buildings. I thought, I need something that gives the audience the feeling of the earthquake. Or, a feeling of this couple's experience of the earthquake.

I thought the only way I could show this – [to] give this feeling to the audience – was through this long forklift shot. From the beginning, I wanted to use this shot. I thought the shot could give this feeling.

At the same time, I wanted the shot to be interesting. While I was editing […] I thought it could give the surreal feeling of the mindset of this couple, going through all these experiences. To achieve that, I had to play with the sound. The real sound, the piano, and also the silence.

It's a very bold and formally daring sequence. What about the long driving sequence? It sort of echoes the ending of *Camel(s)* and more broadly, one of the stylistic continuities from your narrative work to this documentary, is your preference for long takes, without cutting. How did you develop this style, and what attracts you about it?

Long takes? I think […] I started to use long takes because I was not very comfortable with editing. I wasn't good at editing.

Or should I say, I was not good with scene breaking. When I was at film school, the most difficult and fearful part of film-making was scene breaking.

What do you mean by "scene breaking?"

Scene breaking means, breaking a scene into shots. Where should I put the camera for the opening shot, how do I break this scene into shots? That was the most difficult and fearful [thing]. It made me feel very uncomfortable.

Of course, I could deal with it in a conventional way. But that always made me feel, you know, not right. I was just doing what everybody [else] did. That was not interesting for me at all.

Then, later on, I encountered Hou Hsiao Hsien's films. I realized I could make a film without editing [laughter]. Just one scene, one shot, style. I was surprised, and I was also very much encouraged by Hou Hsiao Hsien's films. I don't know why, but I just liked them.

Later, I read somewhere that Hou said something quite similar to my experience. He was asked by the interviewer, "How did you

develop this style, using long takes?" and he answered, "Probably because I'm not a good editor." I don't know if this was his real answer, or if he was just joking, or teasing, but anyhow, I was introduced to this long take style through Hou Hsiao Hsien. Of course, Hou is not the only film-maker who makes films in this way, but from then on, I tried to copy Hou, or I felt encouraged to do something similar.

I like continuous shots without cutting, because I think that's real. When you edit a shot, you decide what the audience should watch. This part, that part. Of course, film is all about making decisions, but rather than cutting a scene into smaller and smaller shots, I liked the subtle, small details that accidentally happened, or unintentionally arise, during a long take.

Every time I use long takes – of course, I like them – but I fear that the audience will hate this. But the reason I use this method repeatedly is because it makes me comfortable.

ZTF: You've mentioned to me before, that after a screening of *Camel(s)*, Hou Hsiao Hsien approached you and said, "That was a bit slow, wasn't it?"

PK: Actually, he said to me, "The takes were very long!" I told him, "I'm just learning from you!"

"No, your shots are much longer than mine!"

ZTF: What you were saying about the accidents or coincidences that happen during a long take, we can see in *Moving* as well, in the way the light changes over the course of the interview. This was something you hoped for?

PK: Sure. Well, I can't say that I hoped that it would happen, but I liked that it happened. I can't say I expected or looked forward to it happening, but the result is, I liked that it happened.

ZTF: Do you consider yourself a Korean director? Even after coming to New Zealand, your subject is to do with Korean immigrants.

PK: It's strange, because when I was in Korea, I never considered myself a *Korean* director, I only thought of myself as a director. I thought I could make a film anywhere.

But my experience of living in New Zealand for a year and a half makes me think, perhaps I *am* a Korean director. Now, I'm not so sure that I can make *anything*, that I can make a film *anywhere*. Probably because my experience in New Zealand has made me think in this way.

Before, I thought I could understand people *other* than Koreans. If I go to England, I would understand the English, if

I make a film in Germany, I would understand Germans. That's what I thought.

But I found out it was much more difficult; it was much more complicated than I thought. So at this stage, I don't know. I can't say that I can make a film about just anything, or anywhere.

ZTF: As a migrant here, do you sympathize with some of the feelings or experiences the couple in your film talk about? Obviously, your situation is different …

PK: Possibly, in some ways. I'm not an immigrant, but we're the same generation. Our ages are very similar.

ZTF: *Moving* is probably one of the more challenging films in the documentary section of the 2011 New Zealand International Film Festival, especially for a film that has been produced in New Zealand. How do you feel about that?

PK: [Laughter]. Well, I never intended to be this difficult person, or this difficult film-maker, or someone who makes difficult films. It just happened that way. Sometimes, I kind of feel sorry about this. I want to be able to show my films to my parents, to make them happy, to make them proud of me, but until now, I couldn't do that.

But the thing is, I can't lie. I make what I am. So this documentary is what I am in 2011, in New Zealand. If I made this documentary as [someone] who only visited here for a short time, then things would be different. It's because I was here, I was living here for more than a year, not as an immigrant, [that] maybe I felt […] what the situation of an immigrant is. I felt more affected by this story. I think I sympathize with the story more than just a visitor.

ZTF: You came here with an established reputation in Korea. What's your perspective on the film industry in New Zealand from your time here so far?

PK: Unfortunately, I haven't experienced as much of the New Zealand film industry, or film-making in New Zealand as I expected, because I wasn't given the chance. I regret that, but in that sense, I can't say much about the industry.

[With regard] to what I felt and what I saw during the year and a half I stayed in New Zealand […] Before coming here, I knew something about the industry because I had worked with the industry [from Korea] on several occasions.

I expected the people in the film industry to be more daring, but I was disappointed. I can't really say what the reason is, but

the films that I saw from here, I mean old films, like *Goodbye, Pork Pie* and also the early films made by Roger Donaldson, were very daring. They had an independent spirit and were very interesting.

But recent films, they don't have that spirit, that kind of indie spirit, which I think the New Zealand film industry really needs, because this is a small country, with a small population. The industry, if you take out Peter Jackson, is really nothing. So without this spirit, how can you survive?

Chapter 16

"What I Really Saw Could Not Possibly Be Reflected in a Movie": Abbas Kiarostami on *Life and Nothing More* …

Translated by Hossein Najafi

Hossein Najafi: I am researching the impact of the earthquake in Iranian cinema and literature. You were in direct contact with earthquake victims [in Koker]. As an artist and film-maker, how do you see the role of the earthquake in Iranian art?

Abbas Kiarostami: Well, that's not my job. I can just tell you about the experience of my journey to the earthquake zone. I was only there for a day. I have shown what was possible in *And Life Goes On …* because what I really saw could not possibly be reflected in a movie. The title of the film says it all, *And Life Goes On …*

I had some preconceptions before traveling to the area but when we got there, my thoughts completely changed. It was just me, my son and three other companions. We couldn't find the children who played [the main characters] for us in *Where Is the Friend's House? …* it was so disheartening. The area was completely devastated and I knew that most of them were dead. But, in the end, we returned home with very positive feelings. It was the same feeling we all experience when we go to a funeral ceremony; we return and unconsciously a sense of life has been intensified within us. We all know this feeling well. Even those who have not experienced a natural disaster can understand this feeling; in that respect, the death of a single human being is not so different from the death of many. Upon returning from a funeral, all of us have had a feeling of exhilaration which cannot be expressed but is somehow embedded in the ceremony for the dead. Laughter, for instance, is something I've personally experienced at these ceremonies. Someone will suddenly laugh, unable to control themselves, an uncontrolled rare laugh which actually affirms life, and reminds us that time is going so fast and you have to grasp life. Death is closer than your eyelids. This is what I got out of my visit to the area, not as a film-maker but as a normal human being who went there to see what happened. I've tried to show that in the movie.

Whenever something like an earthquake happens everyone tries their hardest to initiate life once more from the beginning, to remove the traces of the disaster as fast as they can. They bury the traces,

pour soil over them and try to begin life again. I've tried to show that in the movie. The old lady whose husband has recently passed away is trying to roll out her carpet and find her kettle to make tea … she hasn't had a cup of tea for three days. There were many other scenes like this that I couldn't show in the film. I don't remember them all because it's a long time since I've seen the film. Wherever you looked there were signs of the victory of life over death.

There is a verse in *the Quran*, some parts of which I still remember: "when the earth is shaken with a mighty shake, when the earth brings forth her burdens, and Man says What ails her?, upon that day she shall tell her tidings" [*The Quran*, Sura 99]. When the earthquake happens, the dead are expelled from their graves; they all have their own stories. I saw many who could save themselves but couldn't save their children. It was unbelievable. A column fell on two brothers, one managed to save himself and the other died. The mere sense of life moves you to save yourself yet the one who can't is sentenced to death. This was shocking. The verse in *the Quran* says that those are convicted to death. They discover the truth that is *And Life Goes On*.

HN: What scenes or images didn't you show? Are there stories which only you can tell?

AK: There was a scene that's still stamped in my mind. A crowd of people were standing around laughing. We asked what happened and they answered in loud hostile voices that this bastard guy who'd lost three children and his house and everything he had, well, now he was making love with his wife in their tent. They saw them doing it early one morning. A couple of those teenage hoodlums beat him up. They didn't understand that this was truly a part of life. You've lost your children but your wife is alive and, without noticing it, the sense of being alive, the celebration of understanding that you are alive, will rise up in you. This is the sense of survival, a desire to make other kids. There's a poem that says "I'm returning from a funeral and I want to make love with the one I don't know." They were treating him very roughly. The wind had blown his tent down and they were caught in the act. They wanted them to put the tent back up further away from everyone else. It was a great scene! Regretfully, I couldn't put it in the movie but I loved the story and the way those people couldn't understand what was going on.

In another way, the character "Hossein" in *Under Olive Trees* says "let's marry as soon as we can because we may die in the next

earthquake." We are threatened by death so we have to embrace life. The ceremonies for remembering the departed are held after three days, seven days, then forty days. During this period relatives try not to celebrate a wedding because the time for mourning hasn't ended. But Hossien says, "Let's marry soon because death is threatening." This was a true story. After *And Life Goes On* I decided to work on this story, it became *Under the Olive Trees*.

I received all these ideas and impressions from the people and the place. I had no story in my mind and no preconceived ideas. Everything came from the impact made upon me by the people I met, like those two girls washing dishes next to a river. The desire to live was so evident. Just a portion of it was reflected in the movie. It's the same everywhere. Whenever an earthquake happens they screen these two movies of mine. I was invited to a Japanese festival, when I went there I saw that the Japanese, who had also experienced the earthquake, could deeply understand my films … it was so obvious that this desire is the same everywhere. There are no cultural differences and whenever death threatens people, the desire to live creates such energy in them that they really become powerful creators and innovators. Look at the tsunami. I was about to make a film in Japan but a week before that the tsunami happened. Shooting was cancelled and I thought, "[W]e're not going to make this movie anymore." A year later they invited us back. I saw that all the signs of the tsunami had been cleaned up and cleared away. Of course some part of that is due to the spirit of Japanese people but any disaster anywhere creates a force in people to move on and remove any traces of the catastrophe.

HN: This sense of life is evident in your other works. In your short film *The Ducks,* when the water moves the eggs of a duck, I was so overwhelmed by the sense of life in them.

AK: Oh, yes, that's right, that's so true. I remember in the days after making *And Life Goes On*, I used to say the same thing … I'd say "I won't make any other films except *And Life Goes On*" … every time, a new form of the same narrative. It's true. We're living in a country where death is more highly valued than life. Everything ends up in death, it's one big deathbed. This applies to the people too, they are praised after they die, but wherever I look, I only see life.

HN: Years after the Manjil earthquake we had the Bam earthquake. Do you have anything to say about that?

AK: Well, no, one is enough in my opinion. Seyfollah Samadian, a good friend of mine, has travelled to Bam a couple of times and made a very good film about it. I view the Manjil and Rudbar earthquake in the same way as Japan's earthquake. Even the BouinZahra earthquake, which happened forty years ago, is the same to me, naturally, as Bam. They're all the same. I don't have anything to add. I don't need to look at it regionally, because, in that case, I'd have to refer to statistics and numbers, who provided aid, the refugee camps, the problems etc. That's not my primary concern.

HN: In Hollywood disaster movies, people scream and run and trample over each other to save their own lives but in your film and in Iranian cinema in general, we tend to see a more humanistic approach …

AK: I don't know, you to have to discover that for yourself. Even now if you go to Manjil and Rudbar, people have lots of original stories. All of them, even if they're uneducated, will tell you many philosophical narratives. Their sense of life and their escape from death are wonderful. I was very severely criticized by the critics here [after *And Life Goes On*]. One of those profound critiques caused me a lot of problems; it was written by one of the religious critics, the one who was killed by a mine later on [Morteza Avini, an Iranian war photographer, documentary film-maker and critic]. He wrote that my film was not humanistic. He questioned whether it was possible for someone to get married a few days after an earthquake. He didn't get my message at all. He himself was one of those who married when he was very young. Marriage is not something forbidden. I was scolded so much about this movie because of the naked truth I had shown. The truth was so blindingly obvious that I didn't make anything up myself.

As I said, there were plenty of other things I couldn't show. The man with the broken arm who was trying to set up his antenna to watch the football match was really real. I saw him with my own eyes. We recreated that scene later on. Actually most of the things you see are recreated. Let me tell you something unbelievable that I also saw with my own eyes. I was taking photos of the ruins and, accidentally, I saw an old man sitting amongst the rubble masturbating! He was around seventy or eighty … his penis was stretching like a rubber hose … he wasn't even horny but he was trying hard to arouse himself under the hot sun. I couldn't believe my eyes so had to look twice just to make sure. I asked myself, "is this for real?" I looked again and, yes, it was real … here he

	was, an old man amidst the rubble, literally with one foot in the grave, trying to relive the joys of better days. I remember him very clearly. He was so skinny, he had on a pair of baggy boxer shorts. It wasn't something I could easily forget. We arrived in the area the third day after the earthquake. There was still lots of dust in the air. The helicopters were still flying around. All of the victims hadn't been found yet. Imagine, in that situation I saw this scene. I wish we had better film-making conditions in Iran then I could show scenes like this. I didn't say or show anything like this and still got mauled by the critics really badly. Oh, who was that man?!
HN:	I think he was Morteza Avini.
AK:	Yes, he wrote a very bitter and devastating critical article on my film. I was blamed for being heartless. Well, in those days, at that time, everyone was pretending to be radical in order to try to seem closer to the regime. He wasn't a film-maker; he wasn't even as Muslim as me. He was an opportunist. But I was hassled a lot because of this article.
HN:	It's so long ago. I don't remember clearly but maybe I read that article 12 years ago.
AK:	If you find it, include it in your research. It's so revealing. It's a great critique! You know, we're living in a country of falsehood and pretence. Self-censorship is rife. Even those in front of the camera or the microphone change their manner and become someone else. They put on a mask and hide their true selves. It's an important subject to expose.

Chapter 17

Tres semanas después/Life Goes On

José Luis Torres Leiva/Translated from Spanish by Stephen J. Clark

I was at home when the quake struck. We suffered no major damage, so it didn't seem very remarkable to me, especially since I don't have a fear of earthquakes. In 1985 it was a different story. I was in a supermarket, in broad daylight, and it was much more dramatic. I remember there was a cashier overcome by a panic attack, and it was the first time that I saw someone get slapped in the face to make them calm down, just like in the movies. Everything came crashing down. I remember the sound, the smell.

At first, I followed the earthquake on television, but the coverage struck me as pornographic. It focused on titillation, splashy headlines and sound bites – a war among the channels to see who could get the most spectacular shots. Even the residents of the affected areas failed to grasp the reasoning behind such coverage. In Constitución we were told that the first people to arrive were journalists. They would come in by helicopter, do their reports and then take off. At that moment, people were in desperate need of assistance. The news focused on the building that collapsed in Concepción, but in Talcahuano there was a devastating tsunami that received much less coverage in the media.

I had no plans to make a film about the earthquake. Some friends of mine made videos that they uploaded to the Internet. I had done some of that myself, but not anything related to the quake. I filmed a friend, the actress Gabriela Aguilera, who had recently had a baby, but I wasn't interested in doing anything directly related to the earthquake. A girl that I knew from our schooldays died in Constitución during the quake. So, more than anything, that project was dedicated to her. It was my way of dealing with her death.

Fernando Prats and I have a mutual friend who lives in Barcelona, as does Fernando. Before the quake, we were about to work together on another project in Chaitén. The themes of his work deal with the changing geography of Chile. In fact, he has a project based on the earthquake of 1960. Our plan was to document the art that Fernando would create in Chaitén, but we never managed to coordinate our schedules and he ended up working with the photographer Enrique Stindt.

When the earthquake struck, Prats was here preparing an exhibition in Valparaíso. He called me because this was his sort of topic and he wanted to do something, but nothing elaborate. Basically I set out to document his process, what he does: he blackens some special papers, puts them on the cracks in the ground and makes an impression. My task was to document that procedure, which is where the possibility of a joint venture arose. The idea is for the documentary to be part of his exhibition.

It all happened very fast. He called me two weeks after the earthquake, and three days later we headed south. There were still plenty of aftershocks down there. We travelled in a ramshackle van with a driver who was very familiar with the area. Our first priority was to get to Talca and then focus on seeing whatever interested us the most. We arrived along the coast and travelled through all the small towns. It took us a long while to reach Talca because of all the detours, and there was practically no place to stay. But as we got closer, we had no problem finding lodging. On our first day in Talca we were able to stay in some cabins, thanks to a friend. The last day we were in Coronel, we stayed in a motel, but in between we only stayed in private homes. In Constitución, we were hosted by townspeople. There was a collaborative atmosphere, and in that sense, we never had any problems finding lodging.

The deeper we penetrated into the areas most affected by the earthquake and tsunami, it was as if time stood still, even though it had been a while since the events. Nevertheless, the people tried to stick to their daily routine in the midst of the devastated landscape that surrounded them. That was really hard to watch. And the closer we got to the epicentre, many more people would come up to talk; such was their need to share their experiences.

But I wasn't interested in recording personal testimonies. I didn't really have a clear idea about what I was going to do, but I did know that I wanted to do something with the landscape. I wanted to show how such places change violently, and what they will become later. It was a reaction against what was being shown on TV, and to me it was also was more important to try to reflect what had occurred by way of the landscapes.

I was only familiar with certain parts of the route, such as Constitución. It was overwhelming to see the devastation. Destruction was everywhere; nothing was left standing. A lot of places were closed off, including Dichato, and we needed a pass to enter. The soldiers themselves told us to be discrete because the residents were fed up with being filmed. We were even warned that in some places people were throwing stones at videographers, but we never saw anything like that.

I brought with me a camera that had its own microphone. Post-production was handled by Roberto Espinoza. He did great job in improving the sound quality since there were a lot of sequences in which only the wind could be heard. But he was very faithful to the original material. I wanted to respect the tone of the moment, but Roberto provided a unity of sound that was lacking during my editing, and that proved to be vital.

At the beginning of the film, I decided to include a sound lasting the duration of the actual earthquake, with the screen totally black. So Roberto made a video using low-frequency sounds. So when the film is shown, the whole theatre shakes, which functions as a sort of preamble for the viewer.

The first time I saw the documentary was when I screened it at the FIDOCS (the Santiago International Documentary Festival). I had just finished it. Then I showed it in Marseille. People were very curious about the earthquake because very little information was available in Europe. After two days of coverage, there had been no additional reporting on it. It's the same thing that happens to all of us when there's an earthquake far from where we live.

The work Prats had done on the 1960 quake was based on a novella by Heinrich von Kleist, "The Earthquake in Chile," which is about the great quake of 1647. Using films and photographs from the 1960 quake, Prats reflects on the idea of the disappearance of social classes after the quake, which was an implicit reality in all the places we visited ourselves.

I didn't have a great deal of material to work with. I made an initial edit while recording the film, in chronological order. I was faithful to the journey we took, from Talca to Lota, and that was the storyline of the documentary. I wasn't concerned with pointing out which places we were visiting. For me the journey itself was the most important element. I don't think it was too important to identify specific places. All told, I worked from March to the end of May. It was fast. I'm not used to working at such a pace. Usually my process in making a film is much more deliberate. But this was a different sort of process given that Fernando Prats needed the material and because of the opportunity to screen the film at FIDOCS.

It always takes me a long time to finish a film. I spent about a year making *Ningún lugar en ninguna parte* (*No Place Nowhere*): two months taking pictures and talking to people, and then ten months of filming. Now I've been researching *Ciego, sordo, mudo* (*Blind, Deaf and Dumb*) for about a year, and it'll take me another year to film it.

For the tracking shots, I mounted a tripod in the van and filmed from the back seat. The first time I did this was in Constitución, which is on the coast. I wanted to capture the dimensions of the trail of rubble that goes on forever. It was tough going for the driver because the road was very rough. He had to avoid the rubble and cracks, and the pavement was very uneven. But he managed to drive along at a perfect speed for filming.

I hadn't filmed on my own since *El tiempo que se queda* (*The Time That Rests*). Working with a team is a very different experience. In this particular case it was good to be on my own because I was able to film whatever caught my eye. And since I was pre-editing as I filmed, I tried to focus on details. With a team it would have been much more difficult.

I included residents in the Cobquecura scene, the city that was right at the epicenter. There was no tsunami, but the quake was very strong. At night Cobquecura would turn into a ghost town as the people would leave to sleep up in the hills. But the atmosphere there was very different than in other places, such as Dichato, where there was a lot more tension in the air. In Cobquecura the people were very kind, always concerned for their neighbors and eager to help each other out. This really struck me, which is why I filmed these people. For example, I recall a woman sitting in the sun outside her house and chatting in a casual, everyday fashion with a man who lived nearby.

I don't consider it an act of opportunism to have made this documentary, although such judgments depend on one's point of view. Kiarostami made *And Life Goes On* after an earthquake, yet his film is not considered opportunistic because it also speaks about other things. Nor was it my intention to take advantage of contingency. Contingency generally doesn't motivate me; it was the circumstances surrounding this project that motivated me to undertake it. And in a certain way, I believe it's related to the other projects I had done previously. So I didn't feel out of place. I believe this film continues my keen interest

in centring films on landscapes. What interest me are places, atmospheres, textures, and sounds; I take all of that and create something out of it.

We arrived just when the landscape was being destroyed so that everything could eventually return to normalcy. I'm referring to all the houses that were being demolished, or to the burning of rubble. It was another type of destruction, and I think the documentary revolves around that idea: for something new to emerge, people must engage in destruction. The geography of Chile is a direct result of earthquakes. In Puerto Saavedra, the sea has engulfed a section of land where part of the town once stood. We have to get used to such geographic changes. There is no doubt that something will be reborn there again.

The shot in Talca was very meaningful to me, the one in which the main street was totally destroyed and people were going to work like on any other day, but they had to march through the rubble to get there because life must go on. In Dichato, there might be little work and a lot of destruction, but people get on with their daily lives.

The feeling I was left with after making the documentary is still with me: that the earthquake is something that's not going to end there, it's going to keep reverberating.

Tres semanas después is a documentary that is part of the 8.8 project by the Chilean artist Fernando Prats. It was filmed three weeks after the earthquake in the regions of Talca, Curepto, La Pesca, Rancura, Ilosa, Duao, Constitución, Cobquecura, Pellhue, Dichato, Talcahuano and Lota.

Many thanks to Jorge Morales and José Luis Torres Leiva for permission to reprint the article which first appeared in *Mabuse: Revista de Cine*, vol. 86. http://www.mabuse.cl/cine_chileno.php?id=86466.

Notes on Contributors

Joel Neville Anderson is a film-maker and scholar working in independent cinema and visual culture. He is completing a Ph.D. in the University of Rochester's graduate program in Visual and Cultural Studies. Joel has worked with the Museum of the Moving Image, Jacob Burns Film Center, Purchase College, the New School, and DCTV. He curates JAPAN CUTS: The New York Festival of Contemporary Japanese Cinema, and co-programs Rochester's avant-garde film series "On Film." He served as Managing Editor of *InVisible Culture: An Electronic Journal for Visual Culture*, and regularly publishes essays in the *Directory of World Cinema* series.

Axel Andersson is a writer and critic whose work deals with the intersection of cultural history and media theory. He studied at the University of Edinburgh and the European University Institute in Florence and is the author of *A Hero for the Atomic Age: Thor Heyerdahl and the Kon-Tiki Expedition* (Peter Lang: Oxford, 2010). He has written on Michelangelo Antonioni in *The Cinema of the Swimming Pool* (Eds. Christopher Brown and Pam Hirsch), and 'Technological Metafiction: Recursive visual culture in the cinema of the late 1990s' (*Film International*, Vol 12, No 2, June 2014).

Yuri Averof has studied Anthropology and Sociology and has researched, produced or directed more than thirty documentaries for the award winning series "Reportage Without Frontiers", broadcast by ERT. He is a founding member of Anemon; an Athens based non-profit company dedicated to making films that promote inter-cultural and historical understanding, human rights and sustainable living. His projects have received numerous awards and have been screened at many festivals and on various international television channels. *Earthquake* is available at http://www.anemon.gr/films/film-detail/earthquake

Alex Bates is Associate Professor of Japanese Literature and Film at Dickinson College. His research is focused on representations of the 1923 Great Kantō Earthquake and his interests have expanded into Japan's 2011 earthquake and tsunami disaster. Other research interests include ecocriticism, urban modernism and early post-war Japanese literature and film. His book on the Great Kantō Earthquake is forthcoming from the University of Michigan Center for Japanese Studies Press.

Giorgio Bertellini is Associate Professor in Screen Arts and Cultures and Romance Languages and Literatures at the University of Michigan. His books include a monograph on Bosnian director Emir Kusturica (Italian Ed. 2011; English. Ed. 2015) and the award-winning *Italy in Early American Cinema: Race, Landscape, and the Picturesque* (2010). He has published numerous essays on questions of geographic, racial, and national difference in Italian and silent cinema. Recently he edited *Silent Italian Cinema: A Reader* (2013), a Finalist for the *2013 Richard Wall Memorial Award* (Theatre Library Association, New York).

Steve Choe is an Associate Professor of Film Studies at the University of Iowa. He is the author of *Afterlives: Allegories of Film and Mortality in Early Weimar Germany*, published by Bloomsbury. Choe researches and teaches courses on German cinema, South Korean cinema, and topics in film theory, philosophy, and phenomenology.

Stephen Clark is Professor of Spanish and Program Chair for Languages and Spanish at California State University Channel Islands in Camarillo, California. His scholarly work as a critic and translator focuses on Latin American literature and includes Denzil Romero's *Belated Declaration of Love to Séraphine Louis* (1999), Emilio Bejel's *The Write Way Home: A Cuban-American Story* (2003), Leonardo Padura's *Faces of Salsa: A Spoken History of the Music* (2003) and Fernando Fabio Sánchez's *Artful Assassins: Murder as Art in Modern Mexico* (2010).

Kevin Fisher is a Senior Lecturer in the Department of Media, Film & Communication at the University of Otago, New Zealand. His research interests include phenomenology, special effects, audio-visual analysis, and documentary. His essays have appeared in *Meta-Morphing* (2000), *Cinephilia in the Age of Digital Reproduction* (2008), *Māori Media in Aotearoa/New Zealand* (2013) and *Science Fiction Film & Television, The New Review of Film and Television, The New Zealand Journal of Media Studies,* and *Refractory*.

Antonia Girardi is a researcher and teacher, graduated in Aesthetics at the Catholic University of Chile, with a Diploma in Film Studies at the same university and Masters in Latin American Studies from the University of Chile. She is co-author of *The Brand New Chilean Cinema* (2011) and member of the staff of editors of the magazine lafuga.cl. Her research addresses the contemporary documentary film, specifically in Latin America, and its relations with themes such as subjectivity, landscape and territoriality.

Abbas Kiarostami has been making films since 1970, including shorts, documentaries and feature films. Kiarostami attained critical acclaim in the 1990s for directing the Koker trilogy, *A Taste of Cherry*, and *The Wind Will Carry Us*. His most recent film is *Like Someone in Love* (2013). He is also a poet, photographer, painter, illustrator, and graphic designer.

Park Kiyong is a South Korean writer, producer, and director. His first feature film, *Motel Cactus* (1997) won the FIPRESCI Award at the Rotterdam Film Festival and the

Jury Prize at the Fribourg International Film Festival, and was an Official Selection at Berlin and Sundance. His second film, *Camel(s)*, was awarded the Grand Award at the Fribourg International Film Festival. In addition, Park Kiyong has served as the executive director at the Korean Academy of Film Arts for almost ten years, as deputy dean at the Asian Film Academy, and as co-director of the Cinema Digital Seoul Film Festival.

Jinhua Li is Assistant Professor of Chinese Studies and Language at the University of North Carolina Asheville. She received her Ph.D. in Comparative Literature from Purdue University, specializing in comparative cinema studies, transnational cultural studies and gender politics. Dr. Li's research focuses on gender politics in contemporary Chinese cinema. She has published several journal articles, book chapters and reviews on the subject and is currently working on a monograph.

Allen Meek is a senior lecturer in the School of English and Media Studies at Massey University, New Zealand. He is the author of *Trauma and Media* (Routledge 2010) and *Media, Catastrophe and Biopolitics* (forthcoming 2015). His research is concerned with natural history and biopolitics as conceptual frames for understanding the media representation of catastrophe.

Stephen Morgan is a film historian interested in notions of national (and transnational) cinema and cultural identity, particularly the relations between British and Australian cinema, society and culture. His research has appeared in *Ealing Revisited* (BFI/Palgrave), *Studies in Australasian Cinema*, *Australian Studies*, *Directory of World Cinema: Britain* (Vol. 2) and *World Film Locations: Sydney*. He is an AHRC doctoral candidate at King's College, London.

Hossein Najafi graduated in Cinema from the University of Tehran and has worked as a lecturer in Iran and Turkey. His research interests include Iranian Cinema, Literature in Film, Cognitive Psychology and Digital Media. He is active in film production and has worked with major Iranian and Turkish directors. As an animation and visual effects artist, he has explored his artistic and academic research in a series of interdisciplinary projects about digital cinema, interactive media and digital storytelling.

Nora Niasari was born in Tehran, Iran, and is based in Melbourne, Australia. Nora obtained a Bachelor degree in Architecture from the University of Technology, Sydney in 2010. Her films explore the intersection of documentary and fiction. Exile, identity and memory are the main themes of her work. Nora's short films have screened at film festivals in Australia, Chile, Mexico, Lebanon, France, Portugal and the USA. She recently completed the Masters in Film and Television at the Victorian College of the Arts (VCA). For recent projects, including *Talca Interrupted*, visit: www.noraniasari.com

Eija Niskanen is the Artistic Director of the Helsinki Cine Asia film festival and coordinator for the Finland Film Festival in Japan. She teaches film, animation and Japanese popular culture at University of Helsinki where she is a Ph.D. candidate in the Department of World Cultures.

Ozge Samanci is an Assistant Professor in the Department of Radio, Television and Film at Northwestern University. Formerly she was an Andrew Mellon Postdoctoral Fellow in the Art Practice Department of the University of California, Berkeley. Samanci has an extensive background in comics and media arts. Her interactive-digital media installations and other collaborative works have been exhibited in many international venues. She is the author of *The Irresistible Rise of Animation*, (Istanbul Bilgi University Publications). Her autobiographical graphic novel, *Dare to Disappoint*, will be released in November 2015.

José Luis Torres Leiva won the distinguished Fondart State Award for his 16mm short film *Los Muertos* (1998) at the age of 23. Since then he has made several critically acclaimed independent videos, including *No Place Nowhere* (2004) and *The Time that Rests* (2007). *The Sky, the Earth and the Rain* (2008), for which he received support from the Hubert Bals Fund, was his first fiction feature.

Alan Wright teaches Cinema Studies at the University of Canterbury, Christchurch, New Zealand. He has published essays on Godard, Kluge, Tarkovsky, Kenneth Anger and New Zealand film. His film *Scuppered* was screened at the International Documentary Festival CRONOGRAF in the Republic of Moldova.